Teaching Art

A COMPLETE GUIDE FOR THE CLASSROOM

RHIAN BRYNJOLSON

PORTAGE & MAIN PRESS

Portage & Main Press gratefully acknowledges the financial support of the Province of Manitoba through the Department of Culture, Heritage, Tourism & Sport and the Manitoba Book Publishing Tax Credit and the Government of Canada through the Book Publishing Industry Development Program (BPDIP) for our publishing activities.

Printed and bound in Canada by Friesens

Cover and interior design by Relish Design Studio Ltd.

LIBRARY AND ARCHIVES CANADA CATALOGUING IN PUBLICATION

Brynjolson, Rhian
 Teaching art : a complete guide for the classroom / Rhian Brynjolson.

Includes bibliographical references and index.
ISBN 978-1-55379-195-9

 1. Art--Study and teaching (Elementary). I. Brynjolson, Rhian.
Art & illustration for the classroom. II. Title.

N362.B79 2010 372.5'044 C2009-906816-8

PORTAGE & MAIN PRESS

100-318 McDermot Ave.
Winnipeg, MB Canada R3A 0A2
Email: books@pandmpress.com
Toll free: 1-800-667-9673
Fax free: 1-866-734-8477
www.pandmpress.com

ENVIRONMENTAL BENEFITS STATEMENT

Portage & Main Press saved the following resources by printing the pages of this book on chlorine free paper made with 50% post-consumer waste.

TREES	WATER	SOLID WASTE	GREENHOUSE GASES
37	16,787	1,019	3,486
FULLY GROWN	GALLONS	POUNDS	POUNDS

Calculations based on research by Environmental Defense and the Paper Task Force.
Manufactured at Friesens Corporation

Mixed Sources
Cert no. SW-COC-001271
© 1996 FSC
FSC

This book is dedicated to young artists and their teachers.

ACKNOWLEDGMENTS

I would like to thank all of the very talented, hard working teachers and artists with whom I have had the privilege of working, and who have generously shared teaching strategies and ideas.

Thanks especially to Joe Halas who wrote the foreword and to the Spotlight contributors: Cheryl Zubrack, Catherine Woods, Jennifer Cobb, Briony Haig, Olivia Gude, Cam Forbes at Art City, Ann Rallison, Cameron Cross, Jen Kirkwood, and John Barrett.

Thanks also to Andrea Stuart and Donna Massey-Cudmore who continue to teach me through their good examples and dedication to child-centred education.

Thank you to all of the students whose works appear in this book – these young artists and their teachers generously shared their artworks with me.

Thanks to my family: to Noni and Iain, for their earlier artwork, to Noni for recent contributions as a researcher and art historian, and to Dale for the background music.

Thank you to editor Leigh Hambly for supplying guiding questions and careful attention to detail. Thanks also to Marcela Mangarelli for managing hundreds of photographs.

CONTENTS

ARTFUL LEARNING CHANGES EVERYTHING

"Consider that the goal of art education is to support, nurture, and inspire the growth of every student as an *artist* and as an *artful learner*."
— Manitoba Education, Citizenship and Youth (MECY) 2007

By implication, one could extend the preceding ideas and say that the goal of art education is to essentially transform the way most students learn, most teachers teach, and most schools function. Now, *that's* a goal!

The Student as Artist

If we are to view our students as developing artists, then we must also view ourselves accordingly as providers of varied, regular, and ongoing opportunities that allow our students to *be* artists. This would include supporting students in becoming adept at exploring and using artistic media to communicate. As well, we would have to help them constantly improve their ability to see: to observe sensitively and respond thoughtfully to both the work of other artists and the visual world in which they live. Art education, at its core, is about helping our students understand and use a visual aesthetic *language*. Becoming an artist means becoming artistically literate. In this regard, learning in art provides both an alternative and a powerful complement to students' developing verbal skills and other language systems.

The Student as Artful Learner

To view our students as *artful learners* is to consciously support them on a path toward constructive self-direction, toward enabling them to think for themselves (and sometimes to stop ourselves from thinking for them). Of course, in art, *thinking* is a form of *playing* – imaginatively and intellectually, as well as through the physical hands-on exploration of media. As students become artful learners, classrooms become purposeful, creative playgrounds, and this holds for learners of all ages and levels.

The artful learner is able to use artistic processes to connect to, deepen, and express ideas that may be drawn from other disciplines. Artful learning, therefore, blurs curricular boundaries and encourages "bigger picture" thinking. Artfulness can make learning lively, profound, and often deeply enjoyable. A commitment to artful learning can indeed transform everything.

"Fine, but what I want is something I can do with my students tomorrow!"

So how does profound artful learning occur? How do we, as educators, begin and sustain the work of supporting, nurturing, and inspiring the growth of every student as a young artist and artful learner? How do we open ourselves to the positive transformation of schools that quality art education can potentially bring? And, big picture stuff aside, what are the small steps? What can we do *tomorrow*?

The answers to the above questions will vary – depending on one's educational background, experience, and teaching situation. There are skilled art teachers in many of our schools, but also, particularly in early and middle years, many more teachers who are expected to teach art with minimal or no art training whatsoever. For all of the above, but particularly for the latter group, good art teaching resources are essential. The best resources are practical and easy to use, but are, at the same time, attuned to the larger goals of art education. A good art resource provides many possible smaller steps, but always the steps go in the right direction.

Enter Rhian Brynjolson

I have had the privilege of working with Rhian Brynjolson on several art education projects over the years. For me, each project has been an opportunity to witness her deep understanding of and commitment to artful learning. Rhian knows the what, why, and how of it. She has served as a member of the development team for Manitoba's Kindergarten to Grade 8 Visual Arts Curriculum Framework, and she well understands the philosophical and pedagogical intent of the art curriculum. Rhian knows the ultimate destination, but she also knows how to break the journey down in an endless variety of ways through daily classroom practice.

Teaching Art is Rhian's way of encouraging artful learning in classrooms everywhere. But do be careful how you use this resource: What may start innocently enough as a search for an art activity you can do tomorrow, might just lead to a major transformation of learning-as-you-know-it!

That's my hope, at least.

Joe Halas,
Arts Education Consultant
Instruction, Curriculum and Assessment Branch
Department of Education, Citizenship and Youth
Province of Manitoba, Canada

INTRODUCTION

WHO THIS BOOK IS FOR

Teaching Art: A Complete Guide for the Classroom is written for classroom teachers, art teachers, childcare workers, artists working in schools, parents who home-school their children, and school administrators. It can also be used as a textbook for art educators. The book provides a framework for teaching art in a way that is integrated with regular classroom activity. The book focuses on art for primary and middle school students from pre-school to grade 8. Many exercises in the book will also successfully engage secondary school students.

INTRODUCTION TO THE SECOND EDITION

I have written *Teaching Art* in response to some major changes in art education since the publication of the first edition, *Art & Illustration in the Classroom*, in 1998.

It is exciting to see the developments in new art curricula being written in Canada, the United States, Australia, and New Zealand. Today's art curricula incorporate an understanding of a constructivist approach to education. This approach depends less on teaching isolated facts, and more on how children *construct* an understanding of the world through learning experiences. This is a much more challenging – and rewarding – way to teach! Two expanded chapters, Visual Literacy and Assessment, model how to put this approach into practice.

Another change since the first edition is the availability of images on the Internet.[1] It is now possible to cyber-visit museums around the world, as well as many contemporary artists' studios. Such accessibility is advantageous to teachers. It is also an enormous advantage to students, who no longer have to squint at postage-stamp-sized reproductions in textbooks.

A feature new to this edition is "Viewing." Researcher and art historian Noni Brynjolson has taken care to ensure that each artwork referenced in Viewing provides the best demonstration of the topic. Her selections are balanced throughout the book and showcase artists from various time periods, places,

1. The website addresses added in this edition are monitored and updated on the publisher's website at <www.pandmpress.com>.

and cultural backgrounds. Her commentary, which accompanies each work of art, is to help you introduce both the artist and the artwork to your students – and to initiate discussion. Viewing and discussing are important components of art education.

The updated lists of picture books include several new books and illustrators. Children's picture books continue to be a useful source of images that are designed for children, and the books inherently integrate other curricula through stories and information. This edition also includes updated lists of art materials and of techniques. New materials for printmaking and sculpture, for example, have made some art products safer, easier to use, and more affordable for schools to purchase. In addition, in a new section called "Multimedia," I discuss how to incorporate new technologies into your art program.

In the 11 years since I wrote the first edition, I have had many opportunities to work with some very talented colleagues in the field of art education. Several of them generously share with you some of their best advice, educational experiences, and art projects. You will find their stories throughout the book, in another new section, "Spotlight."

HOW TO USE THIS BOOK

Teaching Art: A Complete Guide for the Classroom is divided into six parts. In Part 1: Art Education (chapters 1–4), you will examine why it is important to teach art. You will also find a discussion about children's developmental progress in art and a theoretical framework for the art exercises. In parts 2–6 (chapters 5–23), you will find information on colour mixing, basic art techniques, helpful tips, multiple activities, examples of students' illustrations, materials lists needed to do the exercises, and lists of reference visuals you will need for viewing in the classroom. The visuals include children's picture books and art images available on the Internet. (For updates, go to <www.pandmpress.com>.)

The chapters and exercises follow in a progressive sequence – a step-by-step art program – that develops skill and ability. The book provides a framework for an art program that you can adapt to your curriculum, your schedule, and the needs and interests of your students. You may, however, choose to adopt *Teaching Art* as a companion for your existing art program.

As well, in each chapter, you will find a section (or sections) called Additional Exercises. In some cases, the exercises are designed to challenge advanced students. In other cases, you will find the exercises provide tips for adapting them for younger or less-confident learners. This section also provides methods you can use to extend the exercises to illustrate and enrich student writing.

At the back of the book, you will find glossaries of technical terms and art materials.

So many people have told me how helpful the first edition, *Art & Illustration for the Classroom*, has been to them as a classroom resource. I hope this newly expanded and updated edition is equally useful!

Rhian Brynjolson, *War Zone*,
acrylic latex on canvas, 26" x 30"

ART EDUCATION

In Part 1, you will read about basic approaches to art education and ways to establish a visual art program in your classroom. You will also find practical suggestions for teaching successful art lessons and tips for assessment.

Part 1 explores the theory behind teaching visual art and why art education is important. It discusses visual literacy, and summarizes children's developmental progression in art so that teachers can use this information to help them plan appropriate exercises for their students. There is also a brief discussion of using visual art to teach "reluctant" learners, and tips for teaching "gifted" students.

ART FOR THE CLASSROOM 1

EVERYONE CAN LEARN TO DRAW

How students feel about their art is important. In the classroom, students often point to one classmate and say: "She's the artist here." This implies that the other students do not see themselves as artists. They do not believe they have the ability to learn to draw.

Interestingly, as a rule, students do not single out a classmate and say: "She's the author." Writing, whether fun or functional, is an ordinary part of the school day. Although we recognize some students who excel, we encourage all students to view themselves as writers. We should be using the same kind of positive approach when we teach art.

In many cultures, proficiency in drawing is widespread. "(W)here drawing is a prescribed part of the curriculum, or…where drawing constitutes an important vein of cultural life, nearly every child manages to obtain and retain a certain minimal level of competence" (Gardner 1980, 160). Adult students with no art experience or ability enrolled in beginning-level drawing courses can make significant progress. This kind of progress is documented by Betty Edwards (1989), who asked her students to make portrait drawings before and after some practice and instruction in look-drawing. The progress was dramatic. With some instruction on observation, blind contour drawing, and proportion, her students were able to produce competent portrait drawings. I have documented similar improvements in my own teaching experiences.

Some people may have more or less drawing experience. However, I have taught drawing to hundreds of children and adults, and I can say with certainty: "Everyone can learn to draw."

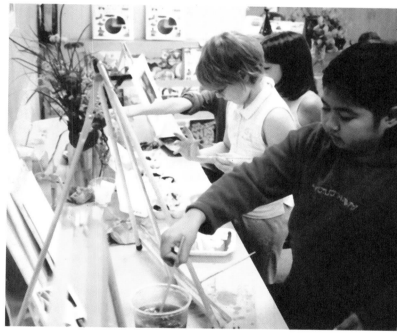

grade 1 classroom, École Constable Edward Finney School. Teacher: Andrea Stuart

Figure 1.1. Young students are painting at easels.

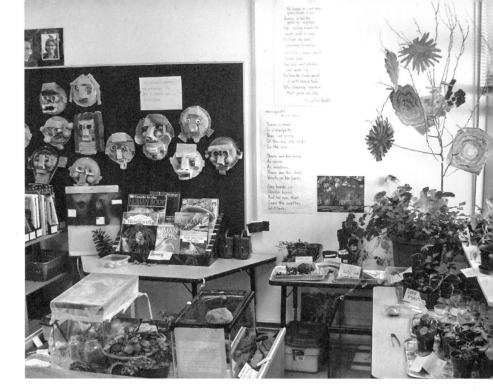

grade 1 classroom, École Constable Edward Finney School.
Teacher: Andrea Stuart

Figure 1.2. This artful classroom provides a rich learning environment for students.

WHAT IS ART EDUCATION?

Arts education is the study of dance, theatre, music, and visual art. Through the arts, students can learn about the world around them and about their place in it.

Art education, traditionally, has been the study of visual art such as painting, architecture, sculpture, drawing, and printmaking. Art education may also include the study of religious icons and cultural artifacts, as well as traditional art such as weaving, ceramics, and fabric arts. In more recent times, art education has also included photography, video, computer graphics, performance, and installation.

Educating students in visual art includes teaching them to view and make judgments about artwork, to understand the cultural context of a range of artworks, and to understand art vocabulary and concepts. Art education is also about making art, gaining experience with tools and materials, and learning to express ideas and feelings through visual media. Art education is about teaching thinking skills and concepts. It is about giving students art activities that challenge them, offer them choices, and provide opportunities for problem solving.

A good visual art program teaches students how to do the following:

- observe their surroundings closely, and view art images critically
- be aware of the sensory qualities of what they see, as well as of the concepts implied in an image and how those concepts are presented
- use learned strategies to access their imaginations, solve problems, develop and revise their understandings, and represent their ideas visually
- become independent thinkers able to make informed aesthetic choices
- use art vocabulary, and apply concepts of design

TIP For specific ideas on integrated curriculum projects, including art projects, to teach about important historic events or cultural or religious celebrations, see your school's curriculum guide.

- practise with hands-on, experiential learning
- work both independently and collaboratively
- use and care for a variety of art technologies, tools, and materials safely and competently
- make interdisciplinary connections, by seeing the big ideas or themes
- develop preferences about the content, meaning, style, and aesthetic qualities of their own and others' art-works
- discuss preferences with peers, and present their artworks to an audience
- understand historical, social, and cultural contexts of local and international art, artists, and art movements

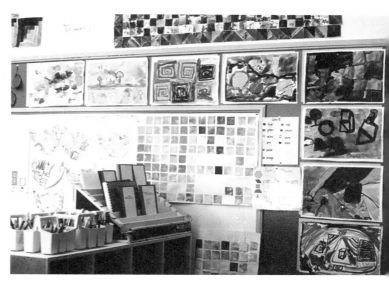

grade 1–3 classroom, Wolseley School. Teachers: Donna Massey-Cudmore and Andrea Stuart

Figure 1.3. The students in this classroom are learning about colour and shape.

WHAT A SUCCESSFUL ART PROGRAM LOOKS LIKE

A successful art program is one that encourages students to do the following:

- Explore a variety of art media and tools, because each new material will lead to a new way of seeing a subject, a different tactile experience, and a new spatial understanding. For example, drawing may provide students with the opportunity to observe the edges or textures of an object, painting may give students an understanding of colour relationships, and cutting and pasting may allow them to see how the subject relates to its surrounding space.

- Practise specific techniques and new approaches that help them gain confidence and expertise.

- Learn art vocabulary and concepts as a foundation for abstract thinking. Concepts relating to art principles such as unity and contrast, or single perspective versus multiple perspectives, are aesthetic ideas useful in other arts, including literature. These concepts are also foundations for the "big ideas" that underscore learning in the arts and sciences.

- View, think about, and discuss visual information so that they can become critical viewers of visual art, television, visual print media, advertising, video, and the Internet.

- Work with subjects and ideas that are of importance and interest to them, which gives their learning some relevance. To teach a subject successfully, you have to be able to answer this essential question: "How is this important to my students?"

- Inquire about the context in which a work of art is made, considering the time period, place, historical events, political conflicts, and/or the artist's life, culture, and beliefs. All of these are contextual clues that can help viewers decode more difficult or controversial artworks.

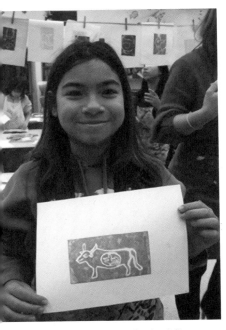

Machray Elementary School. Art Teacher: Ann Rallison

Figure 1.4. Following a demonstration by Ann Rallison, this student made a print of an ox.

- Develop original ideas and images through creative processes. When students are encouraged to make rough drafts of their visual works, they are more likely to follow up with research, discussion, experimentation, and innovation.

- Learn strategies for solving problems, while they make decisions about drawing, building, and revising their work. There is a reason for the phrase "back to the drawing board"! Visual models for solving problems are used in professions such as engineering, dentistry, design, and mathematics.

- Assess and revise their own work according to criteria. Formative assessment is an effective teaching tool; it is even more effective when students are involved in deciding the importance and relevance of each criterion. Creating criteria and revising work require higher-level thinking: evaluating, comparing, and synthesizing.

WHAT ART EDUCATION IS NOT

Researchers studying creativity at Cornell University (Brittain 1979, 154–155) experimented with an "anti-creativity program." They thought about what kind of classroom would discourage creative thinking, innovative visual art, and individual expression. They concluded such a classroom would have the following characteristics:

- materials stored safely out of students' reach
- prescribed times for drawing and painting
- complete demonstration for every lesson
- teacher's model for the end product
- step-by-step procedures for cutting, pasting, and folding
- rewards for conformity and similarity
 - photocopied sheets for colouring activities
 - emphasis on neatness
 - extra practice time assigned to students who are developmentally unready
 - stereotyped designs for holiday projects

You may find it helpful to seek out resources that, and resource people who, can help you provide a creative environment for your students. Professional development and collaboration among classroom teachers, art teachers, artists, administrators, and museum and art gallery staff have been found to be effective in interdisciplinary art education (Roucher and Lovano-Kerr 1995, 22).

Art activities should not be mere fillers between other subjects or used as Friday afternoon rewards. Nor should they be prescribed, patterned activities or simple exercises in how to follow directions. Clip art and colouring sheets, for example, serve no useful purpose in the classroom.

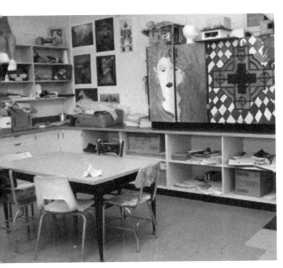

Elmwood High School. Teacher: Briony Haig

Figure 1.5. Students at this high school helped design the art studio.

I have worked in many classrooms that are similar to the anti-creative model just described. However, I do not believe that the teachers in the classrooms I visited intentionally suppressed creativity. Rather, they taught as they themselves had learned. One kindergarten teacher told me that when she attended elementary school as a child she was once sent to the corner as punishment for not using the "correct" colour. She clearly remembered the humiliation she felt. For years, she said, she was afraid to try art activities with her students for fear of not knowing how to teach them properly. (To her credit, her sensitivity to this issue has made her an outstanding teacher – of art and of other subjects.)

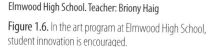

Elmwood High School. Teacher: Briony Haig

Figure 1.6. In the art program at Elmwood High School, student innovation is encouraged.

There are several problems with colouring sheets, including the following:

- They do not teach useful observation skills. In fact, many pre-made outlines are poorly drawn and inaccurate. It would be more useful to have students look carefully at quality photographs, children's book illustrations, or quality how-to-draw books.

- The sheets convey a negative message. When students are asked to fill in colouring sheets, they may feel they are being discouraged from trying to draw a subject themselves. The message many hear is: "My own drawing isn't good enough." Students' efforts – including their first awkward efforts at drawing – need to be encouraged and valued. If students like colouring, they can colour their own drawings.

- They do not teach useful drawing skills. Colouring sheets do not teach students how to draw the underlying structure or details of a subject.

- They suppress students' imaginations. Many pre-made outlines offer a standard cartoon version, much like video games, television shows, and toy stores do. They provide students with very few opportunities to develop original ideas.

- They waste time. Classrooms are busy places. Teachers and students need to concentrate on activities that effectively meet curricular outcomes and expectations.

Having students make holiday art is too often a time-wasting activity. Typically, a "bad" art activity involves little originality or choice, and all of the end products look very similar. Here are some simple, alternative projects that teach art skills and can be done to celebrate holidays, or to send home as gifts on special occasions:

- Watercolours give students opportunities to draw their own images and explore painting techniques. When made on good-quality paper, watercolours (see chapter 14) provide beautiful results for a holiday book or cards, or you can frame the artwork with frames from a bargain store.

Pussy Willows, Kara, age 4, Wellington School. Teacher: Jennifer Cobb

Figure 1.7. Very young artists should be encouraged, and their artworks should be celebrated.

grade 1 classroom, École Constable Edward Finney School. Teacher: Andrea Stuart

Figure 1.8. An art-friendly classroom can be beautiful, as well as functional.

- Eric Carle's collage techniques (see chapter 15) allow students to explore paint media freely and yield colourful results. I have seen collage projects laminated as placemats.
- Calendars can be decorated with small samples from students' experimentations with a new medium or technique. Cut small swatches from a colourful painting, crayon on sandpaper, leaf rubbing, and so on, and glue them onto computer-generated calendar pages.
- The D.I.Y. (do-it-yourself) movement celebrates the learning of useful, historically honoured skills. Learn how to dip candles, saw wood, sew, quilt, or cook. These are all more interesting learning experiences than cutting out traced paper turkeys, and they may even fit into your curriculum.

THE ART-FRIENDLY CLASSROOM

Art activities should be a regular part of classroom activity. This is easier to accomplish if the classroom is set up for project work.

An art-friendly classroom has most or all of the following:

- A variety of art materials. Supplies for drawing, painting, printmaking, illustration, collage, and sculpture are availableto students on a rotating basis. Make sure art materials are of good quality and safe for student use (see appendix A).
- Labelled storage containers. Keep the containers within easy reach, for organizing commonly used items and for easy cleanup.
- A variety of visuals. Have children's picture books, calendars, posters and art cards, and natural objects (including items such as leaves and stones in an assortment of shapes, colours, and textures) available, at eye-level, to your students.

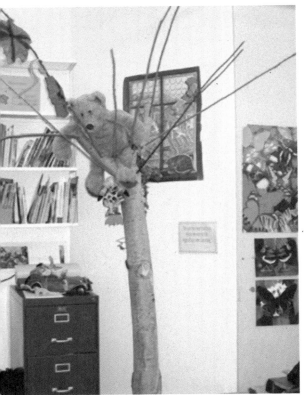

art studio, Machray Elementary School. Teacher: Ann Rallison

Figure 1.9. An art-friendly classroom has imaginative displays and high-quality visuals.

- A sketchbook for each student. Have students use their sketchbooks (or journals) for drawing and writing (see page 12).

- An assortment of visuals and/or objects that relate to a current topic of study. Displaying these materials is an art in itself. Aesthetically pleasing displays stimulate students' senses and imaginations.

- Prominent displays of students' artworks and process works.

- Paint easels and low tables for young students. Tables provide more space and flexibility than individual desks.

- An art centre in a corner of the classroom. The centre gives students a quiet working space with materials close at hand.

- A quiet, calm atmosphere. Art, like other subjects, requires concentration. Students should feel safe, relaxed, and free from excessive distractions.

The routine in an art-friendly classroom includes the following:

- time set aside for observational drawing

- art activities incorporated into core curriculum teaching

- longer blocks of time scheduled to complete larger projects

- time set aside for teaching students how to clean up and care for art tools and materials

- field trips to community spaces, museums, and art galleries, and classroom visits from artists

grade 1 classroom, École Constable Edward Finney School. Teacher: Andrea Stuart

Figure 1.11. Labelled containers make art materials accessible and the work space easy to clean up.

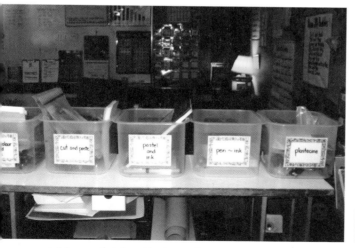

grade 1 classroom, École Constable Edward Finney School. Teacher: Andrea Stuart

Figure 1.10. These bins contain art materials, tools, images, books, and objects for study.

grade 1 classroom, École Constable Edward Finney School. Teacher: Andrea Stuart

Figure 1.12. Art activities for young artists require preparation.

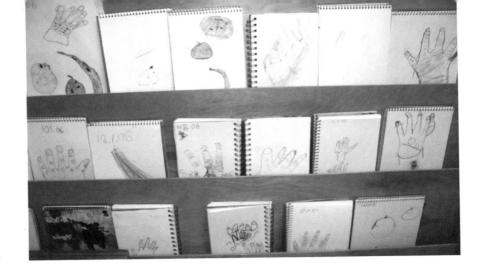

grade 1 classroom, École Constable Edward Finney School. Teacher: Andrea Stuart

Figure 1.13. Student sketchbooks are a useful learning tool.

In terms of the physical space, an *ideal* art classroom has:

- sink (or pails of water) for paint water and cleanup
- large windows that let in natural light
- tiled (not carpeted) floor area for easy cleanup
- large bulletin boards for displaying artworks
- lots of accessible shelf space for storing art materials and supplies
- closed cupboards or storage boxes for storing more occasional, expensive, or fragile materials

STUDENT SKETCHBOOKS

Students may use their sketchbooks exclusively for drawing, or as "idea journals" in which they include both writing and sketching. The sketchbooks of Leonardo da Vinci, for example, contain careful studies of hands, faces, and draped cloth as preparation for his paintings and sculptures; fanciful caricatures and designs for flying machines; and careful representations of plants and anatomy about which he had developed some scientific theories.

grade 1–3 classroom, Luxton School. Teacher: Kathy Redekopp

Figure 1.14. Iain used his sketchbook to document the growth of tadpoles.

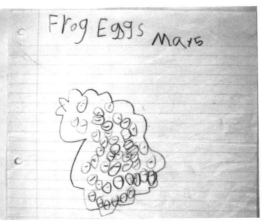
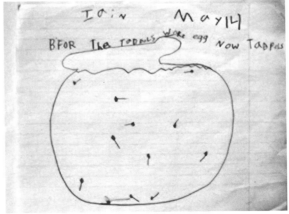

Students will practise several ways of drawing (and writing) in their sketchbooks, including the following:

- Look-drawing, or observational drawing (see Part 2), and the development of other drawing skills. Keep your students interested in art by giving them simple objects to draw, in 10- to 15-minute sessions, several times a week. Ideally, these objects will relate to topics being studied, or they will be topics of special interest to your students.

- Drawing objects from different points of view. Students will find even a simple object, such as an apple, interesting to draw when you challenge them to draw it from the top, or draw a cross section or the core of the apple.

- Using a new medium or technique on a small scale. Students can work on 4" x 6" (10 cm x 15 cm) pieces of paper and then glue them into their sketchbooks. For example, have students place a piece of window screen underneath the page and use coloured pencils to make rubbings, or have them dip twigs in ink and draw on the page (see following chapters for more ideas).

- Drawing sessions to exercise students' imaginations. Scenarios such as the following work well: "Pretend you have won the prize for the book of the year. Draw the front cover of the book." Or: "Leonardo da Vinci designed a flying machine almost 500 years ago. It was to be built out of wood and metal. What do you think it looked like?" If your students' eyes light up and they produce wacky, elaborate drawings, you know you have given them an interesting problem. This kind of exercise is an important first step in problem solving and in generating new ideas. It is also fun.

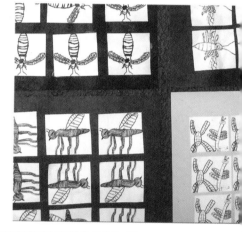

- Drawing exercises that relate to the curriculum or to topics that are being studied in class. Some sketches might become the starting point for a journal entry or a story. The Anti-Coloring Book series is a good resource of imaginative problems that are especially useful on those days when you run out of ideas.

- Keeping research notes. During visits to the library or while on field trips, students can both draw and write information in their sketchbooks. A student who draws and labels an insect is likely to remember it has three body parts, six legs, and strange mouth parts. Students who are studying ancient Egypt may sketch tombs and hieroglyphs, and write short descriptions. The popular Eyewitness book series is a good example of how visual images can spark students' interests in a subject while providing valuable information. The completed research projects of students who write notes in their sketchbooks in this way are more likely to contain students' own descriptions of the visual information than a word-for-word copy of the original text.

grade 1 classroom, École Constable Edward Finney School. Teacher: Andrea Stuart

Figure 1.15. Students used these small observational drawings to study insects, symmetry, and pattern.

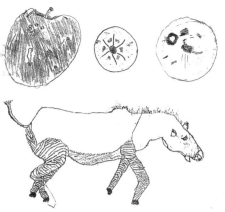

Faye Millen, age 10, San Antonio School

Figure 1.16. These illustrations are from Faye's sketchbook. She picked simple subjects to draw — an apple and a zebra — that related to topics she and her classmates were studying.

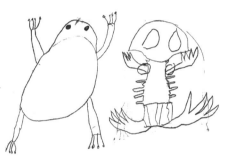

Jeffrey Gagnon, age 10, San Antonio School

Figure 1.17. Jeffrey was challenged to think about what an x-ray view of his subject might look like.

Jeffrey Gagnon, age 10, San Antonio School

Figure 1.18. Jeffrey used his sketchbook when he and his classmates were studying underwater creatures.

- Developing ideas. When students are thinking creatively, they often draw several versions and revisions. As they draw (and re-draw) their plans, they try to visualize, describe, and "flesh out" ideas that may be clear in their own minds. Sketchbooks are safe places to work through first drafts, erase, research, and re-draw, before showing plans to a teacher or classmate. This process is similar to the pre-figuring done in math class, where we ask students to "show their work."

TEACHING ART LESSONS

Interesting Subjects

Ensure the theme or subject of an art lesson has relevance to the curriculum and is of interest to your students. Although bottles, bones, and flowers are common still-life subjects in famous paintings, they will not necessarily grab your students' attention. Model animals hidden in a jungle "habitat" of houseplants (with burlap draped over a coffee can and orange tissue paper stuffed in the top for a "volcano") is an example of a far more interesting and relevant study for young students.

Preparation

Preparation is key to successful art lessons. Art materials that are readily available in your classroom make setup much easier. Lay out all the necessary supplies ahead of time, along with supplies for cleanup. Find quality visuals to show your students. You might want to try a new art technique yourself before attempting a demonstration in front of your students. As in a new science experiment, you may need to adapt the materials and process to ensure that the technique works for you!

View and Discuss

Use quality visuals to demonstrate a concept, medium, or technique. Images may be in the form of book illustrations, calendar photos, original artworks, PowerPoint slideshows, art books, postcards, photographs, a scene through a window, or any other visual that provides a clear example. Spend some time with the visuals. Ask students to sketch or respond to the image. Ask general questions to help them observe more closely; for example: "Tell me everything you notice in this image." Ask leading questions, and encourage student questions that may lead to aspects of the image that you would like to focus on in your lesson.

Demonstration

It is important that you demonstrate the technique being taught, because visual learners may have difficulty following oral or written instructions. You can do your demonstration at the beginning of the class, or step-by-step throughout the lesson. Some students may want to copy your model exactly, so I recommend

an "incomplete demonstration." Somehow, you have to demonstrate a technique and still encourage student innovation! Try demonstrating only a piece at a time. For example, for the lesson on shadow puppets, cut out a dog's head, a turtle's body, and an elephant's leg. Punch a hole in another piece of paper, and attach movable pieces without making a whole shadow puppet. In a painting class, show students how to mix a variety of green paint colours, but do not paint a whole landscape yourself. Help those students who are insecure by brainstorming with the class for a list of ideas for drawing subjects or for possible solutions to problems.

grade 1 classroom, École Constable Edward Finney School. Teacher: Andrea Stuart

Figure 1.19. Use quality visuals to demonstrate a concept, medium, or technique.

Attitude

You do not need to be an artist to teach art. However, your own attitude toward trying art exercises will affect your students. Model a positive, problem-solving attitude to your own efforts. Be clear about the specific skills or techniques you want students to learn, and explain why it is important that they learn them.

Start Small

When introducing a new technique, subject, or approach to your students, try a very small sample, or short drawing session, first. You may have to adapt the lesson for your students, and it is better to discover this on a postcard-sized painting than on a wall mural. A teacher whom I admire used to send her students into the hallway, two at a time, to try a new art technique with a parent volunteer. Their samples were collected from September to November and used to decorate calendars (which became presents for parents). When students had mastered a new technique, they could apply it to the book illustrations that they had been planning in their sketchbooks.

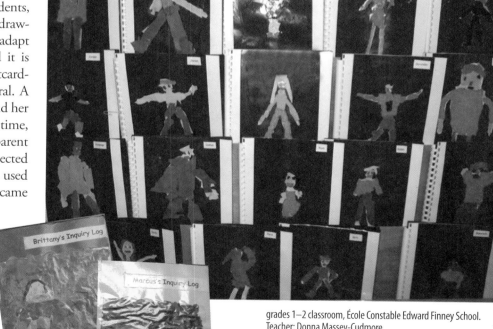

grades 1–2 classroom, École Constable Edward Finney School. Teacher: Donna Massey-Cudmore

Figure 1.20. Students made these pictures of people by tearing and gluing together small pieces of coloured paper.

grades 1–2 classroom, École Constable Edward Finney School. Teacher: Donna Massey-Cudmore

Figure 1.21. Small artworks make good book covers.

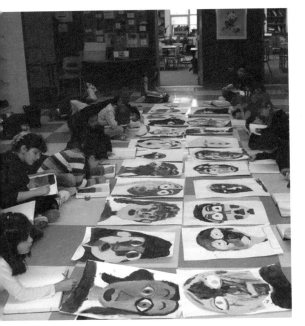

grade 1 classroom, École Constable Edward Finney School. Teacher: Andrea Stuart

Figure 1.22. Students reflect on their learning after painting portraits with complementary colours.

Suggestions or Criticisms

When you offer suggestions or criticism to students, be tactful. Remember that many students are terrified to put a mark on paper. Always offer a positive comment before making a suggestion to the student about how to improve the drawing. Make only one suggestion at a time, and offer it in the form of a problem to solve: "You drew the ears exactly the right shape! Oh, but the dog looks smooth. How could you make it look furry?"

While students are working, point out the strengths in each student's work: "I like the way the tree branches overlap the sun in this picture, Danna." Or: "The texture marks you used really make your dog look furry, Laura." Or: "Jessica, you have the rectangular shape of that cow's head exactly." When students hear these kinds of comments, they learn from one another's strengths. They also realize that they each have something to offer their classmates.

Process

In math lessons, we normally ask students to show their work. This is doubly important for visual art. The process of developing an image from the rough-sketch stage through to the finished picture that is displayed on the bulletin board allows students to, literally, see the steps they used in problem solving and completing a project. This gives you opportunities to teach strategies for creative thinking and problem solving, and to observe the processes that students used in carrying out their projects.

View and Reflect – and Share with Classmates, Colleagues, and Parents

In their rush to finish projects, teachers often neglect to give students time to view and reflect on their work and the works of their classmates. However, this is an important teaching step. Here are some strategies for reflection that allow students to learn from other students, notice their own progress, and celebrate what they have learned.

- Documentation panels are used at Reggio Emilia schools.[1] Photographs are taken that document the process of how the artwork was made. Rough drafts are included as samples, and written captions explain the thinking that was done by the students at every stage (the photographs and writing maybe done by students: "First we…." "Then we…."). The advantage of displaying these panels is that the emphasis is on the process and student learning rather than on the end product. It may be difficult, for example, for parents

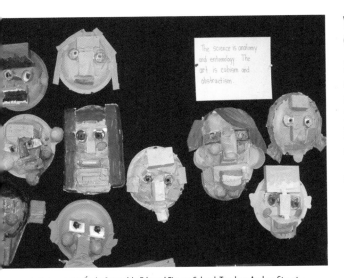

grade 1 classroom, École Constable Edward Finney School. Teacher: Andrea Stuart

Figure 1.23. Students build sculpture, and they also build vocabulary and understanding.

1. The importance of an aesthetically stimulating environment is part of the philosophy of Reggio Emilia schools (Nancy B. Hertzog, University of Illinois at Urbana-Champaign, ECRP Vol. 3 No. 1. Spring 2001, <http://ecrp.uiuc.edu/v3n1/hertzog.html>).

to appreciate the work done by kindergarten students who studied geometric shapes, colour-mixing, and observation as they painted their tulips, if all the parents can see are green stripes and pink ovals on the wall.

- Gallery walks give students opportunities to see the various ways their classmates may have solved a problem, as they take a walk around their classroom. Students may need to be encouraged to focus on specific aspects of the artwork or to offer specific, positive feedback to their classmates.

- Written reflection pieces or exit slips use phrases that help students focus on their learning: "What I am most proud of is…." Or: "Please notice the texture on the…." Or: "My finished piece is different from my rough draft…."

Scheduling

Art explorations take time. Allow time for viewing and discussing images, demonstrating techniques, setting up, working, stopping to view and reflect, discussing one another's work, and cleaning up. If you need to, re-arrange your schedule to allow for longer blocks of concentrated project work.

Cleaning Up

Avoid chaos at clean-up time by dividing the job into specific tasks and assigning tasks to each student. Some jobs, like washing paintbrushes, may need to be explained, modelled, and supervised. Use incentives to reward students who provide extra help with cleaning.

grade 2 classroom, Sister MacNamara School. Teacher: Cathy Woods

Figure 1.24. In this display of student artworks, the students tell how the artworks were made.

art studio, Machray Elementary School. Teacher: Ann Rallison

Figure 1.25. Teach students the proper care of art tools and materials.

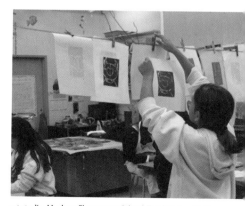

art studio, Machray Elementary School. Teacher: Ann Rallison

Figure 1.26. Teach students procedures for organizing and storing their artworks.

Cheryl Zubrack

Spotlight
TEACHING ART TO TEACHERS
by Cheryl Zubrack

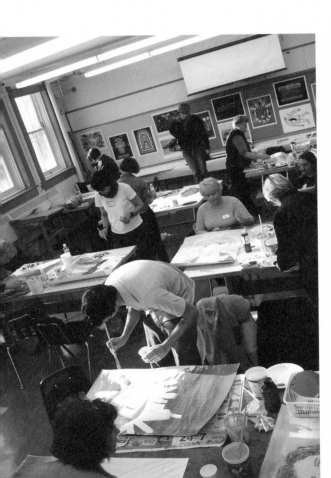

Cheryl believes in the importance of professional development for teachers. Here, art teachers participated in a workshop led by a professional artist, who demonstrated painting techniques and discussed idea development.

Exploring learning through the creative process and using the visual arts as a vehicle for this journey can be an exhilarating and enlightening experience – especially when the explorers are making new discoveries about themselves. As a visual arts consultant responsible for delivering professional development in art education, I have often had the privilege of observing this exhilaration and enlightenment in the workshops and sessions I have facilitated. The positive energy experienced by adult learners inspires me to truly believe, more than ever, that learning through creative exploration and creative expression are essential in the education of our children.

My favourite adult learners are the teachers who believe, for any number of reasons, that they are not creative or artistic. In my workshops, I often hear: "There is not a creative bone in this body!" or "I can't draw a straight line!" Some even experience fear or panic when they are asked to draw.

The challenge with teaching art is that far too many students think only those who are "talented" or "gifted" can actively participate. So many times, I have had the privilege of observing that moment of initial recognition when teachers realize they *can* learn to make art. These moments can occur at any time during a workshop. I have seen it happen, for example, during media exploration when teachers are encouraged to make marks without drawing anything realistic. I have seen it happen as teachers draw self-portraits after being given the tools they need to decipher proportions (relative sizes and placement of parts of a visual form). Their recognition of these new-found abilities and exciting possibilities reaffirms my deepest belief that everyone has the capacity to be creative and artistic; we can nurture and cultivate these skills and habits of mind. These moments of self-discovery are truly inspiring.

It has allowed me to take a risk in art. I am not trained in the fine arts discipline. The students in my class have difficulty in dealing with whether or not they are great artists. Many of them become very frustrated with their final pieces. They are at times very hard on themselves. My motivation and excitement was evident when I spoke to them about my creation. This energy spreads into the class and the students pick up on it. In seeing my excitement, it shows the students that they too can be risk-takers. They know that I am not trained as an art teacher. They respect that. My artwork became a vehicle for discussion and exploration. There is a story behind my artwork. My students see me as a teacher, but also as a person who has a story to tell and share. I'll never forget when I first brought my painting into my grade 9 class. They were so into "my story." It inspired many of them to create projects with "their own story."

— from a teacher with little prior experience in art who participated in Cheryl's workshops

Just as you do not need to be a scientist to teach science or a mathematician to teach math, you do not have to be an artist to teach art. Nonetheless, we expect educators to understand the pedagogy and learning process involved, and to facilitate deeper comprehension and exploration of skills and concepts in the visual arts. That is why it is important for teachers to have the opportunity to attend art education workshops, play with ideas and media, share experiences, exchange ideas with other teachers, ask questions, and search for answers. We should not be shy about learning alongside our students. It is so important for our students to see us as learners and risk-takers, modelling a positive attitude toward our own learning.

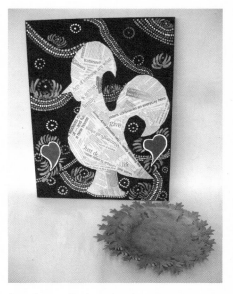

Artworks created by the teacher who wrote the letter (above)

I believe that we can use the visual arts as a means to offer our students the opportunity to learn about themselves and the world they live in – through inquiry, visual literacy, play, idea development, personal expression, cultural awareness, aesthetics, and social context. It is vital that we celebrate playfulness, curiosity, imagination, experimentation, and the journeys these all entail for both our students and ourselves. It is imperative that we recognize and acknowledge the value of media exploration, the development of unique and individual ideas, the importance of personal interpretations, and the richness of thoughtful reflection as part of the creative learning process.

As educators, it is time for us to personally experience, understand, appreciate, and embrace the visual arts and the creative process as a critical piece of the learning puzzle.

Cheryl Zubrack is an art consultant for the Winnipeg School Division.

PERSPECTIVES ON ART EDUCATION 2

WHY TEACH ART?

Why teach art? This question continues to be asked by those unfamiliar with the benefits of arts education. In many schools, visual art programs are nonexistent, under-funded, misapplied, and/or taught in isolation from other curricula. This situation indicates a profound misunderstanding of the pedagogy of art education and of the creative and cognitive processes involved in visual arts.

To be fair, most teachers, childcare workers, parents, and school administrators have received very little training in visual arts. Added to this limitation is a cultural myth about the "genius" of artists and artists' personalities. This myth supposes the visual arts are inaccessible to the average person and best left to experts. There is also confusion about what constitutes "good" art, and a barrage of media images – kitschy, commercial, abstract, and photographic – seems to defy classification. An influential and recurring "back to the basics" movement narrowly defines education as reading, writing, and arithmetic, separate from and excluding other areas of study. School budgets and professional development are now more likely to be allocated for expensive new technology than for art training and materials.

There are, however, compelling reasons why art should be taught at every level. First, art is an important means to communicate and understand ideas, emotions, and aesthetic experiences. The practice of making art is an activity with intrinsic value, making us active participants, rather than passive consumers, of our culture and identity. The arts enhance living by heightening our awareness and attentiveness to experience. Second, art education has been proven to increase student engagement, creativity, and cognitive skills. Art is also an effective vehicle for teaching other subjects.

The United States Department of Education recognizes both the intrinsic and broader educational value of the arts:

> The arts are essential to every child's education, which is why the arts are one of the core academic subjects in the No Child Left Behind Act (NCLB). ...Secretary of Education Rod Paige said that cutting arts is "disturbing and just plain wrong."

felt pen on paper, Iain Brynjolson, age 4

Figure 2.1. Lines and letters decorate the page. At this young age, drawing is a way to learn coordination, spatial orientation, and the idea that symbols on paper can be used to communicate an idea.

Similar to English, math, science and the other core subjects, the arts (dance, music, theater, and visual arts) are challenging subjects with rigorous content…. They require highly qualified teachers who challenge all students, not just those who are considered artistically talented, to perform works of art, create their own works, and respond to works of art and the ideas they impart.

In addition to studying the arts for their own sake, experiencing and making works of art benefits students in their intellectual, personal, and social development, and can be particularly beneficial for students from economically disadvantaged circumstances and those who are at risk of not succeeding in school. Research studies point to strong relationships between learning in the arts and fundamental cognitive skills and capacities used to master other core subjects, including reading, writing, and mathematics.[1]

A survey by researchers in art education from Princeton University documents a wide spectrum of benefits to art education, including increased student engagement and motivation, cognitive development, opportunities for challenge and enrichment, creative-thinking skills, comprehension and retention, cultural awareness, and a desire for continued, life-long learning. The survey suggests arts education can also provide the most effective medium for integrated, interdisciplinary learning.[2]

A study from Queen's University found that students who participate in school arts programs are more engaged, "attentive," and enthusiastic, and they score "significantly higher" in mathematics tests. The study also documents improved school attendance, and social benefits such as increased confidence and teamwork. Other benefits include in-creased "emotional involvement" and opportunities for self-expression. Teachers reported qualitative changes, such as seeing "joy" in their students.[3]

pencil on paper, Iain Brynjolson, age 6

Figure 2.2. Children create intricate worlds as they struggle to make sense of their feelings and experiences.

In addition, some specific reasons for teaching visual arts in the classroom include the following:

- Drawing is an important pre-writing activity. A strong relationship exists between drawing and writing. Graphic symbol systems are an early means for organizing, expressing, and communicating ideas (Wilson and Wilson 1982, 23). Through drawing and painting, young children develop motor skills, and they learn that putting marks on paper is a way to communicate ideas.

1. *Improve Student Performance, Teacher Update*, U.S. Department of Education, August 26, 2004, <http://www.ed.gov/teachers/how/tools/initiative/updates/040826.html>.

2. From: *Why Strong Arts Programs in Schools Are Essential for All Students*, Compiled by Kevan Nitzberg, Past President of Art Educators of MN. Princeton University website <http://www.princetonol.com/groups/iad>.

3. Dr. Rena Upitis and Dr. Katharine Smithrim, Faculty of Education, Queen's University, Kingston, ON, April 2003, Learning Through the Arts *TM, National Assessment 1999–2002. <www.ltta.ca/discussionzone/press/LTTAjun03-ResearchReport.pdf>, pp.19–21.

Teaching Art

- Students' development can be observed and tracked through their drawings (Brittain 1979, 203). Progress in the ability to draw closed forms and then organize those forms on paper can indicate readiness for shaping letters and learning to read and write.

- Art provides opportunities for experiential learning. As students handle materials, they gain sensory knowledge and vocabulary about shapes, lines, textures, patterns, values, spatial relations, and colours (ibid., 171). They learn to hold and manipulate a variety of tools, such as pencils, scissors, paintbrushes, markers, hammers, and glue.

- Art involves cognitive processes. As children draw, paint, cut, and paste, they are learning how to make choices and solve problems. On another level, they are learning models for cognitive processes – a schema for how to think. What children perceive about themselves, their family, and their environment are symbolized graphically and re-ordered on paper. Like young scientists, they are constructing visual models of their experiences that they can re-arrange and re-construct (Arnheim 1969, 257).

- Thinking skills taught in an art program – visual-spatial abilities, reflection, self-criticism, and the willingness to experiment and learn from mistakes, to name a few – are unique. According to Ellen Winner and Lois Hetland (2007), these skills are necessary for many careers, but they are ignored by most standardized tests. Other important skills taught in arts programs include persistence, expression, making connections, observing, envisioning, non-verbal thinking, innovating, and self-evaluation.[4]

- Art is a learned activity that requires instruction. Unfortunately, a majority of students do not receive training in basic art skills. Research shows that at about the age of eight or nine many students stop drawing if they are not properly instructed and encouraged (Gardner 1980). This age represents a critical period in the development of students' drawing skills. Many become very dissatisfied with their own work and easily frustrated if they cannot yet accurately draw a realistic representation.

- Children learn standard modes of representation. They learn how their peers, teachers, families, and the media represent the world around them. As they are taught the step-by-step process of representing, they learn a common language of visual communication (Kindler 2003, 233).

- Art contributes to understanding and development in other subject areas. The cognitive skills students learn through arts education include observation and perception, curiosity, and critical and "divergent" thinking. These skills are required in every aspect of society, from business to environmental issues, where linear, mathematical thinking is not sufficient. "Predictable calculations and mathematical formulations often prove inadequate to the power of creative conceptualization" (Swartzentruber 2005, 24).

- Increasingly, our culture relies on visual clues for communicating ideas. Visual and linguistic information are combined in every mode of communication, all subject areas, and many careers (Johnson 1993, 23). Navigation,

pen on paper, adult drawing

Figure 2.3. If students reach the critical age of eight or nine without receiving instruction in drawing, they might not progress, or they may give up drawing entirely.

4. Ellen Winner and Lois Hetland, "Art for Our Sake: School arts classes matter more than ever – but not for the reasons you think," in *Boston Globe*, Sept. 2, 2007.

biology, industrial and mechanical engineering, architecture, advertising, fashion, physics, and computer technology are just a few of the areas that use graphic communication.

- Learning is enhanced when several modes of communication are actively engaged. "The visual imagery a person remembers due to pictorial input is recalled more rapidly, more holistically than the words the person uses to describe the images he or she is remembering" (Sinatra and Stahl-Gemake 1983, 203).

- Making art is fun. Mixing colours with goopy paints or building a model city out of wooden crates is engaging and challenging work in which students willingly participate. Using art projects to teach core curricula can turn bored students into enthusiastic learners. Discipline issues often decline during art activities. Including more visual art as part of the regular program can help to create a happier classroom.

- Making art is empowering. Art allows students to transform aspects of their identity, community, or subject of study through imagination.

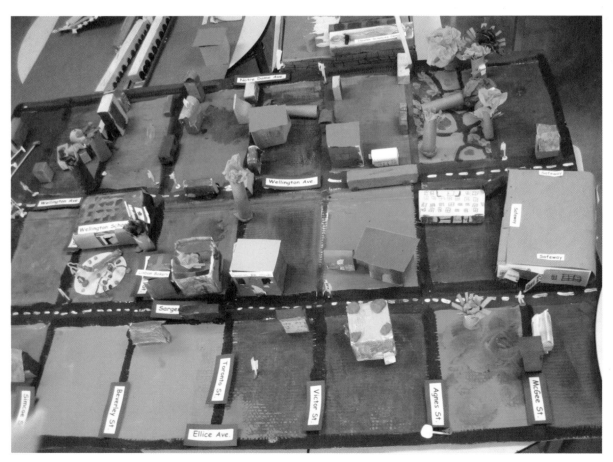

grade 2 students, Wellington School. Teacher: Alan Kopstein

Figure 2.4. "Our Community" project

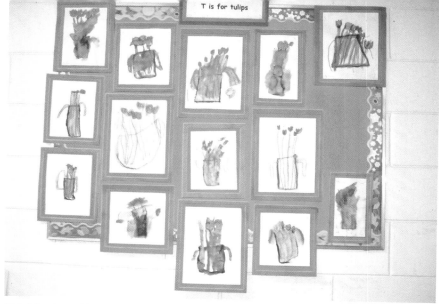

T Is for Tulips, 4-year-old students, Wellington School. Teacher: Jennifer Cobb

Figure 2.5. A display of drawings by young students

DEVELOPMENTAL STAGES IN ART – AN AGE-APPROPRIATE, STAGE-APPROPRIATE PROGRAM

As artists, we generally pass through a sequence of predictable stages in our artwork, parallel to our development in other areas. Recent studies indicate that these phases, once thought to be pre-determined, are strongly influenced by being instructed step-by-step, watching peers, and being exposed to visual culture (Kindler 2003, 233). Each phase requires a slightly different approach in art education.

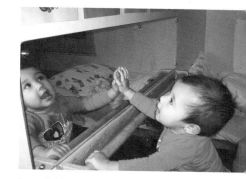

Parent-Child Centre, Villa Rosa

Figure 2.6. Raign is exploring the visual aspects of her environment.

Very Young Artists

Children begin making art by scribbling. They learn to grip a pencil (or crayon), develop motor skills, and discover that the pencil leaves marks on paper. They progress to closed forms that are roughly oval or circular. These forms typically evolve into "tadpole" people, with a closed form for the body, lines for appendages (legs and arms, and later, toes and fingers), and dots and lines for the eyes and mouth. At this stage, children's drawings are very symbolic. They draw what they know or perceive about a person; they are not at all concerned that their drawings do not correspond to a person's actual appearance. In fact, children seem unconcerned about their end product, although they may be vulnerable to an adult's response, whether critical or supportive.

There are several important issues for early-years educators to be aware of when working with this age group, including the following:

watercolour, 4-year-old student, Wellington School. Teacher: Jennifer Cobb

Figure 2.7. This flower was painted by a very young child.

- Children take their art seriously. Provide them with opportunities to practise their art. Respect their determination. Introduce a variety of tools and materials, such as pencils, hole punches, felt pens, crayons, paintbrushes, glue, and modelling clay. Adult "help" can interfere with young children's struggles to master the task, and it can remove the satisfaction that comes from succeeding (Brittain 1979, 196).

- Very young children are much more interested in the process (the doing) than they are in the product (the result) of their art activity. Craft and teacher-directed activities may produce items that are acceptable to adults, but they are of little value to very young children. In fact, directed activities with standard outcomes might actively discourage children, as their own efforts do not match the teacher's model.

- Complicated art projects require a great deal of housekeeping by adults. This can be time-consuming, and it cuts down on the time that a teacher can spend interacting with students. Very young children require basic materials and the opportunities to master tools and basic skills. They need freedom from pre-planned or prescribed patterns in art activities.

- Very young children often talk to anyone who is watching them draw or paint. This interaction is an important part of the process. Researchers have found that nursery students spend longer at an art activity if an adult is present to listen, encourage, and offer choices about materials and methods (ibid., 142).

- Very young children often change their ideas about what the marks on their paper represent. For example, what begins as an alligator at the start of the painting session may evolve into a boat. It is interesting that experienced artists allow this evolution in an image as well. Children understand that their marks on paper can be a subject of dialogue. They are beginning to realize the use of drawing as a means for communication. This is an important parallel to, or early phase of, the writing process, which also requires using graphic symbols on paper.

Beginning Artists

During the early years, students begin to master more complex symbols. They can eventually organize houses, people, and trees onto a baseline at the bottom of the page, with a strip of blue and a sun representing the sky at the top. This is not what the sky actually *looks* like – but the young artist has spatially organized the sky to be above the rest of the picture.

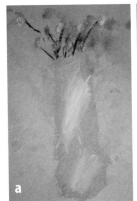

chalk on paper, 4-year-old students, Wellington School. Teacher: Jennifer Cobb

Figure 2.8. Very young artists can learn observational drawing. These pictures were drawn by: (a) Xuan, (b) Angela, (c) Cordell, and (d) Jill.

Children at this stage remain relatively unconcerned about the visual appearances of the subjects they draw. They are still recording what their experiences of their subjects are, rather than what they see. This leads to inventive solutions – x-ray vision, simultaneous views of all sides of an object, and cross sections. Complex parts of a subject are represented by shapes and lines that the child knows how to make – a triangle for a nose, a line for a finger. Children seem unaware, or unconcerned, that their drawings do not match appearances. This is why talking to young artists about their work requires tact.

Children's efforts need to be respected. Their awkward attempts to represent and re-order their subjects are important learning processes for them. Their abilities to spontaneously create, and their innovations with form and colour, can produce playful, expressive, and beautifully inaccurate images. In fact, by viewing children's work, we can learn a great deal about imaginative ways to see the world.

The organization of subjects in the picture emerges parallel to narrative sequence. As forms are organized on paper, so, too, is a comprehensible narrative about the picture. Left to themselves, children will create "spontaneous story drawings" (Wilson and Wilson 1982, 102).

Children at this stage sometimes become preoccupied with violent themes in their drawings. Cartoon violence with imaginary characters provides a safe means for children to explore "all of the power, passion, fears, and hopes that can populate the mind of a young child..." (Gardner 1980, 113–114). An adult can provide moral perspective by responding sensitively and discussing the artwork with the child.

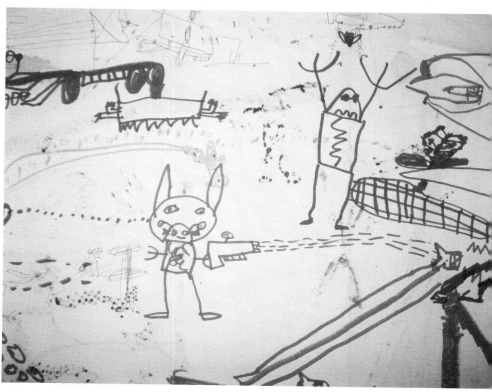

Iain Brynjolson, age 6

Figure 2.9. Very young artists may build imaginary worlds and elaborate action scenes in their artworks.

As organization and storytelling emerge in children's artwork, the beginning artist can use these developing skills in illustration. At this age, students are able to plan their work. You can have your students use storyboards to develop a pictorial sequence with accompanying text (see chapter 9). The storyboard is a good tool for teaching students how to write. It is also a good way to develop a child's interest in drawing and writing, and it shows the child how to achieve a sense of competence as a young illustrator and author. Writing and illustrating stories can become an important classroom activity at this stage.

Beginning artists require some time apart from directed art activities to explore their own themes and concerns, or to respond to their environment.

grade 1 classroom, École Constable Edward Finney School. Teacher: Andrea Stuart

Figure 2.10. Young artists need time to explore art materials and concepts.

In addition to illustration projects, here are a few other strategies that can be added at this stage:

- Collage. The beginning ability to organize the picture may be aided by the use of a cut-and-paste approach (see chapter 15). Cutting and pasting gives students more choices and more control over where to place each part of the picture, relative to other pieces.

- Art materials. Introduce students to a variety of art materials to build experience and vocabulary, and to help maintain their interest in visual art. Art materials should be readily accessible in the classroom.

- Observational drawing. Instruction in look-drawing may be introduced at this stage (see chapter 5). When students observe and draw a variety of subjects, they often find new solutions for representing forms on paper. The resulting visual awareness – experience with form and technique – will be helpful to them as they begin to want to draw more accurately and communicate more sophisticated ideas.

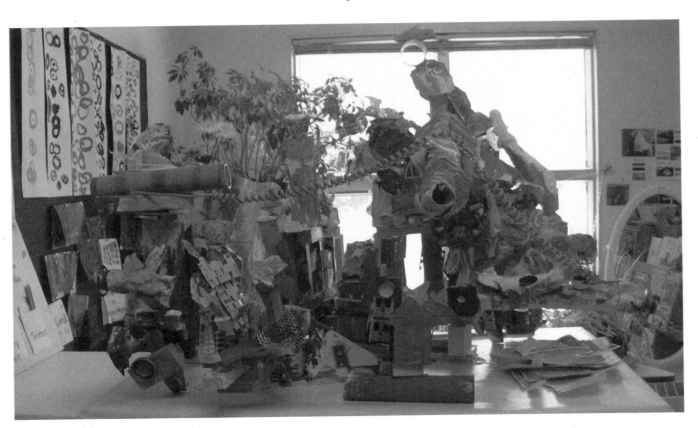

grade 1 classroom, École Constable Edward Finney School. Teacher: Andrea Stuart

Figure 2.11. This mixed-media sculpture shows what students can do when they have the opportunity to experiment with a variety of art materials, tools, and techniques.

Expose young children to a variety of art images. These may include picture-book illustrations and narrative art (pictures that seem to tell a story), images with subjects of interest to students, and images that clearly illustrate the idea or medium they are exploring at the time. Take time to discuss images with students, to wonder aloud about parts of the image, to ask students if they can find hidden details, and to encourage them to observe closely and offer their questions and opinions freely.

Developing Artists

Very young children tend to approach art spontaneously and expressively. Sometime between ages 8 and 12, this approach may be replaced by dogged realism and literal images. This is when students show "a single-minded determination to achieve photographic realism in drawing – to show everything just the way it appears to the lens of the camera" (idid., 11).

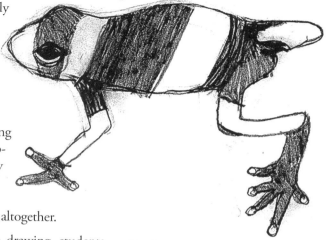

The expressive content of artwork may decline as developing artists, of any age, become more interested in the accurate representation of their subject. If students have not previously been taught how to draw, they need instruction and encouragement during this phase of dissatisfaction. Otherwise, they may become discouraged with their efforts and stop drawing altogether.

During this period of mastering accurate representation in drawing, students may discard the schemes and symbols they have used up to this point. As students attempt to represent what they see, their transitional artwork will appear awkward, even ugly. These awkward images, however, should be recognized as indications that students are grappling with new solutions (Arnheim 1969, 266).

Poison Dart Frog, pencil on paper, Tessa Millen, age 10, San Antonio School

Figure 2.12. Sometime between grades 2 and 3, students begin to strive for and value accuracy in their drawings.

Some students may be cautious about trying new solutions, since the results will not be immediately satisfactory. For students with low self-esteem or for those who lack confidence, going from the familiar to the unfamiliar, as they reach for new solutions, is a scary and unsettling process.

As students struggle with making accurate drawings, they may become very self-critical or aware of how they measure up against their peers. At this stage, it is important for you to model a positive and self-forgiving attitude toward your own efforts to draw. This will help students channel their growing self-awareness into constructive, formative assessment of the particular parts of an artwork that are successful and the particular aspects that need to be revised. You can also show students how professional artists' works evolve over time, as an example of personal growth and change. Seek out artists who are role models for your students. Continue to offer examples of non-representational artworks, as alternatives to realistic depiction. It is important for developing artists to study abstraction, conceptual art, and video, for example, and to experiment with a variety of art forms.

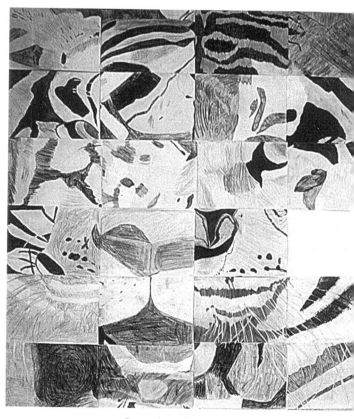

Students can continue learning art concepts and vocabulary as they improve their ability to develop original artwork. To improve their skill level, students may feel safer working on small-scale design problems exploring value and colour theory, playing with patterns or motifs, and experimenting with a variety of art media, styles, and techniques.

Tiger, grade 6 students, Niakwa Place School

Figure 2.13. Older students can build confidence in visual arts with projects that are cooperative or media based.

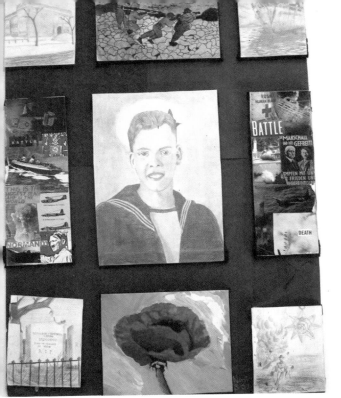

Images of WWII, mixed media, Noni Brynjolson, grade 10, Gordon Bell High School. Teacher: Theresa Kuzyk

Figure 2.14. Collage and mixed media allow students to synthesize ideas. This project integrated social studies and art curricula.

Proficient Artists

Typically, between ages 13 and 17, young people begin to shake off the grip of literal thinking and become interested once again in self-expression. Social interaction, identity, and powerful emotions become important concerns, and important subjects for artworks. Artists at this stage are able to use design concepts in their compositions to express more sophisticated ideas.

Favourite subjects are portraits and people, which is natural since social relations become of foremost importance at this age. Students may also be interested in cartooning and caricature. Cartoons are perceived as a *safe* style of drawing, because they are not intended to be accurate representations. Cartooning and caricature give artists an imaginative escape, or an opportunity to transform reality. Some artists construct whole worlds of fantastic characters and gain "solace and strength" from graphic activity (Gardner 1980, 206). Teachers should strike a balance between (potentially intrusive) instruction in art and free drawing time.

Doodling is an indicator that students are ready to experiment with more abstract expressions. Proficient artists may be challenged to apply the concepts of design to issues and topics of interest to them. Emphasis on design problems can provide a formula for organizing and expressing complex ideas and images.

Opportunities for artists to view and explore art relevant to their own lives and interests are critical. As with literature, themes of identity, isolation, connecting with community, political perspective, sexuality, meaning, change, and moral values have the potential to lead to self-understanding and growth. Encourage students to work through a variety of "big ideas" in their artwork. The problems presented to students should be both intellectually challenging and responsive to their interests and concerns.

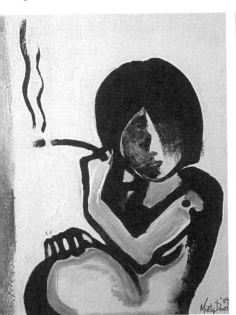

untitled, acrylic paint on canvas, Misty, alternative high school

Figure 2.15. Misty is exploring body image through artwork.

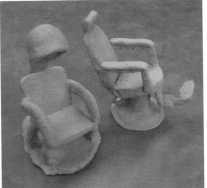

clay scupture, Kryssy, high school student. Teacher: Rhian Brynjolson

Figure 2.16. These clay sculptures of hairdressers' chairs are part of a diorama planned by a student who is confident with sculptural forms.

In summary, proficient artists need a balance between self-expression, experimentation with media and design, and exploration of significant themes.

Students With Special Needs

The integration into classrooms of exceptional students with diverse needs, life experiences, and abilities means that we need to be aware of the widely differing ways in which our students learn. Multiple aspects of intelligence have been

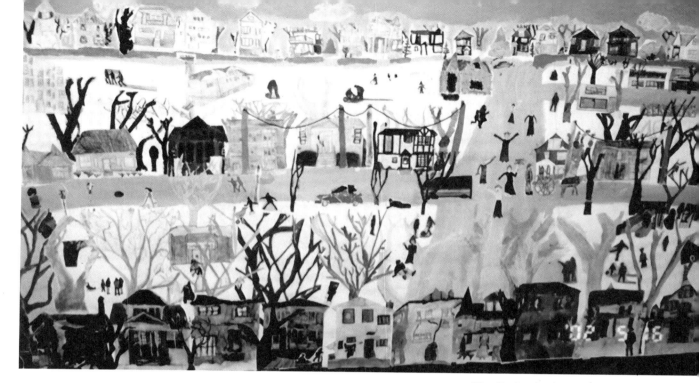

Winter Mural, grade 1 classroom, École Constable Edward Finney School. Teacher: Andrea Stuart

Figure 2.17. This is a cooperative project completed by young artists.

recognized and studied since Gardner introduced his theory of multiple intelligences in 1980. He identified eight categories of intelligence: spatial (defined as orientation, recognition, depiction, and symbolization, or "picture smart"), bodily-kinesthetic, inter-personal, intra-personal, linguistic, logical-mathematical, musical, and natural (Gardner 2000).

For students who seem to demonstrate predominately, or exclusively, spatial intelligence, visual art makes school comprehensible and bearable. Many students who are diagnosed as academically delayed, learning disabled, or who have behaviour problems may have normal or exceptional abilities in drawing or other art forms (Gardner 1980, 151). These students may not fully comprehend oral or written instruction, but they may respond to a visual-kinesthetic approach. They may excel if projects are introduced through demonstration, or if they can solve graphic problems and use art materials to express their understanding. This also happens to be good teaching. By communicating in a variety of modalities (music, visuals, literature, project work, field trips, drama), we are reaching, for example, students who are just learning the language of instruction, students who are gifted and bored, students who learn best through interacting with peers, and students whose talents we have yet to discover.

There is evidence that development in drawing ability – gaining confidence in self-expression through drawing, developing coordination and concentration, and gaining experience with problem-solving and thinking skills – may transfer to other endeavours (Gardner 1983, 308). Teachers describe many students as "slow," "difficult," "having a behaviour problem," "rude," "hard to motivate," "disruptive," "learning disadvantaged," "having a short attention span," or (speaking more diplomatically) "bouncy." Not all of these students respond positively to all visual art activities; however, a large proportion do. Some of these revelations are dramatic:

- One little boy in a nursery class was completely nonverbal. He watched very carefully as we demonstrated how to spread modelling clay on a cardboard backing and made basic fish-like shapes. He not only (mutely) accomplished these tasks, which were challenging enough for his classmates, but he was innovative. The fins of his fish stuck out from the picture. He impressed texture onto the fish with a pencil, overlapped weeds in front of his fish, and added bubbles. This demonstrated sophisticated visual reception and thinking skills that had been previously unrecognized.

- A young student was extremely disruptive. He frequently left his seat and talked loudly off topic and out of turn. He seemed unable to focus on written work, and he had trouble sitting through our initial (and mainly verbal) presentation. He seemed distracted while we demonstrated the process. However, when the time came to apply the painting technique, he went right to work and became very involved in studying his landscape photograph and in mixing colours. His painting showed that he had paid attention to the instructions (or the examples) of colour mixing and light and dark values, as well as to which materials he would need and how to use them. He sat through the remaining 75-minute period without moving from his seat or speaking, and he had the patience to complete his painting. He even repainted an area of the sky that he was dissatisfied with. His teacher was surprised that the student had not been "a problem" during the class.

- A middle-years student who we worked with had not demonstrated much competence in any subject. He was barely passing, and his attendance at school was becoming less frequent. When we invited a television director to work with our students, he came alive. It became evident that he really understood television! He became an expert at editing video and knowing how to set up a shot. That experience of success helped him to stay in school and put more effort into other subjects.

In the years that I have worked in schools as a visiting artist and as an art teacher, I have encountered many students who appeared not to understand oral and/or written instruction. For such students, viewing and representing are the only means of communication that make sense. Opportunities to learn from visual models and to express what they know through artwork is important, even necessary, for these students. Art classes can make school less mystifying, even more bearable, for them.

Tucker (1995, 27), a teacher and educational researcher, writes of his experiences with the "visualizers" in his class: "I concluded that it was not mere laziness or stubbornness, but a cognitive mismatch between them and a class where most of the thinking was done by writing or talking about writing." For these students, the more oral instruction they are given, the more confused they may become. For them, presenting information or instruction with few words, with more demonstration and graphic displays combined with tactile information – opportunities to handle materials – is most effective. For students who may otherwise see themselves as failures at school, the opportunity to improve and excel in visual art, to receive recognition for their competence and the expression of their ideas, makes a world of difference.

Specific ideas for adapting an art program for exceptional students include the following:

- Demonstrate and use visual aids for each step of the process, including cleanup. Post photographs or images to remind students of what good art practice or behaviour *looks* like.

- Be flexible and resourceful. Students who are physically unable to hold art tools may need adaptations doing things such as holding tools in their mouth or toes, placing pre-painted or pre-cut pieces onto paper, or indicating a choice of design options from a prepared set. Students for whom hand-eye coordination is difficult may prefer making collages, using larger tools on large surfaces and computer-drawing programs, or making videos or taking photographs with a tripod and remote control.

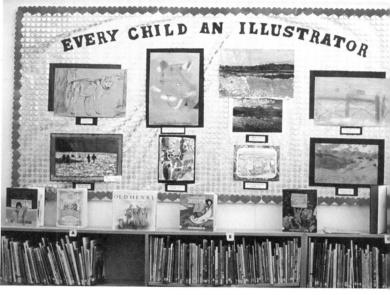

grade 5 students, Wellington School. Teacher: Jean Rennie

Figure 2.18. A display of students' artworks

They also may prefer to work on collaborative projects where they can contribute ideas, do research or writing, or make an oral presentation rather than manipulate art materials.

- Describe a subject, art tools, materials, and concepts. This is good teaching practice, because it helps all students develop their vocabulary and comprehension, and it is a necessity for visually impaired students. Tactile, touchable models are useful for all students, as a way to deepen their experience of a subject. Students with colour blindness can use labelled materials that clearly indicate colours. Visually impaired students can create images with textures and raised surfaces and participate in sculptural work.

- Provide a quiet work area where a student may work apart from distraction, such as a desk or small table surrounded by room dividers, a tent, or a seat between bookshelves. This adaptation is especially important for students who have difficulty focusing on their work. Keep the area free of clutter, pictures, or text. Some students prefer an enclosed area in order to feel safe or to be able to concentrate. Be tactful, because there are many reasons why a student may be unable to concentrate on schoolwork, such as hunger, family issues, homelessness, illness, lack of sleep, bullying, abuse, neglect, learning disabilities, and mental illness.

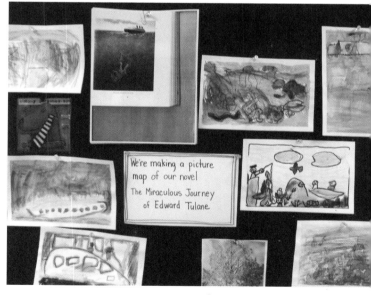

grade 1 students, École Constable Edward Finney School. Teacher: Andrea Stuart

Figure 2.19. Drawing can be used to assess students' understanding.

- Provide standing easels, substitute an exercise ball or stationary bicycle for a chair, devise errands or responsibilities that require occasional walks. These are especially helpful for energetic and restless students who find it difficult to sit for long periods of time. Occasionally, have the whole class stand for regular stretches.

- Take photographs of works in progress. The photographs may be helpful to students who require more time to plan or finish a project. Some students may use the photographs to revisit a task in a variety of other contexts in order to master a skill and transfer their learning. To reinforce their learning, have the students who require repetition sort the photos and write about their work. Throughout the duration of the project, display the photos and writing on the wall as visual reminders.

- Be conscious of student safety when distributing hard, sharp, or breakable tools and materials for student use. The majority of students will handle "adult" tools such as saws and hammers with respect, if they are given clear instructions about safe practices. However, use your judgment with impulsive students, and adapt the activity, materials, and level of supervision as needed.

- Put students with special needs in a positive position with classmates. Give them the art materials or treats to distribute, or let them announce winning tickets from a draw. Teach them that positive social behaviours – such as sharing materials, holding the door open for others, and giving compliments – are required in school.

- Affirm what students are able to do. Acknowledge success, no matter how small. Students will feel motivated to try again. Keep track of and compare the number of positive versus corrective comments you make to a particular student during a school day. Try to balance your feedback with positive reinforcement.

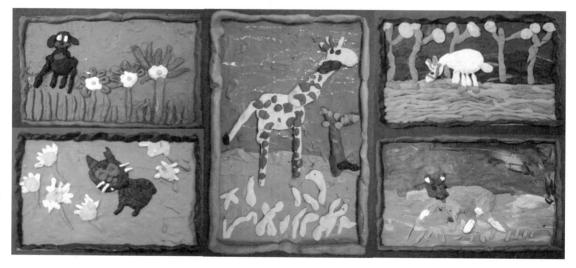

grade 1 students, Wellington School. Teacher: Harbans Rihal

Figure 2.20. Young artists used modelling clay to make these images.

Gifted and Talented Students

In some cases, students who draw well, mix colours intuitively, notice and remember visual detail in their surroundings, formulate original and creative ideas, have precise hand-eye coordination, or build intricate structures are recognized as gifted and talented in visual art. Gardner (1980, 221) uses the term "advanced," because these students progress more quickly through developmental stages and may exhibit advanced skills for their age. An early aptitude in visual art may, or may not, be an indicator of later proficiency, interest, or a career in

the arts. Proficiency in visual art may, or may not, be linked to skill or experience in other subject areas.

Gifted and talented students present a challenge to educators. They tend to be more interested in personal exploration and expression than in lessons. In fact, it may be very difficult to question aspects of their work, as advice is seen as an intrusion, or as a threat to their established competency. They have a system that works for them, and they want to stick to it.

Young artists who are gifted and talented must be coached with enormous tact and forgiveness. Artistic ability may be the only area that they believe – or have been told – is "special" about them. Students who believe that they already know how to draw may simply ignore suggestions, or they may feel uncomfortable with the awkward results of trying a new technique or medium. Painting or collage may seem very imprecise compared with what they can accomplish in a pencil drawing. It is important that they are allowed to continue their own explorations, develop original ideas, and pursue unique, even divergent, approaches. However, it is equally important for advanced students to experience a range of possibilities for their work. Young artists need to be exposed to work by professional artists and allowed to experiment with a variety of media, techniques, and art forms.

Specific ideas for adapting an art program for exceptional students include the following:

- Encourage young artists to experiment on photocopies or traced copies of their work, so they do not "ruin" their original drawings. Introduce design problems to challenge advanced students to solve problems in their sketchbooks. Show examples of how professional artists worked through their ideas in multiple studies and media before producing a finished artwork.

- Use tact when commenting on student artwork or making a helpful suggestion. Artists – of any age and ability – may perceive your comment as a criticism. Be positive and encouraging, be specific, and frame your suggestions carefully. It is often best practice to point out only positive aspects of student work and make suggestions only when you are asked!

- Teach art vocabulary and concepts, and make sure students are aware of a variety of artists, artworks, and visual cultures. Young artists need to be visually literate in order to progress in their work. They need to be able to make judgments and choices, and to respond to visual information. Although exposure to these kinds of information is important for advanced students, all students will benefit from broader knowledge of local and international artworks, visits to museums and artists' studios, and discussions about art.

- Negotiate with students who would like extra art time in their schedule. Young artists may require extra time to complete their projects. Proficient artists may need time to develop ideas in their sketchbooks, experiment with a variety of approaches, complete more detailed artwork, or reflect on what they learned.

- Use visuals when presenting or reinforcing a subject or topic. For students who are proficient in art, but not in other subject areas, drawing and visuals can be used as a bridge to other curricula. Students can draw a story (see

chapter 9); images can teach information about a subject (see the EyeWitness book series); students can draw math problems and possible solutions; they can use visual forms, such as drawings, posters, diagrams, photographs, PowerPoint, and video, for presentations. All students, not just those proficient in art, will benefit.

- Help young artists attend art programs in the community. Art programs outside of school hours can give students the opportunity to experience new materials and techniques, develop their skills and confidence, meet like-minded peers, become involved in their community, develop a work ethic, find opportunities for life-long learning, find mentors and role models, and consider opportunities to volunteer or find employment in the arts.

VISUAL LITERACY 3

WHAT IS VISUAL LITERACY?

Learning to be visually literate is not the same as learning art appreciation. Visual art, like the written word, is a means of communication. It is not enough to merely "appreciate" art. We need to be able to read it, digest it, grapple with ideas it portrays, struggle with its meaning. Visual literacy comes from (1) knowledge of visual forms in art and in the environment, (2) understanding the influences of culture and context, and (3) grasping the fundamentals of design and the meaning of graphic symbols.

WHY VISUAL LITERACY MATTERS

Sight is an important part of our orientation. We watch the road as we ride a bike, read complex human emotions in people's faces and body language, and scan computer images. Learning to observe closely and be attentive to what we see is one component of visual literacy. We enhance the sensory experience of daily living when we notice the colours of street lights reflecting on wet pavement, the tertiary colours and organic shapes of fruits piled in the market, or the intricate geometric patterns in a rug. Learning concepts of design, viewing artists' representations, and exploring art materials help us to see differently, with an eye that is alert to example and comparison. From Egon Schiele, we learn to see reflections in water as a wobbly paint line.[1] Piet Mondrian can teach us to see the shapes of spaces between tree branches.[2] Claude Monet shows us that, if we watch carefully, we see that everything is continually transformed by a subtle palette of changing light and colour.[3]

We live and work within a constructed environment. Our buildings, furniture, and tools are the works of architects and designers. Even though we are not always conscious of doing so, we are constantly responding to visual forms.

Emmy, grade 12 student, Kelvin High School.
Teacher: Jen Kirkwood

Figure 3.1. Emmy's sketchbook contains research, development of her visual ideas, and experimentation with design and media.

1. Egon Schiele. *Harbour of Trieste*. 1907.
2. Piet Mondrian. *Gray Tree* (and tree series). Circa 1912.
3. Claude Monet. Rouen Cathedral series. Circa 1892.

When we learn about design and the context and history of aesthetic movements, we become able to make informed aesthetic judgments. We also become aware of, and more open to considering, alternate approaches. A walk past Antoni Gaudí's buildings in Barcelona, Buckminster Fuller's geodesic dome in Montreal, or the multiple roofline of a Japanese shrine, will forever change one's concept of what a building is.

In our visual culture, images communicate a wide spectrum of information, concepts, and emotions. The sheer volume of visual information is staggering. Street maps, billboards, book covers, newspaper and magazine photographs, food labels, assembly instructions, websites, logos, and our favourite TV shows are just some examples of the images and symbols we commonly view. We leaf through picture books and photographs, live in designed spaces, and use tools and appliances made of beautiful or convenient materials. We respond to visual symbols at bus stops, in public washrooms, and on traffic signs. We receive messages about ideal body types, which products to buy, and what it means to be "cool."

People who are unaware of the manner in which they are affected by visual culture are vulnerable to influence by perceptual forces they cannot understand, judge, or change. Such people are, in effect, perceptually illiterate (Chapman 1978, 121). The need for critical viewing becomes more apparent when we consider that we may be exposed to as many as 5000 advertisements, logos, or slogans per day (Phillips and Rasberry 2008). Experts on art education are critical of the lack of "visual thinking skills" being taught to students:

> …the plethora of mass-produced and standardized imagery bombarding us daily is very likely to shut us down rather than encourage us to focus and think. And it is somewhat paradoxical that the growth of the visual culture has not produced a concurrent evolution of strategies that teach us to decode complexity (Yenawine 2002).[4]

Critical viewing means understanding what we are seeing, who made it, the intended and unintended messages and impact of the image, why it was made, whether or not it was altered, the bias of its creator, and which images are excluded. These questions may be asked about mass-media images such as photojournalism, advertisements, and music videos. These same questions are relevant to artworks, artists, and art movements. The study of visual art gives history, experience, and depth to our viewing of contemporary culture.

Visual art provides an accessible means to study culture and history. A single painting by Goya or Picasso provides a glimpse of the human tragedy of war. A quilted and painted image by Faith Ringgold gives us a glimpse of family life, a child's view from a rooftop in Harlem, and an opportunity to study an historic journey out of slavery.[5] Paintings by Daphne Odjig teach us timely lessons from the Anishinabe worldview about our connectedness to the earth, the environment, animals, and each other.[6] The architecture of the ancient Maya leaves us in awe of a society of accomplished engineers, scientists, and sculptors.

4. The article refers to visual thinking strategies researched by cognitive psychologist Abigail Housen and Philip Yenawine's application of this research to art education. An illustrative video of students using visual thinking strategies is available on YouTube. Go to: <http://www.youtube.com/watch?v=aVzcknOWpaE>.

5. Faith Ringgold. *Tar Beach*. 1988.

6. Daphne Odjig. *The Indian in Transition*. 1978.

TEACHING VISUAL LITERACY

To be visually literate,[7] we need to be able to have aesthetic experiences and observe, describe, analyze, interpret, and evaluate our ideas and practices. We need to find some meaning of importance to us. We need to ask the bigger questions about the artwork's place in our visual culture and its role in helping us understand "big ideas." Our students, too, as developing artists, need to know how and why an artwork was made. They also need to be given opportunities to respond to visual experience by communicating their ideas through visual media – by creating artworks of their own.

Learning Environment

Begin by creating a visually rich and aesthetically pleasing environment in your classroom (see chapter 1). While students are learning established curricula in school, they are also learning aesthetic perception and codes. Avoid pre-packaged visuals. "The flatly colored, outlined stereotyped images of the posters and bulletin board borders talk down to children and assume that they are not capable of responding to the rich, diverse images and artifacts, including images from popular media culture, which the world's cultures have created" (Tarr 2001).

Bring in real objects and artworks from outside the classroom to enrich students' experiences. A rich classroom environment can teach your students as much about their world as the curriculum can. In schools where art education is valued, the learning environment is described as "the third educator" (ibid., 2001). Classrooms can become extensions of the community and contemporary culture. The structure, décor, and objects should contain real elements.

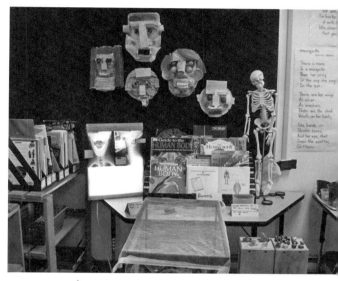

grade 1 classroom, École Constable Edward Finney School. Teacher: Andrea Stuart

Figure 3.2. Students in this classroom learn in a visually rich environment.

Tips for creating a visually rich classroom environment include the following:

- Store clutter away in storage tubs, cupboards, or boxes. Display images and objects on a rotating basis, grouped by theme. Use file boxes, a flipchart, PowerPoint, folding Coroplast boards, or oversized books to store visuals. Avoid plastering your walls with random images, because important messages will be lost, and visual learners will be distracted.

- Find and display pictures relevant to topics your students are currently studying (check out children's picture books, calendars, art postcards, and posters). Provide real objects, artifacts, natural items, plants, flowers, and animals, and ask students to help sort, display, and/or care for them.

- Avoid slick, commercial images. Ask students to draw pictures, or use photographs or artists' representations of a topic of study. Your students will learn by creating, or sorting and selecting, these images themselves.

7. The suggestions for teaching visual literacy and how to look at, talk about, interpret, and value artwork are adapted from a variety of sources and classroom experiences (see references).

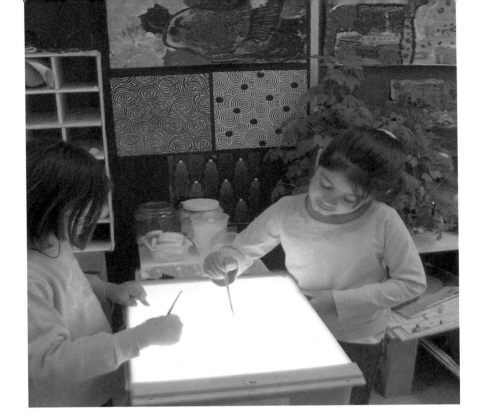

grade 1 classroom, École Constable Edward Finney School. Teacher: Andrea Stuart

Figure 3.3. Students are using a light table to help them transfer their sketches onto clean paper.

- Take field trips to art galleries and museums, and find opportunities for real-life experiences. Display photographs to document and reinforce learning while in the classroom and on field trips. Borrow museum kits and materials, and put students in charge as curators of a classroom display.

- Be aware of the elements and principles of design when you set up your classroom or classroom displays. Challenge students to help with this work.

Observation

An important step in becoming visually literate is learning to be attentive and to observe one's surroundings. Unfortunately, this is now a relatively rare experience. Whereas an artist may spend considerable time studying one image, a more common viewing experience is to watch digital images flash across a screen for split seconds. Here are some suggestions for teaching observation skills:

- Look more slowly. When you slow down and spend time looking at a subject, you have time to notice more and be attentive to details.

- Model close observation techniques for your students. Sit with students, and wonder aloud about the aspects of an image you are looking at: "I wonder how the artist made that swirl of blue?" Or: "I wonder why the person on the left looks so sad?" Or: "Why does this remind me of the poem we studied?" Do not feel obligated to answer the questions, but do create a safe environment for students to wonder and ask questions of their own. Later, after allowing students time for research, revisit the image, and encourage students to ask more informed or profound questions.

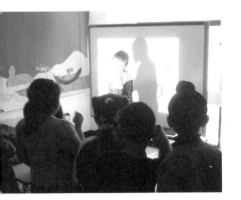

grade 3 students, Wellington School. Teachers: Emily Deluca Taronno and Crystal Millar-Courchene. Support Teacher: Val Mowez

Figure 3.4. These students are using a SmartBoard to show their mind maps to another class.

- Provide students with access to tools that invite close observation. These include magnifying glasses, mirrors, grid lines drawn on Plexiglas, binoculars,

kaleidoscopes, cameras, video cameras, viewfinders (a rectangular hole cut in a piece of heavy paper), thick drinking glasses or containers of water (for bending light), microscopes, tinted glasses, 3-D glasses, and access to a variety of good-quality images.

- Provide optical illusions and "I Spy" images. "I Spy" images contain hidden objects that encourage students to spend time looking carefully at the details in a single image.

- Provide collections of mysterious, unlabelled objects. These will encourage your students to speculate about the purpose and design of each object.

Malhalia, Kelvin High School. Teacher: Jen Kirkwood

Figure 3.5. Malhalia's sketchbook shows what students can do when teachers encourage close observation and creative-idea development.

Description

Description is an important tool to help students organize and communicate their observations. By describing a work of art, students are observing, noticing detail, sharing their knowledge with classmates, and learning that their peers may see different aspects. Learning about multiple points of view is an important thinking and collaborative skill (Housen 2002). Talking about art is an important method of building art vocabulary and concepts; however, description is not limited to speaking and writing. Students can describe a work of art through a variety of modes. Some of these modes are: brainstorming as a group to list everything that students see; drawing, painting, or sculpting details they notice in an artwork; using drama to create a tableau (in which students re-create the artwork by acting it out and freezing in place); and enumerating parts of the artwork ("six houses, three shades of green…").

Use the following strategies for describing artworks:

- Ask questions. The simplest and most useful question you can ask is: "What do you notice about the artwork?" You may be surprised at what students see and how widely varied their perceptions are from one another. Allow time for students to look carefully and find the words to describe what they see, or for students to complete careful observational drawings. Questions and students' comments about the artwork will lead into the next stages of visual literacy: analysis, interpretation, evaluation, and synthesis.

- Build vocabulary. Write students' observations on a flipchart. Revisit the list, and add "juicy" descriptive words. Encourage students to be specific about what they see and to help one another find words that are precise. They might describe, for example: an "enormous, looming, scary" shape; a "blue-violet flower with lacy edges"; or a sky "full of thunderous, swirling, blue-black clouds." Encourage older students to use a thesaurus to extend their word choices.

- Encourage students to transfer their observation skills to other subjects. Ask students to look closely at objects as they study science, such as the growth of a plant, parts of an insect, or properties of minerals. In language arts, have them study a story by drawing a scene from a descriptive passage.

- Use prepositions to describe the placement of parts of an artwork: Is one piece *above, below, in front of, behind,* or *apart from* another piece?

Analysis

Formal analysis means identifying the visual design aspects of an artwork. As students describe an artwork, they may begin to comment, or ask questions, about composition and media. They may notice types of lines, point out geometric shapes or colours, or describe the patterns or movement in an artwork. Some elements or principles of design will be more or less important in a specific artwork. Challenge your students to make decisions and offer their opinions about the composition of an artwork and which aspects are most interesting. Composition and media are important to create both visual interest and meaning in an artwork.

COMPOSITION

Composition refers to the elements and principles of design and how they are arranged and applied in an artwork.

Elements of Design

The *elements of design* are (1) line, (2) shape and form (three-dimensional solids), (3) texture, (4) colour and value (lightness and darkness of a colour), and (5) space (depth, surrounding spaces, and the negative spaces contained within and between parts of the subject). Any visual information, view, advertisement, design, artwork, or environment can be analyzed by looking at the elements of which it is composed.

Here are some suggestions for teaching the elements of design:

grade 6 student, Wellington School. Teacher: Cathy Woods

Figure 3.6. A student used simple shapes for this figure drawing.

- Encourage students to be aware of the elements of design in their environment. Have students sketch the shapes of houses and car tires while on a community walk. Bring flowers and fabrics into the classroom as examples of colour. Allow students to handle objects that have a variety of textures.

- Ask students what elements they notice in an artwork. Look for dramatic examples of the use of elements of design to share with your students. Picasso, for example, created a series of blue paintings such as *The Old Guitarist*.[8] Paul Klee used geometric shapes in his painting, *Castle and Sun*.[9] Other examples of design elements include the use of strong light and shadows in old black-and-white movies, and the geometric sail forms of the Sydney Opera House.[10]

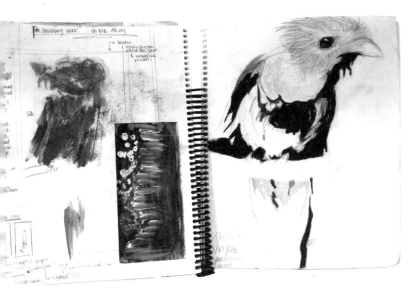

Emmy, grade 12, Kelvin High School. Teacher: Jen Kirkwood

Figure 3.7. A high-school student used her sketchbook to study the colour, texture, and value of her subject.

8. Pablo Picasso. *The Old Guitarist*. 1903.

9. Paul Klee. *Castle and Sun*. Date unknown.

10. Sydney Opera House. Architect Jorn Utzon. 1957–73.

- Challenge your students to make decisions about the elements of design in their own artwork. They can use a variety of media and tools such as photography, computer graphics, and collage to create images that have simplified elements. Examples include: a mosaic image made only of square shapes, a painting made by mixing only tints and shades of green paint, or using light and shadow to create a range of values in black-and-white photography.

- Comment to students about their use of elements in their own artwork: "Yes, you're right, the dog's face is a triangle shape." Or: "I like all the small texture marks you used to draw the tiger's fur." Or: "It's interesting how you switched the positive and negative spaces; the bicycle shapes are blue like sky and the spaces are painted red."

- Analyze art elements as a strategy for drawing difficult subjects (see chapter 7). A drawing of a bicycle, for example, is composed of lines that represent the frame, circular shapes for the tires, and triangular negative spaces between the spokes and surrounding the frame. A sculpture of a bicycle would be formed of a thin, cylindrical frame. A bicycle generally has a smooth, hard frame, with bumpy tires. A light shining on the frame might produce lighter and darker values (reflections and shadows). Bicycles can be painted a variety of colours. When you vary the established elements, you can produce a surprising or absurd image, such as a bicycle with square tires.

VIEWING

Tony Tascona. *Yellow Transmission*. 1961.

Figure 3.8. This painting by Manitoba artist Tony Tascona references many of the elements of design. In it, we see the repetition of triangles and rectangles, lines of different widths, and colours of different values. The positive and negative spaces work to create a background and foreground. Note how different the bright yellow looks when it is placed next to orange, green, turquoise, and dark yellow. Ask students which words they would use to describe the elements of design in this work. Is the painting soft, light, passive, and weak? Or is the painting strong, hard, forceful, and vibrant?

Principles of Design

The *principles of design* are (1) balance (symmetrical and asymmetrical), (2) proportion (comparative sizes and scale), (3) movement and expression, (4) emphasis (dominance and subordination) and focal point, (5) contrast and variety, (6) unity and harmony, and (7) repetition (pattern and motif) and rhythm.[11] Any visual information, view, design, advertisement, artwork, or environment can be analyzed by looking at how the elements are organized according to principles of design.

Here is an example of how the principles of design can be used in composition. A simple set of objects – math blocks, chairs, or shapes in a painting – may be arranged in a uniform row to produce a sense of stability. When those same objects are placed in a haphazard stack, they produce a sense of instability; they look as though they are about to topple over into the space around them. The objects can also be tilted and drawn with rough edges to create a sense of movement, grouped in opposing corners, arranged to appear to recede into the distance, or arranged in a pattern of alternating colours and shapes. One object may be slightly brighter or larger so that it stands out, or its edges can be softened so that it seems to recede into the background. These aesthetic choices create a

11. The list of words used to describe these principles will vary in different sources; however, the concepts are similar.

VIEWING

Andy Warhol. *Sixteen Jackies*. 1964.

Figure 3.9. The principles of design include pattern and repetition. In some artworks, patterns create meaningful visual forms. Often, patterns are part of a shared cultural aesthetic. Andy Warhol, however, used repetition to emphasize the banality of images within mass culture. Warhol began his career as a graphic designer, and he would have used principles of design in creating his early work. Later images (such as this one) have no obvious focal point or emphasis, and limited variation. While Warhol used printmaking to achieve his desired effects, students might use a variety of media to experiment with repetition and pattern-making.

pleasing or disturbing visual experience, and help to create meaning in an image.

These same principles are applied in more complex compositions to create mood, to draw attention to particular elements, and to lead the viewer's eye through a space. When you view a complex image, take note of where your eye goes first, second, and last. What drew your attention to those areas of emphasis? It may have been lines, colours, or groupings that created a path for your eyes to follow. Perhaps the use of contrasting colours, sizes, and values made one element stand out. What did you notice much later, when you looked more closely? Does the image have unity and harmony? Are any colours or shapes repeated? Is there a symmetrical or asymmetrical balance of large and small forms? Is there more emphasis on variety, movement, contrast, and discord? (See figures 3.8 and 3.9 as examples.)

Here are some suggestions for teaching principles of design:

- Encourage students to be aware of the principles of design in their environment. Observe and describe movements of children in the playground or of treetops blowing in the wind. Identify and photograph patterns of windows and fence boards while on a community walk. Bring flowers and fabrics into the classroom as examples of colour harmony or contrast. Allow students to handle objects that have a variety of textures and describe the differences between them.

- Challenge your students to describe the principles of design that are important in specific artworks. Look for dramatic examples of the use of principles of design to share with your students. In Picasso's series of blue paintings, such as *The Old Guitarist*, the monochromatic (one colour) scheme gives unity to the composition. Paul Klee used a pattern of geometric shapes to represent a building in his painting, *Castle and Sun*. In the picture book *Olivia*, by Ian Falconer, small amounts of bright colour are used to emphasize Olivia, who is the focal point of the illustrations.[12] Emily Carr painted the sweeping movement of tree branches in wind.[13] Diego Rivera used dramatic size and scale in his epic mural paintings.[14]

12. See References for bibliographic details of this book.
13. Emily Carr. *Abstract Tree Forms*. 1931–32.
14. Diego Rivera. Palacio Nacional, Mexico City. 1929–35.

- Challenge your students to experiment with composition. Encourage them to plan their work in their sketchbooks. There, they can try different placements, arrangements, and colour schemes in quick rough drafts before they begin a large project. Collage, photography, and computer graphics are media that are suitable for easily re-arranging elements and experimenting with placement and proportion.

- Ask students to discuss their compositions and to explain how the overall impact or meaning of their artwork was affected. You might say: "You made the little girl small, and her brother is much bigger. Did you want to show that he is important, or scary?" Or: "These zigzag lines make the car look like it's moving really fast." Or: "I notice that you tinted all of your colours with white. That gives the colours harmony because they all have the same value."

- Connect the principles of design to other subject areas. Through drama, dance, and music exercises, students can create compositions with balance, contrast, patterns, rhythm, harmony, emphasis, and movement. Students can study grouping, number pattern, proportion, or symmetry and asymmetry in mathematics.

Media and Techniques

What is the artwork made of, and what tools and techniques were used to make it? The use of different materials, tools, and processes will affect the visual experience of an artwork. For example, in interior design, organic materials such as wood and fibres have a sensory impact that is very different from metal and plastic. Paintbrushes, used with thinner or thicker paint, make different kinds of marks from those made by palette knives. A variety of papers, available in assorted weights, surface textures, and fibres, display marks and absorb ink and paint differently. Media and techniques are most noticeable when they fit a subject well (leather to represent a wrinkled face), or when they are wildly different (Meret Oppenheim's teacup made of fur,[15] Deborah Butterfield's scrap-metal horses).[16]

Examples of a variety of media and techniques are widely available. An Internet search of the simple subject "dog art" turns up a range of photographs, drawings, paintings, video, stained glass, game boards, tessellation, advertising, prints, sculptures, artifacts, modelling-clay images, and a controversial art installation involving a live dog. Each approach changes how we view the subject and allows for different aspects of the subject to be noticed.

15. Meret Oppenheim. *Object*. 1936.

16. Deborah Butterfield. Untitled (series of horse sculptures, scrap metal). 1986–2009.

Sister MacNamara School. Teacher: Cathy Woods

Figure 3.11. Pastel and paint drawings of famous architecture (above, and page 47, right)

Book illustrations, once limited to engraving or pen and ink, now incorporate a wide variety of art media on a variety of surfaces. Compare the media used for the illustrations in *Have You Seen Birds?* (modelling clay), *The Paper Crane* (cut paper and drawing), *The Dragon's Pearl* (paint mixed with grass and earth on canvas), *Zoom Away* (pencil on paper), and *Knuffle Bunny* (photography, drawing, and collage).[17] The artwork in each of these books looks very different, because each illustrator used different media and techniques.

Here are some suggestions for teaching media and techniques:

- Encourage students to be aware of natural and manufactured materials in their environment. Identify and document building materials at a construction site, or materials in common household items. Examine the properties of a variety of materials, and categorize them by their visual and tactile qualities, such as hardness, softness, transparency, colour, and glossiness. Bring flowers and flowery fabrics into the classroom as examples of how natural items have influenced manufactured materials. Allow students to handle objects made of a variety of materials.

- Make a variety of art materials available to your students on a rotating basis, or organize the materials in accessible containers at an art centre. Teach each technique on a small scale first, so that students gain some confidence and experience before working on larger projects.

- Challenge your students to identify or speculate about the materials, tools, and techniques that were used in specific artworks. Look for dramatic examples, such as Meret Oppenheim's teacup made of fur, Deborah Butterfield's scrap-metal horses, Andy Goldsworthy's compositions of natural materials, or Julian Beever's sidewalk chalk illusions. Older students might be challenged to explore controversial artworks, such as the human body exhibits prepared by Gunther von Hagens.[18]

- Challenge your students to experiment with materials, tools, and techniques. Students can make the same small image repeatedly, using different media and observing how the different materials affect the outcome. Encourage students to use a variety of tools when drawing (for example, blending stub, softer pencil, or oil pastel), painting (a palette knife or sponge makes a mark different from a brush), or modelling clay (impress textured objects, or carve with wider or narrower tools).

- Comment on students' choices of materials – especially if they use the materials in inventive combinations, or in ways that enhance or detract from the image. For example, you might say: "I notice that you chose to glue fabric on for the girl's jacket, and you used scrap paper for her hair." Or: "In this part of the picture, you applied some interesting paint drips and brush marks. That gives your picture variety."

- Research the processes used by professional artists. Films and videos of artists at work are available in which the artists teach art techniques or speak about how a particular work of art was made. These technical processes may be of interest to the developing artists or young scientists in your class. They also

17. See References for bibliographic details of these books.
18. See appendix E for website addresses and References for bibliographic details of books about these artists.

 Teaching Art

teach students that there is often repeated experimentation, failure, persistence, innovation, and risk-taking involved in the process of creating art.

■ Discuss how to properly and safely use art tools and materials. Check to ensure that the materials in your classroom are non-toxic and safe for students' use.

Interpretation

Interpretation involves finding meaning in an artwork. When we view art, we discover or construct meaning through a variety of contexts. These include visual content, narrative, imagination, mood and emotion, personal connection, historical and cultural context, symbols and metaphors, the artist's life and statements, critical and audience responses to the artwork, comparison and contrast to similar artwork, composition, materials, and technique.

The visual content of an artwork are the recognizable pieces. In a landscape painting, there may be sky, trees, and a horizon line that are easy to "read." A horizontal line in a more abstract piece may also be interpreted as the horizon in a landscape. In a portrait, we see parts of a face, and we understand something about the person's mood or character. This familiar content gives us a beginning point for our interpretation.

The response of the audience is not always what the creator of the artwork predicts it to be. Scenes of childhood, familiar places, emotions, and events enable us to make powerful personal connections that may be far removed from the artist's intended meaning. A landscape painting may remind us of a favourite childhood haunt. A conflict enacted during a performance art piece may bring back memories of an argument with someone in our own family.

Most artworks require some thought, imagination, or supporting information before the viewer can gain some depth of understanding. For example, when we view a religious icon from outside our own culture and experience, we can make judgments about the aesthetic or personal value it has for us. However, we likely do not know anything about why or how it was made, what it was used for, whether or not it is a typical example of its type, what meaning it held for the people who originally viewed/used it, or where it came from.

These same unknown qualities are present in pop art from the 1960s, graffiti in a subway station, ancient petroglyphs, or classical Greek sculpture. In each case, there is a background story or a set of circumstances that led to the creation of the artwork. Artists are influenced by traditions, styles, and movements in art and ideas. They work within a particular society formed by particular social, economic, political, and historical circumstances. They work within, or in opposition to, a particular visual culture with a visual system or language of communication. They create art in a variety of forms, for a variety of purposes, and communicate ideas to specific audiences.

Here are some suggestions for teaching strategies for interpretation:

- Some artwork has identifiable visual content. Students can begin by listing, describing, and speculating about aspects of the objects, people, creatures, places, and events in an artwork.

- Some artwork tells a story. The content in some artworks, photojournalism, and illustrations has an obvious narrative or enough visual clues to imagine a likely scenario. The viewer can test this with research into other aspects of the image or accompanying text. Book illustrations in wordless picture books, such as *Window*, by Jeannie Baker, or *A Boy, a Dog and a Frog*, by Mercer Mayer,[19] convey the meaning of an entire story without words and provide an easy example for beginners looking at narrative art.

- Encourage students to make connections with an artwork. Connections may be personal, reminding the student of a familiar person, place, or event. Connections may also be made to other artworks, inviting students to compare and contrast aspects of the work. Connections may be made to aspects of culture, past and present, by finding similarities in movies, literature, society, and visual culture (architecture, design, artifacts, clothing, and so on).

- Activate students' curiosity by talking about the artist's life or reading a story related to the topic. Use pre-teaching (teaching topics related to the work), or storytelling, to increase students' interests and attention spans. Engage in a multi-sensory exploration of the topic by touching, tasting, viewing, listening, and smelling related objects.

- Activate students' imaginations. Imagination is an important component of interpretation. Feldman (2004), an early authority on art education, uses a number of exercises to help students engage imaginatively with a work of art. For example, ask students to pretend they are the artist and speak about his or her work. Take a "walk" through the painting, and talk about what you hear, see, feel, taste, and touch. The kind of exercise you present to your students may vary with the content and composition of the artwork. For example, have students view Paul Klee's *Castle and Sun*. Then, challenge them to describe, verbally or in a drawing, what the king and queen of the castle might look like, perhaps using only the geometric shapes and bright colours of Klee's painting.

- Engage students by using logical thinking. Encourage students to ask questions about the artwork. Treat the artwork as a visual puzzle. Use the aspects of content and composition as starting points to deduce how or why the artist made each aspect, and how that aspect contributes to the meaning or impact of the artwork.

- Ask students for their interpretations of an artwork. Look for dramatic examples of artworks that carry strong messages, such as the painting by Francisco Goya, *El Tres de Mayo*, which shows a dramatic scene from war in Spain in 1808.[20] The events, emotion, and information about the horror of war are clear in the content of the painting. Discuss the composition, which uses dramatic light and dark values (called *chiaroscuro*), isolated colour, and lines

19. See References for bibliographic details of these books.
20. Francisco Goya, *El Tres de Mayo*. 1814.

created by the guns and the victim's arms to emphasize the victim. Students can further engage with the image by imaginatively stepping into the picture as a news reporter describing the scene. Students could research either the events of the War of Independence or the life and work of Francisco Goya. They could extend their understanding by comparing the work to modern images of war, other epic paintings, or by enacting a drama exercise based on the image.

watercolour and ink, Noni Brynjolson, age 11

Figure 3.12. To the viewer, a drawing can convey a strong emotion.

- Comment to students about the meanings in their artworks: "The person is blue in this picture. Is she magical, is there a blue light shining on her, or is she sad?" Or: "It's interesting that you chose to put the word *freedom* in a sealed jar. It makes me stop and think about how our ideas sometimes stay bottled up inside. Is that the meaning you were hoping to convey?"

- Observe responses to the artwork. What was the critical response or audience reaction to the artwork when it was exhibited? These responses are clues to how other people have interpreted the artwork.

- Look for symbols. Artworks often contain symbols or visual metaphors. Symbols with which your students may be familiar include a dove to symbolize peace, a heart symbolizing love, or two locked hands symbolizing friendship. Frida Kahlo uses an architectural column to represent her damaged spinal column in a self-portrait.[21] Some symbols are more obscure, or specific to a particular time, place, or culture. For example, the flying cow in a painting by a Central American artist baffled me until I learned that it represented a shortage of food. The red, yellow, black, and white colours in the Anishinabe medicine wheel each represent specific cultural teachings.

- Encourage students to reflect on their work. Begin by saying: "Tell me about your artwork." Challenge advanced students to make conscious decisions about the meanings conveyed in their own artworks, and whether their intended meanings are supported by the content, symbols, composition, materials, mood, and cultural references (art form and style) they have chosen. Beware of clichés. Older students can use Internet search engines as a kind of visual thesaurus, looking at clichés and alternative, more visually interesting, interpretations of visual ideas.

- Challenge students to relate the content and meaning of the artwork to themes of study, current events and issues, and big ideas. Study the artwork in the context of the art movement, culture, time period, and place in which it was made. Museums and galleries offer interpretive tours, and many have useful websites that provide information about particular artworks and art movements. In addition to the "isms" in art history – realism, impressionism, cubism, expressionism, surrealism, symbolism, and abstractionism – there is a world rich in international art, female artists, contemporary art movements, and local artworks to explore.

21. Frida Kahlo. *The Broken Column*. 1944.

Daphne Odjig. *The Indian in Transition*. 1978.

Figure 3.13. Artwork is representative of the culture in which it is made. It can be viewed from within political, historical, and social contexts. Daphne Odjig's painting tells the story of the colonization of Aboriginal Peoples in Canada. On the left, a figure with a drum is depicted next to a symbolic Thunderbird. Moving to the right, Odjig has depicted the negative effects of European civilization on Aboriginal Peoples. On the far right, the Thunderbird returns, creating a message of hope for the future. Odjig's work brings up the importance of evaluating artwork based on its cultural context. Students should be encouraged to make artwork that expresses their own family or cultural traditions.

Evaluation

Evaluations are sometimes made on the basis of personal preference and whether or not an artwork has personal meaning. The Generic Game, developed at Harvard University,[22] is a questioning technique used to view artwork. It begins and ends by asking students: "Do you like this work of art? Why or why not?"

Students' opinions about artworks often change after they have taken time to observe, describe, think about, and interpret them.

The evaluation of an artwork includes judgments about both its aesthetic qualities (visual and affective aspects) and pragmatic qualities (content and meaning). Some images are created for pragmatic purposes, for example, to sell products or to raise awareness about social issues. Some images have a primarily aesthetic intention, for example, to experiment within a style of art or to provide a pleasurable view. Art may have both aesthetic and pragmatic purposes, such as posters that use elegant fonts, ceramic vessels, documentary films, or architectural design.

Decisions may be made about whether the composition, technique, or materials are effective in the artwork. The intention of the artwork may be to be beautiful, disturbing, or challenging, and the decisions that the artist has made will make the work more, or less, successful. Judgments about the impact of the artwork are based on whether the content and themes in the work contribute to, or challenge, our understanding of important ideas.

One criterion for evaluating an artwork is its impact and influence. Artworks provide representation, interpretation, analysis, and evaluation of important themes such as the civil-rights movement, environmental responsibility, global conflict, and local or contemporary issues. Artworks also have the potential to create a sensory, emotional, and experiential impact on viewers that enables them to make deeper connections.

22. Generic Game, Project Muse.

Artists' interpretations of historical events may provide an uncommon point of view – that of a witness, a victim, a minority, or another voice not usually heard in a textbook or news media version of events. *The Indian in Transition* (1978), by Daphne Odjig, for example, which is about the history of European contact, depicts broken circles resulting from battles, residential schools, and epidemics.

Evaluation is a higher-level thinking skill (see Bloom's Taxonomy[23]) that requires time, learned strategies, and practice to develop.

Teaching strategies for evaluation include the following:

- Encourage students to be aware of the judgments that they make about art in their environment. Ask students what exactly it is that they like about a building's façade, the design of a car, or a style of clothing. Consider specific aspects of each example, and help students discern the underlying reasons for their choices.

- Ask students to offer judgments about an artwork. Look for examples of artworks that will extend their understanding of what "good" art is. View art from a variety of cultures, places, and times, and art made in a variety of styles, from a variety of materials. Visit museums, galleries, and artists' studios so that students will build experience and context for making their own judgments about art.

- Challenge your students to make judgments about their own artworks. Encourage students to look at particular aspects of their works that they think are more, or less, successful (see chapter 4).

- Comment to students about what is more, and less, successful in their artworks: "I like all the small texture marks you used to draw the tiger's fur. The tiger really does look furry." Or: "It added visual interest when you switched the positive and negative spaces; the bicycle shapes are blue like sky, and the spaces are painted red" (see chapter 4).

- Encourage students to think about audience response to artwork. Students can begin by giving and receiving positive responses about each other's work.

- Find examples of critical responses to art exhibits or to an artist's body of work. These are clues about how other people made judgments about an artwork. How did the audience respond? Is the work viewed differently now from how it was at the time the work was made? Would the meaning of the work change if it was placed in a new context, or viewed by a different audience?

- Encourage your students to explore the impact of art in their community. Encourage them to study and express ideas about themes of personal, social, political, and cultural importance. Examining problems, and transforming them imaginatively through art, is an empowering experience. Residents in one inner-city youth program transformed an empty lot into a green space by claiming it with hand-painted billboards and benches. In a multi-age classroom, students built a model of a new zoo that provided more space and activities for the animals, and then presented their model to the mayor at

grade 3 classroom, Wellington School. Teachers: Emily Deluca Taronno and Crystal Millar-Couchene

Figure 3.14. In this cooperative installation project, students built this boat as part of an ancient Egyptian museum exhibit.

grade 3 classroom, Wellington School. Teachers: Emily Deluca Taronno and Crystal Millar-Couchene

Figure 3.15. This shows painting detail from a column in the Egyptian museum exhibit. The Egyptian project met curriculum outcomes/expectations in social studies, language arts, drama, science, and visual arts.

23. Benjamin Bloom (1956) proposed a hierarchy of thinking skills, including (from lowest to highest) knowledge, comprehension, application, analysis, synthesis, and evaluation. This hierarchy is discussed in "A Taxonomy for Learning, Teaching, and Assessing – A Revision of Bloom's Taxonomy of Educational Objectives."

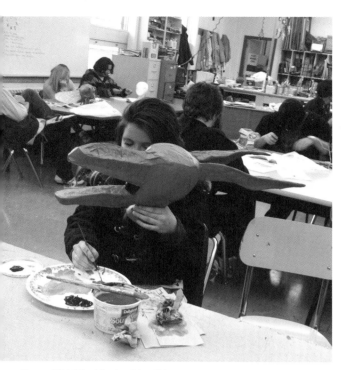

Elmwood High School. Teacher: Briony Haig

Figure 3.16. A creative student finds an innovative solution to a sculpture assignment.

city hall. A student council designed a new playground for their school. Middle-years students made ceramic bowls and sold them as part of a project to raise funds for a local food bank.

But, Do You Like It?

Students will often seek the teacher's personal reaction to, or approval of, their works. Ideally, we take each opportunity to use our feedback as a means to teach specific aspects of visual literacy. However, classrooms are busy places, and we do not always have time to reflect on an ideal statement when a student presents us with his/her artwork. How we respond, in the midst of a busy lesson, may be very important to the student. We might simply give a personal response, such as: "Yes, Harry, that big yellow sun reminds me of summer. It makes me feel happy and warm." As a result, Harry may not draw anything but big, yellow suns for the rest of the year! However, he may also have learned that his work can communicate feelings and ideas, and that his artwork is valued.

ASSESSMENT 4

EVALUATION AND ASSESSMENT

Evaluation was discussed in the previous chapter as a higher-level visual thinking skill required to make judgments about a work of art. Evaluation includes judgments about the aesthetic qualities (visual and affective aspects) and pragmatic qualities (content and meaning), and the impact and influence of a work of art. These qualities result from the use of materials, composition, form, content, and the context of visual culture.

Evaluation in education is a process of judging a student's progress against standard measurements. These standards are usually expressed as curricular outcomes or expectations, which describe what a student must be able to do at each particular grade level.

Assessment is a learning opportunity. Formative assessment (feedback given to students about works in progress) helps students form judgments, so that they can revise and improve their artwork. Self-assessment requires students to identify desirable outcomes/expectations, and compare their work against these criteria. They can then make decisions about what specific aspects they want to change. Assessment uses higher-level thinking skills – comparing, synthesizing, and evaluating.[1]

Assessment can be (1) formal, with set criteria and numeric values; (2) informal, responding to the needs and achievements with comments, spontaneous suggestions, or modelling alternative strategies; or (3) anecdotal, where the teacher or peers describe and discuss aspects of an artwork or creative process.

Iain Brynjolson, age 4

Figure 4.1. Discuss artwork with students to establish a vocabulary for viewing and problem solving.

Setting Criteria

The process of negotiating criteria together with students can be a learning opportunity. Negotiating may be time-consuming, but it is so worthwhile for students to understand why they are working, what they are learning, and why they are learning it, and to have some ownership of the process. The process

1. See Bloom, B. S. *Taxonomy of Educational Objectives, Handbook I: The Cognitive Domain*. New York: David McKay Co. Inc., 1956. There are adapted versions of Bloom's taxonomy available on a variety of education websites.

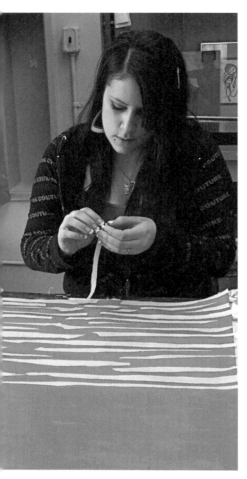

Dawn, Villa Rosa Alternative High School.
Teacher: Rhian Brynjolson

Figure 4.2. Dawn is making decisions about her painting project. She is using masking tape to block out areas of colour on her painting.

Machray Elementary School. Teacher: Ann Rallison

Figure 4.3. A student works carefully on a relief print.

described below works well with students of all ages.[2] For younger students, the process can be simplified, but the discussion pieces are equally important.

1. Start with clear objectives for learning. You can define these as the "big ideas" you want your students to understand, a specific curricular outcome or expectation you want students to meet, or a technique you think is important for your students to master before they can progress. Remember to tell your students why the activity is important and what they will learn from doing it.

2. At the beginning of the project, or after a couple of working sessions, ask students what they think are the most important aspects of the project. Write their responses on flipchart paper. Ask them questions to find out if they understand why those aspects are important. This discussion may reveal gaps in understanding of ideas and provide an opportunity for students to ask questions, initiate further research, make comparisons with visual examples, or consider alternate approaches.

3. The criteria that students begin with may be superficial. One so-called "advanced placement" class I worked with listed "neatness" and "staying in the lines" as their *only* two criteria for a well-designed postcard project. This led to a discussion of what postcards are for – communicating with others, conveying a sense of place, and (for that project) sending messages about caring for the environment – that helped to clarify the task and focus students' attention on the important aspects. The criteria your students offer will point to gaps in their understanding. You can use this information to direct your teaching.

4. In the middle of the project, after students have had some time to work, ask them to stop and revisit the criteria. What have they learned or added to their pieces that they believe is important? You can hope that students will add concepts that you are trying to teach, but be willing to consider their original discoveries as equally valid aspects. Revise the list of criteria, as neccessary.

5. At the same time, or closer to the end of the project, if you need to mark the projects, ask students to assign numerical values to the criteria. Which are the most important aspects? Which ones should be worth fewer marks? This is another opportunity to ask questions, discuss, and refocus.

6. Students frequently ask if their artwork is "good," or if the teacher likes it. Students often declare they are finished and then need to be convinced to work a bit more on their pieces. As each student completes his or her project, say: "Check the flipchart page to see if you're finished, or if you'd like to change something, or add something." This puts the student in charge of making decisions about revising his or her own work. If students still need help, you can model how to use the criteria to compare and check if each aspect is completed.

7. For students who tend to be critical of their work, it is helpful to have them identify those specific parts of their artwork they are unhappy with. Once identified, those areas can be changed, or drawn differently the next time.

2. The ideas presented here have been influenced by Pauline Clarke, Thompson Owens, and Ruth Sutton, and I recommend their series of books – Creating Independent Student Learners – for a more thorough discussion of assessment strategies. What follows is what I learned from colleagues at Wellington Elementary School, and through trying different models of assessment with my students.

When students are pleased with their efforts, it may be helpful to them – and to the students near them – to understand which particular aspects of drawing or design caused the artwork to be successful. Students can use this information to repeat their success.

8. At the end of the project, students may give themselves a mark (or checkmark) based on each criterion. The teacher has a right to disagree, but needs to give reasons that are based on the criteria. This process makes evaluation easier and fairer. Students understand what they are earning the marks for, and what their goals for improvement might be for the next project. Using clear criteria also means marks can be readily justified to administration and parents.

In one classroom that I visited, the students' project was to make plaster masks. During the first session, students were asked to develop a list of what they thought were the most important criteria (figure 4.4).

| Put lots of Vaseline on your face so the plaster doesn't stick. |
| Add cardboard and stuff to make interesting shapes. |
| Don't waste plaster. Don't put plaster in the sink. Be careful. |
| Get along with other people. |
| Be creative. |

Figure 4.4. Initial criteria

After three classes, students revised the criteria (figure 4.5). Revising each criterion gives the teacher an opportunity to check what the students understand to be important about their project. Can you determine from the revisions (below) which concepts were worked on during those classes?

| Use the materials safely and carefully. What this looks like: Put Vaseline on your face. Keep plaster on the newspapers. Rinse your hands in the bucket. |
| Add cardboard and 3-dimensional stuff (materials) to make interesting shapes and solids. |
| Get along with other people. This means: Help each other. Listen to people when they talk. Share your ideas. |
| The mask shows an expression. Something I feel: happy, angry, surprise, sad, thinking, sneaky, or…. |
| The mask has writing inside. The writing shows what I am thinking when I have that expression (happy, angry…). |
| Be creative. What this looks like: Your mask looks different. You used your own ideas. |
| Paint colours that show how you feel. Mix your own paint colours. |

Figure 4.5. Revised criteria

You do not have to mark every project unless you are required to assign percentage marks at the end of the term. If you must assign marks, you can ask students to help assign numerical values to the criteria. In the classroom I was visiting, each criterion was assigned a mark, based on what students believed was most important (figure 4.6). I would have preferred to assign more marks for facial expression (specific points, for example, like building eyebrows) and more time for discussing the written piece. The classroom teacher did have the option of extending the writing and developing a separate set of criteria for how to write about feelings on the inside of the masks.

/3	Use the materials safely and carefully. What this looks like: Put Vaseline on your face. Keep plaster on the newspapers. Rinse your hands in the bucket.
/4	Add cardboard and 3-dimensional stuff (materials) to make interesting shapes and solids.
/3	Get along with other people. This means: Help each other. Listen to people when they talk. Share your ideas.
/5	The mask shows an expression. Something I feel: happy, angry, surprise, sad, thinking, sneaky, or….
/2	The mask has writing inside. The writing tells what I am thinking when I have that expression (happy, angry…).
/2	Be creative. What this looks like: Your mask looks different. You used your own ideas.
/4	Paint colours that show how you feel. Mix your own paint colours.

Figure 4.6. Marks assigned for each criterion

Criteria can be simplified for younger students. For example, start the process by asking students: "What will our finished pieces look like if we do a good job?" For older students, extend the set of criteria into a rubric that shows students what each aspect of the project might look like if done well (figure 4.7).

You may find it useful to keep an anecdotal account of how each student approaches problem solving, cooperates with other students, and/or uses art vocabulary during a class. If you do choose to do this, hold conversations or conferences with students about their progress in using the techniques and handling materials, or about how effectively they are expressing their visual ideas.

For integrated projects, criteria need to match curricular outcomes (objectives) for each subject that is being studied. For example, when making the masks, we needed to include the art curriculum outcomes for handling materials safely, the art concept of unity (a design principle) and skills for mixing and applying colour, as well as the math component of naming and building three-dimensional solids.

Mask Project:	Marks: 1-2	2-3	3-4
Uses tools and materials	▪ Vaseline on face. ▪ Plaster on the newspapers. ▪ Rinses hands in bucket.	▪ Uses materials safely and carefully. ▪ Creates an organized workspace.	▪ Uses materials safely and carefully. ▪ Creates organized workspace. ▪ Chooses to add new materials that enhance design.
Adds 3-D forms	▪ Adds shapes and solids to build facial features (parts of the face).	▪ Adds a variety of shapes and solids to build facial features.	▪ Adds a variety of shapes and solids to build facial features. All features are well-attached.
Cooperative skills	▪ Sometimes helps others, listens to others, shares ideas.	▪ Usually helps others, listens to others, shares ideas.	▪ Always helpful to others, listens to others, shares ideas.
Mask expresses feeling	▪ Some parts of mask show expression: happy, angry, etc.	▪ Most parts of mask contribute to a recognizable expression.	▪ Whole mask expresses a strong emotion in a unified way.
Writing expresses feeling	▪ Writing inside mask tells about a feeling: surprised, sad, etc.	▪ Writing inside mask expresses some of same feeling as outside of mask.	▪ Writing inside mask clearly expresses the same strong emotion as outside of mask.
Originality/ creative solution	▪ Mask shows some difference from models and other students' masks.	▪ Mask shows marked differences from models and other students' masks.	▪ Mask shows understanding of concepts; however, the overall appearance or solution is unique.
Colour	▪ Colour expresses feeling: mad, calm, etc.	▪ Student mixed colours to match the expression of the mask.	▪ Student mixed colours and used a colour scheme to enhance expression and composition.
			Total /28 Marks

Figure 4.7. Rubric

Assessment and Innovation

A balance needs to be struck between the teacher's requirements for a project and student innovation. On the one hand, if students' art projects all look the same, then the lesson was not anywhere near as successful as it could have been. Innovation and creative thinking are the defining elements of artists' works. These characteristics have been much admired and imitated by artists throughout history. When an artist creates an artwork, his or her initial concept develops and changes through the stages of planning, creating, revising, and experimenting with materials, tools, and techniques.

On the other hand, the basic criteria of the project, based on the curriculum outcomes/expectations, need to be met. If you ask students to represent texture in their drawing and one student omits, or refuses to include, texture in a drawing of a hedgehog, this is a problem. Has the lesson been explained well enough? Does the lesson fit the student's abilities? Does the student lack the confidence to try a new approach? Is the student so committed to one approach to drawing that he or she is reluctant to stretch? Is the student willing to try the new approach on a smaller scale?

Some students require more individual attention and support than others. Do the criteria need to be adapted to fit their individual goals, interests, or learning styles? Are there other issues in their lives that distract them from schoolwork? Teaching is usually easier when you are armed with a sense of humour: If a student tells you that he or she has invented an alien hedgehog with no prickles, hand the student a pencil – he or she has the beginnings of a great story! Remember that everyone sees things a bit differently, and the acceptance of multiple perspectives is an important collaborative skill to model for your students.

Student Portfolios

Encourage students to collect and organize their artwork in portfolios. In addition to keeping their work in one location, portfolios serve two important functions: (1) students have a record of what they have learned over an extended period of time, and (2) students can see for themselves how they have progressed.

Original works belong to the students who created them, and they have the right to take their artworks home. Make sure you ask permission before you display a piece, or photograph, scan, or photocopy their artwork for a display, portfolio, or publication.

To make portfolios, students can paste two-dimensional artworks, or photographs, into scrapbooks or slip their works into the plastic sleeves of binders, along with descriptions of the process and reflections on what they learned from each assignment. Students can make electronic portfolios with a camera and PowerPoint, Photo Story, or iMovie software. Students can also make a class portfolio, with photographs and descriptions to document learning that takes place throughout the school year.

Make sure students are aware of why they are creating portfolios. This knowledge will help them set criteria for determining which pieces they will select. Professional artists' portfolios are collections of their best work to showcase their range and ability with a variety of content, media, techniques, and composition.

The main purpose of a student's portfolio is to show growth. A student may be unwilling to include a drawing made at the beginning of the year, or a rough draft, if he or she does not understand that the portfolio is documenting the progress made from a beginner level of proficiency to a more advanced level. Portfolios help students realize that it is possible for them to learn, see what they have learned, and reflect on how they have learned it. Understanding how we learn – metacognition – helps us to be aware of strategies and techniques that will help us with future learning.

Teachers may use a student's portfolio to assess a student's progress in visual art. Be aware of some of the bigger questions when assessing learning in art:

- Does the student's collection of work (practice sketches, notes, problem-solving processes, response journals, artworks, and so on) indicate that he or she is able to arrive independently at creative or innovative solutions to visual problems?

- What strategies and skills does the student use in the process of idea development?

- Has the student mastered a technique, tool, or medium?

- Is the student able to transfer skills? Does the student apply techniques and concepts learned in previous lessons to other projects, subjects, or areas of study?

- Does the student's work show progress and increased confidence over the course of a project, or during the school term?

- What ideas, images, and concepts are most interesting to the student? Is he or she engaged, curious, and open to new ideas? Why or why not?

- What supports or challenges are required to extend the student's learning?

Cathy Woods

DISPLAYING STUDENT ARTWORK
by Cathy Woods

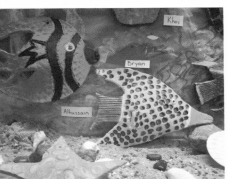

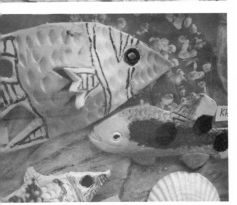

Ceramic sea creatures and detail from the sea creature display, by grade 5 students at Sister MacNamara School

Displays of students' artworks are an important way to celebrate student learning, share work with parents and school staff, get students excited about art, and demonstrate to students that their artistic experience is valued.

At Wellington School, large display cases are located in prominent areas. They contain overhead lights that shine directly on the artworks. The cases are deep enough to exhibit three-dimensional works in front of paintings, drawings, and relief works. The display is often embellished with "extras" such as sand, moss, soil, pickling salt for snow, and other natural objects. Although each artwork was created as an individual piece meant to "stand on its own," within the display, artworks are grouped so that they create unified themes or scenes. This helps students see the context and connections for the artworks.

We also display students' art in community venues. The display case can grow to the size of an entire storefront, with artworks created with particular sites in mind. Large storefront windows provide space to display works that the school building and its fire codes might not accommodate.

Here are some principles to keep in mind when displaying students' artworks:

- Artwork belongs to the student. It is fine to borrow a piece for display, with the student's permission, but always return original work. Take photographs or make colour photocopies of student work for long-term or permanent display, and for student portfolios.

- Credit each artist with a tag that has the title, media, artist, and size of the artwork. Other student writing may be integrated into the display. Place pieces of text and photographs carefully so that they do not overlap or detract from students' artworks.

- Photographs are good for capturing and displaying fragile artworks such as collage and those made from modelling clay. For 3-D artworks, tape a large piece of paper to the walls so that it curves down to rest on a horizontal table against the wall. Set the camera to the close-up. Avoid using the zoom; get close for better resolution. Do not use the flash, as it tends

to reflect off artwork. If you position the piece in the frame effectively, you can avoid having anything other than the paper in the background of your photograph. Photograph from more than one angle.

- Students' works that are matted and framed appear more finished and demonstrate to students that you value their work. Exhibition frames can be purchased fairly inexpensively. Good frames have clips for easily changing artwork, and have Plexiglas rather than glass.

 Mat a student's artwork by rolling a piece of masking tape onto the back of the work and placing the artwork on a larger piece of coloured paper. Avoid putting staples through art pieces. Window mats look much more finished; however, they are more expensive. For matting and framing artwork, choose a colour already in the artwork that you want to emphasize.

- Take photos of students' artwork – in progress and upon completion – throughout the year so that you have images available when art displays are required. PowerPoint, iMovie, and Photo Story presentations are excellent for classroom or school events. These programs provide you with the means to show students at work and their work in progress. In turn, students can reflect on, write about, and speak about their learning.

- Display the process pieces along with the finished work. Describe how the art was made, what steps were involved in problem solving and learning, what questions were asked, and what students consider important about the project. Include curriculum outcomes/expectations, learning intentions and criteria, as well as photos of students engaged in each step of the process. Then involve students in sorting, sequencing, and writing about the photographs. This is review work that reinforces learning, and it also allows colleagues, parents, and school administrators to appreciate the thinking and learning accomplished during the project.

- Make displays inclusive. Give all students the opportunity to have their artworks displayed and their learning celebrated. This is easiest to do with collaborative projects. Try to change displays monthly.

- Hang artwork at a child's eye level. Think about the elements and principles of design, as well as the purpose of the display. Arrange pieces in balanced groups, measure the spacing, and check that the work is level. Create some variety by including process work or photographs, or different versions of the same subject made in another medium or using a different technique.

- Involve students in the selection of their works for display. Discuss the job of a museum curator, or visit a local gallery or museum for ideas about how artwork can be effectively displayed. For formal exhibitions, have each student write an artist's statement to describe the intent of his or her work.

Cathy Woods is an art teacher at Wellington Elementary School.

Wellington School. Teachers: Cathy Woods and Chris MacKay

Display of community buildings at Wellington School. The wooden structures were made by grade 2 students and displayed with students' research and a community map.

Hint: To create a line for hanging artwork, use a piece of string and two pushpins. Stretch the string tight between the pins. Measure up from the floor at each pin, or use a carpenter's level to create a horizontal line. The string provides a guide for hanging the top row of frames.

Detail from display of community models. The grade 2 students from Sister MacNamara School used coarse salt to represent snow.

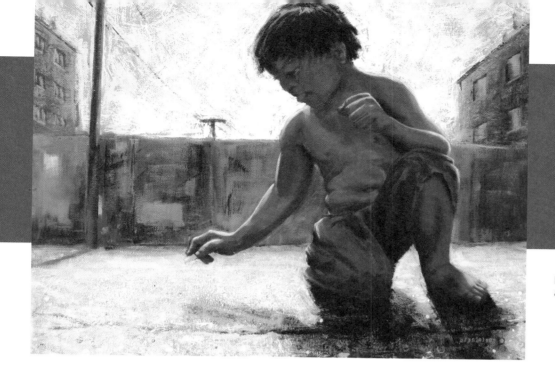

Rhian Brynjolson, *And This Is Me*,
acrylic latex on canvas, 26" x 30"

PART 2

LEARNING TO DRAW

For students to feel successful with visual art, it is important for them to learn some basic drawing skills. As they begin to see the world through the conventions of photography and realistic representation, they want their own drawings to "look real." Unless they receive some instruction in drawing, in addition to experience with more abstract or conceptual art forms, they may become dissatisfied and give up art altogether.

Adults who see themselves as "bad" at art will be relieved to know that age is not a barrier to learning to draw. Anyone can learn, if taught some very basic skills. Drawing classes should be free of comparisons and ridicule, including self-ridicule. Drawing is not a contest. It is a pleasurable and worthwhile activity.

The drawing exercises in Part 2 focus on observational drawing, which is sometimes referred to as "look-drawing" in early-years programs. Observational drawing is drawing what is seen, rather than what is assumed about a subject. To supplement observational drawing in the classroom, you may want to incorporate the following into your students' drawing program:

- Sketchbooks. An artist's sketchbook is central to an art program. A sketchbook is used to practise drawing techniques and media on a small scale, collect images, and develop visual ideas. Students may use their sketchbooks to paste photographs of their artwork at different stages of development, and to write about what they have learned.

 Students can also use their sketchbooks to record activities and reflections in a combination of writing and pictures. Sketchbooks or response journals may be used by students to remember and reflect on field trips, class activities, or guest presentations to the class. Sketchbooks might also become science journals for sketching, for example, changes in plant growth or new inventions.

- Reading response, or guided imagery. Students read, or are read to, and then sketch their interpretation, or favourite part, of a story or poem. Reading response may also be used as a directed activity where students are asked to draw how the main character may have felt in a particular situation, what the most exciting part of the story was, and so on. If students have had basic instruction in drawing, reading responses may be used to assess how much of the text students absorbed, understood, or made a personal connection to.

- Invention and problem solving. Students can use drawing to solve a math problem, or to design a simple machine or a computer circuit board. These sketches are often symbolic or schematic rather than realistic, and may include some written notation. They can provide a bridge between hands-on materials and written work in most subject areas. These sketches are an important aid for visual thinkers. Teachers can use the sketches to see the processes each student uses to solve a problem and to assess a visual model of the student's interpretation.

- Projected images. Students use an "accidental" image as the starting point for a picture. They make a small, quick scribble on their page and then look closely to see if they can turn this haphazard collection of lines and shapes into a picture by emphasizing some lines and adding details. Turn this into a game! Have students take turns making scribbles for one another. Students might look at cloud shapes, paint blots (dab a bit of paint on the paper, fold in half, and open the paper to see an interesting shape), or a series of cracks in a ceiling (see *It Looked Like Spilt Milk*, References). Projected images allow students to use their imaginations to transform images, and to produce fanciful, rather than realistic, images. Students may also learn to enjoy drawing. This exercise is successful if students become more spontaneous with their drawings and begin to experiment with new approaches.

- Free drawing time. Students should also be encouraged to draw subjects of their choice. If students seem stuck for ideas of what to draw, have some resources handy: "how-to-draw" books, The Anti-Coloring Book series (see References), calendar photos, simple objects (small toys or natural items), children's picture books, postcards, websites, and so on. You may wish to set some parameters – for example, no hurtful or derogatory drawings. Free-drawing time may be assessed based solely on the time a student invests in drawing, or by the range or depth of ideas that a student communicates visually. When students are encouraged to draw, they are given time to develop comfort and skill with visual representation, and they learn that drawing is a valued activity.

- Transformative drawings. Look at imaginative picture books, such as *The Mysteries of Harris Burdick, Imagine a Night*, or *Changes* (see References). Discuss how the illustrators made the pictures interesting by combining unrelated subjects into one drawing (for example, by turning a bicycle wheel into an apple, or a quilt into a landscape). Then, students can try to do the same thing by combining magazine photos or real objects in a drawing. Students may want to begin with a small, quick pencil drawing in their sketchbooks to see how their transformations will look. This exercise is a good starting point for creative writing.

DRAWING THE ELEMENTS OF DESIGN 5

- sketchbooks
- paper (see Tip, below)
- pencils (HB graphite is fine; an assortment of hard [H, 2H] and soft [B, 2B, 4B, 6B] pencils provide a range of fine, light grey to thick, black marks)
- erasers (white erasers will not leave a coloured mark on the paper)
- rulers
- scissors
- glue or glue stick
- objects with interesting textures
- visual references (photographs and/or objects)
- clear plastic sheet
- felt pens (fine-tipped, black, permanent, labelled *non-toxic*, e.g., Sharpie)
- optional: see Additional Exercises (pages 69, 72, 75, 77, 78, 84)

INTRODUCTION

In this chapter, the basic elements of black-and-white drawing – shape, line, texture, value, form, and space – are treated as distinct approaches to drawing. Pattern and proportion (principles of design) are included here as fundamental to perception and drawing skills. Colour, another basic element, is discussed in chapter 11.

Students will require visual references – something to look at while they draw – for the exercises in this chapter. The students are not "copying." They are gathering and recording visual information while observing and learning about a subject. Learning to draw an accurate representation should not deter students from expressing their own vision or style of drawing. Nor should it prevent a teacher from valuing unorthodox, quirky, or imaginative solutions. Students can be actively encouraged to add imaginative elements later – to take their "literal" drawings and transform them into something symbolic, whimsical, or meaningful.

An interesting outcome of the drawing exercises that follow is that students may begin to look at and interpret what they see differently. If they have been working on negative space drawings, for example, and then they look at trees

Triceratops, marker on paper, Iain Brynjolson, age 5

Figure 5.1. Children begin drawing with a playful, symbolic approach to their subject.

TIP An artist's sketchbook is central to an art program. A sketchbook is used to practise drawing techniques and media on a small scale, store collected images, and develop visual ideas. Sketchbooks may be a place to paste photographs of artwork at different stages of development. Students also use them to write about what they have learned. For a substitute sketchbook, staple together or hole-punch white photocopy paper, 8½" x 11" (21.5 cm x 28 cm). Students can make hardcover books (see page 149). Students can also experiment with drawing on a variety of surfaces: coloured paper, rougher and smoother papers, textured papers, Bristol board, cloth, cardboard, tracing paper, brown wrapping paper, wood, painted papers, patterned papers, large and small paper, and so on.

on their way home from school, they may begin to see the spaces between the branches and focus on the interesting, irregular areas of sky rather than on the tree's branches. If they have been spending several sessions on contour drawings, they may stop and observe the paths of crooked tree trunks, branches, and twigs. You may notice that your students are becoming more visually aware.

TIPS FOR SUCCESSFUL DRAWING CLASSES

Before your students start observational drawings, here are some suggestions for successful drawing classes:

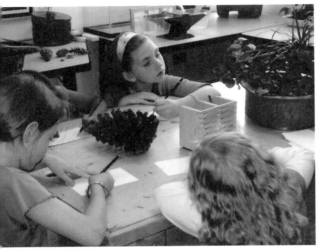

École Constable Edward Finney School. Teacher: Andrea Stuart

Figure 5.2. Students learn to observe their subject carefully, looking for variations in lines, geometric shapes, interesting textures, areas of light and dark values, form, and negative spaces.

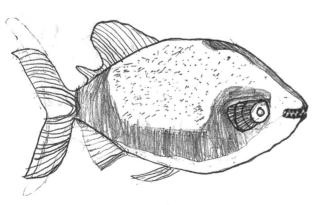

pencil on paper, Scott McPherson, grade K–3, San Antonio School

Figure 5.3. Start drawing lessons with simple subjects that relate to the students' topic of study. Scott did this pencil drawing while he was researching fish.

- Collect materials and subjects for drawing. Begin with simple subjects that relate to your topic of study and that are of interest to your students (figure 5.3). For example, you might start with fruits and vegetables, beetles, fish, or leaves. Later, students can draw more difficult subjects or groups of subjects such as spiders, buildings, a stack of toys, or a bicycle. These subjects might be presented as actual objects, photographs, magazine or calendar photographs, posters, another artist's drawing of the subject (on an art postcard or website), or a toy or model of the subject.

- Try the exercise before you introduce it to your students. You will then know if the subjects are appropriate, where students might experience difficulty, and how much time they will need to complete the exercise. Think about what aspects of drawing are suitable to emphasize. For example, will you focus on the shapes of the bicycle wheels, the lines of the frame, or the negative spaces between the spokes? You will also get a sense of how the students will react to the exercise. Will they find it difficult, relaxing, fun, or challenging?

- Make sure your students have their own sketchbooks and portfolios for storing loose drawings. Sketchbooks and portfolios are ideal for organizing students' work and for keeping a record of their progress in drawing throughout the year.

- Decide which vocabulary, concepts, or curriculum objectives to integrate with the drawing exercise. For example, you might select a pumpkin as the subject for a drawing. When you ask students what they notice about a pumpkin, they can enrich their vocabulary for creative writing with words such as *bumpy, huge, smooth, hard, grooves, orange, speckled*, and *warty*. If you slice the pumpkin open, it might make a more interesting drawing subject. In addition, you could use the seeds for teaching numeracy, and the slices to teach fractions or a cooking class. Older students might notice the curvature of lines of longitude on the pumpkin, or transform their pumpkin into an illustration of the coach in the Cinderella fairytale.

- Think of leading questions to ask your students that will help them become interested in the subject. You might begin by simply asking them what they see or notice (see chapter 3).

- Discuss parts of the subject that students might find difficult to draw. If they are drawing leaves, this might include intricate parts (the veins on a leaf), overlapping parts ("one leaf is on top of another – I can see only part of the oak leaf"), or unusual views ("one leaf is curled over, so we can see the underside").

- Present a quick demonstration of the skills required for the exercise. For beginners, demonstrate a few steps at a time. Model a good attitude toward drawing – and remember that a sense of humour always helps! Think aloud as you demonstrate, so that students can learn the "self-talk" required to solve problems as they draw: "Hmm, that circle looks a bit squashed, so I'll take my pencil around again and try to make it a bit taller. It's a bit wobbly on one side. Ah, that's better. Now I can erase this extra line."

- Give incomplete demonstrations. When you give a demonstration, there is a danger that students will simply copy your product. Because you want to encourage individual and innovative work, demonstrate only the necessary steps. Leave your example unfinished, and discuss or model alternative solutions.

- Begin with short drawing sessions (10 minutes). Work up to longer sessions as students learn how to observe, concentrate, and become more involved in their drawings. One of my colleagues tells her students: "Drawing exercises are like push-ups for artists. You need to do your exercises to improve your drawing skills."

SHAPE

A shape can be defined as an enclosed area, having two dimensions when represented on paper. A shape is also a schematic device for analyzing a subject for a drawing. Artists may use geometric shapes (circle, oval, square, rectangle, triangle, hexagon, and so on) and lines as a system for drawing complex forms.

Exercises for teaching about shape – scribbled drawing, gesture drawing, negative-space drawing, and geometric-shape drawing – show students how to do the following:

- see a subject as a whole entity
- become more aware of the subject's size and placement on the page
- begin to judge proportion (sizes and placement of the parts of the subject relative to each other)
- see the shapes contained within the subject

Fundamental to the drawing process is knowing how to draw shapes. Scribbling and drawing simple enclosures and shapes that symbolically represent the subject are early phases in a child's development in drawing. Scribbling the gesture of a subject or building up a subject from geometric shapes is a common means

pencil on paper, Noni Brynjolson, age 11

Figure 5.4. Simplifying a subject into geometric shapes is the most basic and important lesson in learning how to draw. A horse is difficult to draw, but ovals, rectangles, and triangles are easy to draw! Learning to see the geometric shapes contained in a subject will solve problems with proportion and placement later on.

BOOKS TO HAVE HANDY

PICTURE BOOKS

Strega Nona, written and illustrated by Tomie dePaola.

Shapes, Shapes, Shapes, written and illustrated by Tana Hoban.

The Shape Game, written and illustrated by Anthony Browne.

Zoom Upstream by Tim Wynne-Jones, illustrated by Eric Beddows.

pencil marks, Noni Brynjolson, age 12, Luxton School

Figure 5.5. Noni experimented with a variety of pencil and eraser marks.

pencil on paper, Noni Brynjolson, age 11

Figure 5.6. A finished scribbled drawing looks like a shadow.

TIP Encourage your students to hold their pencils loosely, rather than in a tight death grip. That way, they will get a more relaxed scribble and a lighter mark on the paper. Ask students to check their drawings periodically, to see if their marks are light grey or black. It may help students to imagine that their pencils are feathers, which, if squeezed too hard, may break. Resting an arm or wrist on the tabletop can help to steady young hands.

for a visual artist to begin a representational drawing. Just as a drawing of an orange begins with a circle, a drawing of a horse can begin with an arrangement of circles, ovals, and rectangles (figure 5.4). The structure of the subject is established before lines, textures, patterns, and values are added. Experienced artists may appear to skip this step if they have internalized this schema.

Appropriate Subjects

Get your students to look at objects that have obvious geometric shapes or that have fairly simple forms without excessive details. Almost any subject can be simplified into basic geometric shapes. Fruits and vegetables have fairly obvious shapes. Trucks, simple machines, and small buildings (houses rather than cathedrals) may also contain straightforward shapes. Animals have basic shapes (a bird, for example, may have an oval body, round head, and triangular beak).

Scribbled Drawing

Scribbling is an excellent warm-up exercise for drawing. Before your students begin their own drawings, have them look carefully at the drawings in *Zoom Upstream*. Encourage them to notice how each drawing is made almost entirely of a variety of scribbled pencil marks!

In their sketchbooks, have students practise scribbling side-to-side and round-and-round (figure 5.5). Have them experiment by pressing gently or more forcefully with their pencils to make lighter or blacker marks. These "tornado" drawings help students *feel* the weight of the pencil on the paper and realize how gently or tightly they grip their pencils.

Now, let your students select objects they want to draw. Have each student make a scribbled drawing of his or her object. The results will be scribbled silhouettes or shadows of their subjects (figure 5.6). This same scribbling technique is used for quick gesture drawings of people or animals in motion (see chapter 7).

Negative Space

Students from about age six and up may be ready to try negative-space drawing. Explain to students that negative spaces are the areas between and surrounding parts of objects. Some examples are the hole in the centre of a bagel, the spaces between the spokes of a bicycle wheel, and the irregular spaces between the petals of a daisy.

Negative space drawings help students see how parts of their subjects fit together (figure 5.7). Have your students use scribbling to fill in all the shapes around the subjects, leaving the subjects themselves blank.

Geometric Shapes

Practise drawing geometric shapes. Encourage students to sketch lightly around the outside of their shapes a couple of times. Moving their pencil around the perimeter a few times allows them to reconsider and make small revisions in the directions of their lines. Ask them to press lightly and hold their pencils gently. Their hands will be steadier if they rest their elbows or forearms on the table and hold the paper with their non-dominant hand.

Look at *Strega Nona* with your students. Ask: "What geometric shapes can you see in the houses?" Look at *Zoom Upstream*. Ask: "What shape is the cat's head?" "What shape is the body (the legs, the ears)?"

Model how to look for the geometric shapes contained within, and surrounding, a subject. You can do this by placing a clear plastic sheet over a large photograph and drawing the shapes with a felt pen, or by using an image projected onto white paper or a SmartBoard.

Next, ask students what shapes they see in their own subjects. Have them draw simplified geometric versions of their subjects in their sketchbooks. Explain that they are analyzing the shapes contained in their subjects and using pencil lines to describe the shapes on paper.

Learning to use geometric shapes to construct a subject is an important step in learning how to draw. The more practice students have drawing underlying shapes, the more confidence they will have in their drawing.

Additional Exercises

Have your students try some of the following exercises to build their awareness of shape:

- Play with pattern blocks and tangrams. While they play, students will discover how pieces interlock and combine to make pictures (figure 5.8).

- Cut cardboard or mat board into geometric shapes. Students can arrange these into recognizable forms or patterns, glue them onto a cardboard backing, and then paint them. (See Part 4 for more on paint and painting techniques.)

- Take a walking tour of the neighbourhood. Identify, sketch, or photograph the geometric shapes seen along the way. Some examples that may be seen are square windows, rectangular fence boards, and circular wheels.

- Use tear-and-paste to build up the shapes of a subject (figure 5.9). Tear small pieces of construction paper, and glue the pieces onto a coloured paper background. Pieces can be easily added or deleted to obtain an image. This exercise works well for very young students who have trouble using scissors.

- Look at quilts and quilt patterns. The pieces in each block are made from geometric shapes. Students can design quilt squares of fabric, or of oil pastel and paint on paper, cut them out, and glue them onto sturdy paper or heavy fabric.

- Borrow some "how-to-draw" books from the library. Most of these books start with drawings of simple geometric shapes. These reinforce the drawing

pencil on paper, grade 4–6 students, Luxton School

Figure 5.7. Looking at the negative spaces that surround a subject gives clues about how (top) the parts of the subject fit together, and (bottom) the subject relates to the background and to the edges of the page.

cut paper collage, Noni Brynjolson, age 8, Luxton School. Teachers: Andrea Stuart and Donna Massey-Cudmore

Figure 5.8. Noni made this simple picture from tangrams (geometric shapes) cut out from coloured paper and glued onto foil.

I Fell Into a Bee's Nest, coloured paper collage, Iain Brynjolson, age 6, Luxton School. Teacher: Kathy Redekopp

Figure 5.9. Iain used small pieces of cut and torn paper to make this image.

BOOKS TO HAVE HANDY

PICTURE BOOKS

Grumpy Bird, written and illustrated by Jeremy Tankard.

Would They Love a Lion?, written and illustrated by Kady MacDonald Denton.

Posy! by Linda Newbery, illustrated by Catherine Rayner.

process you are teaching and give students experience drawing a variety of subjects.

- Draw on a piece of paper that has already been cut into a geometric shape that approximates the shape of the subject. For example, draw a flower or a curled-up cat on a circular piece of paper, or draw the side view of a bus on a wide rectangular piece of paper.

- Cut out more intricate silhouettes. This exercise helps students see an object, or group of objects, as a whole.

LINE

A line is created when a pencil is pulled across a piece of paper. The line may be very light, very black, even engraved into the paper. Its weight, or darkness, depends on the grip on the pencil, how sharp the pencil is, and the hardness or softness of the graphite. Line exercises help students develop observation skills, hand-eye coordination, and patience with detail.

Lines are also present in a subject. Lines may be easy to discern, as in the straight contours (edges) of a table, the zigzag contours of an animal's fur, or a loop of wire. Lines may also be created when the viewer "connects the dots," such as a line of boats on the water, a line of clouds across the sky, or a line created by an arm pointing to an object in the distance.

Contour lines are the outside and interior edges. When drawing an accurate contour of a subject, it is important to draw what you see rather than what you assume the subject looks like (figure 5.10). The contour of an apple, for example, is usually not a smooth circle, but has bumps and dips in its curvature.

pencil on paper, Iain Brynjolson, age 7, Luxton School

Figure 5.10. To make this drawing, Iain looked carefully at the contours of the main branches, where the lines bend, wobble, and overlap.

pencil on paper, Danna Slessor-Cobb, age 10

Figure 5.11. Danna experimented with a variety of lines.

Appropriate Subjects

Have students begin contour drawings with simple subjects, such as leaves, fruits, and vegetables, and build toward more intricate forms such as hands, plants, faces, animals, machinery, and bicycles. Students will require a visual reference – a photo, object, or model – to look at while they draw.

Younger students may find it easier to perceive the edges on a two-dimensional subject, for example, a photograph of an apple, because the image is flat and the edges are definite. Line drawings are a learned schema of representation. There is learned perception involved in representing a three-dimensional apple in a two-dimensional line drawing. An apple is a sphere, so it does not *really* have edges.

Process

Show *Would They Love a Lion?* or *Grumpy Bird* to your students. Discuss the interesting line qualities – straight or wobbly, thick or fine, broken or smooth. Students may wish to quickly make these kinds of lines in their sketchbooks. They can do this by drawing a variety of lines. Encourage them to experiment with more or less pressure on the pencil, drawing lines quickly or slowly, until a page is filled (figure 5.11). With students, discuss the kinds of lines they have discovered (wavy, straight, thick, loopy, and so on). Look for similar lines in works by other artists.

Kiakshuk. *Composition*

Figure 5.12. Inuit drawings and prints often involve clear, simple lines that have the look of embroidery and sewing techniques. In this drawing, the artist, Kiakshuk, has created a narrative image depicting the connections between humans and animals. The thin, scratchy lines provide outlines of the figures, and add texture. They also join human and animal forms, as the line of one person's arm becomes an animal's leg, and the line of a fishing rod joins humans, boat, and fish. Lines are not only the basic unit of drawing, but can be looked at playfully, expressively, and metaphorically.

Blind Contour Drawing

This exercise helps students of about age 7 and up observe details in the subject in front of them, learn hand-eye coordination, and develop a feel for a descriptive line. A blind contour drawing rarely looks like an accurate drawing of the subject (figure 5.13). The results are quirky, funny, and often more interesting than a straightforward representation.

Have students select a subject to draw. Then, demonstrate blind contour drawing, exaggerating how slowly students will need to move their drawing hand – very s-l-o-w-l-y! The idea is to not look at the paper while drawing, but to look

Cat, pencil on paper, Danna Slessor-Cobb, age 10

Figure 5.13. (left) A close-up photograph of an animal makes a good drawing subject. Danna looked carefully at this photo when she made her blind contour drawing. (right) Blind contour drawings produce quirky, expressive drawings, with no form to hold the details together. It is an important exercise for teaching observation skills and hand-eye coordination. The results are always fun!

TIP Have students trace over photographs of their subjects lightly with pencil (or in the air between their eyes and their subjects) to help them feel the way their hands will move when they are drawing.

TIP Remind students to not peek at their drawings when they are doing blind contour drawings. Also, remind them that the slower they move their pencils, the more time they will have to see the details. Be prepared for giggling when students finally peek at their work! Blind contour drawing is especially fun for drawing faces – from magazine photos, posing friends, and reflections in mirrors. The results, if recognizable, are caricatures (or aliens!).

closely at the edges of the subject. Before students begin their blind contour drawings, have them observe their subjects carefully. Ask them to note the outside edges and interior details, the jagged edges or bumps where pencil lines will need to change direction or become wobbly, and the smooth edges where lines can curve gently or become straighter.

Have students hold the photographs of their subjects in front of their drawing papers and turn sideways in their chairs, or they can put a piece of loose paper over their drawing hands. This way, they can see their photographs, but they will not be able to look at their drawing paper.

Suggest that they not lift their pencils off the paper. It may help to give a time limit for the first few attempts, starting with a very short time – one minute – for the first attempt. Emphasize that they are not to peek at their drawings! As students learn to move more slowly and observe more closely, their patience for this exercise will increase, and longer sessions will be possible.

Laugh with your students at the weird results from this exercise. At the same time, remind them that blind contour drawing is a valuable way for them to train their observational skills and develop their fine-motor skills. Blind contour drawing is a technique practised by many professional artists.

Contour Drawing

When students have experienced blind contour drawings, and have practice with close observation, they will have an easier time with contour drawing. With contour drawing, they can sneak glances to see where their pencils are on the paper. The emphasis is still on looking carefully at the subject, rather than looking at the paper.

Encourage students to use multiple outlines. As they draw the contours of their subjects on paper, urge them to draw around the edges two or three times, with one line more or less on top of the other. Every time they draw the contour of the subject, they may notice a slightly different aspect of the subject. Afterwards, they can choose which line they think is the most accurate or interesting, and erase the excess lines. Alternatively, students can leave the extra lines in to show an object in motion, or to make the space around the object more interesting. Making multiple outlines may help students become less cautious and less easily frustrated with their drawings (figure 5.14).

Lynx, pencil on paper, Iain Brynjolson, age 7, Luxton School

Figure 5.14. The partially erased pencil marks and detail in Iain's drawing show that he was reassessing his original marks and observing new things about his subject. He also selected and outlined what he felt to be the most successful part of his drawing. Using multiple outlines gave him the confidence to continue and not erase the whole drawing.

Additional Exercises

Here are some more exercises your students can do to build confidence and experience with line drawings:

- Make line drawings with different media (for example, a sharpened twig or pointy paintbrush dipped in ink, three coloured pencils taped together, a fat marker, a squeeze bottle full of paint, and a squeeze bottle of glue followed

by a line of string). A variety of media will result in different qualities of line (figure 5.15).

- When the leaves are off the trees in late autumn or early spring, go outside and look at tree branches – they are crooked, straight, curved, droopy, and so on. Sketch or simply describe them. What other lines can you see? Look for, and sketch or photograph, lines formed by telephone wires, cracks in the sidewalk, fence boards, and so on.

- Take time for sketching and doodling in sketchbooks. Sketchbooks can be rich sources of ideas for stories and more elaborate drawings later.

- Younger students may draw long chalk lines (for example, wavy, zigzag, curved, dotted) on cement and walk on them for a kinesthetic understanding of lines.

TEXTURE

Texture[1] can be defined as "how something feels when you touch it." Textures are furry, smooth, bumpy, rough, soft, feathery, scaly, and so on. It is challenging to represent these textures on a smooth piece of drawing paper. Artists are creating a two-dimensional illusion of texture in a drawing.

Encourage students to gain a sensory awareness of texture. Begin by having students touch objects that have interesting textures, such as feathers, shells, fur, and sandpaper. Ask students to touch their hair, the bumpy bottoms of their running shoes, and the soft or textured fabric of their clothing.

To draw textures that represent tactile information on a two-dimensional plane, students need to experiment with a variety of ways to make marks on paper.

Appropriate Subjects

Appropriate subjects for texture drawings have interesting surfaces. Some examples include a close-up photograph or accurate model of an alligator, a scaly fish, a furry fox, a prickly cactus, or a wrinkled face (figures 5.16 and 5.17).

Camping Out, oil pastel cutouts on paper, Noni Brynjolson, age 8, Luxton School

Figure 5.15. After Noni looked at illustrations by Ted Harrison, she drew with oil pastels, then she cut out pieces of the drawing and spaced them on black paper to create interesting, flowing lines.

TIP If a subject is furry, the length and direction that the fur grows will determine the length and direction of pencil marks. A rough, furry, or bumpy surface will also affect the contours (edges) in the drawing. Fur may also cause the pattern on an animal to have jagged edges (for example, the stripes on a tiger are jagged, not smooth).

Young Crocodile, pencil on paper, Noni Brynjolson, age 8, Luxton School

Figure 5.16. Adding texture provides some of the detail that helps to make a drawing look "real." A bumpy, scaly crocodile makes an interesting subject.

1. Although texture and pattern are different design concepts, they are lumped together here because they are commonly added into a drawing at the same stage, after the shapes and lines have been established. Texture and pattern are also compatible in terms of technique – each requires careful observation and recording of detail, often with repeated pencil marks. Often only one or the other is important in a subject, although very challenging subjects may combine a variety of textures and patterns.

Iguana, pencil on paper, Matthew Banman, age 11, Elm Creek School

Figure 5.17. Matthew had the patience required to faithfully reproduce the texture of this iguana. The pencil marks form an intricate pattern on the paper.

PATTERN

Pattern, in drawing, refers to repeated shapes, lines, or colours. The spots on a leopard, areas of colour on a butterfly, and stripes on a tiger are all examples of patterns. Often the challenge for students is to see the variety inside the pattern. For example, leopards' spots are not circular, but are shaped like irregular paw prints; the black triangles on a butterfly's wing may vary in size; a tiger's stripes are composed of irregular, curved shapes with fuzzy edges, not regular, vertical lines (figure 5.18). Young students are apt to see the pattern, but not the differences within it.

Appropriate Subjects

Interesting subjects for drawing patterns (in addition to leopards, butterflies, and tigers) include buildings (the windows form a geometric pattern), tropical fish, insects, and tropical plants.

Tiger, pencil on paper, Kelvin Thielman, age 10, Elm Creek School

Figure 5.18. Kelvin accurately drew in the contours and patterns of a tiger.

Process for Drawing Texture and Pattern

Look at *Brian Wildsmith's Animal Gallery* with your students. Say to your students: "The paper that the bear is printed on is smooth to touch, so how does the artist let us know that the animal is furry?" Point out the areas of colourful geometric patterns that decorate parts of Wildsmith's illustrations.

Have students describe the textures and patterns of the subjects they are going to draw. Ask them to think about what kinds of marks they might make with their pencils to show those textures and patterns in their drawings. Have them try out different kinds of marks in their sketchbooks. For texture, students can use pencils to make dots, parallel lines (called *hatching*), intersecting lines (called *crosshatching*), small Xs, short repeated marks for fur, and light marks by running the edge of an eraser through areas that have been shaded. Drawing patterns may require drawing the outlines of repeated shapes, such as ovals or squares, or using a thicker drawing tool to represent areas of darker value (figure 5.19).

Additional Exercises

Here are additional exercises your students can do to build their awareness of texture and pattern:

- Make crayon rubbings. Place lightweight paper, such as photocopy paper, over a hard, bumpy surface. Rub the paper with the side of a peeled crayon or oil pastel. Lego, window screens, pegboard, corrugated cardboard, and tree bark are good examples of objects that have bumpy surfaces. Rubbing over the textured surface will leave a pattern on the paper. Crayon rubbings can be done in the classroom or outdoors. If students press hard, these crayon marks will show up when students apply watery tempera paint over the crayon. This technique can also be used to pick up text from inscriptions on plaques (while on a field trip, for example).

- Provide, or ask students to collect, materials with a variety of textures and patterns, such as scraps of fur, lace, screen, and fabric. Then, cut and glue the scraps onto cardboard to produce a collage.

- Impress textured items, such as burlap, mesh bags, buttons, and plastic forks, into modelling clay.

- Place an assortment of objects inside a blind touch box. Have students reach into the box and describe the objects by feel. Ask students to record the words they use, and enrich their vocabulary with the aid of a thesaurus.

- Long strips of paper work well for showing repeated patterns. Students can tack the strips along the edges of bulletin boards as border designs.

drawings, Xuan, Angela, Jena, and Jill, age 4, Wellington School. Teacher: Jennifer Cobb

Figure 5.19. The students looked carefully at the texture and pattern on a prickly pineapple.

- Sort objects or photographs by texture category (for example, rough, furry, smooth), and describe the textures.

- Sketch, sample, and describe the textures of various foods.

- Use a viewfinder (a square of cardboard with a small rectangle cut out from the middle) to isolate small areas of a pattern or of textures. (Students will be able to see parts of the design more clearly.)

CAUTION! Be aware of student allergies before allowing students to sample food.

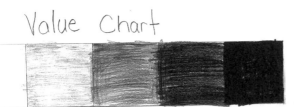

Value Chart

Figure 5.20. A value chart ("grey scale") is a good warm-up exercise for drawing with a variety of light and dark colours.

VALUE

Value refers to the light and dark colours of a subject, as well as to areas of reflected light and shadow. Adding shading and highlights will make a subject appear three-dimensional – as if it has form or solidity (the three dimensions are height, width, and depth). The ability to discern areas of light and dark values is necessary before tackling the extra challenge of working in colour.

Appropriate Subjects

For value drawings, the easiest subjects to work with are black-and-white photographs from magazines, calendars, or photocopied images. The images should have bright whites, a range of grey tones, and blacks. Most young students and those inexperienced in art can draw light and dark patterns (like stripes on a zebra), but they may find areas of reflected lights and shadows difficult

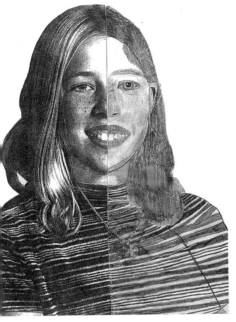

Self-portrait, photocopy and pencil on paper, Pamela Greenwood, grade 6, Treherne Elementary School

Figure 5.21. Half of Pamela's picture is a photocopy; the other half is a pencil drawing. She has done a careful job of matching the values in her photocopy.

BOOKS TO HAVE HANDY

PICTURE BOOKS

Jumanji, written and illustrated by Chris Van Allsburg.

The Magic Paintbrush, written and illustrated by Robin Muller.

The Night Rebecca Stayed Too Late by Peter Eyvindson, illustrated by Rhian Brynjolson.

VIEWING

James McNeill Whistler. *Arrangement in Grey and Black: No. 1, or the Artist's Mother.* 1871.

Figure 5.22. This painting, commonly referred to as *Whistler's Mother*, is one of the most widely recognized icons of American art. Whistler intended the title to refer to the influence that music had on his artwork. If one can enjoy music purely for the notes, harmony, rhythm, and melody, why cannot one enjoy art for the colour, line, shape, and value? Notice how the contrast between black and white is echoed in the curtain, the picture frame, and the woman's dress, with the wall uniting these opposing values in its broad expanse of grey. Whistler's attention to value and contrast creates the overall mood of the painting, which many would describe as calm and reflective.

to discern. Advanced students are able to work from colour photographs and interpret the colours in terms of light and dark values.

Process

Have your students look at *Jumanji* and notice where parts of the drawings are white, grey, or black. Ask them to guess what the light source is (sunlight, a lamp, candlelight, and so on).

Shadows can become an important part of a picture's content. Find interesting shadows in picture books such as *The Magic Paintbrush* or *The Night Rebecca Stayed Too Late*. Ask students: "How do these shadows affect the mood or meaning of the illustration?"

Have students make a value chart, called a *grey scale*. Have them draw a long rectangle, divide it into boxes, and shade each successive box darker than the one before it – from very light pressure on the pencil to very firm, black marks (figure 5.20).

Next, ask students to notice the light and dark values on their subjects. Have them draw a portion of their subjects in their sketchbooks and practise shading in the darker values. If their drawings become too dark, students can "draw" highlights with their erasers, using an edge of the eraser to lighten areas of their pictures.

Additional Exercises

Have students do some of the following exercises to build their awareness of light and dark values:

- Look at picture books that show night scenes. Notice how changing the light source changes the atmosphere or mood of the picture. Describe or draw how the atmosphere or mood changes.

- Create a grey scale, or make a value drawing with white chalk on black paper, charcoal and chalk on grey paper, white and black paint on grey paper, or use black paint and varying amounts of water on white paper (figure 5.21).

- Use an overhead projector to make hand shadows or silhouettes of objects or people, and trace the resulting shadows onto black paper.

- Make shadow puppets (see page 153).

- Shine a flashlight on simple geometric solids such as spheres, cubes, pyramids, eggs, or small toys or models. Predict where the edges of shadow and reflected light will fall. Sketch or photograph the results (see Form and Space, page 79).

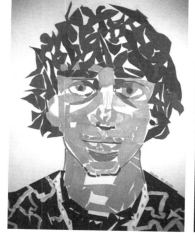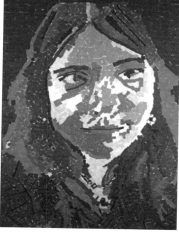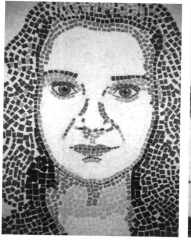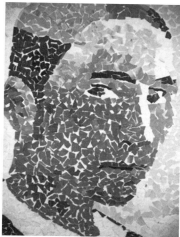

self-portrait value studies by Steven, Olana, Storm, and Mitchell, students at Elmwood High School. Teacher: Briony Haig

Figure 5.23. These students looked at the areas of light and dark values in black-and-white photographs. They cut up small squares of white, grey, and black, to create these mosaic self-portraits.

TIP If students are drawing "from life," for example, (hard-boiled) eggs or a stack of white geometric solids such as cubes and spheres, values will be difficult to see in diffused light. Set the objects on pieces of white paper. Then, turn off the overhead lights, and use direct sunlight, or aim desk lamps at the objects, to provide more obvious light and shadow.

Fawn, pencil on paper, Noni Brynjolson, age 11

Figure 5.24. These successive drawings show how (1) shape, (2) line, (3) texture and pattern, and (4) value are added in the progression of a finished drawing.

COMBINING BASIC ELEMENTS

Students are now ready to combine shape, line, texture, pattern, and value in a single drawing (figure 5.24).

Explain that an artist may begin a drawing by quickly sketching geometric shapes or a scribbled contour as the rough blueprint for the drawing. This allows the artist to see how to arrange the parts of the image on the paper and to determine if the placement and proportion of each part are accurate or fit the composition as a whole.

An artist may then add a line drawing over the shapes. The lines are often added more slowly and carefully, with attention to how the contours flow around or break away from the underlying structures.

Texture marks or patterns are added next, with an eye for small details and variations in the size, placement, and direction of marks.

Finally, areas of light and dark values are added to make the subject appear more solid and to provide some contrast from the value of the paper.

All together, these elements add up to a finished representation of a subject. A challenging subject will display all the elements (see also Form and Space, below, and Part 4, Working in Colour).

Students might make complete drawings of a variety of subjects. These drawings take time. You may want to have several short drawing sessions, and add one additional element with each session. This is not to say that an artist will always progress through these steps, or work in this order. As your students become comfortable with drawing each element, they may experiment with starting a drawing with value, or work with two or three elements in different combinations.

Additional Exercises

Here are some additional exercises your students can do to practise combining drawing elements:

- Study artworks done by a variety of visual artists and illustrators. Look carefully, and discuss which elements of drawing are present or emphasized in each artwork (see page 42).

- Engage students to think about how the elements are used in their own drawings. Draw a subject, using only one or two different elements. Reflect on whether the element(s) changed the visual impact or interpretation of the subject. Discuss which elements of drawing feel most comfortable and which are more difficult to use, which elements could be most expressive, or which medium your students think is best for each element.

Landscape, watercolour and ink on paper, John Madina, age 10, Wellington School

Figure 5.25. In this drawing, John used overlapping to achieve an illusion of depth. He made the close-up building larger and set it lower on the page so that it overlapped one of the buildings in the background.

ink and wash drawing, Travis Spence, age 14, San Antonio School

Figure 5.26. Travis, an advanced student, did this black, white, and grey study of a landscape as a preliminary to a watercolour painting. He picked out the light and dark values from a colour photograph.

FORM AND SPACE

Shape, line, texture, pattern, and value are elements that help the artist draw or analyze particular aspects of a subject, or a piece of background detail. The element of form indicates a three-dimensional object. A 3-D object can be created either in a sculpture or by adding an illusion of depth and solidity to a drawing. Working with form in a drawing means using light and dark values (discussed above) to show reflected light and shadow. In this way, flat shapes are given the appearance of solids, such as spheres, cubes, rectangular prisms, cylinders, and cones.

The element of space has to do with drawing the environment, structures, or areas that surround a subject, indicating the depth of the image. The element of space helps the artist make decisions about where and how to place subjects or parts of subjects in the picture. Space has to do with designing a whole scene, including considerations of depth and perspective, into which the subject may be placed.

Some images contain very flat space, such as the patterned and colourful images in *How the Animals Got Their Colors*. Other images, in *If You're Not From the Prairie* or a landscape photograph, for example, achieve an "illusion of depth" in some areas. This is an illusion because, even though the image fools the eye into seeing a distant view, the paper that the image is on is a flat, two-dimensional object.

Creating an Illusion of Depth

On a flat, two-dimensional piece of paper, an illusion of depth is created in the following ways:

- Size and Placement. To show the distance between subjects, one object may be drawn larger and placed near the bottom of the page, while an object that is faraway may be a mere dot placed higher on the page.

- Overlapping. Some parts of the picture may overlap other parts to indicate, for example, that one building is in front of, and partly obscuring, the building behind it (figure 5.25).

pencil on paper, Katie MacSwain, age 15, Wanipigow School

Figure 5.27. Katie shaded these volumes with pencil to produce the light and dark values that make them appear three-dimensional.

BOOKS TO HAVE HANDY

PICTURE BOOKS

How the Animals Got Their Colors by Michael Rosen, illustrated by John Clementson.

If You're Not From the Prairie by David Bouchard, illustrated by Henry Ripplinger.

Zoom Away by Tim Wynne-Jones, illustrated by Eric Beddows.

- Light and Shadow. Use light and shadow to create form. Shading and erasing create lighter and darker values to indicate shadow, and reflected light and shadow. Objects will appear three-dimensional, rather than flat on the paper (figures 5.26 and 5.27).

- Foreshortening. A foreshortened view of an elephant's trunk, for example, will give a sense of its length. The trunk is wide at the tip where it is closest to the viewer, and it recedes into the faraway distance of the elephant's head – just like the road in the single-point perspective drawing below (figure 5.28).

- Colour. The parts of the landscape that are in the far distance tend to take on a bluish tinge and have paler, less intense colour. A colour may be reduced (mixed with its complement), paled (tinted), or cooled (mixed with blue) to make it appear to have faded into the distance (see chapter 11).

- Perspective (discussed below). Perspective simply means a point of view. European Renaissance artists developed a view from a single point in space – a trick used to indicate depth and distance. This technique is often used in architectural drawings, and it is evident in photography. This way of viewing is often thought of as "realistic." However, it works only for viewing the surface appearance of a still object, viewed at a particular point in time, from a fixed point in space. In other art traditions, the world may be viewed from multiple perspectives, imaginatively transformed, or represented symbolically.

- Architectural Drawing. Advanced students can make structural drawings, using three-dimensional forms instead of flat shapes. (See page 83 for how to draw 3-D forms.) This type of exercise can be extended with computer-assisted drawing programs and web-based programs, such as Google SketchUp.

TIP Encourage students to use light grey or dotted lines instead of solid lines to connect to the vanishing point. These will make the drawing process less confusing.

Road to Hollow Water, pencil on paper, Steven Bird, age 15, Wanipigow School

Figure 5.28. This drawing makes use of single-point perspective. The height and width of all the elements of the picture (road, verge, and trees) are determined by lines radiating from one point on the horizon.

Perspective

Drawing one-point (single-point), two-point, or three-point perspective involves learning some tricks and conventions. It is, therefore, worth going through each step. After students have mastered single-point perspective, they can learn two-point perspective, then three-point. (These may be too difficult for very young students to learn.)

Single-Point Perspective

As a class, look at *If You're Not From the Prairie*, or take your students outside. Point out that roads, sidewalks, telephone poles, and fence posts appear to be different heights or widths, depending on how close or far away they are from you. Have students look at people or large objects close to them (as they appear in the picture book or along the street). Have students notice how they must look down to see the feet of these people and the lower areas of the objects. Now, have your students look for the horizon line (the line where the earth and the sky appear to meet). Have students notice that faraway people and objects (near the horizon line) appear smaller and higher up in their field of vision than objects that are near. To help frame the view and make these comparisons more obvious, use a viewfinder (rectangular card with a smaller rectangle cut out of the centre).

Process

The simplest way for your students to start a single-point perspective drawing is by drawing a road that disappears into the distance. You can vary this activity by drawing aspects of the school neighbourhood, a landscape you are studying in geography, or a landscape represented in a piece of artwork. Demonstrate the following method:

1. Draw a horizontal line across the centre of a piece of paper. This represents the *horizon line*. It may be flat to represent the prairies, or it could be bumpy to represent hills or mountains.

2. Place a dot along this line near the middle of the page. This is called a *vanishing point*, because this is where the road will appear to vanish toward the distance.

3. Make two marks, a short distance apart, along the bottom edge of the page. The spacing of these dots determines how wide the road will be in the front of the picture.

4. Take a ruler, and connect each of the two dots to the vanishing point on the horizon. There is now a straight road that vanishes into the distance. Later, students may curve the road, but only if the gradually narrowing width of the path is maintained.

5. Near the bottom of the page, off to one side, draw an object, such as a large fence post, or tree.

Noni Brynjolson, age 11

Figure 5.29. Single-point perspective

TIP For extreme perspective, place vanishing points close together. For more typical views, place the vanishing points as far apart as possible. Students may want to attach their papers to their desktops and place the vanishing points off the page, on the far edges of their desks.

TIP Before your students make their own perspective drawings, demonstrate the method. Have them follow you step by step. Initially, this will be an exercise in following direction. Once students catch on, however, they can begin to transform the roads into landscapes or cubes into buildings, or they can attempt architectural drawings from photographs or field trips.

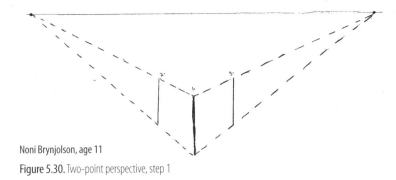

Noni Brynjolson, age 11

Figure 5.30. Two-point perspective, step 1

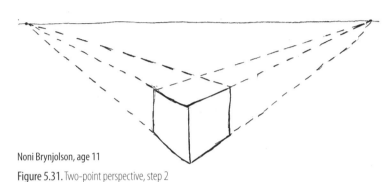

Noni Brynjolson, age 11

Figure 5.31. Two-point perspective, step 2

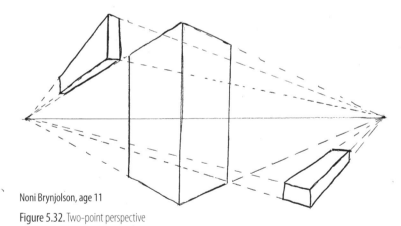

Noni Brynjolson, age 11

Figure 5.32. Two-point perspective

TIP The placement of the vertical lines and the distance between the two vanishing points will affect the shape that you end up with (figure 5.32). If the two lines are equal distance from the vanishing points, you will have a cube. If they are different distances, you will have a rectangular prism (a long box).

6. Use a ruler to draw lines that connect the top and bottom of the object to the vanishing point. These lines will determine the height of other similar objects as they are placed higher up on the page.

7. Draw other objects. Objects will appear to be closer together as they recede into the distance. Fence posts, for example, will appear larger and have wider spaces between them at the bottom of the page; they appear smaller and closer together near the horizon line (figure 5.29).

The vertical objects still appear vertical in this view. Students can check this by *sighting the angle* of items in their view. This is done by holding a pencil at arm's length and tilting the pencil left or right until it lines up with the angle of the object in your field of vision.

Two-Point Perspective

Single-point perspective is adequate for many scenes and is helpful in deciding where to place subjects that are closer to or farther from the viewer. For drawing three-dimensional forms, such as cubes, rectangular prisms, and cylinders, as well as for architectural drawing (drawing the interiors and exteriors of buildings), two-point perspective is required to represent the angles as we see them.

For two-point perspective drawings, begin by having students look at a three-dimensional block or cube, or at the edges where the ceiling meets the walls of the classroom. Point out that each side is a square with parallel edges and right angles. When the cube is turned slightly, however, some of the edges appear to change direction; they no longer appear horizontal.

Look at *Zoom Away* with your students. Have them notice the lines in the illustrations where the walls meet the ceiling or floor. Are the lines horizontal on the page, or do they appear tilted? Remind students that how something looks depends on where the viewer stands, and how he or she looks at it. Try sighting the angles of the lines inside the classroom, where vertical walls meet the floor or ceiling (each student can hold a pencil at arm's length, and tilt the pencil left or right until it lines up with the angle of the object in his or her field of vision). You can try this outside, too, sighting the angles on the outside edges of buildings.

Process

Demonstrate two-point perspective by doing the following:

1. Draw a horizon line across the centre of the page.

2. Place one dot on the far left, along the horizon line, and another on the far right. These are the vanishing points.

3. Draw a vertical line somewhere near the centre of the page, below the horizon line.

4. Connect the top and bottom of this line to each vanishing point, pressing lightly with your pencil. For best results, use a ruler for straight, accurate lines.

5. Draw two vertical lines – one to the left and one to the right of the first vertical line. The heights of these lines will be determined by where they are placed within the connecting lines (figure 5.30).

6. Draw a line from the top of the left-hand vertical line to the vanishing point on the right. Draw a line from the top of the right-hand vertical line to the vanishing point on the left. These lines will form the back edges of the cube (figure 5.31).

Confused yet? Check the diagrams – visual communication is often much clearer for detailed instructions.

Students may not want to go through this lengthy process every time they draw a picture. Now that they have experienced how linear perspective works, they may prefer to carefully draw their subject and then check and adjust their angles afterwards, using the above methods (figures 5.32 and 5.33).

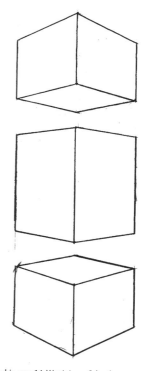

Rachel Bushie, age 14, Wanipigow School

Figure 5.33. Blocks drawn with two-point perspective

Creating the Illusion of 3-D Forms

After students have practised using perspective to draw three-dimensional volumes (or solids), such as cubes and rectangular prisms (above), they can try drawing cones and cylinders. For a cylinder, draw two parallel lines, join them at one end with an oval, and join them at the other end with a curved line that follows the curve of the oval. To draw a cone, draw a wedge, or letter *V* shape, and close the open end with an oval. Seen from the side, the oval will be quite flat; from above it will appear rounder. Test this by tilting a can or cup to see how the shape of the top circle becomes an oval, called an *ellipse*, as the object is tilted.

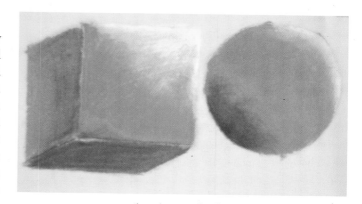

oil pastel on paper, Noni Brynjolson, age 8

Figure 5.34. Noni added light and dark values to make these forms appear three-dimensional.

Drawings can be given an illusion of three-dimensional solidity (figure 5.34) by adding shadows and reflected light. A sphere, for example, is simply a circle with light and dark values drawn in. To see where lights and shadows will appear on a surface, shine a flashlight on simple geometric volumes (solids) such as spheres, cubes, pyramids, eggs, or small toys or models (the diffused light of overhead light fixtures will not produce defined areas of shadow). Students can do "before" drawings to predict where the shadows will fall, and then they can test their predictions.

Castle, pencil on paper, Iain Brynjolson, grade 3, Luxton School

Figure 5.35. To do this drawing, Iain looked carefully at a photograph of a castle.

Additional Exercises

Here are additional exercises your students can do to build their awareness of form and space:

- Make architectural drawings of buildings in your neighbourhood (figure 5.35).

- Use cutout drawings to make collages. Another useful way to create an illusion of depth, combined with other basic considerations of space, is to have students work with cutout subjects. They can do this by drawing various subjects, photocopying the drawings for a variety of sizes, and cutting them out. The cutouts may then be placed on a background to maximize an illusion of depth (figures 5.36 and 5.37).

- Look at houses from a variety of places in the world. Use books and websites as visual references. (Comparing homes and possessions in places around the world is the subject of *Material World: A Global Family Portrait*. Photojournalists travelled to several countries around the world and convinced families to remove all of their possessions from their homes, then took a photograph of each family surrounded by everything they owned!)

- Study and sketch famous landmarks or buildings designed by famous architects such as Antoni Gaudi. Look at the onion domes of Byzantine churches, multiple roof lines of Japanese shrines, the geodesic dome designed by Buckminster Fuller in Montreal, the Eiffel Tower, and so on.

- Challenge students to design structures that fit with core curricula or current issues, such as zoo structures and habitats, energy-efficient dwellings, or a new playground structure for the school.

- Look at optical illusions. A variety of visual references are widely available on the Internet, including sidewalk chalk drawings by English artist Julian Beever and detailed drawings by M.C. Escher. Try creating drawings that break the rules of perspective and fool the viewer's eye.

photocopies/cut and paste, Noni Brynjolson, age 11

Figure 5.36. These cutouts were placed in the background drawing with the objective of creating as much depth as possible. The large figure is placed lowest on the page. The medium-sized figure overlaps the small figure reclining in the background.

photocopies/cut and paste, Noni Brynjolson, age 11

Figure 5.37. These cutouts (duplicates of those in figure 5.36) were arranged to make an "impossible" picture. The distortion of space makes the viewer's eye linger on the picture, trying to make sense of the space.

Jennifer Cobb, nursery teacher (left), and
Susan Calanza, educational assistant

ART IN THE PRE-PRIMARY CLASSROOM:

DRAWING WITH VERY YOUNG STUDENTS

from an interview with Jennifer Cobb

Jill, age 4, drew this pineapple in Jennifer Cobb's nursery class at Wellington School, after she looking carefully at shapes, patterns, and textures.

Jennifer Cobb believes in the importance of teaching observational drawing skills to very young children. Her students range in age from three to five years old. She teaches in an inner-city elementary school setting.

Throughout the school year, Jennifer teaches about colours, shapes, lines, textures, and patterns. Students look at objects of study, touch them, then use "juicy" descriptive language to talk about them. As a class, they read richly illustrated picture books. In addition to activity centres where students can play freely with materials such as play dough, sand, water, crayons, and paint, Jennifer introduces a new art technique and medium each week. Each student's artwork is proudly displayed and then collected into a memory book to take home at the end of the school year.

To make pineapple drawings, for example, Jennifer broke down the process of observational drawing into the following small, achievable steps spread out over several short sessions:

1. Experience the subject. The students studied the letter *P*, tasted pieces of pineapple, and passed a pineapple around the circle, discussing its spiny leaves, bumpy and prickly skin, square patterns, and the fruit's oval shape.

2. Build preliminary skills. Students practised drawing ovals, squares, Xs, and long, spiky triangles.

3. Provide experience with new art materials. Using crayons on black paper provided a new challenge. Students discovered that lighter colours showed up more clearly on black paper.

4. Provide a calm, focused environment. Small groups of students sat at a table close to the pineapple, so they could concentrate well and observe closely. An adult sat with them to ask guiding questions that helped them concentrate and see the different features of the pineapple.

5. Examine the shape or structure. Students drew large ovals for the shape of the fruit. They noticed and sketched the triangle shapes for the leaves.

6. Allow student choice. Students debated what shapes to use for the pattern on the skin, and decided to use squares or circles with Xs inside. Adults did not jump in to draw the object for them or correct their attempts. If a student had trouble concentrating, he or she was given another opportunity later.

7. Model close observation. Jennifer looked closely at the pineapple while she was drawing it, and she made animated comments about the details she noticed. (Magnifying glasses are helpful tools to have so that students can model this type of careful looking.)

8. Use art language. By using art terms like *texture, shape,* and *pattern,* Jennifer expanded vocabulary and prepared her students for using elements of design to analyze their visual experiences.

9. Honour every child's efforts. Some students will not be developmentally ready or interested enough to focus on the task. Others may not possess the required fine motor skills to make a recognizable drawing. Jennifer honours all efforts by pointing out to the students what they are able to do.

Jill made this collage while studying artwork by Eric Carle. Jennifer, Jill's teacher, broke the process into short steps and encouraged media exploration, making this a fun and meaningful learning experience.

Jennifer Cobb is a nursery teacher at Wellington School.

Jennifer believes that very young artists should be encouraged to make observational drawings. Angela, age 4, drew these pussy willows while looking carefully at the shapes and colours of the original object (above).

DRAWING MEDIA 6

INTRODUCTION

In this chapter, we explore drawing media other than pencil on paper (figure 6.1). The techniques used for ink, charcoal, and chalk are all extensions of the drawing techniques discussed in the previous chapter. Students may also use multiple images, and add cut-and-paste and retracing techniques to their drawing process. These techniques give students more choices about the placement of subjects in a drawing.

Many students are reluctant to draw with anything that is not as precise or as familiar as the pencil. To coax students to try new media, you might find it helpful to call the drawings "studies." Explain that a study is different from a finished drawing. It is usually a piece of a subject rather than a whole scene. It has unfinished edges, and it may have multiple outlines or even multiple sketches of the same subject on the page where the artist has tried several different versions. A study, then, is a learning exercise rather than an accomplished end product.

Experience with a variety of media will encourage students to do the following:

- Revisit, in depth, some of the basic elements of design (see chapter 5).

- Produce more dramatic and finished end products than are usually produced with a pencil drawing.

- Explore new tools, media, and techniques.

- Make conscious choices about which media and approaches are most suitable for communicating visual ideas.

- Maintain or renew an interest in drawing.

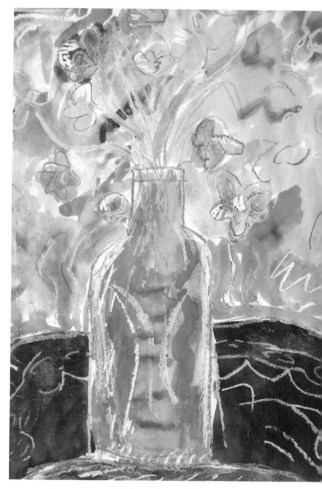

crayon drawing with watercolour wash, Noni Brynjolson, age 10

Figure 6.1. Noni drew contour lines with wax crayons and then added watercolour paint. The playful lines and colour contrasts produce a vibrant image.

VIEWING

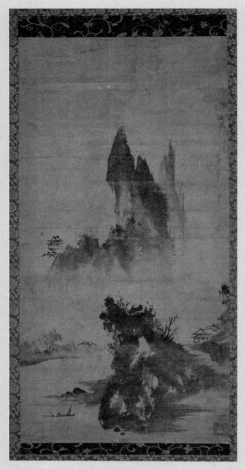

Sessō Tōyō. 15th century CE

Figure 6.2. Sessō Tōyō was a Japanese artist who used ink to make his paintings. This work is an example of a scroll painting and features areas of ink wash and shading. Artists have used ink for thousands of years, with the most ancient works coming from Asian countries. Working with ink can be a way for students to experiment with different methods of creating lines, shades, and textures. It can also be a way to connect with an historical art form that has evolved and taken on new cultural meanings throughout history.

BOOKS TO HAVE HANDY

PICTURE BOOKS

Alexander and the Terrible, Horrible, No Good, Very Bad Day, written and illustrated by Judith Viorst.

The House at Pooh Corner by A.A. Milne, illustrated by Ernest Shepard.

Where the Wild Things Are, written and illustrated by Maurice Sendak.

Would They Love a Lion?, written and illustrated by Kady MacDonald Denton.

Under the Cherry Blossom Tree, written and illustrated by Allen Say.

DRAWING WITH INK

TOOLS & MATERIALS

- sketchbooks
- paper (white photocopy paper, or drawing papers for ink and charcoal paper, approximate size 8 ½" x 11" (21.5 cm x 28 cm), or 11" x 17" (28 cm x 43 cm). Paper designed for ink drawings has a smoother finish. Paper designed for charcoal and chalk has a rougher finish or "tooth"; soft paper such as construction paper, brown wrapping paper, or Manila drawing paper may be substituted.)
- pencils
- erasers
- felt pens ("ultra-fine"-tipped, black, permanent, labelled *non-toxic*, e.g., Sharpie; some markers for overhead projectors fit this description)
- visual references
- optional: see Additional Exercises (page 92)

When students draw with ink, they become more aware of and interested in individual marks and line qualities. The black marks and lines produced by ink can emphasize the texture and pattern in a drawing. This often compensates for other weaknesses in students' abilities to produce aesthetically pleasing pieces of work. Students are likely to be satisfied with, and gain confidence in, their results.

In an ink drawing, the marks are much blacker, more obvious, and much less easy to erase than the marks in a pencil drawing. This may be a problem for over-cautious students who are fearful of making mistakes when they work with a permanent medium. You can, however, turn this problem into an advantage. Show students how they can draw over mistakes — or even incorporate them into their drawings. For example, a blotch of ink might become a rabbit, or the "wrong" line around the subject might be emphasized or turned into a shadow.

Preparation

Collect visual references such as magazine photographs, calendar photographs, books, and objects. Students can use these for observational drawings of subjects and settings.

Plan to do this exercise over several drawing sessions on different days. Have students practise drawing their subjects on the first day. In the following sessions, they can draw a good copy in pencil, experiment with pens, and add ink to the good copy.

Appropriate Subjects

Appropriate subjects for texture drawings have interesting surfaces. Some suggestions are alligator skin, fish scales, fox fur, sweaters, and cacti. Visual references should be objects or close-up photos, with a clear picture of surface detail (see page 73).

Process

Encourage students to make some pencil sketches of their subjects in their sketchbooks. Practice drawings should be small (maximum 4" x 4" (10 cm x 10 cm). Students can begin with scribbled drawing, or they can draw the geometric shapes they see in their subjects.

When students are comfortable with their practice sketches (figure 6.3), have them use pencils to sketch their subjects and backgrounds onto larger sheets of paper. Remind them to draw their subjects large enough to fill the page. While they are drawing, ask them to pay attention to the shapes and contours of their subjects and to avoid shading in areas with pencil. Have them set aside their drawings when they are done.

Students are now ready to begin experimenting with ink. As with pencil drawing, ink drawing uses the drawing elements of line, pattern, and texture. Small, repeated marks are used to produce areas of darker value.

Show students the book *Would They Love a Lion?* Have them note the interesting qualities of the lines – straight or wobbly, thick or fine, broken or smooth. With their pens, students may wish to practise drawing these kinds of lines in their sketchbooks (figure 6.4).

Review with students the kinds of marks they might make with their drawing pens to show the textures of their subject (see page 74). Look at the pen marks, including the overlaid parallel lines, called *crosshatching*, in the books *Where the Wild Things Are*, *The House at Pooh Corner*, and *Alexander and the Terrible, Horrible, No Good, Very Bad Day*, and the small marks and circles in *Under the Cherry Blossom Tree*. Have students make different kinds of marks – dots, Xs, repeated lines, hatching, and crosshatching – in their sketchbooks (figure 6.5).

TIP Students may be apprehensive about figuring out a way to enlarge their small drawings onto a larger surface. They can use any of following shortcuts:

- Photocopy and enlarge the drawing onto 11" x 17"(28 cm x 43 cm) paper.

- Adhere a large sheet of paper onto the wall, and, using an opaque projector, project the original drawing onto the paper on the wall and trace the outline. (If using an overhead projector, first trace the drawing onto a sheet of clear plastic, place it on the bed of the projector, then trace the enlarged outline onto the larger paper adhered to the wall.)

- Take a digital photograph of the image and, using a computer and LCD projector, trace the projected image onto a larger surface.

Students could also enlarge a drawing, and incorporate math skills, by using a grid. Have them follow these steps: (1) Tape a sheet of plastic over a small drawing. (2) Draw a grid onto the plastic overlaying the image. (3) Draw a larger grid with the same number of squares onto a larger sheet of paper. (4) Re-draw the image one square at a time on the larger sheet. (5) Erase the grid. This will help to duplicate the proportions of the original image.

pencil sketch, Noni Brynjolson, age 11

Figure 6.3. When students draw quick practice sketches in their sketchbooks, they find drawing is easier once they are ready to draw their good copies.

pencil on paper, grade 6 student, Luxton School

Figure 6.4. A student experimented with a variety of lines.

pencil on paper, grade 6 student, Luxton School

Figure 6.5. A student filled a page with a variety of lines and patterns.

Armadillo, fine-tipped felt pen on paper, grade 4 student, Luxton School

Figure 6.6. A student used a variety of marks and patterns to represent the armadillo's texture. The initial drawing must be large enough to allow for the addition of interior detail.

Now, ask students to add texture marks to their larger drawings (figure 6.6). Demonstrate that the closer together the marks are, the darker the value. Where their subject is a light value (colour), they should make texture marks farther apart.

For adding controlled amounts of colour, apply small amounts of chalk pastel, wiping gently with a paper towel (see below).

Additional Exercises

Here are additional exercises your students can do to practise drawing with ink:

Dancer, ink drawing, Noni Brynjolson, age 11

Figure 6.7. Drawing with a paintbrush dipped in ink allowed for more variation in the width of lines.

TIP Pen nibs or twigs that have been dipped in ink produce a beautiful, scratchy, often blotchy, line (figure 6.8). If students touch the tip of the pen to scrap paper after dipping it in ink, they can reduce blobs and drips.

- On Mayfair or construction paper, apply chalk (or soft) pastels on top of an ink drawing. Work with a small amount of chalk, wiping and blending colours with a rolled-up tissue. Mix colours (for example, yellow-green), rather than use colours straight from the box (see chapter 11). For a darker shade of a colour, mix brown or dark blue with the colour rather than with black (black will make all the colours appear grey and hide the ink lines if too much is used). To minimize smudging, draw in the lightest colours first, then the medium values, and the dark colours last. To preserve the works and prevent smudging, spray with fixative after students have left for the day (the spray is toxic), or take photographs, or place drawings in plastic sleeves. Set up a display for all to see.

- For an interesting, wobbly line quality, use a penholder and a variety of nibs, paintbrushes, or sharpened twigs of different diameters, dipped in ink (figures 6.7 and 6.9). Apply the ink on a pencil drawing that is not too precious or on a photocopied drawing – in case ink drips and blotches on a drawing that took hours to complete!

- Use ink drawings in a series of illustrations. Work on small 4" x 4" (10 cm x 10 cm) pieces of paper, or photocopy elements of the drawing, and cut and paste them together. For example, make multiple copies of the main character, and then cut and paste the copies onto a background drawing of the setting. For variety, photocopy the setting and re-draw the character in a different pose (see page 98).

- If permanent ink has been used in drawings, apply a wash of watercolour paint on top (see figure 6.1; also see chapter 14). A pre-mixed solution of watery tempera paint may also be used (figure 6.8) to wash over areas of the drawing. You may want to test the ink first to ensure that it really is permanent. Look at *Would They Love a Lion?* as a class. Discuss how the colour does not always follow carefully inside the lines.

- Look at Japanese brush drawings. In these drawings, each stroke of the brush is an expressive part of the drawing. Experiment with a soft, tapered brush dipped in ink or watery black paint, on a variety of types of paper.

TIP Too much chalk pastel will make the ink lines fade or disappear; over-wiping with the paper tissue will cause chalk to disappear and ink lines to fade.

ink and wash drawing, Nicole Hammerstedt, age 12, San Antonio School

Figure 6.8. A wobbly line drawing with a wash of diluted black paint makes for an interesting — and commonly used — illustration technique.

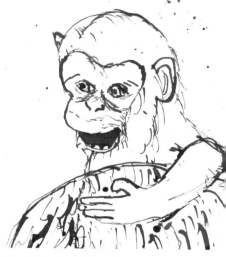

Chimp, ink drawing, Noni Brynjolson, age 11

Figure 6.9. Drawing with a twig dipped in ink resulted in interesting, irregular, blobby lines in this piece.

CHARCOAL AND CHALK

TOOLS & MATERIALS

- "vine" charcoal (good for initial sketches and finer lines)
- "compressed" charcoal (produces a thick, black line)
- white chalk
- optional: coloured chalk pastels (see chapter 11)
- grey "sugar" paper, construction paper, or brown butcher's paper (or paper designed for use with charcoal; make sure it has a soft or textured surface or "tooth" and is a neutral colour)
- facial tissue paper or paper towel
- "kneaded" erasers
- visual references
- desk lamps
- spray fixative (keep in locked cupboard; use in a well-ventilated area when students are not present)
- optional: see Additional Exercises (page 96)

BOOKS TO HAVE HANDY

PICTURE BOOKS

Jumanji, written and illustrated by Chris Van Allsburg.

The Magic Paintbrush, written and illustrated by Robin Muller.

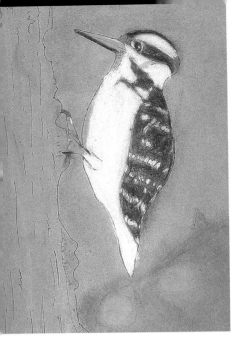

Woodpecker, ink and chalk, Darlene, grade 5, Wellington School

Figure 6.10. Although Darlene used a black pen for her initial lines, the strength of her drawing is in the contrast between light and dark values that were added with chalk and charcoal.

TIP Young students and those inexperienced in art may be able to observe and draw light and dark values (like stripes on a zebra), but they might find it difficult to discern the shapes of reflected light and shadows. Start these students with subjects that have very obvious shadows.

TIP Even a "black" bear may have sunlight reflecting on its back to make it appear white. A zebra has a dark and light pattern, and may also have a shadow on its belly.

TIP Chalk and charcoal drawings smudge easily. There are several ways to cut down on smudging: (1) Start with white chalk, and save black (compressed charcoal) until the end. (2) Blend grey tones (and light colours) with a rolled-up piece of tissue paper. (3) Instead of blowing charcoal dust off of the paper, lift the paper by one corner and shake gently over a garbage can. (4) Place scrap paper under your drawing hand as you draw. Your arm can rest on the scrap paper instead of on the charcoal.

Charcoal and chalk are excellent media for studying value because of the dramatic light and dark effects they can produce (figure 6.10). The resulting drawings tend to contain soft-edged shapes and values rather than definite lines and details.

Charcoal and chalk smudge, and they rub out easily. This may frustrate careful students who strive for perfection in their work. On the other hand, it may help to coax them into a more relaxed drawing style, with soft edges that may be redrawn multiple times.

Preparation

Working with charcoal and chalk can be messy. Classroom desks, tables, and hands will need to be washed after the session. An art studio or outdoor setting is an ideal location. Set out materials in shallow containers, so that chalk and charcoal are less likely to roll onto the floor (or ground). Break charcoal sticks in half for easy sharing.

Review drawing of shape and value (see chapter 5).

Find visual references such as objects, magazine photos, and calendar photos for observational drawing.

Appropriate Subjects

Black-and-white magazine photos are the easiest and most appropriate subjects for students to work with (figure 6.11). Colour photos with obvious reflected light areas and dark shadows also work; these may be photocopied in black and white. When students are drawing their objects (for example, fruit, friends, their own faces in a mirror), they will have difficulty seeing values in a diffused light. Turn off the overhead lights, and use desk lamps instead. Better yet – find a room with big windows that let in lots of sunshine.

charcoal and chalk, grade 5 students, Luxton School

Figure 6.11. Working from two black-and-white magazine photos, students combined the images into one drawing. They used very jagged lines and strong contrast to convey action and drama.

VIEWING

Arshile Gorky. *The Artist's Mother.* c. 1926 or 1936.

Figure 6.12. Working with charcoal can be a way to experiment with looseness, blending, and ambiguity. It can be used to capture the atmospheric effects of nature, or simply to make an image with less rigidity and exactness. Arshile Gorky's charcoal portrait was made from a black-and-white photograph of his mother, a victim of the Armenian genocide in 1915. He created this charcoal sketch years later, and the medium captures his memory of her in a somber and poignant image. Charcoal is often used as a preparatory medium before making a painting, as a way of playing with value and contrast. However, it can also be used to create pictures that have the look of black-and-white photographs, silent films, and portraits such as this one.

Figure 6.13. Having students make value charts is a useful introduction to drawing with charcoal and chalk. Students become familiar with the media and are able to recognize the range of values they can produce.

chalk pastel on construction paper, Noni Brynjolson, age 11

Figure 6.14. For this drawing, Noni did a careful study of colour and value from an art postcard. She began drawing with light colours and added the dark colours last. This work is a study of Tom Thomson's *Woodland Waterfall*.

Process

As a class, look at the book *Jumanji*. Point out the strong contrast between the light and dark areas of the illustrations. In other books, such as *The Magic Paintbrush*, shadows are an important part of the image. Begin by making a value chart or grey scale with white chalk on one end as the lightest value, a mix of chalk and charcoal in the centre, and charcoal at the other end for the darkest value (figure 6.13). Ask students to notice the areas of light and dark values (or colours) on their subjects (figure 6.14).

Before students begin, demonstrate the following method:

Mountain Goat, white chalk and vine charcoal on grey paper, Noni Brynjolson, age 11

Figure 6.15. (left) Noni started by sketching the geometric shapes of her subject. (right) She added the light values with chalk, then the grey tones with a mixture of chalk and charcoal. She added the dark values last, to minimize smudging.

1. With vine charcoal, lightly sketch the geometric shapes of your subject (see chapter 5).

2. Look for areas of white and light grey (or light colours) in your subject and background. Begin shading areas with the lightest values – white and light grey – then add the medium values, followed by the darker grey.

3. To avoid smudging, add the black areas last (figure 6.15).

4. If your subject has a pattern, such as a spotted leopard, shade in the overall light grey tones, then add the spots on top of the lighter values. This is much easier than drawing around each spot.

André Breton. *Landscape*. c. 1933.

Figure 6.16. Almost everyone has played with chalk in the summer, and knows how fun it can be to decorate the sidewalk. Chalk can also be used to make drawings in the classroom. Like charcoal, it produces a hazy, ambiguous line. Many famous artists, including Rembrandt, have used chalk to prepare for large paintings. This chalk drawing by André Breton and several other Surrealists is an example of Exquisite Corpse — a fun drawing game. Each collaborator adds to a composition in sequence, either by following a rule or by being allowed to see the end of what the previous person contributed. The final composition is revealed after everyone has contributed, often with hilarious results.

Additional Exercises

The following are some alternative methods for drawing with charcoal and chalk:

- Cover an entire sheet of white paper with vine charcoal, and then "draw" the light values with an eraser.

- Make value drawings with white chalk on black paper. This exercise encourages students to look very carefully at the highlights, rather than shadows, in their image.

- Fill a squeeze bottle with white glue, and use the glue to "draw" on black construction paper. When the glue dries, it will leave an irregular, glossy black line. Use chalk pastel to mix colours between the lines of glue.

- For oversize drawings, work with compressed charcoal and white chalk on brown butcher paper. Good subjects might be giant insects (figure 6.17) (magnified from magazine photos), dinosaurs, heavy machinery, and buildings. If you have access to a camera, photograph students with their giant creations, and encourage them to write a story, or display the giant drawings to add atmosphere to the classroom!

DRAWING AND COLLAGE

TOOLS & MATERIALS

- sketchbooks
- pencils
- erasers
- paper: 8½" x 11" (21.5 cm x 28 cm); white photocopy paper, Mayfair or Dessin drawing papers
- glue (glue sticks, paper paste, or white glue)
- scissors
- visual references
- felt pens (black, permanent, non-toxic, fine-tipped, e.g., Sharpie)
- optional: see Additional Exercises (page 99)

TIP To preserve and display charcoal and chalk drawings and prevent smudging, spray with fixative after students have left for the day (the spray is toxic). Alternatively, take photographs of students' works or place their works in plastic sleeves.

A collage is created by cutting, pasting, and combining several images into one artwork. Here, collage is treated as an extension of drawing, and as a tool for composing a layered image, with overlapping subjects. This approach to drawing is done in the following stages:

1. Develop a drawing of a subject.

2. Draw several background pieces.

3. Make several copies of all of the drawings, either by photocopying or using an overhead projector to retrace them.

4. Combine the pieces, by cutting and gluing them, and by drawing additional images, to create a single image. The single image can be considered the finished product, or you can rework it using a variety of media.

This approach to layered drawings is similar to an approach used by many artists who draw studies of various subjects in their sketchbooks and then combine the subjects into a single image. For an example, see the sketchbook drawings of Leonardo da Vinci, who practised multiple versions of hands, feet, faces, and poses in preparation for painting. Today's students have an advantage over da Vinci – they likely have access to a photocopier, scanner, camera, overhead projector, or opaque projector to help them re-draw their subjects!

Both young and advanced students will find there are several advantages to using multiple images and a collage or cut-and-paste technique. These advantages include the following:

- They have more control and choices over the placement of parts of their images (see chapter 8 for information on how to compose a drawing). The pieces are separate, and they can be moved around like a puzzle to test different combinations and placements.

- The images they create are crowded, rich in detail, and filled with overlapping pieces. Students who have trouble deciding how to treat the space around their subject, or who are still simply colouring a strip of blue across the top of the page and a strip of green across the bottom, will find it helpful to work with layers.

- The layered drawings work well for young students who often do not have the attention span needed for sustained work on a single project. Students can draw different subjects on different days. The drawings can be photocopied for them, and students can cut out and assemble the pieces later. (See chapter 15 for ideas on how to use these pieces with young students.)

- They can create images that are crowded, richer, and include more overlapping pieces. This kind of image is helpful to students who have trouble figuring out how to treat the space around their subject, or who are still simply colouring a strip of blue across the top of the page and a strip of green across the bottom.

- Beginning artists are often willing to experiment and explore new concepts, media, and techniques with copies of drawings, rather than risk ruining a drawing that took them considerable time to complete.

Preparation

Find a volunteer to help with photocopying, or arrange to have a couple of overhead projectors, an opaque projector, a light table, or access to a window (students can place their original drawings on the window or on the base of the projector, and use the back lighting as a light table to trace their images). Images will show through a piece of paper placed over top of the original drawing.

Review chapter 5 (shape, line, texture, and pattern) for tips on how to approach drawing the subject. Gather visual references.

BOOKS TO HAVE HANDY

PICTURE BOOKS

If You're Not From the Prairie by David Bouchard, illustrated by Henry Ripplinger.

Who Is the Beast?, written and illustrated by Keith Baker.

Changes, written and illustrated by Anthony Browne.

Knuffle Bunny, written and illustrated by Mo Willems.

8 O'Cluck, written and illustrated by Jill Creighton.

The Wolves in the Walls by Neil Gaiman, illustrated by Dave McKean.

chalk and charcoal on brown paper, Derek, age 9, Luxton School

chalk and charcoal on brown paper, Daniel, age 10, Luxton School

Figure 6.17. Derek and Daniel drew these giant bugs on brown butcher paper. They then painted backgrounds to use for these photographs.

Ben Gammon, grade 6, Luxton School

Figure 6.18. Ben drew a jagged line to show the furry edges of his subject.

Appropriate Subjects

Students need visual references of their subjects such as objects (for example, a model dinosaur) or magazine photos. An appropriate subject is any object that is easy to recognize. Calendar photos of animals in a setting work well; crowded landscapes are more difficult. In the case of subjects that are strictly imaginary (for example, dragons), it may help to find photos of related subjects (see chapter 7).

Process (for initial drawing)

Encourage students to spend time on their initial drawings, because they will be re-using their images with a variety of media and techniques. Remind students to practise drawing in their sketchbooks. Have them try scribbled drawing, drawing geometric shapes, and blind contour drawing as quick warm-up exercises (see chapter 5).

When your students are ready, have them draw or trace their subjects on white paper. Remind them to pay special attention to the contours and surface textures (figure 6.18), and to avoid shading in the dark values.

Ask students to focus on one subject in their drawing. For example, have them draw only the owl and the branch it is sitting on, not the forest. They will draw in background elements separately.

On another piece of paper (and perhaps after more practice in their sketchbooks), students can draw parts of their backgrounds (figure 6.19). Use visual references. For example, look at the book, *Who Is the Beast?* Notice how the different leaves and flowers are shaped, contain interesting patterns, and how the leaves are attached to branches. Students may draw fewer "lollipop" trees after viewing these illustrations. Remind students to pay attention to edges, pattern, and texture, and to avoid shading in. If they are drawing an outdoor scene, they may draw particular pieces of the background – individual leaves or trees – rather than the whole forest.

pencil on paper, grade 3 student, Luxton School

Figure 6.19. A student practised drawing pieces for the background.

TIP Distribute glue after students have arranged most of their pieces. This will encourage them to give thought to the placement of each piece – re-arranging and overlapping the pieces – before they begin to glue them.

Process (for copying)

TOOLS & MATERIALS

- access to photocopier, window, opaque projector, light table, or overhead projector
- photocopy paper, 8½" x 11" (21.5 cm x 28 cm)
- scissors
- pencils
- glue or glue sticks
- felt pens (black, permanent, non-toxic, fine-tipped, e.g., Sharpie)
- pencil crayons

Make multiple copies of each finished drawing (figure 6.20), including some that are larger than and some that are smaller than the initial drawing.

As a class, look at the book, *If You're Not From the Prairie*. Encourage students to note the following:

- Elements of the pictures that are close up are larger and are positioned near the bottom of the page.

- Elements in the middle distance are slightly smaller and are higher up on the page.

- Elements that appear to be in the distance are much smaller and nearer to the horizon line, where the sky meets the ground.

Ask students what all of the preceding points suggest to them about where they should place their large, medium, and small cutouts on the page, in order to create an *illusion of depth* in their picture.

Look at the book *Who Is the Beast?* with your students. Notice how the tiger is hidden by the leaves (the *foreground* elements) and how some of the flowers and leaves are hidden behind the tiger (these are in the *background*). Encourage your students to overlap their cutout drawings in a similar way.

Students can begin cutting out their various copies. Remind them to save their original drawings and one or two photocopies for other projects. Encourage them to experiment with different arrangements of these pieces, beginning on small sheets of paper 8½" x 11" (21.5 cm x 28 cm). This small size of paper will seem crowded, but will encourage overlapping, and a much richer image will result.

Have students draw on or around the pasted pieces to complete the image.

The students' finished black-and-white images may be photocopied or photographed for use with other media (figure 6.21).

Additional Exercises

Here are some additional exercises students can do:

- Use multiple copies in an extreme way. Photocopy and cut out, or trace, a number of copies to use as border designs or to create crowds, flocks, forests, or cities.

- Make multiple images that can be used to develop images for any media or technique. The initial focus on drawing will help students develop a strong image that they can use with other media. Using cutouts allows for discussion of depth and perspective (see chapter 5).

- Cutouts allow students to easily integrate short sections of their stories or poems for use as illustrations. By using cutouts, students may only have to draw their main character once and re-draw the background, or draw one background and paste in drawings of different characters. It is easy to make multiple drawings to illustrate stories when photocopies are used. These

photocopies, Noni Brynjolson, age 11

Figure 6.20. Multiple copies can be made on a photocopier. The advantage of using a photocopier is that images can be enlarged or reduced to fit the size of the drawing. Multiple copies can also be made by tracing the image several times onto white paper or directly onto the good copy. For tracing, hold the paper against a bright window or on the glass of an overhead projector. By tracing the backside of an image, the subject can face in the opposite direction.

Rabbits, cut-and-pasted photocopies with watercolour, Noni Brynjolson, age 11

Figure 6.21. Elements of the picture (see figure 6. 20) are crowded together and overlapped. Even beginners will be able to understand the concepts of *in front of* and *behind*.

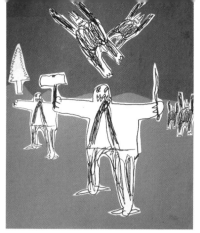
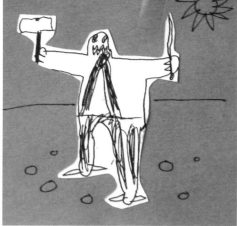

cut-and-pasted photocopies on coloured paper, 7-year-old student, Luxton School

Figure 6.23. The advantage of using a photocopier is that it makes it easy for students to illustrate a story. The student who drew these images used many photocopies of his scary character to produce one full-sized illustration. Other illustrations in his book may be quite small and simple — like the combination of photocopy and drawing on the right.

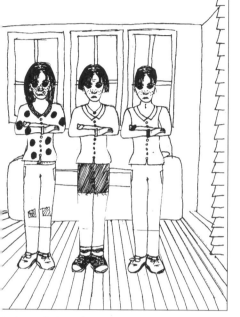

photocopies /cut and paste, Noni Brynjolson, age 11

Figure 6.22. These three characters were photocopied from the same original drawing. Noni cut or drew over the hair and clothing on the photocopies to create three different appearances.

VOCABULARY

chalk pastels	overlap
collage	pattern
compressed charcoal	perspective
contour	projector, opaque
contrast	projector, overhead
crosshatching	projector
cut and paste	shadow
depth	shape
drawing ink	smudge
hatching	surrealism
highlights	reflected light
juxtaposed	texture
light table	value
line	value chart
line qualities	vine charcoal
look-drawing	(see appendix B for definitions)
marks	

cut-and-paste illustrations can be photocopied (to look like one smooth piece of paper) and coloured or shaded with pencil crayon (figures 6.22 and 6.23).

- Teachers of young students can use multiple drawing cutouts for math (counting, number groups, addition), class stories with lots of characters, or a class mural (for example, "our trip to the zoo"). Enlarge drawings to 11" x 17" (28 cm x 43 cm), cut out, arrange, and paste on larger paper.

- Take a cutout of a subject, and place it in an unlikely setting. Some examples are a dog driving a taxi, a shark in the refrigerator, and an apple wearing a suit. Resulting images may be surprising, horrific, or humorous. You can find many juxtaposed drawings in magazine ads. Look at *Changes* or at paintings by René Magritte, a French surrealist artist, for other examples.

- Integrate photo montage, using student photographs, magazine photos, or calendar images. The use of selected pieces of photos glued into the picture can add interest. See the book *8 O'Cluck* for an example of this collage technique, or *The Wolves in the Walls* and *Knuffle Bunny* for examples of how photographs may be combined with drawing.

- With good-quality paper and permanent pens, students can use watercolour techniques on their original drawings. To preserve a copy of the original drawing in case of a painting disaster, make sure the drawing has been photocopied first. Trace additional copies onto watercolour paper. Adhere the papers to a light table or window for easy viewing (see chapter 14).

- Make several copies of students' finished works. Students can use these copies to experiment with a variety of the art techniques and approaches described in other chapters. Since students will have invested a great deal of effort into the initial drawings, it makes sense that they get maximum use out of their works. The photocopies will also give students a way to see how different the same image can look when different treatments are applied. For examples of this, look at *Walking Woman*, a series of paintings by Canadian painter Michael Snow. Students could also research how a subject (such as a portrait) is handled by different artists, or look at how illustrations for the same fairy tale look very different with different illustrators.

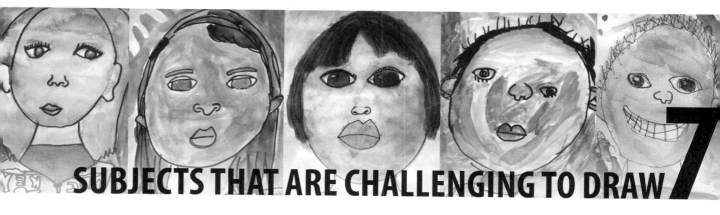

SUBJECTS THAT ARE CHALLENGING TO DRAW 7

INTRODUCTION

Students may find that some subjects, such as people and portraits, are difficult to draw. (Portraits and figure drawings are dealt with in some detail in this chapter.) For anyone learning to draw, part of the challenge is putting aside what a subject is assumed to look like, and drawing the visual information as it actually appears.

Drawing imaginary creatures presents a different kind of challenge. Instead of simply recording visual information, the artist composes an image of imagined or partially remembered fragments, reassembling a new creature. Because there are no eyewitnesses to these creatures, there is no right or wrong way to represent such creations. Yet, to make the creations convincing, the artist must borrow from experiences in drawing a variety of animals, people, and objects. Alternatively, the artist can use visual references from a variety of sources and combine them into a single image.

Other subjects that may be challenging are familiar subjects in odd poses or seen from new angles, subjects that are grouped, subjects with many detailed and overlapping parts, and subjects without a clear geometric structure, such as irregular folds in fabric.

Strategies for drawing challenging subjects include the following:

- Look for underlying geometric shapes. A complicated subject is much easier to draw if you see it, for example, as a stack of rectangles or connected ovals (see Figure Drawing, page 109).

- Check for negative spaces. The shapes of negative spaces (the spaces around the subject, such as the space between the arm and the side of the body) will provide clues about the placement of parts of your subject.

- Rotate the image (and your paper) if you are working from a photograph. If you view the image upside down, or from an angle, you are less likely to "read" the image quickly, and more likely to see the subject as composed of shapes, lines, and values.

- Sight the angles. To check the angle, or tilt, of part of your subject, hold your pencil in the air, and tilt it until it is parallel to the line you are trying to draw. Now, transfer this angle to your paper.

Self-portrait, pencil crayon on paper, grade 6 student, Matheson Island School

Figure 7.1. The student who drew this self-portrait used an extreme facial expression, then added background and costume to his self-portrait, to illiustrate a scene from a survival story.

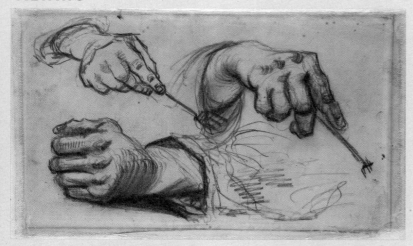

Vincent van Gogh. *Three Hands Two Holding Forks*, 1885.

Figure 7.2. In this sketch, van Gogh has practised drawing the hand, a notoriously difficult drawing subject. Van Gogh did not begin to make art until he was in his late twenties. Many of his early drawings demonstrate the lessons he learned at the Royal Academy of Art, with attention paid to anatomy, geometry, and miniscule details. In this drawing, one can see the many lines that the artist made in attempting to capture the expressive gestures of hands. Drawing is the most basic element of art-making. It is used by many artists regardless of the medium they use for their final work; for example, paint, sculpture, installation, video, textiles, and performance.

- Measure part of your subject, and check proportion (relative sizes of each piece). Hold your pencil at arm's length. With one eye, line up the eraser end of your pencil with one edge of your subject. Place your thumb where the portion ends. Transfer this measurement to your drawing, or use this method to compare the relative sizes of two parts of your drawing. This method is more easily done with photographs, where you can actually measure with a ruler. For an example of how to use proportion in drawing, see Portrait Drawing, below.

- Use a grid. For challenging subjects or large drawings, artists may use a grid, or technology such as a projector, to assist with accurate drawing (see chapter 5).

- Practise drawing your subject several times. Use each of the methods described in chapter 5 to sketch different aspects of your subject (shape, line, value, and so on). Draw several studies of your subject from a variety of angles. Isolate specific details, and draw them separately. An artist may draw 30 versions of a subject before feeling confident with the results, just as a photographer may take 100 photographs before finding the perfect shot.

- Re-draw before you erase. If you are unhappy with part of your drawing, decide which particular part is not working. If you erase the entire drawing and start over, you are likely to make the same mistake again. For a cleaner "good copy," place a second paper over your drawing, and trace the parts of your drawing that you are satisfied with.

- Take advantage of "mistakes." Erasure marks, multiple lines, inaccurate proportions, and irregular lines can all provide visual interest and add an expressive quality to a drawing. Turn smudges or splatters into part of the drawing. Transform them into shadows, objects, or interesting abstract shapes.

- Look at drawings by a variety of artists to see how they handled a particular subject. Play with a variety of approaches.

- Be patient with yourself. It takes time to develop new skills.

IMAGES TO HAVE HANDY

ART IMAGES

Self-portraits by Vincent van Gogh, late 1800s.

Self-portrait. Picasso. France, 1987.

Self-portrait With Masks. James Ensor. Belgium, 1899.

Self-portraits by Frida Kahlo. Mexico, circa 1940.

Photographs by Annie Leibowitz. American, contemporary.

Portraits by Chuck Close. American, contemporary.

Shepard Fairey's poster-art images. American, contemporary.

TIP To draw a fold of skin for an eyelid, shade slightly above the line, and use an eraser to "soften" each end of the pencil mark.

PORTRAIT DRAWING

Portrait drawing involves learning to accurately represent facial features (eyes, nose, mouth, ears, hair), drawing the nuances of expression and personality, and combining all these elements in correct proportion.

Drawing people can be a challenge. At a very young age, children begin to draw rough circles with dots for eyes and a line for a mouth. Later, children may add lines for arms and legs, a dot for a belly button, and/or marks for fingers and

toes. As children get older, the marks take on closer approximations to life (for example, they may draw a triangle for a nose, oval eyes, and a longer torso). Still, the marks remain symbols rather than records of visual information. To progress beyond symbolic drawing, encourage students to look carefully at their own faces in the mirror or at a friend's face. Remind students to observe and record what they see, not what they assume a face looks like.

TOOLS & MATERIALS

- sketchbooks
- pencils, crayons, oil pastels
- erasers
- visual references
- masking tape or glue
- scissors
- pocket mirrors, ideally 6" to 8" square (15 cm to 20 cm square), with plastic edges, self-standing, one per student
- white paper (photocopy paper, or Dessin or Mayfair drawing paper, 8½" x 11" or 11" x 17" (21.5 cm x 28 cm or 28 cm x 43 cm)
- optional: see Additional Exercises (page 107)

Preparation

Collect a mirror for each student in the class — a plastic locker mirror is ideal. Apply masking tape over any sharp or cracked edges on the mirrors. Find picture books, art images, or magazine photos with close-up faces that portray a range of expressions — the more extreme the expression, the better. Collect artists' portraits in a PowerPoint presentation, or from posters, books, or art postcards.

Try the drawing exercises (below) yourself first, so that you are comfortable demonstrating the techniques to your students.

Process

Distribute a pocket mirror to each student (figures 7.3 and 7.4). Have students examine their own faces in the mirrors, then have them practise drawing parts

BOOKS TO HAVE HANDY

PICTURE BOOKS

Best Friends, written and illustrated by Steven Kellogg.

The Magic Paintbrush, written and illustrated by Robin Muller.

The Essential Calvin and Hobbes, written and illustrated by Bill Watterson.

TEACHER REFERENCES

New Drawing on the Right Side of the Brain by Betty Edwards.

TIP For students who are shy about making faces in a mirror, give them extra space away from other students (some may even prefer to face a wall). This exercise may help students build positive self-images by making them aware that every face is different, and that each has individuality. Depending on classroom dynamics, it may not be appropriate to have students draw each other. It may also be difficult to get some students to sit still long enough to be drawn.

TIP Shade areas of the face by making gentle, repeated pencil marks, or by softening dark lines with an eraser or blending stub.

Self-portrait, ink and soft pastel, pencil on paper, Robert Shindruk, grades 5–8 class, San Antonio School

Figure 7.3. (left) Robert drew the contours of his face carefully, then shaded in some of the darker values of the folds in his sweatshirt.

Figure 7.4. (right) This student has propped up a large mirror in order to see the contours of his face.

Figure 7.5. Eyes drawn by grades 5–8 students at San Antonio School

Figure 7.6. Noses drawn by grades 5–8 students at San Antonio School

Figure 7.7. Mouths drawn by grades 5–8 students at San Antonio School

of their own faces – eyes, noses, mouths, ears, hair – with varying expressions, in their sketchbooks (figures 7.5 to 7.9). This exercise may take up an entire class lesson, or you may want to use short (10–15 minute) sessions for each part of the face. To have some fun, introduce each part with blind contour drawing (see chapter 5).

Eyes

Have students look carefully at their own eyes, and discuss the general shapes they can identify. Although the eye is a sphere, like a Ping-Pong ball, the eyelids change the appearance of the parts of the eye that we can see. For example:

- The eye is shaped like the outline of a lemon or a football.
- The white parts of the eye appear to be triangular.
- The iris (the coloured part of the eye) is round.
- The pupil is a smaller circle in the centre of the iris.
- Eyelashes do not grow in straight lines, but dip in odd directions.
- Light reflections (dots or small rectangles) make the eyes look alive.

Students can practise drawing each shape separately: large and small circles, footballs ("a hill and a smile put together"), and swooshes. Students can then practise drawing circles inside footballs.

Next, encourage students to again look carefully at their own eyes in their mirrors and draw in details such as tear ducts and the folds of eyelids above the eyes. If students shade in the iris and pupil, remind them to leave the areas of light reflected on the surface of the eye or add these in with the tip of an eraser (figure 7.5).

Have students draw several eyes, each with a different expression; for example, wide-open eye, squinting eye, partly closed eye, smiling eye, angry eye.

Nose

Demonstrate that the lower part of a nose can be drawn with a letter *C*, followed by a small bowl shape and another, backwards, letter *C*. Contour lines should be drawn around the bottom of the nose only; in a front view, the bridge of the nose is represented by soft shading on either side, rather than by a definite line.

Students can look in their mirrors and compare this simplified shape with their own noses, and adjust their drawings (figure 7.6).

Have students draw a nose that is wrinkled, a nose on a face that is tilted slightly down, up, or turned to the side for a profile. Have students hold their mirrors straight in front of them and draw their own noses. Tell them not to hold the mirrors under their nostrils – this will produce very unflattering views!

Mouth

A mouth can dramatically change shape with different facial expressions. A basic mouth shape might be an almost straight line that dips a bit in the middle. Add a volcano shape for the top of the upper lip and a bowl shape for the bottom line of the lower lip.

Have students look in their mirrors to see where the lines of their own mouths dip or rise, and where there might be a bit of shadow above, below, or beside the line.

Students can draw several mouths – a closed mouth, an open mouth, a mouth with the tongue sticking out, a smiling mouth, a frowning mouth, and a mouth with teeth showing (figure 7.7). The line drawn for the opening of the mouth should be darker than the lines that indicate the edges of a colour change above the top lip and below the bottom lip.

Teeth are difficult to draw, because each tooth has its own definite size and shape. For students who want to draw teeth, have them count carefully how many teeth they can actually see when they smile in their mirrors.

Ears

Ears are a difficult study, because they have lots of overlapping lines (figure 7.8). Have each student draw a side view of a friend's ear. Students can soften the ends and edges of the overlapping lines with an eraser – a fold of skin is represented by a line that fades out gradually, or smudges a bit. When ears are viewed from the front, they stick out less than you would think, and they have a rectangular shape. An ear is about the same height as the distance between the eye and the nose.

Hair

Draw bunches of hair rather than single strands. Use pencil marks to indicate the length and direction the hair is growing. Draw dark values into the hair, then use the edge of an eraser to create highlights. Dark hair requires pencil marks placed close together. To show light reflecting on hair, make lighter marks that are spaced slightly farther apart (figure 7.9).

Observe the hairline. Notice how the hair springs up from or hangs down around or over the forehead. Look carefully at the individual hairs in eyebrows.

Proportion

Before putting all the parts of the face together, demonstrate the basic proportions for drawing a face (figure 7.10). The basic rules of proportion are as follows:

- Eyes are located halfway between the top of the head and the bottom of the chin (along the horizontal dotted line). This will look strange until the forehead and hair are indicated!

- Eyes are equal widths and are placed one eye-width apart. Measure this on your own face. You will find a width of one eye between your eyes.

- A nose is one eye-width long and, at the bottom, one eye-width wide.

- The upper lip is about half an eye-width down from the bottom of the nose, although this distance does vary from person to person.

- The mouth, with a relaxed expression, equals the width from the inside of the iris in one eye to the iris of the other eye.

- The chin is just over an eye-width high, although this distance does vary.

Figure 7.8. Ears drawn by Noni Brynjolson, age 11

Figure 7.9. Hair drawn by Noni Brynjolson, age 11

TIP Even black hair may have sunlight reflecting on one part of it to make it appear lighter. Faces will have shadowed areas. Look for shadows and areas of reflected light around folds in clothing. Use a blending stub and an eraser to help with shading and drawing highlights.

TIP An eye-width is a standard of measure for drawing the face in proportion. A nose is one eye-width wide, and one eye-width long. The mouth and edges of the face are aligned to the eyes (figure 7.10).

pencil on paper, Noni Brynjolson, age 11

Figure 7.10. An eye width is used to measure the placement and size of facial features.

- The edges of the face may be less than an eye-width from the eye, although this distance does vary.

- The height of the ears stretches vertically from approximately the eye to the mouth. The ears will appear lower if the head is tilted up; higher if the head is tilted down.

- The neck is about as wide as the head. Shoulders are far wider than the head.

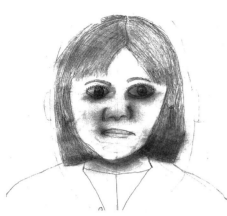

Self-portrait, pencil on paper, Ashley Smith, grades 5–8, San Antonio School

Figure 7.11. The five students who drew these self-portraits worked hard to reproduce the contours and some of the shading of their features. It is interesting to see how some students view themselves. These simple line drawings could be developed into more expressive or more finished portraits, which might reveal more about self-concept, interests, or state of mind. Remind students that large drawings allow for more accuracy and detail.

Self-portrait, pencil on paper, Vincent Bushie, age 16, San Antonio School

Self-portrait, pencil on paper, Ryan Johnson, grade 8, San Antonio School

Self-portrait, pencil on paper, Aldeana Wood, grades 5–8, San Antonio School

Self-portrait, pencil on paper, Kelvin Millen, grade 8, San Antonio School

Proportion can be a difficult exercise for students, particularly those who are very young. Here are a few methods for teaching proportion:

- Draw a number of large features (eyes, noses, mouths, and so on) with a colour medium such as crayons or oil pastels. Cut out the features, and arrange them on an oval shape that represents a face. Demonstrate placement that is too low, too high, too close together, and too far apart. Each time, ask students where they think the features should be placed.

Have students create their own facial features and place the pieces on oval shapes to create large, colourful faces. They can use glue or rolled-up tape to attach their pieces. Vary this exercise by having students create three-eyed monsters and aliens with several mouths.

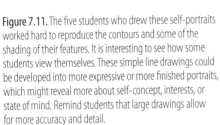

TIP An alternative method for marking the placement of features is to draw the oval and guidelines on a separate piece of paper and slide it under the drawing paper. Placed on a window or light table, the lines will show through the paper as guidelines.

- When students are ready to put all the parts of the face together, distribute large sheets of paper. Challenge them to come up with interesting and extreme facial expressions or expressions that communicate something about how they feel. Suggest that they start with very gentle pressure on their pencils so that they can erase lines easily. They can darken the lines later. Large portraits allow students to draw more accurately and with greater detail.

- Older students may be interested in trying to draw accurate proportion (figure 7.11). Have them do the following: (1) Draw a large oval. (2) Pressing very lightly with a pencil, draw one dotted line vertically down the centre and one horizontally through the middle of the oval. (3) Place the eyes, nose, and mouth on the face (use the dotted lines as guides to prevent the features from being crooked or out of place). (4) Erase the oval, and draw in a more accurate facial contour around the chin and jaw line. (5) Add some expression, as this type of straight-ahead-view drawing tends to look a bit stiff otherwise. (6) Erase the dotted lines.

Additional Exercises

Here are some additional exercises that students can do for building skills and exploring other forms of portrait drawing:

- Draw cartoons and/or caricatures (figure 7.13): Make the expressions of eyes, nose, and mouth very extreme, or exaggerated. Do this by drawing them ridiculously large or small. Put them together, breaking all the rules of proportion. Hair can be an expressive part of the face as well. Hair may indicate mood in a caricature. Some examples are morning hair, or hair standing up to indicate fright. Hair might also indicate personality; for example, coiled in a tight bun, tied with colourful scarves, or in a wild tangle.

- Look carefully at how other artists have drawn or painted self-portraits and portraits. How did the artists use or distort the rules of proportion? How did they make the portraits interesting to look at? Artists often draw attention to a subject's eyes by making the eyes darker, larger, or more shadowed than other features.

- Draw or paint large ovals, and add background colours. Now, cut out some of the features from practice drawings, and arrange these on the ovals to create interesting faces.

- Draw the face in profile, tilted, or from odd angles (figure 7.14).

- Create self-portraits that show something about who they are or what things are important to them. Students can bring

Frida Kahlo. *Self-Portrait with Cropped Hair.* 1940.

Figure 7.12. Self-portraits can say a lot — not just about what we look like, but also how we think of ourselves. In this self-portrait by Frida Kahlo, she has depicted herself as a man with short hair. She often painted herself in traditional Mexican dress. In this picture, however, she is wearing men's clothing. The painting was done after she divorced husband Diego Rivera (also an artist) for being unfaithful to her. Kahlo's hair is scattered over the floor, perhaps representing the remains of her former self. Students can be encouraged to connect their self-portraits with meaningful events in their lives, as Kahlo has done in *Self-Portrait with Cropped Hair.*

Mr. Hogg, pencil crayon on paper, Noni Brynjolson, age 11

Figure 7.13. Caricatures or cartoons tend to break with the rules of proportion. Small, widely spaced eyes, a low forehead, and a pig nose give this fellow a unique character.

pencil on paper, Danna Slessor-Cobb, age 10

Figure 7.14. When drawing a profile, it is important to notice the changed shape of the eye (almost triangular), the wide distance between the eye and ear, the wide distance between the ear and the back of the head, and the sloping line of the jaw between the chin and the neck.

Self-portrait, photocopy and pencil on paper, Roger Rheault, age 11, Treherne Elementary School

Figure 7.15. Roger learned how to add light and dark values to his self-portrait by drawing from a photocopy. Student photographs were photocopied, cut in half, and students were asked to shade in the missing half, paying attention to values.

favourite objects or images from home to draw or paste onto their self-portraits. They can draw themselves in a favourite place or provide viewers with some clues to what they are thinking or dreaming about. They may also cover the drawing with layers of tracing paper to partially disguise what the original looked like, and re-draw parts of the face.

- Create a three-dimensional sculpture, starting with a Styrofoam head (the kind used to display wigs or hats). Cut the top of the head, and insert pieces that show great ideas, inner thoughts, and emotions. Students may add wire, cloth, papier-mâché, or other sculpture media, found objects, text, and acrylic paint, to express their ideas (see chapter 18.)

- Use self-portraits as an introduction to making masks (see chapter 19).

- Alter the self-portraits into interesting characters for illustration. To do this, re-draw, trace, or photocopy selected parts of the drawings. Look at magazine photographs for specific features such as beards, wrinkles, hats, and mouths with missing teeth. Work from imagination or from photos of lizards, mammals, or birds to create a space alien, mythical being, or mutant. Students may want to disguise the characters with partial masks and create superheroes. Add interesting backgrounds, such as the inside of an alien spaceship or the deck of a pirate ship.

- More advanced students can work with vine charcoal and look at value. Value refers to the areas of reflected light and shadow in a drawing. Notice the areas

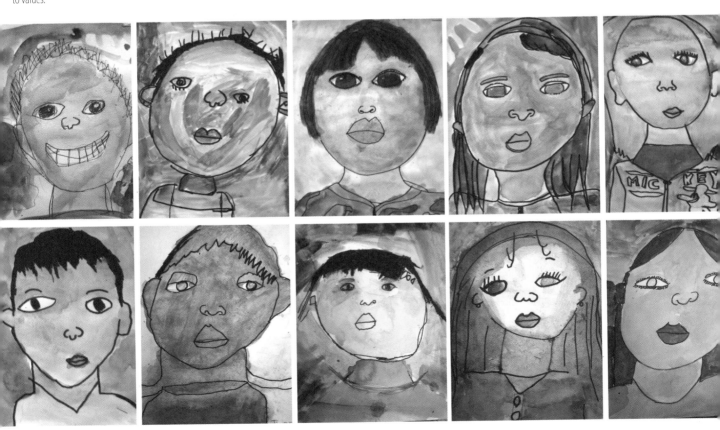

self-portraits by grades 2–3 students, Wellington School. Teacher: Rhian Brynjolson

Figure 7.16. Students began by practising to draw parts of their faces. Next, they drew their faces onto watercolour paper, which they outlined with a permanent pen. Last, they added a wash of watercolour paint.

VIEWING

Suzanne Valadon. *Toilette de deux enfant dans le jardin*. 1910.

Figure 7.17. The human figure is one of the most commonly represented subjects in art. Practising figure drawing combines the challenges of proportion, movement, expression, detail, and gesture. In this study by French artist Suzanne Valadon, several figures are represented. Valadon knew how to depict the body realistically, as she had modelled for other artists, including Renoir. This work includes figures drawn in several different poses. Valadon captured their actions very specifically to express a moment within a particular familial scene.

of light and dark values on a face. Black-and-white magazine photos, or any other photo with bright light and dark shadows, are the easiest subject for a value study. (See Value, chapter 5.) If students are drawing "from life," values will be difficult to see in diffused light. Turn off the overhead lights, and use sunlight or a single desk lamp to make reflected light and shadows more obvious (figure 7.15).

- Make portraits from a variety of media, such as torn or cut paper collage, paint, or pastel (figure 7.16).

TIP Have self-conscious students pose for a short period right after recess, when they are still wearing their bulky, outdoor clothes.

TIP Remind students to hold their pencils loosely, near the eraser end, to get a more relaxed scribble. For variation, encourage students to hold charcoal pencils and washable markers the same way.

TIP Negative space drawing will help your students see the shapes of spaces between parts of their subjects. The best poses for this are ones that "contain" some space (hands on hips, legs apart, and so on).

FIGURE DRAWING

TOOLS & MATERIALS

- sketchbooks
- pencils, or colour media such as crayons, pencil crayons, or oil pastels
- erasers
- visual references
- rulers
- white photocopy paper, or Dessin or Mayfair, 8½" x 11" or 11" x 17" (21.5 cm x 28 cm or 28 cm x 43 cm)
- optional: see Additional Exercises (page 113)

pencil on paper, grade 1, Cranberry-Portage School

Figure 7.18. These two drawings were made the day before the lesson on figure drawing.

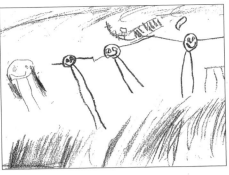

Figure drawing, or life drawing, means drawing people. People are a common drawing subject, and learning to draw figures can help boost students' confidence in their drawing abilities (figure 7.18). Figure drawing is helpful for studying movement, expression, and gesture, which are important aspects of visual communication.

Artists and illustrators commonly study figure drawing from nude models. They may use photographs or movable wooden figurines to model active poses. Artists may also study anatomy, so that they can represent skeletal and muscular structures accurately. In a classroom setting, students can begin figure drawing by looking at photographs of athletes, dancers, or other children in motion, or they can take turns posing for each other.

Figure drawing combines the challenges of proportion, movement, expression, and detail. This approach to drawing human figures can also be used for drawing animals (see chapter 5).

Preparation

Figure drawing does not require much preparation. Assemble the tools and materials, and try the exercises yourself first so that you can demonstrate them comfortably. Figure drawing can be taught as a series of short lessons: scribbled or gesture drawing, shape drawing, proportion, blind contour drawing, and lengthier combined drawings.

Figure 7.19. Artists and illustrators use movable models similar to this one when they sketch figures in motion.

Appropriate Subjects

Action photos of athletes from sports magazines or websites are good subjects for practising figure drawing. The poses tend to be active, with figures running, falling, jumping, and so on (see Books to Have Handy, page 109). Dance images, playground photographs, and children's picture books are useful as well. Students may also pose for each other, or use a movable figurine or doll (figure 7.19).

Process

Students can use scribbled drawing (see page 68) to reproduce the shape of their model. This kind of scribbled drawing – capturing active poses that suggest movement and expression – is called *gesture drawing*. Look at *Amazing Grace* or at Marvel comics with your students. An active pose makes an illustration more interesting and communicates the action in the story.

Older or more advanced students may want to try negative space drawing, by scribbling in all the shapes around and between parts of the subject (figure 7.20).

Keep the initial drawing time short – 60 seconds or so for each pose – and encourage gymnastic poses (see scribbled drawing, page 68). If students pose for

crayon on paper, Noni Brynjolson, age 11

Figure 7.20. Noni scribbled in the negative spaces surrounding the figure, for a reverse image. Advanced students can try this exercise.

each other, be sensitive to student bullying about clothing or body image. (One teacher I know has students pose in their bulky winter clothes to avoid embarrassment.)

The most basic approach to drawing the shape of a subject is to look for the geometric shapes contained in it. Ask your students if they can see circles, ovals, or rectangles in the figure. Ask them about the shapes of the head, torso (upper body), arms, legs, and so on. Students can start with quick drawings – geometric and simplified versions of their models in their sketchbooks (figures 7.21, 7.22, and 7.23).

Advanced or older students might be more comfortable defining these shapes as volumes – solid spheres, cylinders, rectangular prisms, or cubes. Three-dimensional volumes more properly describe the structure of the body, and may be useful when drawing difficult poses, such as a foreshortened arm (reaching toward the viewer.)

Students can also do blind contour drawings of the human figure. Encourage students to notice things such as facial features, fingers, feet, and the wrinkled edges in clothing. Allow five minutes or more for students who are experienced. Their results, if recognizable as human figures, may take on the qualities of caricatures or aliens (figure 7.24).

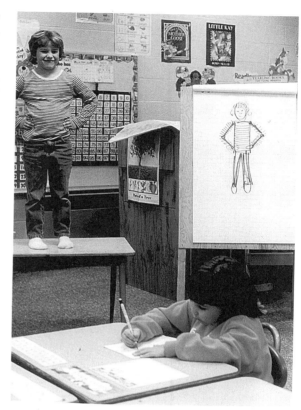

grades 1–2 class, Cranberry-Portage School

Figure 7.22. The students in this class had fun posing for each other. Working with an older group, later in the year, the same class tried some of the extreme poses and contortions of Olympic athletes.

crayon on paper, Noni Brynjolson, age 11

Figure 7.21. Complicated shapes such as hands and feet are easier to draw as geometric shapes.

pencil on paper, grade 1, Cranberry-Portage School

Figure 7.23. These drawings were done by two students after they received instruction on how to draw people. Their earlier drawing styles (figure 7.18) were the result of lack of instruction rather than a lack of developmental readiness.

My Dad, pencil on paper, Noni Brynjolson, age 11

Figure 7.24. Blind contour drawing produces a quirky, expressive result. Be prepared for lots of giggling when students look at their finished drawings.

TIP Think of arms and legs as long rectangles with circular joints. Think of the head as an oval and the shoulders and "trunk" of the body as rectangular. Hands can be tricky to draw – try to see them as squares with rectangular fingers and with the rectangle of the thumb attached to the side of the square (figure 7.21).

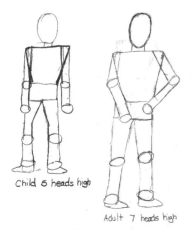

Danna Slessor-Cobb, age 10

Figure 7.25. These geometric drawings show the proportions of the human figure. Adults are about seven heads high. Children's heads are larger than adults' heads, relative to the size of their bodies. Arms should be drawn long enough so that fingertips reach halfway between the hip and the knee.

crayon on paper, Noni Brynjolson, age 11

Figure 7.26. The drawings indicate how using geometric shapes can help students learn to draw figures in action.

Basic Proportions of the Figure

Introduce your students to the basic proportions of the human body (figures 7.25 and 7.26). To demonstrate, invite a student volunteer to stand at the front of the classroom:

- Measure how many times the height of the student's head fits into the length of his or her body from top to toe. This measurement varies with age: young children may be only 4½ heads tall; adults are approximately 7 to 7½ heads tall. Superheroes are drawn with noticeably smaller heads, which makes their shoulders appear larger.

- Arms are longer than you might think they are. Fingertips reach down to a point between the hips and the knees.

- Hands and feet are longer than most expect them to be. A hand, for example, can stretch from chin to eyebrow.

- Legs are long. The mid-way point of the body is near the hips. Look at the shape of the space between the arms and the body – the space is very narrow, and there are places where the arms touch the body.

- Look at a side view. Notice how an arm hangs in front of the body from this view. Notice how the top of the shoulder forms an upside-down U.

In their sketchbooks, have students make a quick sketch of a classmate or of a figure from a magazine photograph. Remind students to pay attention to the

basic rules of proportion. Challenge students to find interesting poses for their models. Students may also try interesting views, including close-up, distant, side, front, back, and top.

Students are now ready to begin their figure drawings on larger paper. Encourage them to continue with a relaxed, almost scribbled line. A looser, scribbled line conveys action and is interesting to view. For a combination of approaches, draw the underlying geometric shapes first, to judge proportion and pose, and then add contour lines on top for interesting line quality and detail. Students may then add the texture and pattern of clothing, and the values of reflected light and shadows (figure 7.27). (See chapter 5.)

Additional Exercises

Here are additional exercises students can do to practise and extend figure drawing:

- Draw one another in costume, wearing masks, or in wrappings that disguise part of the face or body (figure 7.28).

- Make "celebrity" drawings of guest teachers, principals, visitors, or classmates on their birthdays. Visit a dance troupe in rehearsal, or a basketball game, to practise gesture drawing.

- Use similar drawing approaches (see above) for drawing live animals. Observe the classroom hamster, or take a field trip to a zoo or marina.

- Make drawings from videos of dancers, athletes, or children playing (figure 7.29).

- Finish figure drawings with pen and ink, with permanent pens and a watercolour wash, or by reassembling several overlapping cut-out images onto coloured sheets of paper (figure 7.30).

- When using figure drawings as illustrations, choose poses and costumes that fit the action in the story, or that express something about the character (figure 7.30).

- Use drama techniques or games to copy a pose in a painting or an illustration; there is a kinesthetic understanding that communicates meaning about how the character's body feels in that situation.

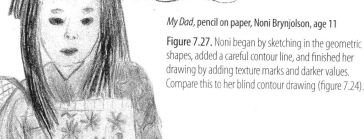

My Dad, pencil on paper, Noni Brynjolson, age 11

Figure 7.27. Noni began by sketching in the geometric shapes, added a careful contour line, and finished her drawing by adding texture marks and darker values. Compare this to her blind contour drawing (figure 7.24).

Samurai, pencil crayon on paper, Jessica Howison, grade 6, Luxton School

Figure 7.28. The Samurai warrior provided an interesting study of a figure in costume.

pencil on paper, Sherman Baptiste, age 15, Wanipigow School

Figure 7.29. Learning to draw realistic figures — with accurate muscle structure and with darker values shaded in to produce a 3-D effect — is important to students like Sherman who want to draw superheroes.

Figure Skating, pencil and watercolour on paper, Noni Brynjolson, grade 6, Luxton School

Figure 7.30. The winter Olympics provided plenty of opportunities to study figures in action.

BOOKS TO HAVE HANDY

PICTURE BOOKS

Dragonology: The Complete Book of Dragons by Ernest Drake, illustrated by Wayne Anderson, Douglas Carrel, and Helen Ward.

Monsterology: The Complete Book of Monstrous Beasts by Ernest Drake, illustrated by Douglas Carrel, Nicholas Lenn, and Helen Ward.

Saint Francis, written and illustrated by Brian Wildsmith.

Where the Wild Things Are, written and illustrated by Maurice Sendak.

COMPOSITE CREATURES DRAWING

TOOLS & MATERIALS

- pencils
- sketchbooks
- erasers
- visual references
- white photocopy paper, or Dessin or Mayfair, 11" x 17" (28 cm x 43 cm)
- felt pens (black, very fine-tipped, non-toxic, such as Sharpie brand.) Other media may be used to finish the drawings (see Part 4).
- optional: see Additional Exercises (page 117)

Drawing composite creatures provides students with a method for combining observational drawing with fantasy or imagined subjects.

Many students spend hours copying comics, cartoons, and sports logos. By copying a well-drawn figure such as Batman over and over in a variety of poses, students can learn a lot about drawing anatomy, figures in action, foreshortening, and the conventions of comic-book art. To supplement this activity — and to gently nudge students into creating their own characters and scenarios — have students use the same creative process as other artists and writers: Take pieces of familiar subjects, and mix them with imagination.

Appropriate Subjects

Students can research a topic that involves some kind of mythical or imaginary creature (figure 7.31). Appropriate subjects might include dragons, creatures from ancient myths and fairy tales, space aliens, mutants, "wild things," wizards, hobbits, imaginative artworks (such as work by Inuit sculptor Manasie Akpaliapik), or transformations. Subjects will depend on your students' interests and your current topic of study.

Preparation

Gather visual references that relate to the description of the creature. To create dragons, for example, you will need photos of animals with wings (bats, birds, insects), claws or talons (lizards, eagles), scales (fish, lizards) or feathers (birds), long bodies (snakes, lizards, alligators), long tails (snakes), and so on.

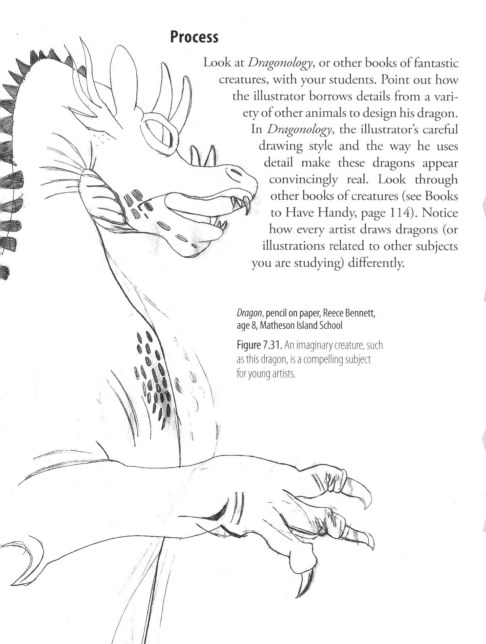

Process

Look at *Dragonology*, or other books of fantastic creatures, with your students. Point out how the illustrator borrows details from a variety of other animals to design his dragon. In *Dragonology*, the illustrator's careful drawing style and the way he uses detail make these dragons appear convincingly real. Look through other books of creatures (see Books to Have Handy, page 114). Notice how every artist draws dragons (or illustrations related to other subjects you are studying) differently.

Dragon, pencil on paper, Reece Bennett, age 8, Matheson Island School

Figure 7.31. An imaginary creature, such as this dragon, is a compelling subject for young artists.

TIP Some students may have the patience to draw a quick study of their creature in their sketchbooks and re-draw a "good copy" onto a larger sheet of paper. Younger students may want to work directly on their good copies.

TIP Some students rush to draw an entire creature. To slow them down, ask them to sketch a required number of eyes, claws, bodies, and so on, before continuing. Advanced students may have strong visual memories, and may insist on designing their creatures by assembling, from memory, pieces of drawings they have done before. Be tactful of their efforts, and suggest that they look for two or three parts of their creature that they may improve by drawing from a visual reference.

TIP Because most students are exposed to creatures regularly seen on television and video, you may have to (gently) insist that the creatures be the students' own designs; that is, no ready-made characters such as Batman, Superman, Transformer, SpongeBob, Goku, Wolverine, or Shrek. Explain that copyright laws protect those designs from being copied by others. Students may want to draw the copyright symbol © to protect their own work.

Challenge students to design their own creatures. Have them draw details from a variety of animals in their sketchbooks – different kinds of eyes, wing shapes, animal feet, claws, and so on. Encourage students to collect pictures of body parts of animals. However, tell them that they are not to combine the parts into a creature until they have collected several possible options. For tips on how to draw the body parts, see chapter 5. Remind students to pay careful attention to contours, textures, and patterns in their sketches (figure 7.32).

After students have drawn a number of detailed animal parts in their sketchbooks, they are ready to design composite creatures on large sheets of paper. Ask students to work carefully – light pressure with pencil marks results in lighter lines that are easier to erase. Encourage students to draw their creatures large enough to fill the page. To fit a long creature onto the page, the neck or tail may have to bend or loop around. A bendable toy animal may be a useful prop to demonstrate this idea. Students could also make a model of their creature with modelling clay and experiment with different poses before starting their finished drawings.

Point out the different pen marks used by the illustrators of *Where the Wild Things Are* and *Saint Francis*. Then, have students trace over their pencil drawings with fine-tipped, black, felt pens. Students may want to experiment with various pen marks before they outline their good copies. As a shortcut, drawings may be photocopied rather than inked, which will provide a similar black line if the original pencil line is dark enough (see chapter 6).

Darcy, age 10, Wanipigow School

Figure 7.32. The jagged contour lines and repeated pencil marks indicate the furry and feathered textures of these animals.

Composite Creatures, pencil on paper, Gilbert, Jamie, Jocelyn, and Harley, age 10, Wanipigow School

Figure 7.33. After students designed these fantastic creatures, they were asked to describe them and use them as characters in a story.

Chinchilkoalabirdmouse, ink and pencil crayon, Noni Brynjolson, age 11

Figure 7.34. This is a finished composite creature, outlined with a fine-tipped felt pen and coloured with pencil crayon. The name of this piece is fun, too!

Additional Exercises

Here are additional exercises students can do to practise drawing composites:

- Use the creatures they created as characters in a story (figure 7.33). (See chapter 6.) Consider what environment, food, and character traits might best suit the composite creatures that have been created.

- Use coloured pencils to add colour to drawings (figure 7.34). Before starting, make sure pencils are sharp. Press lightly and blend colours; the drawing will be more interesting if the colours are richer. For example, green can be varied by adding yellow, blue, or brown. Instead of using black, use dark blue, brown, or purple for shading. Press slightly harder next to the outside contour lines, as darker edges next to the ink lines make the subject appear more three-dimensional. Place a piece of window screen, plastic mesh bag, or other flat, fine texture under the paper when colouring, to provide a pattern resembling scales (see chapter 11).

Wraith, Chris Bushie, grades 7–8, Wanipigow School

Figure 7.35. The close-up of this nightmarish creature was drawn with attention to texture marks and light and dark values.

Wild Things, paint, ink, and collage, Edward, age 5,
Pine Dock School

Figure 7.36. Edward drew these creatures with a fine-tipped, permanent, felt pen and painted them with tempera paint. He then cut out the creatures and glued them onto a drawn and painted background.

- Advanced students can draw their creatures in action, or from various viewpoints. Decide how the creature will be posed – flying, sleeping, walking – and if the view is close up, distant, from above, from the side, frontal, or facing backwards (figure 7.35). A three-dimensional model provides a useful prop for this exercise. Use a toy with a related shape that can be turned over and viewed from different angles. For example, a toy dinosaur from the back may give clues about drawing a dragon from the back. Students may also sculpt a figure from modelling clay that will bend in a variety of poses.

- Young students can make crayon- or pastel-resist pictures of their creatures. Have them draw their creature with wax crayon or oil pastel, making sure to press hard. The patterns or textures of the creatures can be emphasized by placing a textured surface under the paper, such as pegboard or Lego flats. Paint over the drawings with watery tempera paint (figure 7.36).

- Students can use recycled materials or other sculpture media (figure 7.37), such as papier-mâché (see chapter 19), to construct fantastic creatures.

VOCABULARY

anatomy	parts of the eye: iris, pupil
background	
blind contour	portrait
caricature	pose
composite	profile
contour	proportion
creature	self-portrait
expression	shape
figure drawing	sight an angle
gesture	texture
grid	value
line	volume
look-drawing	width
overlap	(see appendix B for definitions)
parts of the body: torso	

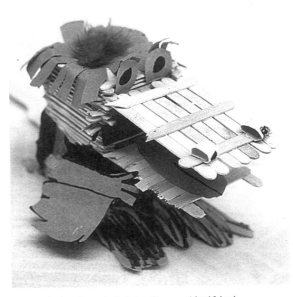

Mascot, mixed media, grades 5–8 class, Stevenson Island School

Figure 7.37. This creature was constructed from materials that were handy – Popsicle sticks, construction paper, and feathers.

Briony Haig

AN ART PROGRAM THAT MEETS STUDENTS' NEEDS

from an interview with Briony Haig

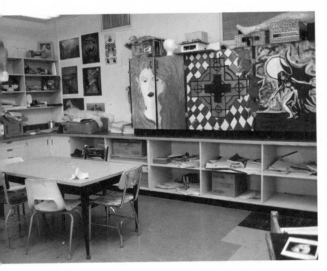
Students have had a hand in designing their art space at Elmwood High School.

Written assignments help to keep a diverse group of students on task and provide a range of options for individual projects.

Briony Haig manages an art program for a diverse population of students who have a range of needs and interests. Inclusive teaching can be challenging, but Briony has developed some strategies that work for her and her students.

Student sketchbooks are a required part of the art program. The sketchbooks are marked on the time and the effort students invest in drawing and writing in them. Students draw whatever subjects interest them. Briony notes that students' drawing often improves simply as a result of spending time drawing in their sketchbooks. Students can work out their visual ideas on a small scale before trying them out on a large project.

Over the years, Briony has collected an image bank filled with hundreds of calendar photos, posters, and photographs. She has organized the images by topic for easy reference. The most popular image categories are people, animals, landscapes, and cars.

Internet access is also an important tool, because it enables students to find visual references quickly and independently. Students often go online to look for specific images they can draw or print and incorporate into their own work.

Briony hands out written instructions for assignments, even though she knows that many of her students do not read them. She says that the written lesson plans and assignments are a way for her to keep her teaching organized and focused. Written assignments are useful for students who (a) have fallen behind and need to catch up, or (b) have completed their class work and are ready to move forward to the next project. The assignments are also helpful when she is sharing ideas with colleagues or communicating the expectations for an assignment to parents.

Flexibility with subject matter and criteria is important in a diverse classroom. Students may request or require adaptations to an assignment, and Briony is willing to consider her students' needs and their innovative ideas. Criteria

for an assignment may be adjusted for an individual student. Students may want to start small, with familiar subjects, tools, or techniques – such as copying cartoon images into their sketchbooks – before gaining the confidence needed to work on larger projects.

Providing source materials and issues of interest to students is an important part of a successful art program. Art is not just about tools and techniques; art is also about ideas. Briony has incorporated First Nations artists into her course outline to make her program more representational of her student population. These artists may serve as positive role models, and they also deal with issues of importance to her students: identity, cross-cultural conflicts, and connecting people and the environment.

Briony is open to topics that are of interest to her students. This means she is willing to accept their interpretations of assignments. For example, one student of Briony's used cars as the topic of all of his art assignments!

Briony is wary of discussing a student's work in front of a group. She realizes there may be bullying dynamics in the classroom that she is not aware of or sensitive to. In addition, some students may lack confidence to speak in front of a group or discuss the highly personal content of their artwork. For these reasons, she prefers to hold individual conferences. In these conferences, she is able to listen carefully to each student, respond thoughtfully to the student's ideas, and exercise tact with her suggestions.

Briony believes it is important to balance drawing instruction and non-representational approaches to making art. She gives some drawing instruction and requires students to regularly practise drawing still lifes (collections of objects arranged for their visual interest). However, Briony understands that drawing is not the only way to communicate ideas visually. She encourages students to use colour relationships, incorporate text, explore media, and experiment with more abstract image-making. Briony has had success with project work based on artists such as Jane Ash-Poitras, whose multimedia work combines abstract painting and photography.

Experienced artists, as well as beginners, need time to explore materials and tools. Just as professional artists spend time learning new techniques and mastering the properties of a new media, students need time to experiment – with different thicknesses of paint, new collage materials, and combining media in new ways. ("See what you can make with this.")

Originality is a requirement in art projects. Although Briony encourages students to study works by other artists and make notes about the artists in their sketchbooks, she values the students' own thoughts and solutions in their project work.

Briony engages her students in creative projects. These sculptural heads were built with Styrofoam heads, wire, a skin of nylon painted with PVA, and then painted.

Briony's enthusiasm and the supportive environment she creates in her art studio encourage students to take risks and think creatively. One aspect of encouraging creativity is honouring a variety of approaches.

Briony Haig is an art teacher at Elmwood High School.

Rhian Brynjolson, *Inside Out*,
acrylic latex on canvas, 26" x 30"

COMPOSITION, ILLUSTRATION, AND GRAPHIC DESIGN

Visual art is a rich visual language of communication. In Part 3, you will introduce your students to the "grammar" of art – the organizing principles and design choices that artists, illustrators, and designers make when they compose interesting images.

Composition refers to the way elements of an artwork are organized. In chapter 8, students will explore the principles of design and learn how they can use these principles to add meaning and visual interest to their artwork.

Illustration is the art of creating a visual narrative (telling a story through images). In chapter 9, you will show students how to combine words and images and how to use storyboards and illustration as part of the writing process. In the classroom, illustration can provide an important bridge to literacy. Students may become interested in books and in reading by looking at engaging picture books. Students can also adapt storyboards to fit other art projects such as video projects, theatre sets, and documentation panels.

Creating narratives in pictures is important for young students and visual learners as a pre-writing exercise. Students can then look at their pictures and describe what they see. Even reluctant writers enjoy producing stories when they are given opportunities to work with art materials and make their own books – they feel like "real" authors and illustrators.

Graphic design and illustration are closely related. However, in graphic design the emphasis is on commercial arts, including advertising, magazine pages, book covers, page layouts, posters, and websites. It includes practical applications of design principles in specific areas, such as fashion, interior design, landscape design, and product design. Graphic design is the foundation for

students interested in pursuing careers related to art and design. In chapter 10, you will show students how to look critically at advertisements and become educated consumers of commercial art. Students will also create their own graphic design projects.

COMPOSITION 8

INTRODUCTION

Good artwork contains components that fit together to create both meaning and visual interest. Composition includes (a) communicating layers of meaning through the selection, placement, and relationship of parts of the artwork, and (b) making the artwork aesthetically (through the viewing experience) pleasing, disturbing, or engaging. Artists, illustrators, and designers make choices about composition, consciously or unconsciously, based on principles of design. They are engaged in visual thinking.

In this chapter, the principles of design are applied to visual ideas as well as to interdisciplinary topics. Students studying design principles in artwork are developing thinking skills that may be applied throughout the arts and sciences.

To explore the principles of design with your students, look at quality examples in artworks, picture books (see Books to Have Handy, right), photographs, and commercial art and design. Notice how parts of the images fit together, and what choices the artists made about each element. The principles of design are a component of teaching visual literacy (see chapter 3).

Encourage students to explore the composition in their own artwork. The collage methods described in chapters 6 and 15 work very well for experimenting with composition. Collage allows students to place and re-arrange parts of their compositions for alternative effects.

THE PRINCIPLES OF DESIGN

The *principles of design*[1] are (1) balance (symmetrical and asymmetrical), (2) proportion (comparative sizes and scale), (3) movement and expression, (4) emphasis (dominance and subordination) and focal point, (5) contrast and variety, (6) unity and harmony, and (7) repetition (pattern and motif) and rhythm (figure 8.1 a–f).

1. The list of principles of design varies, depending on the source. This list is compiled to include principles of design from K–12 visual art curriculum documents in Manitoba, Ontario, British Columbia, and California.

BOOKS TO HAVE HANDY

PICTURE BOOKS

Changes, written and illustrated by Anthony Browne.

Effie by Beverley Allinson, illustrated by Barbara Reid.

Have You Seen Birds? by Joanne Oppenheim, illustrated by Barbara Reid.

Jumanji, written and illustrated by Chris Van Allsburg.

Piggybook, written and illustrated by Anthony Browne.

Strega Nona, written and illustrated by Tomie dePaola.

The Magic Fan, written and illustrated by Keith Baker.

The Magic Paintbrush, written and illustrated by Robin Muller.

The Mitten, written and illustrated by Jan Brett.

The New Baby Calf by Edith Newlin Chase, illustrated by Barbara Reid.

Simon and the Snowflakes, written and illustrated by Gilles Tibo.

Who Is the Beast?, written and illustrated by Keith Baker.

Window, written and illustrated by Jeannie Baker.

Would They Love a Lion?, written and illustrated by Kady MacDonald Denton.

Grumpy Bird, written and illustrated by Jeremy Tankard.

How the Animals Got Their Colors by Michael Rosen, illustrated by John Clementson.

I Spy series by Jean Marzollo, illustrated by Walter Wick.

Figure 8.1a. These quilt squares demonstrate *asymmetrical balance*. The left and right sides of this image are balanced, yet they are not an exact mirror image.

Figure 8.1b. Diagonal lines created by adjacent squares create a sense of flow or *movement*.

Figure 8.1c. Areas of *emphasis* are created where the dark squares appear to frame a small area of lighter value.

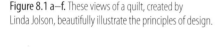

Figure 8.1d. There are many areas of *contrast* that create *variety* and visual interest. In this photo, the viewer can see the complex changes in colour relationships from one piece to the next.

Figure 8.1 a–f. These views of a quilt, created by Linda Jolson, beautifully illustrate the principles of design.

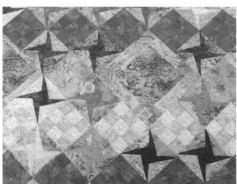

Figure 8.1e. The analogous blue and violet colours *harmonize* beautifully in this section. Some contrast is provided by the smaller, yellow-green squares. Overall *unity* is provided by pattern, background colour, and the use of one type and texture of fabric.

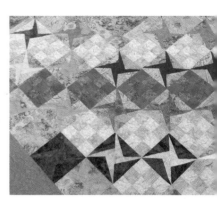

Figure 8.1f. *Repetition* and patterns are created by the shapes of alternating stars and checkerboards. The colours alternate as well, with a *variety* of hues, and light and dark values.

TOOLS & MATERIALS

- tangrams, geometric cutouts, or math blocks
- access to teeter-totter or balance beam
- computer software (Photo Booth or Photoshop)
- movable models and toys, simple machines, Lego, mobiles
- variety of lenses
- objects with texture

Balance

Like a teeter-totter, parts of an artwork work together to create formal balance. Each element in an image carries visual "weight," or impact, because our eyes are drawn to recognizable objects, faces, and bright colours. We also notice differences such as an isolated shape, we follow an implied line such as an arm pointing at an object or a row of dots, we discern a pattern. An artist arranges the subject matter and elements to create balance or imbalance ("tension") in several ways, including the following (figure 8.2):

- Symmetry: One part of an image is a mirror image of another. Approximate symmetry refers to forms that are almost identical on either side of a central axis. In *The Magic Fan*, for example, the shape of the illustration is the same from the left-hand page to the right, but the scene inside the fan is different.

- Asymmetry: Each side of the image is "different but equal." For example, the tiger's detailed face and bright pattern in *Who Is the Beast?* is balanced by the large, brightly coloured and patterned leaves and flowers. Here, a large shape is balanced with a small, isolated piece that "stands out" in another part of the image.

- Radial: The design moves outward from the centre in a spiral or wheel, creating a mandala. See *The Magic Paintbrush* on the page where "Nib" is escaping from the dungeon.

- Crystalline: Elements are placed in an overall pattern. In *How the Animals Got Their Colors*, the pieces are placed, more or less evenly, across some pages for a "wallpaper" effect.

cardboard sarcophagus, "Egypt Museum" project, grade 3 students, Wellington School

Figure 8.2. The pattern and symmetry of this sarcophagus was a whole art lesson in itself.

Students can experiment with balance (and imbalance) in a composition in the following ways:

- Create a three-dimensional sculpture that balances on a small base (see chapters 17 and 19). The physical understanding of balance can also be explored on the playground on a teeter-totter, on a balance beam, or when standing on one leg. The same sense of physical balance is present, in a more abstract way, in a two-dimensional artwork, or (more abstractly) as a concept when discussing ideas of fairness.

- Use tangrams, geometric cutouts, or math blocks to create abstract compositions, and discuss how balance or imbalance is achieved in each composition. Integrate with mathematics exercises to study symmetry.

- Experiment with Photo Booth software effects (Apple) or Photoshop software (Adobe) to explore symmetry.

Proportion

Proportion refers to the relative sizes and placements of parts of a composition. Proportion is also the relative size of one part of a specific subject compared to another. Proportion is important in accurate drawing if the artist is intending to faithfully represent recognizable subjects, such as human figures or portraits (see chapter 7). Interesting drawings can be made by purposefully distorting proportions. Proportion is important in larger artworks and in architecture where size and scale are designed to be the dominant visual experience (figures 8.3 and 8.4).

wooden models of community buildings made by grade 2 students, Wellington School. Teacher: Cathy Woods

Figure 8.4. Architecture is useful for studying proportion and symmetry. The left side of this church building is a mirror image of the right side.

stick puppet made from wooden sticks, modelling clay, fabric scraps, and found materials by elementary student. Teacher: Subbalakshmi Kailasanathan

Figure 8.3. The human body provides a good means for studying proportion and symmetry.

Students can experiment with proportion in a composition in the following ways:

- Exaggerate sizes and placement of parts of an image. Discuss how changing the relative sizes of various pieces alters the composition. View artworks where figures were scaled according to their perceived importance or social status. Discuss the relationship of this visual concept to social hierarchy. Alternatively, find examples of compositions where one idea is "blown out of proportion" (given more importance than facts allow).

- Integrate the study of design with mathematics: Study (1) the "golden ratio" of proportion for art and architecture, and (2) the Fibonacci sequence and spiral. These equations were said to provide ideal proportions and were explored by artists such as Leonardo da Vinci and Piet Mondrian. Use the Fibonacci sequence to simply indicate the numbers of subjects to use in a drawing, or use the Fibonacci spiral as a guide for proportion in composition.

- Study how artists, through the ages, have depicted the human form of the "ideal" man or woman, and how the ideal continues to change. Ideal proportions for the human body have varied over time and between cultures. Body image is an issue for many young people, as they compare themselves to unrealistic ideals portrayed in the media.

VIEWING

Bob Haverluck, *Sometimes the Heart Is Tuned to Sadness*. 2007.

Figure 8.5. In this piece, ink is used loosely and expressively. The artist has contrasted thick strokes with thin, scratchy lines in the background. The composition involves both positive space and negative space in the shape of a missing heart. The added touch of a blue sun sets a tone of sadness. This piece demonstrates the way that space, colour, and gesture can work together to convey emotion in a composition.

Movement and Expression

Movement may be clearly evident in video and kinetic art (moving sculpture). An illusion of movement in a still artwork is created with the repetition of elements, "active" lines (irregular, flowing, or jagged), soft or blurred edges, or the depiction of a subject in movement (a tilted object, an active gesture). Movement can be created by using "tension" or imbalance in an image. The viewer then imagines what happens next, and the movement is implied. A shape precariously balanced or placed on the edge of a cliff is an example of an illusion of movement.

The placement of elements can also move the viewer's eye on a path through the picture (elements placed in a spiral pattern, zigzag, curves, and so on). In *Simon and the Snowflakes*, the row of birds leads the eye across the page. In *The Magic Paintbrush* (the scene where "Nib" is brought before the king), the line along the boy's body and along his arm leads the eye inward toward the central figure.

Expression may be evident in a face or by gesture that communicates emotion. Emotion may also be expressed through active paint marks, in "expressionist" paintings, or with colours that affect the mood of an artwork. Artwork with active marks, or with clear indications of an artist's emotional state, are also said to be expressive.

Students can experiment with movement and expression in a composition in the following ways:

- Use gesture drawing, photography, and video to explore ways to depict moving objects and figures engaged in drama, dance, physical education, sports, and playground activities.

- Explore the mechanics of movement through kinetic (moving) sculpture, movable models and toys, simple machines, Lego sets, and mobiles. Integrate this principle of design with the science curriculum.

- Explore the connections between colour and expression. Look for examples of how artists use colour to create, or enhance, mood and atmosphere in artwork.

- Explore paint marks – active marks can create a sense of movement in an artwork. Experiment with ways of painting the movement of water, wind, or objects. Look at how Emily Carr painted trees to appear as if they were moving in the wind, the marks Claude Monet used to paint ripples in water, or the wind and storms painted by J.M.W. Turner.

Emphasis, Dominance, Subordination, and Focal Point

Emphasis means that one subject, area, or element in the image "stands out" for the viewer (figure 8.6). Emphasis is created with contrasting elements, directional lines (such as an arm pointing at a subject), or subject matter (such as a recognizable item that is eye-catching, emotional, or controversial).

A focal point is created when a particular area of the artwork is strongly emphasized. In *The Magic Paintbrush*, a natural focal point (the scene under the bridge) is created by the illuminated figures near the bottom of the page. A second focal point (the moon) is framed by the archway and pointed to by the crossbeams. Using an area of light to create a focal point in an otherwise dark image is a technique called *chiaroscuro*.

Dominance and subordination refer to areas of an artwork that receive more or less emphasis. Areas of bright colour, larger shapes, and thick, active lines, tend to appear dominant. The viewer tends to notice these areas first. Areas of cool, or reduced, colour (see chapter 11), smaller shapes, and thinner lines tend to be subordinate. The viewer usually notices these areas afterwards, because they appear to recede into the background of an image.

AN ELEMENTAL STRENGTH IN STONE.

The side of the main part of the church of the Nativity of our lady. Built in 1393, the church is one of the few original stone structures to survive repeated renovations of the Kremlin (Russian Government.)

pencil on paper, Alia Millen, grade 8, San Antonio School

Figure 8.6. In Alia's sketchbook drawing, the successive archways emphasize the focal point on the right side of the drawing. The repeated archways also provide motif.

Students can experiment with emphasis, dominance, subordination, and focal point in a composition in the following ways:

- Look at the I Spy series of books. In these books, the subjects are hidden, rather than emphasized. Observe how the artist can make objects "disappear" in a clutter of similar forms. Explain how non-examples can enrich our understanding; one idea (blending in) can help us understand an opposite idea (standing out).

- Experiment with ways to create emphasis in artwork. Select an area of an artwork, and change one element in it to create emphasis. Add a small amount of bright colour, darken a contour line, or shade an area surrounding the selected area so that it "stands out."

- Explore a variety of lenses, such as eyeglasses, projectors, magnifying glasses, binoculars, cameras, and telescopes. Discuss focus and how a clearly focused image is one that can be easily seen. This experience may help students understand the concepts of emphasis and focal point: The artist is organizing the elements in a way that helps our eyes focus on one area of the image.

- Discuss the concepts of dominance and subordination in relation to biology (for example, wolf packs); to games where there are advantaged and disadvantaged players; or to social and political concepts, such as human rights, fairness, and equality. Look for artists who have used these themes in their artworks, and describe how the artists used the principles of design to enhance the communication of their ideas.

Contrast and Variety

When two opposite elements are placed in an artwork, they create visual tension, or contrast (figure 8.7). Examples of contrast are complementary colours (see chapter 11), smooth surfaces versus spiky surfaces, or metal versus cloth as a sculpture material. In *Jumanji*, the strong differences between light and dark values in the images add contrast and make the illustrations more dramatic.

Variations of an element within an image provide visual interest. The variety of lines in *Grumpy Bird* and *Would They Love a Lion?* makes the illustrations more interesting to look at. The viewer tends to slow down and take time to discern the differences, rather than scan or "read" the images quickly.

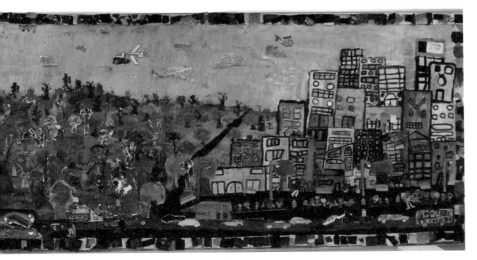

paint and collage, École Constable Edward Finney School. Teacher: Andrea Stuart

Figure 8.7. This country and city mural shows the contrast in the landscape. Students painted a background and then made additional paintings to cut and paste into the mural.

Students can experiment with contrast and variety in a composition in the following ways:

- Look for contrast and variety in visual (figure 8.8) and tactile experiences (such as textures of tree bark, fur, cloth, or stones), as well as conceptually (such as a variation in routine, a variety of personalities in a class, varieties of plants, a variety of cultures in the neighbourhood). "Compare and contrast" is a commonly used strategy for comprehending and synthesizing ideas in most subject areas.

- Identify and sort various categories of elements. Students need to be able to do this before they can apply the principle of variety and contrast. Challenge students to identify strong contrasts (opposing elements) that they can apply in their artworks.

- Find examples of artists who have represented contrasting ideas in their artworks (for example, comic book representations of good versus evil, paintings of night versus day or slavery versus freedom). Notice what visual clues and design principles the artists use to communicate the contrasting ideas. Challenge students to incorporate opposing concepts in their own artworks.

Unity and Harmony

Unity refers to the integrity of an artwork; that is, whether or not it works as a whole. The elements repeat or are interrelated to provide harmony to the image. In *Effie*, for example, unity is provided by the medium – the images are made entirely of modelling clay. In *Strega Nona*, unity is provided by the repetition of simple shapes, dark outlining, and reduced (brownish) colours. A lack of harmony, or discord, occurs when elements are not well integrated into the composition, such as when colours clash. This is different from contrast and variety (described, left), which involve the deliberate placement of counterbalances or differences. Too many discordant elements affect the overall unity of the composition.

Students can experiment with unity and harmony in a composition in the following ways:

- Introduce two opposites within an element, such as geometric versus organic shapes (organic shapes have irregular, or curvy, edges, such as droplets, leaves, or amoebas), light and dark values, or straight and wavy lines. Find ways to produce a unified image, using these opposites. This might be achieved by depicting a transition from one to the other (for example, shapes that evolve from geometric to organic), by creating a pattern with alternating parts (for example, light, dark, light, dark, and so on), or by dividing the paper in half to balance and contain each opposite.

- Experiment with colour harmonies (figure 8.9) and discord in painting exercises (see chapter 11). Look at paint brochures from paint and hardware stores, and match colours that are harmonious and colours that are discordant. Apply these colours in small compositions.

black-and-white pattern, acrylic paint on Tyvek

Figure 8.8. Patterns add visual interest to an image. This pattern was created by painting with white acrylic paint on Tyvek, placing ripped tape on the dry paint, painting with black, and then peeling off the tape.

wolf sculpture outside Wellington School. Teachers: Rhian Brynjolson, Cathy Woods

Figure 8.9. Group projects require design elements that provide unity. The whole school was invited to give suggestions for the theme of this cement sculpture. Small groups of students worked on painting the sculpture over two seasons. The dominance of blue and green paint, and the red-brown outlines, hold the composition together.

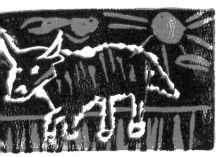

two relief prints by a student at Machray School

Figure 8.10. Printmaking is another medium for testing alternate colours and the effect of multiple copies of an image.

students' drawings at École Constable Edward Finney School. Teacher: Andrea Stuart

Figure 8.11. This project has an insect motif (recurring subject). Students' drawings of insects were photocopied, and the multiples were arranged to show patterns and symmetry.

- Listen to examples of musical harmony (layering in another pitch) and discord with voices or musical instruments.

- Unity and harmony are social ideals as well as principles of design. Explore how artists depict themes of racial and political discord, or global harmony, in their artworks. Examine how the artists may have used the principles of unity and harmony to enhance the meaning in their work.

Repetition (Pattern, Rhythm, and Motif)

Repeated elements, placed at intervals throughout an artwork, create patterns or rhythms. Repetition creates a sense of movement, because it causes the viewer's eyes to travel across the image to discern a pattern or rhythm. The repetition of elements also helps to unify an image. In *Who Is the Beast?*, identifiable patterns (of repeated colours and shapes) are painted on both the tiger and the leaves. In *The New Baby Calf*, the placement of fence posts and lines in the fields creates a regular rhythm; an irregular rhythm is created by the placement of hills, trees, and animals.

A repeated design, or symbol, creates a motif (figures 8.10 and 8.11). Motifs can communicate ideas both visually and symbolically. For example, in *Piggybook*, a repeated pig motif is incorporated into every illustration, indicating the family's unwillingness to help with housework. There is a motif of a recognizable Ukrainian embroidery style in the page designs of *The Mitten*.

Students can experiment with repetition in a composition in the following ways:

- Observe subjects carefully to see variations (see chapter 5). It is generally easier to see a pattern than to discern differences within a pattern.

- Integrate mathematics by studying number patterns, geometric patterns, tessellations, and algebraic equations, using visual examples. Use pattern blocks to create complicated geometric patterns. Tessellation is used in the optical illusions in the artwork of M.C. Escher.

- Use poetry, dance, and music to enrich the teaching of rhythm and pattern.

- Look at quilts, mosaic tiles, and weaving as clear examples of how artists use patterns in artwork, cultural artifacts, and architecture.

Figure 8.12a–g. Photo Booth software provides an instant tool for exploring composition. Iain Brynjolson, age 8, drew a picture of a wolf. The drawing was then photographed with a built-in webcam on a laptop computer that produced altered views of the drawing. All of these variations provide a fresh look at the original drawing.

Figure 8.12a. The original drawing of the wolf.

Figure 8.12b. A glow effect simulates the soft-edged, atmospheric look of a charcoal drawing.

Figure 8.12c. A mirror view of the drawing creates symmetry.

Figure 8.12d. A pop-art view creates a wallpaper effect in a variety of colours.

Figure 8.12e. A bulge effect alters the proportion of an image.

Figure 8.12f. A colour version of the image allows the young artist to imagine how his piece might look in a colour media, with more or less contrast.

Figure 8.12g. A negative view of the image helps us see the space surrounding the wolf.

VOCABULARY

asymmetry	movement
atmosphere	pattern
balance	portrait
chiaroscuro	principles of design
complementary colours	proportion
contrast	radial
crystalline	repetition
dominance	rhythm
elements of design	scale
emphasis	size
expression	subordination
Fibonacci sequence	symmetry
focal point	tangram
golden ratio	tessellation
harmony	unity
kinetic sculpture	variety
medium	visual tension
mood	visual weight
motif	

(see appendix B for definitions)

ILLUSTRATION 9

INTRODUCTION

Illustration is the art of drawing and composing an interesting image for a book, magazine, newspaper, brochure, or poster, to name a few. Illustration communicates a narrative or concept to a specific audience. Illustrations are often based on a manuscript and integrated with text on a page.

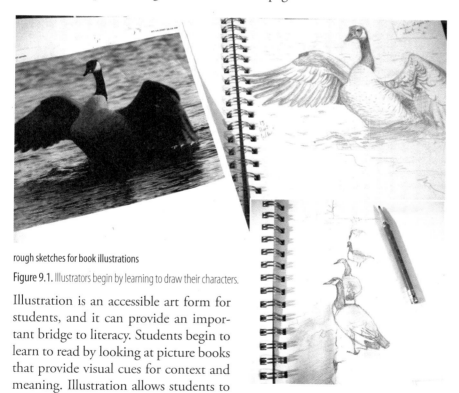

rough sketches for book illustrations

Figure 9.1. Illustrators begin by learning to draw their characters.

Illustration is an accessible art form for students, and it can provide an important bridge to literacy. Students begin to learn to read by looking at picture books that provide visual cues for context and meaning. Illustration allows students to tell, or retell, a story or to visually represent their understanding of a concept through drawing. Illustration also allows students to develop a visual narrative in pictures, as a pre-writing activity. Many students find it easier to draw a story sequence first, and then describe their pictures in words. Building storyboards and books that combine images and text can help students experience success as writers.

visual references on a studio table

Figure 9.2. Illustrators use a variety of visual references to help them visualize a composition and provide visual information about structure and proportion. Illustrators may also consult visual references to draw a particular character, pose, or expression, or whenever accuracy is a concern.

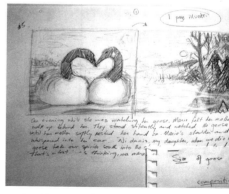

storyboard for the book, *Goose Girl*, written by Joe and Matrine McLellan and illustrated by Rhian Brynjolson

Figure 9.3. Illustrators use storyboards to plan a series of illustrations. Illustrators pay careful attention to the visual narrative (having the illustrations reveal a story), as well as to composition.

illustration in progress

Figure 9.4. Photos, books, calendar pictures, and a view out a window are all good visual references.

illustrations for the book, *Goose Girl*, written by Joe and Matrine McLellan and illustrated by Rhian Brynjolson

Figure 9.5. The finished illustrations for *Goose Girl* are scanned, and a computer is then used to add text.

In this chapter, you will show students how they can (1) "read" illustrations, (2) use illustrations as writing prompts, (3) use storyboards to create stories or document their learning, (4) compose interesting illustrations, and combine these images with text, and (5) build books.

VIEWING PICTURE BOOKS

Illustrations are not merely decorations for text. Richly illustrated picture books are viewed as well as read, and illustrations can powerfully convey aspects of the story that are absent from the text. Not surprisingly, studies have found that quality picture books stimulate language more effectively than the bland pictures in many widely used basal series (Mavrogenes n.d., 239). Look for books that have won illustration awards, such as the Caldecott Medal, the Governor General's Award, the Crichton Award, V & A Illustration Awards, Ezra Jack Keats Awards, or the Amelia Frances Howard-Gibbons Award.

Illustration is an accessible vehicle available to pre-literate children for entering the story. Illustrations in books can interest and excite students – and teach them how to follow a visual narrative – before they are able to decode the text. Wordless picture books tell a story through the illustrations. *Frog, Where Are You?* by Mercer Mayer, *Tuesday* by David Wiesner, and *The Story of the Little Mouse Trapped in a Book* by Monique Félix are excellent examples of wordless narratives. (You might point out to your students that these illustrators also get credit as authors.)

Here are some tips for viewing picture books with young students:

- Begin by silently showing the pictures to your students, and then invite students to discuss or describe what they think is happening in the story. Pause when you read a story aloud, and encourage questions and comments about the illustrations. Ask students what they notice in the illustrations (see chapter 4).

- Read the story first, without showing the illustrations to the students. Afterwards, ask students to describe or draw the characters, settings, and events as they imagine them. As a class, look at the book illustrations. Discuss the similarities and differences between the students' versions and the book illustrations. Did the book illustrator do a good job?

- Read and view the book carefully. Students can pretend they are the book illustrator. What information did you put into the illustrations that is not in the text? How does this change, or add to, the story?

- Choose books to read that are interesting to students. Beware of bland themes that may not capture students' imaginations – remember that you are competing against cable and satellite television! Try undersea monsters, dinosaurs, or an adventure story about the classroom's pet hamster. You may also be competing against real-life issues – hunger, grief, or illness. Encountering these themes in books may help a student feel less isolated or make some sense of his or her situation. Picture books can deal with serious subject matter; for example, *The Rebellious Alphabet* is a story about censorship.

- Reinforce the concept that a sequence of images can tell a story. Students might take photographs of shared experiences and outings and sort them into the beginning, middle, and end of events.

- Allow classroom discussions of the illustrations to take you into discussions of the characters, their expressions, gestures, and motives, the atmosphere and setting, and details in the plot. Charting this information can help vocabulary development and comprehension of story structure.

CREATING NARRATIVE SEQUENCE

Encourage students to draw a story sequence or verbalize a story as they draw. Creating narrative sequence is an important step in the development of writing. Children learn that they can communicate while making marks on paper – they will tell a more involved story if an adult is present to respond to their drawings.

Frog, Where Are You?, written and illustrated by Mercer Mayer.

Tuesday, written and illustrated by David Wiesner.

The Story of the Little Mouse Trapped in a Book, written and illustrated by Monique Félix.

Legend of Chun Hyang, written and illustrated by CLAMP.

VARIETY OF MEDIA

watercolour and ink: *Posy!* by Linda Newbery, illustrated by Catherine Rayner.

modelling clay: *Effie* by Beverley Allinson, illustrated by Barbara Reid.

modelling clay: *Have You Seen Birds?*, written and illustrated by Joanne Oppenheim.

shadow puppets: *The Enchanted Caribou*, written and illustrated by Elizabeth Cleaver.

collage: *Window*, written and illustrated by Jeannie Baker.

cut-paper collage: *How the Animals Got Their Colors* by Michael Rosen, illustrated by John Clementson.

drawing and computer graphics: *The Wolves in the Walls* by Neil Gaiman, illustrated by Dave McKean.

drawing and photography: *Knuffle Bunny*, written and illustrated by Mo Willems.

acrylic latex on canvas: *Goose Girl* by Joe and Matrine McLellan, illustrated by Rhian Brynjolson.

photography and model-building: *I Spy* series by Jean Marzollo, illustrated by Walter Wick.

paint and collage: *This Land Is My Land*, written and illustrated by George Littlechild.

paint: *Josepha* by Jim McGugan, illustrated by Murray Kimber.

pencil: *The Mysteries of Harris Burdick*, written and illustrated by Chris Van Allsburg.

TEACHER REFERENCES

Literacy Through the Book Arts by Paul Johnson.

The Anti-Coloring Book series by Susan Striker, illustrated by Edward Kimmel.

Making Mini-Books by Sherri Haab.

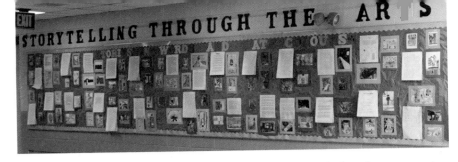

Figure 9.6. Students at Niakwa Place School combined writing with illustration to tell their stories.

Wilson and Wilson (1982) suggest the following practical ideas for encouraging storytelling and narrative sequence in children's drawings:

- Use prompts. To tell a story through drawing, some children may require prompting: "And then what's he going to do?" Or: "I wonder what she'll meet in the forest?" Or: "How does she get home again?"

- Suggest a general topic or theme that might trigger students' imaginations. Follow this by providing students with long strips of paper (to encourage them to draw a number of scenes, one after the other).

- Suggest a specific topic or character.

- Invent a new character or superhero (see chapter 7). What superpowers will the character have?

- Give students a page with pre-drawn frames.

- Read a story to the students. Discuss what they would change about the story. Encourage students to create their own versions of the story.

- Challenge students to look at an ordinary subject from a new vantage point. For example, in the book *Thing-Thing*, as the toy falls it is viewed from a series of windows.

Make sure the above suggestions are open-ended. You want students to create their own stories that are prompted, but not completely guided, by a model or by adult intervention. After students have worked out the narrative in visual form, they can write about the illustrations, or an adult can record students' verbal explanations of the pictures.

Additional Exercises

The following additional exercises use visual art or illustration as a springboard for creating writing. Many are appropriate for older students:

- Create postcards for friends or family. Students can draw or paint an imaginary landscape on a 4" x 6" (10 cm x 15 cm) card. Then, they can write about their trials and tribulations in reaching their imaginary location.

- Create irrational images. Many picture books, such as *The Mysteries of Harris Burdick* and *Imagine a Night*, contain humorous, impossible, or irrational images. *Son of Man*, a painting by surrealist René Magritte, shows a man with an apple for a head. Visual puzzles can challenge students to explain or write a mystery story about the image. These kinds of images also frequently appear in advertisements as a way to get our attention. Students can create irrational images easily by cutting pictures out of magazines and combining unlikely images.

- Write captions. This is a popular exercise for introducing dialogue. White out the caption boxes in cartoons, and have students write their own words. Add dialogue to a humorous or dramatic magazine photo, advertisement, or famous painting.

- Draw cartoons. Encourage students who spend time drawing comic-book characters or caricatures to develop a story sequence and add text (see chapter 7). The text in comics often includes exciting sound-effect words such as *kaboom* or *POW*, which might inspire students to make up their own sound-effect words. Comics also contain strong narrative sequences, dialogue, flashbacks, a narrator, synopsis, and other sophisticated devices that can provide challenges for advanced students.

- Create puppets. Puppets are one of the most powerful devices for developing story sequence. Puppets encourage both visual thinking and play (see Shadow Puppets, page 153, and chapter 19). Story lines emerge as students play together with puppets (for example, "And then pretend my wolf went to the store, and your princess was there…."). A variety of puppets can be used, but shadow puppets are useful, because they translate easily into illustration.

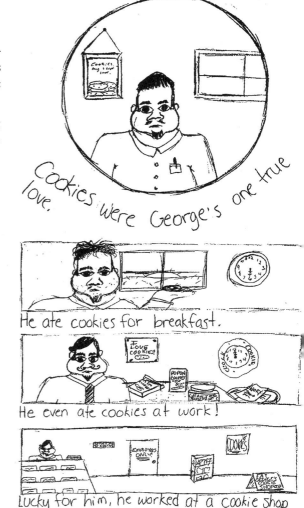

pencil on paper, Noni Brynjolson, age 11

Figure 9.7. These thumbnail sketches reveal George's greatest passion. Noni's story idea grew from her initial sketch of a well-fed character (top).

STORYBOARDS

A storyboard is a visual sequence of ideas (figure 9.7). Storyboards are used to plan and visualize book illustrations, advertisements, videos, and theatre sets. Students can use storyboards to organize and display visual research for a project. Storyboards (that combine photographs, artwork, and text) may also be used to document students' learning. A very simple storyboard may consist of a collection of sketches that plan or map out a more elaborate idea. Storyboards may themselves become works of art if consideration is given to their layout and design. They are called *boards*, because illustrations were once painted on "illustration board" (made of watercolour paper glued to heavy mat board) that was designed for the printing process.

TOOLS & MATERIALS

- sketchbooks
- scrap paper
- pencils
- erasers
- scissors
- glue or glue sticks
- visual references (books, magazines, photos, and so on)
- optional: see Additional Exercises (page 147)

Materials for finishing illustrations

- Dessin paper, or paper that fits your budget (cut the paper into fairly small pieces, about 6" x 6" (15 cm x 15 cm), and glue illustrations into assembled books later)
- felt pens (black, fine-tipped)
- pencil crayons
- optional: a variety of media suitable for illustration (watercolour, oil pastel, paint, collage, and so on, see chapters 6, 13, 14, 15, and 16)

TIP A storyboard can become an interesting finished product in its own right. It may become a display panel for a research project or a novel study.

Preparation

Explain to students that they are each going to make a storyboard to plan a story. Students can use their sketchbooks, or they can use a photocopied page that has a series of boxes. A storyboard planning sheet is similar to the kind of a sheet used to plan a video-sequence shot. Paul Johnson (1997) suggests using an even more structured format, which you might find useful with very reluctant writers. Johnson outlines six boxes. Under each box is an open-ended story line, with a caption such as, "Draw a character in a house setting," or, "Character falls down hole. At the bottom is…?" The story line leads the character into an underground area, to adventure, and back home again. A similar approach is used in single frames in The Anti-Coloring Book series. The narrative is guided but open-ended enough to allow for variation and student innovation. Another good example of pattern in writing can be found in the children's book *Suddenly!* The author uses a recurring device to provide unexpected plot twists.

Before your students begin this exercise, hold a class discussion so that they can make the following decisions about their books:

- Length and format: Some examples are booklet, concertina, postcard, hardcover, pop-up, electronic (see pages 158–159, and Part 6).

- Writing genre: Some examples are poetry, mystery, adventure, fairy tale, western, and imaginary journal.

- Topic: Make sure it relates to a theme of study and is of interest to students.

- Composition: Select elements and principles of design to study (see chapters 5 and 8).

- Medium: Select an art medium that will be used to finish the illustrations. Some possibilities are drawing, paint, collage, photography, shadow puppets, printmaking, modelling clay, and watercolour (see appropriate chapters).

Try to have examples of each of these categories available to students as they begin their projects (see book suggestions in every chapter).

Enrich the activity by giving students time to become familiar with their topics through observational drawing. Experiment and practise with the art media on a small scale. Look at examples in books, posters, and websites, and provide opportunities for students to handle objects and artifacts. Engage students' interest through activities such as games, drama, songs, and cooking. Students produce richer writing and stronger illustrations, and they learn more, when they (a) have access to multi-sensory explorations, (b) become familiar with the visual forms through observing and sketching, (c) explore the art materials, and (d) have visual references available to them.

Creating Stories With Storyboards

Students can use their storyboards to plan the sequence of their illustrations and stories, plan their compositions, and practise drawing their characters and settings. Here are some helpful suggestions:

TIP For students who want to use imaginary subjects, it helps to have them refer to related visual references rather than to have them copy another artist's version. For example, if students are going to draw dragons, have them look for photographs of lizards, bird talons, insect wings, and so on.

- If students have pre-written stories, encourage them to divide their stories into scenes and decide how many illustrations their stories will require (or how many they can realistically complete in the time available). Remind students that not every scene requires an illustration. As a group project students may produce a class book, with each taking one scene from a manuscript to illustrate.

- If students are beginning their stories with drawing, they may start by drawing in their sketchbooks. They might begin with characters (see chapter 7), settings, a problem, a plot or series of events, or a moral or message.

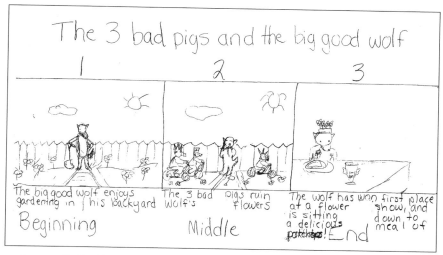

pencil on paper, Noni Brynjolson, age 11

Figure 9.8. Thumbnail sketches provide the outline for illustrating, and sometimes writing, the story.

- Explain that illustrators generally begin with thumbnail sketches (figure 9.8). Thumbnail sketches are usually quick scribbled drawings or shape drawings (see chapter 5). Students can add details, such as gesture, expression, clothing, and physical characteristics later. Ask students to begin with a series of small sketches (maximum 4" [10 cm]). Discourage students from spending more than five minutes on each sketch, as they will need to re-draw these scenes later.

- Thumbnail sketches are a good way for visual thinkers and less-confident writers to begin writing projects. Ask students to look at their sketches to make sure they have included characters, setting, and action in every scene: "Who is in the picture?" "Where are they?" "What are they doing?" and, if students are stuck, "What will happen next?" "What happened just before?"

- As a class, you may want to establish the format first, and have students work in that format for their storyboards. For example, for a six-page story (two pieces of paper, folded in half, with a front and back cover), have students fold two pages into a booklet for their storyboards to help them with the concept of sequence. They will find it easier to understand that they are working in a book format.

- Explain to beginning writers that most story narratives start with a problem, which is resolved, or at least explored, during the story. When students are finished their sketches, do a quick pre-edit of their visual narratives.

TIP Encourage students to try several options before choosing one as a plan for a finished drawing. Ask: "What would that picture book look like if it was oval? Square? If the subject overlapped the edges of the frame?"

After students have sketched out their initial plans, encourage them to take extra time to practise drawing their characters, settings, and actions in their sketchbooks. Some of these practice drawings might be just of details; for example, a tree rather than a whole background. This kind of practice will result in much stronger final images. Have visual references, such as magazine photos, mirrors, calendar pictures, postcards, websites, books, and objects, available for observational drawings (figures 9.9 and 9.10). Encourage students to add aspects that make the characters or settings more interesting to look at. For example, in *The Night Rebecca Stayed Too Late*, the cartoon bear began as a

photographs and pencil drawings glued on cardboard, Noni Brynjolson, age 11

Figure 9.9. Students produce stronger illustrations when they have visual references available to them.

photographs and pencil drawings glued on cardboard, Noni Brynjolson, age 11

Figure 9.10. Noni used visual references as she began a straightforward observational drawing of her subject. She then used her imagination to transform her subject into characters for her story. Elements in the background (house and flowers, for example) may also be included in a storyboard. Advanced storyboards map the progress — scene by scene — of the entire story.

Figure 9.11. Illustrations and reference photos for the book *The Night Rebecca Stayed Too Late*, illustrated by Rhian Brynjolson and written by Peter Eyvindson.

postcard photo of a black bear. The black leather jacket, haircut, and sunglasses were added after viewing examples in magazine photos (figure 9.11). (See page 110 for ideas on drawing figures in action, page 102 for portrait drawing, and pages 104–105 for information on drawing expression.)

Developing Composition With Storyboards

Students can re-visit the composition of their illustrations after they plan the content and sequence of their stories and practise drawing their characters, settings, props, and actions. All of the elements and principles of design also apply to book illustration (see chapters 5 and 8). However, some aspects of composition are unique to the shape of a book's pages:

- The "gutter" (created by the centrefold) means that important elements cannot be placed in the centre of a two-page spread.
- The left-to-right and top-to-bottom sequence of reading and viewing a book page means that an illustration must also have the action flow from left-to-right and top-to-bottom.
- The printing process affects the quality and colour in the reproduction of an illustration.
- The integration of text and the white space of the book page must flow into the illustrations.

A book is written for a specific (often very young) audience, and it communicates a story.

Students may re-draw their initial sketches into slightly larger frames. Alternatively, they can use small pieces of masking tape rolled up on the back of cut-out characters to tack them into larger frames. Parts of the setting, or props, can be added as well. Students can move the taped pieces to change the sequence and grouping. If students are working from a draft or from finished text, they can tape in pieces of text that fit with the rough illustrations.

For larger, group projects, students can use heavy paper, Bristol board, or a bulletin board to display and re-arrange their plan.

When they are developing their storyboards, remind students to consider the following:

- Size and shape of the illustrations on the book page. Have students consider the shapes of their illustrations and how their illustrations will fit the page. Look at the book *Animalia* or at a graphic novel such as *Legend of Chun Hyang*. Ask your students what they notice about the shapes of the illustrations. Point out that illustrations may:

- fill the whole page

- fill two pages for a "two-page spread"

- have an overall shape, such as a round illustration with parts that overlap the frame, where a leg or a wing sticks out from the border of the picture

- have multiple frames, like a comic-book page

- be used to determine the shape of a book's pages. In *The Magic Fan* and *Black and White*, all of the pages are shaped like the books' main subjects. Ask students to decide on the shapes of their book pages and illustrations, and how the shapes will fit on the pages (figure 9.12). Students may choose to sketch scenes in their sketchbook to fit a geometric shape or sketch a shape that relates to their story.

- Placement. Explain to students that how they place and group the shapes on the page affect the balance in their illustration. The difference between composition in an artwork and in illustration is that, in a book, students must consider the white space of the book page, the gutter where the page will be folded, as well as the text, as parts of their composition. Students should be aware of the following:

 - Shapes that are stacked vertically, overlap, or crowd onto one side of the page can make for interesting or dramatic contrast.

 - Shapes spread evenly along a horizontal line, arranged in a radial pattern, or spaced evenly across the page form a more balanced, stable composition.

 - Isolating one shape from the others will call attention to that one shape (figure 9.13).

- Borders. Students may consider a border design that will act as a frame around the outside of the illustration (figure 9.14). Look at *Animalia* with your students. Note the elaborate borders on some illustrations. Some borders are of text; some are simple lines. Look for other books in which the illustrators use border designs to tell part of the story, such as *The Mitten*.

- Combining text and images. In some books, the text becomes fully integrated with the illustrations. Look at *Animalia* or *The Rebellious Alphabet,* and discuss how the text fits together with the pictures.

 - Look for words beside the picture, words as a frame for the picture, words that are hidden on objects inside the picture (for example, on the cover of a book inside the illustration), and even words hidden backwards on a mirror. Challenge students to find an interesting way to place the words in their illustrations (figure 9.15).

TIP Collage is an ideal way to approach composition, because students can physically move cutout shapes around the page (see chapter 6).

TIP Encourage students to add a border. It will add a finishing touch to even the weakest work.

pencil sketch, Noni Brynjolson, age 11

Figure 9.12. By altering the shape of her illustration, Noni adapted it to the space available on the page. The alteration also added visual interest.

TIP Cutting out photocopies of student drawings allows students to move the subject around on the paper and try different placements.

pencil sketch, Noni Brynjolson, age 11

Figure 9.13. In these sketches, Noni grouped the figures differently: (left) the figures are spaced evenly along the fence, and (right) the figures are stacked in the corner.

- Look at the variety of letter designs used in *Animalia*. Challenge students to try different fonts or hand lettering (figure 9.16). Some letters are elaborately designed, and multi-coloured. Graffiti art is another source of interesting letter types.

- Vantage Point. The vantage point is the place from which a scene or subject is viewed. Challenge students to draw their subjects from a new – and interesting – angle (figure 9.17).

pencil sketch, Noni Brynjolson, age 11

Figure 9.14. Noni added a border design to decorate the frame of her illustration.

pencil sketch, Noni Brynjolson, age 11

Figure 9.15. Here are two imaginative examples of incorporating text with an image.

- Look at the books *Have You Seen Birds?* and *Effie*. Ask students to identify different vantage points in the books. They might talk about a view from above ("bird's-eye view"), below, close-up, distant, side, back, and front.

- Look at *Mattland*, and notice the child's-eye view. Challenge advanced students to show their audience a new way of viewing their subject through the eyes of a particular character.

- Look at comic books and graphic novels, which typically use a variety of viewpoints and perspectives. Advanced students could also try one of the following, unusual views:
 - distorted (as seen through water, heat waves, or thick glasses)
 - magnified
 - aerial
 - cross section
 - close-up
 - from a distance

pencil sketch, Noni Brynjolson, age 11

Figure 9.16. Students may use conventional lettering — block letters, balloon letters, computer fonts — or design their own interesting scripts.

TIP Computer fonts and graffiti art may provide some interesting options for size and typeface styles for students' texts.

- through something (looking from inside or outside, looking through an opening or between objects)
- x-ray
- transparent (ghostly, so the background shows through)
- exploded (pieces of the subject)
- simultaneous (multiple views seen at one time)

- Computer software such as iPhoto, Photo Booth, PhotoImpression, and Photoshop can provide some of these unusual views (right) instantly. Students can import a digital photograph of their artwork and explore a variety of effects they might use in it.

- Movement. Dramatic gestures and expressions add interest to illustrations (figure 9.18) and communicate the actions and emotions of the characters in the story.

 - Look at *Best Friends* with your students. Ask them to find expressions and poses that give them clues about how the characters are feeling and what is happening in the story. Challenge students to re-draw their own characters in more active poses or with extreme facial expressions that communicate their characters' roles in their story.

 - One method for drawing figures in action is for students to draw a movable template – a traceable cutout with movable joints – of a subject (see Shadow Puppets, page 153). Students can then change the pose of their template from one illustration to another by tracing it in various poses. Later, students may want to decorate the template and use it to illustrate the front cover of their book (see figure 15.8) or for an animation project (see chapter 22).

 - Students can achieve a sense of movement in their illustrations with any of the following:

 - Diagonal lines. Draw objects that are leaning (for example, a stack of tea cups about to fall over) to create a sense of movement. People and animals tend to lean forward when they are running and when they are walking into the wind.

 - Brilliant and contrasting colours. Fiery orange, for example, is more exciting and energizing than pale peach (see Part 4).

 - Multiple outlines. Draw around the outside of the subject three or four times, then erase lightly to soften the edges. The result is similar to a blurred photograph. Repeated, active, or jagged marks rather than a smooth, continuous drawing line also add a sense of movement (see *Would They Love a Lion?*).

 - Repeated shapes, or several frames on one page, each showing a progressive phase of movement. For example, a sequence can be created by drawing frogs that are higher in each consecutive frame as they "hop" across the page, or a car that gets smaller in each frame until it disappears over the horizon.

 - Drawing the effect of wind on an object. For example, draw a horse with its tail and mane sticking straight out rather than hanging down, or draw trees bent over in a storm.

pencil sketch, Noni Brynjolson, age 11

Figure 9.17. A view through a window (above) and a close-up of a boot (bottom) are two solutions to the problem of finding interesting vantage points.

pencil sketch, Noni Brynjolson, age 11

Figure 9.18. An active pose by the main character, a diagonal fence line, and the flowers leaving the borders of the drawing create a sense of movement in this sketch.

TIP When students are looking for an interesting vantage point, they may find it easiest to work with small, three-dimensional objects such as toy dinosaurs. These kinds of objects can be turned, flipped, and tilted to expose the required view. Objects such as oranges can be cut open to show, for example, a cross-sectioned view.

- Humour and detail. Humour and detail in an illustration encourage the viewer to look more closely to catch the details and visual jokes in the background of the picture (figure 9.19).

 - Look at *Changes* and *Window* with your students. Ask them what they notice is happening from page to page. Challenge students to introduce detail and humour into their own illustrations. Ideally, these changes or visual subplots will relate to and enrich students' stories.

- Scale. Ask students how they will represent scale of their subjects (for example, how they will convey the sense of relative sizes of characters) in their illustrations (figure 9.20). See, for example, *The Baby Who Wouldn't Go to Bed*.

pencil on paper, Noni Brynjolson, age 11

Figure 9.19. Noni's use of humour and detail in the background of this picture almost guarantees that the viewer will take a second look.

pencil sketch, Noni Brynjolson, age 11

Figure 9.20. Relative sizes suggest the scale of these characters. The single-point perspective and overlapping introduce an element of depth.

- Look at *Effie* with your students. Notice how the illustrator fits the ant and elephant onto the same page and what views give us clues about their scale (relative sizes). Many considerations affect the scale of an object in a picture, including the following:

 - Comparison. Compare the size of an ant to a blade of grass. Drawing these subjects next to each other gives the viewer a clue to the relatively small size of the ant.

 - Partial view. Fitting only part of an elephant onto a page is a device that indicates that the elephant is too big to fit on the page.

 - Vantage point. A view from above makes an ant look small; a view from below makes the elephant appear larger.

 - Foreshortening. A foreshortened view of an elephant's trunk will give it a sense of size or length (the trunk is wide at the tip where it is closest to the viewer, and it "recedes" into a faraway distance of the elephant's head – just like the road in the single-point perspective drawing). (See chapter 5.)

- Atmosphere. The atmosphere or mood of an illustration expresses the action or emotion in the story. Often, atmosphere foreshadows things to come.

 - Look at *Owl Moon* for winter moonlight, and *Have You Seen Birds?* for different seasons. For night scenes, look at *Way Home*. Check *The Magic Paintbrush* for interesting shadows. Ask students to think about the moods of their stories and what atmosphere they want to create (figure 9.21) – a dark, windy night for a horror story; a rainy afternoon for a sad event; firelight for a dramatic scene; a sunrise sky for a hopeful ending.

 - Atmosphere can also be determined by:
 - time of day
 - light source
 - placement of shadows
 - season
 - weather
 - inclusion of specific kinds of objects (such as spiders and cobwebs)
 - landscape

- Style. Illustrators work in a variety of styles to suit the genre of the story. Look at how a variety of illustrators represent the main characters in their stories. In *The Nightmare Before Christmas*, Tim Burton's skeletal characters fit the film's odd gothic style. By contrast, George Littlechild's playful colours and pattern in *This Land Is My Land* sneak up on the reader and ambush him or her into considering the more serious meaning in Littlechild's work.

pencil sketch, Noni Brynjolson, age 11

Figure 9.21. The night sky and shadow lend atmosphere to this sketch.

Additional Exercises

Here are additional exercises your students can work on to practise working with storyboards:

- As a special project, students may wish to make a storyboard for display or for easy reference for group projects such as stories, animation, and theatre sets.

- Use storyboards to plan large or complex art projects. Murals, movies, and theatre sets are planned using the processes described in this chapter, and combined into one larger storyboard. The storyboard is then used to break the project into parts and to delegate tasks. Murals, scenes, and theatre sets may be drawn, painted, and assembled as separate pieces by individuals or by small groups of students and combined later. Posters or advertisements can be completed using storyboards, and then working on larger paper with a variety of media to finish the illustration.

- Look for elements and principles of design in other illustrated children's books. Ask: What do you notice in the work of various illustrators? Students can sketch details or impressions of illustrators' styles in their sketchbooks.

- Look critically at a variety of new picture books, then consider all the elements of design. Next, as a group, decide on who should win an illustration award. Send a letter to the winning illustrator to let him or her know of the decision. One school I visited did just that and received a gracious reply from the illustrator (I am sure he was very flattered). What a great way to get students looking critically at visual art!

"GOOD COPY" ILLUSTRATIONS

To this point, students have been working on a storyboard to plan their illustrations. Now, it is time for them to transfer their drawings from the storyboard or from their practice drawings in their sketchbooks to a new piece of paper that will become part of their book. Students can do this in a variety of ways:

- Make the illustrations separately from the text. The advantages are:
 - A variety of messy media, such as paint, collage, and printmaking, can be used.
 - Text can be incorporated with the illustrations in interesting ways.
 - A new piece of paper can easily be substituted if students make mistakes while drawing or writing. Use hand-lettering, or cut out pieces of computer-printed text, and glue them into the book. Students may want to print on a separate piece of paper, and glue it onto their book page later.
 - Illustrations may be photographed, and the digital images integrated with text on a computer, using a variety of software programs. *The Wolves in the Walls* is an example of seamless integration of drawing with computer graphics.

- Re-draw the picture(s) onto an appropriate surface. A good copy of their illustrations may be produced in a variety of media. Papers may be cut to a small size and glued onto a book page. Models and sculptures of characters may be photographed. Digital copies may be created, altered, or printed, using a computer. The illustrations do not have to be large, unless students intend to create an oversize book. A 4" x 4" (10 cm x 10 cm) illustration fits nicely onto a book page.

- Use a brightly lit window, a light table, or an overhead projector to trace parts of their drawings onto clean paper. Encourage students to re-arrange parts of their compositions as they re-draw them.

- Use collage techniques (see chapter 15). Make photocopies of characters or parts of the setting from students' practice drawings, and have students combine them with photographs, magazine photos, cut paper, or their artwork in other media. If students have drawn a character once, it can be photocopied or photographed, cut out, and pasted into multiple illustrations.

- Although students are encouraged to practise drawing their subjects, they do not have to be able to draw in a realistic style to make beautiful illustrations. Look at *Would They Love a Lion?, Posy!,* or *How the Animals Got Their Colors.* Although the illustrations are very beautiful in each of these books, the characters have been drawn quite simply. Encourage students to play with a variety of simplified or cartoon styles.

- Use a media-based approach. Less-experienced artists will find cut paper, textured paint, collage, and shadow puppets (see pages 153–156) are forgiving media to work with. When students use these media, they can produce strong images, even if their initial drawings are somewhat weak.

TIP Not all illustrations need to be full colour or full size. Choose the most exciting or interesting scenes for the full-sized pictures.

TIP It takes a lot of hard work to draw a series of pictures. Some students may become tired or lose interest, especially if the initial drawings are done slowly. There are many ways to make this task simpler: (1) use smaller paper (4" square/ 10 cm square), cut out, and glue onto larger paper with text, (2) make illustrations in black and white, (3) use photocopies, trace students' drawings from sketchbooks, or use printmaking or photography to produce multiple images that can be pasted into illustrations.

TIP If your students have trouble with a drawing, and you do not have time for a how-to-draw session, suggest that they simplify the view. They can draw the back of a character, place hands in pockets, zoom in and draw enlarged details rather than the whole subject, or overlap easy-to-draw objects in front of difficult ones. Look for these examples in published picture books.

- Illustrations may be left as pencil drawings, or they may be outlined with black felt pens and coloured with pencil crayons. However, students may also explore a variety of other media. Look through children's picture books with your students. Have them guess what media or techniques the illustrator used to make the illustrations. (See Books to Have Handy, page 137, for a list of books with illustrations made using interesting media or techniques.)

patterned paper, cloth, found materials, Ash, grade 12. Teacher: Rhian Brynjolson

Figure 9.22. Ash made this touch-and-feel book for a baby. The book has a variety of textures and patterns. The ribbons add to the design and provide a sturdier construction.

BUILDING BOOKS

TOOLS & MATERIALS

- paper (plain, coloured, decorated), file folders (various colours), cardboard
- rulers
- scissors
- hole punch
- stapler and staples string, ribbon, tape (duct, bookbinding, hockey)
- fabric
- discarded books
- software (see appendix D)
- optional: see Additional Exercises (page 152)

Making a handmade book is an engaging project that allows students to see themselves as authors and illustrators (figure 9.22). Student books can be used to tell stories or organize research. Book-making can be an involved process focusing on a book as a sculptural object, or students can use a folded piece of paper that becomes a daily part of writers' workshops in your classroom. The following are some of the types of books (figures 9.23–9.36) that students can make in the classroom:

- Softcover books. A book can be made by simply folding a piece of paper in half. To add more pages, fold more pieces of paper. By stapling along the side rather than through the centre, extra pages can be added later. Colourful file folders make excellent book covers: Trim the folders to page size plus a ½" (1.5 cm) margin. Stitch, staple, or hole punch and tie pages together, and use bookbinding tape, hockey tape, or colourful duct tape to reinforce the spine along the outside of the central fold. Attach the cover.

- Hardcover books. Cut three pieces of cardboard: two slightly larger than the book page to allow for a ½" (1.5 cm) margin, and one the height of the book page, plus ½" (1.5 cm) margin and the width needed for the thickness of the book (¾" [2 cm] or more). Attach the pieces together with durable tape. Cover the pieces with a single piece of plain or patterned cloth, or use decorated paper, folded over the edges of the cardboard. Stitch or staple the book pages together, and attach to the cover with more tape. To cover the folded edges and the tape, glue in decorated or colourful end papers.

- Sculptural books. Interesting options are concertina, origami, and pop-up books designed and made by book artists. Making books can be an art form in itself. (See pages 150–152.)

Figure 9.23. Books may be built by using a hole-punch with ribbon, or a coil binder.

Figure 9.24. Book covers and pages can be cut in the shape of their main subject (see *Making Mini-Books* by Sherri Haab).

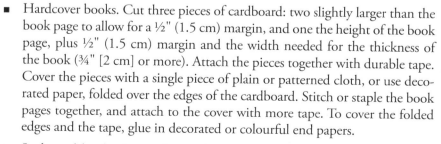

Figure 9.25. These shape books have folded pages that open like a concertina or accordion (see *Making Mini-Books*, by Sherri Haab).

Figure 9.26. These books are great for organizing information. The pages are arranged and stapled to leave room for headings. They were made in a workshop with book artist Janet Carroll.

Figure 9.28. This is another great book format for organizing information. This place-value book was made by a grade 4 student in a workshop with book artist Janet Carroll. The pages are made from a piece of heavy paper that was first folded to produce a pocket, and then folded into a concertina, or accordion form.

Figure 9.29. This pop-up page was made by cutting two parallel slits in a folded piece of paper and pushing the resulting "box" shape forward. Cutouts were then glued to the front of the box. Pop-up book pages must be built before the book is assembled.

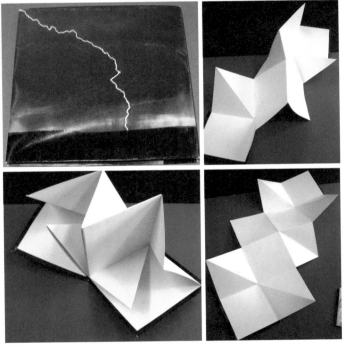

Figure 9.27. The pages of this sculptural book fold outwards into surprising forms. This book is made with three square sheets of paper, carefully folded and overlapped. The cardboard cover has a magazine photograph glued over it. It was made in a workshop with book artist Janet Carroll.

Figure 9.30. This flag book has interesting shapes and colours. It was made in a workshop with book artist Janet Carroll.

Figure 9.31. These concertina, or accordion, books, made by book artist Janet Carroll, have beautifully decorated cover papers.

Figure 9.32. These softcover books were made from used, colourful file folders and coloured duct tape. The pages are simply folded and stapled to the cover, using a long-armed stapler.

Figure 9.34. This hardcover book is made of cardboard covered with cloth. The pages are folded in half and stitched with a sewing machine. The endpapers are glued in to attach the pages to the inside of the front and back covers.

Figure 9.33. This sculptural carousel book can stand or hang, and then fold, into a conventional book. The pages have a heavy paper frame glued across them, which prevents them from opening fully. The book was made in a workshop with book artist Janet Carroll.

Figure 9.35. These sculptural books are simple and elegant. A rectangular piece of heavy paper or Bristol board is cut on the diagonal. Then the top edge of a setting — such as treetops, city skyline, or a castle — is drawn and cut out. The characters and text may be drawn on, or cutouts of the characters may be placed in front of the scene, to act out the story. The books fold up, so the lowest portion becomes the front cover of the book.

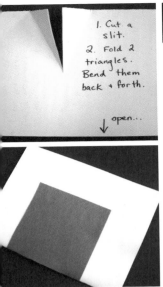

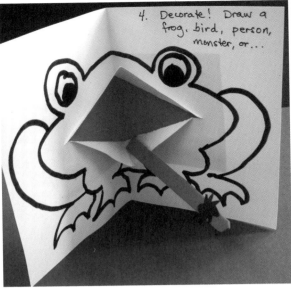

Figure 9.36. This pop-up book page was made by cutting a slit in a piece of paper, gluing coloured paper across the back, and then pulling out and decorating the resulting "mouth."

■ Altered books. Turn old, discarded books into objects of art.[1] Students may use discarded books as beginnings for their own projects, gluing, folding and cutting, and adding in their own themes or stories. Respect the original copyright of the author – use books with expired copyrights.

■ Electronic media. Many software programs are user-friendly.[2] Look for a program that allows students to import photographs of their own artwork, write, move, and modify their text, and use an inexpensive (or built-in) microphone to record voice-overs. The program should also make it easy for students to edit and save their work. Many of these programs provide animation effects that can interest reluctant students. An efficient way to use this kind of program is to teach it to two or three students, then ask them to tutor other students.

Additional Exercises

There are many ways to celebrate books in your classroom. Enlist the help of your school librarian or your community library. Here are some exercises your students can do:

■ Make oversized class books, with each student contributing one page.

■ Have a book launch in the school library for authors of class-published books. Read to classmates. Invite guests, and serve snacks. Add a blank page in the back of each book, and invite readers' comments.

■ Invite local illustrators and authors to your classroom to present their works.

■ Visit a print shop to see how books are printed and assembled.

■ Have a special place of honour in your classroom or school library for completed (class-published) books (figure 9.37).

■ Hold a "read-in," and ask students to judge new picture books. Brainstorm a list of criteria with students (refer to the elements and principles of design, chapters 5 and 8). View and discuss the illustrations. After ranking and voting on the books, send a letter of congratulations to the illustrator who won. Students from one school who wrote to an illustrator received an original piece of artwork in the mail!

Wolseley School. Teachers: Andrea Stuart and Donna Massey-Cudmore

Figure 9.37. Set up a classroom illustration centre. The centre can include labelled activity bins, a place to display finished books, and a quiet space where students can go to illustrate their stories.

1. For websites, go to http://naturebooksart.wordpress.com/, and scroll down to "Altered Books Resources."

2. At the time of publication, Photo Story3 and Comic Life are popular programs in schools; older students may have success with PowerPoint and iMovie.

SHADOW PUPPETS AND STORIES

TOOLS & MATERIALS

- heavy black paper (construction paper, Bristol board, or black Mayfair paper)
- wooden slats
- single-hole punches (at least one per four students)
- scissors
- brass paper fasteners
- overhead projector(s)
- Scotch tape
- optional: clear plastic
- optional: see Additional Exercises (page 156)

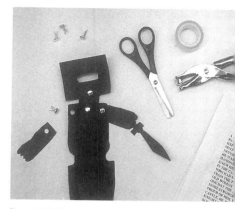

Figure 9.39. These are some of the materials you will need to make shadow puppets. To make movable parts, cut out the pieces separately, punch with a hole punch, and attach with brass paper fasteners.

Introduction

A shadow puppet is a flat, cutout figure with movable parts, made from paper. Some shadow puppets are very elaborate. Traditional Indonesian shadow puppets, for example, have intricate designs carved into the paper and are waxed to be translucent. The puppets described in this section are much easier to make, and have been adapted for use in the classroom. While Indonesian puppets are used behind a back-lit paper screen to act out a story, you will find an overhead projector is a simple solution for the classroom.

Shadow puppets are an effective device for developing stories through play. Shadow puppets allow students to create visuals and act out their stories before recording them. This is especially helpful for students with beginning or weak writing skills. These students often find it easier to describe aloud the actions of their shadow puppets than they do to write a story directly into print.

BOOKS TO HAVE HANDY

PICTURE BOOKS

How the Animals Got Their Colors by Michael Rosen, illustrated by John Clementson.

The Enchanted Caribou, written and illustrated by Elizabeth Cleaver.

TEACHER REFERENCES

The Shadow Puppet Book by Janet Lynch-Watson.

construction paper, Darlene Paranaque, grade 3, Prairie Rose Elementary School

Figure 9.38. Shadow puppets engage students' interest and are effective in helping them develop story scenarios. Students can also use the puppets as illustrations for their finished stories.

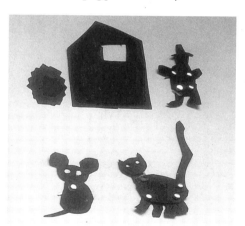

TIP To help students who want to create imaginary animals such as dragons, find related visuals (birds' talons, bat wings, lizard skin, and so on). (See chapter 8.)

TIP Some students may produce shadow puppet pieces that are too small or narrow for the hole punch. Encourage them to work larger, and to solve problems with Scotch tape and grafts of larger pieces of paper taped on.

Appropriate Subjects

Many subjects are appropriate for shadow puppets: animals, composite creatures (page 114), dinosaurs, and athletes are just a few. Shadow puppets work well for profiles (side views) of movable subjects. Creatures that grow, metamorphize, or transform, such as insects, amphibians, and magical beings, are also good subjects, because pieces of paper can be folded in or out, and pieces added, as required.

VIEWING

Indonesian shadow puppet

Figure 9.40. Puppet making is an excellent way to connect creativity, design, and play. Puppets often tell stories, acting as characters in myths and folk tales. Many cultures throughout history have created their own distinctive version of the puppet. Indonesian shadow puppets, *Wayang Kulit*, are moved between a screen and a light source, and are often intricately carved. Legend has it that shadow puppetry was developed in Indonesia after the region became Islamic. Authorities no longer allowed religious figures to be publicly displayed. However, putting a screen between the puppet and the audience allowed for an image to be projected without breaking the law of idolatry.

Preparation

As a class, decide on a topic for puppets. Gather materials and visual references. Then, decide on the story genre – adventure, legend, fantasy, mystery, and so on – and on how students will approach the writing component (see page 140).

Process

Introduce your students to shadow puppets by looking at *The Enchanted Caribou* as a class. This book is illustrated entirely with paper cutouts. The last page shows how the puppets were constructed with movable parts.

Have each student pick an animal, character, mythical beast, or some other subject that relates to the classroom theme or topic of study. Explain to students that they will be making shadow puppets with movable body parts. Have students study the visual references available in the classroom so that they become familiar with their subjects.

Explain how each body part of the subject (legs, tail, wings, head, and so on) needs to be cut out separately. Now, demonstrate how to make the parts movable: Take two connecting parts (such a leg and the torso), and, with a single-hole punch, punch a hole in each piece where you want them to connect. Attach the two pieces with a brass fastener.

Ask students to think about how they can represent interior details (for example, eyes, mouth, fur marks) on their shadow puppets. Set up an overhead projector. Put some pencil marks on a piece of black paper, and use the projector to display the paper on the wall or screen. From this demonstration, students can see that pencil lines do not show up! Eyes and other details have to be cut out in order for light to show through and have them appear on the screen (figure 9.41).

Distribute black construction paper and scissors to your students. Encourage them to try out their puppets on the overhead projector as they work, so they will be able to see the shadow shapes reflected on the screen. When students finish their first shadow puppets, look again at *The Enchanted Caribou*. Point out how each picture contains several characters as well as background elements. Discuss with your students what they can do to make a whole picture. Ask leading questions such as: "What kind of place would this dinosaur live in? What would it eat? What might be close to it, or far away in the distance? What is it doing?"

Decide how students will record their stories. A story will emerge through puppet play – with more or less prompting – and students will require a format for recording the story. Some options include the following:

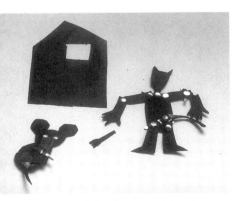

construction paper, Darlene Paranaque and Chantal Del Carmen, grade 3, Prairie Rose Elementary School

Figure 9.41. Darlene and Chantal created some interesting characters. Notice that details — such as the fingers and the fork — were cut out, not drawn.

- Students might use an overhead projector to help them play out a story – until they can decide on a beginning, middle, and end. They do not have to verbalize the entire story at this point. You may have to prompt them with a question such as: "What happens first?" Or: "Where is she going?" After students try the initial puppet play on the overhead projector, they might make an outline, story web, storyboard (see page 139), or quick rough draft of the story. Then, students can draw, write, or dictate their story.

- Stress the idea that stories have a beginning, a middle, and an end. Have students act out several scenarios with their puppets, then they can decide which scene comes first, which comes second, and so on. Ask them to describe what happens in each scene.

- Shadow puppets are good for demonstrating the characters, settings, and actions in a story. After students make shadow-puppet characters, prompt them with questions about where their characters live or where the characters might travel to. Have students cut out props and the pieces of the setting or background from black paper.

- Stories need an interesting problem. Help students make up starting points for their stories. If a shadow puppet is alone on the white screen, perhaps it has nowhere to live, or it has no friends or food. Ask students how the puppet will find these things (figure 9.42).

Janine Lea, grade 3, Pine Dock School

Figure 9.42. As students work, encourage them to use the overhead projector to test their puppets. Ideally, groups of students will gather at the projector, and small scenarios will emerge: "Pretend my cat is chasing your bird...," "...and then my bird flies away and hides in a tree." "We need to make a tree!" Characters, action, and settings are quickly created during these sessions.

Have students complete all their shadow puppets (for example, T.rex attacking a hapless diplodocus) and background elements (volcanoes, trees, grass, clouds, and so on), and write a beginning, middle, and end to their stories. When they have done all of this, they are ready to tell their stories to their classmates, using the puppets in a play or as illustrations. Have them try one, or a combination, of the following approaches:

- Use the overhead projector as a shadow-puppet screen.

- Attach wooden slats to the puppets' movable parts (slender pieces from a bamboo window blind will do). Construct a shadow-puppet theatre; hang up a white sheet, and use an overhead projector or gooseneck lamp behind it as a light source.

- Use the puppets as stencils. Trace the puppets onto paper in a variety of poses. Outline the background pieces (trees, stars, houses, and so on) with a black pen, and add colour with tempera paint, watercolour paint, or pencil crayons.

- Trace the shadow puppets onto coloured construction paper in a variety of poses (figure 9.43), and use paper cutouts to decorate a story (see *How the Animals Got Their Colors* for ideas).

- Use a photocopier to make illustrations directly from the shadow puppets. (Have a volunteer work with a student at the photocopier.) The photocopy becomes a black-and-white illustration. If students have written a story, have them cut out the text and place it beside the shadow puppet, so that both the puppet illustration and the text appear on the same photocopied page. This

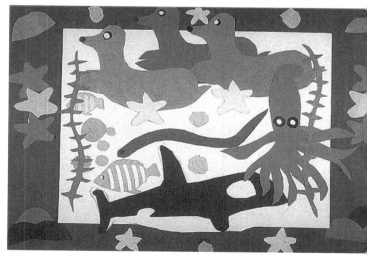

paper cutouts, Maria Juliana Rufo, grade 3, Wellington School

Figure 9.43. Students can easily change their shadow puppets into paper cutouts. Trace puppets onto a variety of coloured papers. Encourage students to trade pieces with classmates so they have a variety of characters in their pictures. For details, pattern, and a border design, students can decorate with more cutout shapes.

Shaman Puppet, Nicole Selkirk, age 7, Pine Dock School

Figure 9.44. Nicole's inspiration for making her puppet came from prints by Inuit artists. The shaman's face is inside the two-headed bird image. The whole creature folds into an egg shape and can "hatch" into the more complicated image.

VOCABULARY

atmosphere	perspective
background	pop-up book
balance	pose (gesture)
border	profile
character	props
composition	scale
concertina	scene
contrast	setting
end papers	shadow puppet
expression	shape
font	storyboard
frame	text
gutter	thumbnail sketch
illustration	transform
line	unity
manuscript	vantage point
metamorphosis	visual reference
movement	(see appendix B for definitions)

is a very simple and effective illustration technique, which allows students to change the position of the puppets and move pieces of the background to tell their stories.

Additional Exercises

Here are some additional exercises to extend the activity:

- Make shadow puppets that can change from one kind of creature to another – transformers, insect metamorphism, shamans, magical beings, and so on. This can be done by making more than one head or extra body parts: (1) Attach body parts using one brass fastener. (2) Fold each part separately, out of sight over the body. (3) Use the same fastener to attach wings and arms. (4) Make a tail that folds out, and attach it to the fastener. (5) Add additional pieces as required. This idea also works for creatures hatching out of eggs, creatures that are growing, and so on (figure 9.44).

- Put pieces of clear plastic in cut-out windows of black paper, then attach "floating" pieces to the plastic. This works well for small parts; for example, the iris in an eyeball, an x-ray view of stomach contents, or objects that should look like they are floating. Students may also draw on the plastic with overhead projector markers.

- Attach sticks or wires to stiff paper pieces to make proper shadow puppets. Cut out a window in a large cardboard box or piece of Coroplast. Construct a simple screen out of thin, white paper, and adhere the screen paper into the window. The box may be decorated to look like a puppet theatre; however, the puppets will be behind the screen – only their shadows are visible to the viewer. Students will need to work in groups to present their stories this way. They may need coaching on developing their characters' voices and voice projection (figure 9.45).

Darlene Paranaque and Chantal Del Carmen, grade 3, Prairie Rose Elementary School

Figure 9.45. These shadow puppets were manipulated on the bed of an overhead projector while the students read their story aloud.

GRAPHIC DESIGN 10

INTRODUCTION

TOOLS & MATERIALS

- sketchbooks
- pencils
- art media of choice (The examples in this chapter use computer graphics rendered in PowerPoint. For other suitable software, see appendix D. Students can also use traditional art media (such as pencil crayons or paint) to experiment with graphic design.)
- optional: see Additional Exercises (page 162)

Graphic design and illustration are closely related. However, the emphasis in graphic design is on commercial arts, including advertising, magazine pages, CD and book covers, page layouts, typography (font or letter design), maps, medical drawings, T-shirts, posters, and websites. Design may also include other practical applications in specific areas, such as fashion design, interior design, landscape design, and product design.

Commercial art is typically a more condensed art form than illustration, and the visual narrative (story), or message, may need to be communicated in a single image or a single symbol. Graphic design art may also incorporate text design, or typography, as part of the composition.

In this chapter, students find out how they can become educated consumers of commercial art, and they create their own graphic design projects. Students interested in pursuing careers related to art and design require skills in composing images (see chapter 8), creative problem solving, and using computer graphics applications. Students may also be interested in multimedia applications, such as animation (see chapter 21) and video (see chapter 22).

VISUALS TO HAVE HANDY

magazines, newspapers, book or CD covers, product packaging, video, television

Preparation for Graphic Design Projects

Before students begin working on their own graphic design projects, select several popular advertisements. As a class, view and identify the advertisements, using the variables listed below.

1. Message or product: What is the product or message that is being promoted? The choice of topics offered to students should relate to an area of study. Ideally, the topic will have a community connection, a real-life application, or provide career experience. Some examples include environmental responsibility, fundraising for a charity event, or a campaign poster for a favourite book character.

2. Audience: Who is the target audience for the message, or who is likely to buy the product? Students can conduct a survey to find out how their target audience feels about a particular message or product, or what advertising approach they might respond to.

3. Format: What is the most effective format being used to convey the message, or to sell the product? Some examples include magazine and newspaper advertisements, television and radio ads, CD, DVD, magazine or book covers, calendars, scrapbooks, flyers, T-shirts, banners, posters, cards, product packaging, logos, billboards, signs, and websites.

4. Medium: Which art medium was used to create the advertisement? What media will students use for their project? Graphic designers use a range of media and tools, including photography, collage, computer graphics, printmaking, paint, and pen and paper. Look carefully at the media used in a variety of examples (figure 10.1).

5. Composition: What elements and principles of design stand out in the advertisement? Have students look carefully at the composition of a variety of well-designed advertisements or packages. (There are links to award-winning advertisements on the Internet).[1] Which principles of design will students focus on for their project? (See chapters 8 and 11.)

6. Text: What are some unusual or effective word choices in the advertisement? Look for creative typography. Challenge students to find or create examples of interesting typography, concrete poetry (poems with words that form the shape of their subjects), or images integrated with text (figure 10.2).

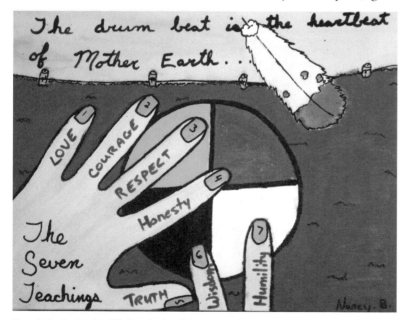

Nancy, high-school student, Villa Rosa. Teacher: Rhian Brynjolson

Figure 10.1. In this painting, Nancy has incorporated text directly into the painting and added a medicine wheel to symbolically communicate her ideas.

1. A good source is the Cannes Lions advertising awards video. Go to: <http://video.google.ca/videosearch?q=cannes+lions&hl=en&emb=0&aq=f#>.

7. Eye-catcher or "hook": What hook was used to get the viewers' attention? Hooks are used in advertising and in packaging. We see thousands of ads, logos, signs, and packages in a day. What approach will students use to get the viewers' attention? Advertisers use a variety of devices, such as:

- Cuteness. The "awww" factor works when we see babies, fuzzy animals, or bubblegum pink and other pastel colours.

- Insecurity. Ads play on our insecurities about how we look or on how successful we can be. Without their product, they say, we will be social outcasts or financial failures.

- Cool factor. These ads show images of rich, fashionably dressed people. The people are often air-brushed (blemishes removed) and digitally altered to be taller or thinner than they are in real life. We might believe that if we buy the product we can be cool, too.

- Target groups. These ads show people who are the same age, wear the same types of clothing, and have the same identifiable characteristics as the target audience.

- Star power. Famous actors, singers, and athletes are featured or quoted. If you recognize the star, you might take a second look at the message or product.

- Humour. Funny ads get our attention, and we tend to think positively about the message or product.

- Statistics. "Two out of three people prefer" our product. The numbers might not mean much, but we might believe the message anyway.

- Testimonial. Someone tells you a story about how much the product helped them, so you believe it will help you, too.

- Action and expression. Dramatic movements, such as dancing, leaping and falling, or facial expressions, such as wide grins or grimaces, add interest and emotional content.

- Shock. Ads sometimes use surprising, disturbing, or controversial concepts to get our attention.

- Simplicity. If we would only buy the product, everything would be easy, and we would be happy.

- Good design. The composition of the ad is beautiful or visually interesting, aiming to hold our attention longer.

This is only a partial list. Challenge students to identify the hook as they observe advertisements or look at commercial packaging. Challenge them to include a hook in their own design project.

Process for Graphic Design

The process for developing graphic design projects is similar to that of illustration projects. Students use a storyboard to develop an idea, and they experiment with a variety of compositions (page 139) until they find a solution that is visually interesting and communicates their idea clearly. Alternatively, or as a next

Figure 10.2. There are many interesting fonts available in word processing applications. Here are three examples. WordArt offers more options.

This is the original painting Nancy made in order to experiment with graphic design.

Text was added with Quick Styles and Effects.

When the image is selected, the formatting palette allows for colour changes. Here the image is slightly transparent, allowing the background colour to show through.

A small image allows more emphasis on text.

Figure 10.3. In this series (above, and page 161, right), Nancy's painting was photographed, imported to computer, and altered using PowerPoint. This is an example of how students can use very basic software to experiment with graphic design.

step, they may use computer software to experiment with a variety of compositions. As a teaching device, have students save some of the early versions of their process work (those that they consider to be unsuccessful). Use these as discussion pieces for how they made their choices about composition.

Process for a graphic design project:

1. Choose the variables of the project: message or product, audience, format, art medium, or computer program (see appendix D), composition, text, and eye-catcher or hook.

2. Research the variables. For example, look at similar messages or products, survey the target audience, and collect samples of the chosen format (flyers, packages, and so on).

3. Collect visual references (for observational drawing), and collect other visuals, including good examples of similar designs by other graphic artists. Collect these in a sketchbook, or as JPEGs (a standard compressed computer file format recognized by most programs) in a computer folder or on a memory stick.

4. Use a sketchbook, storyboard, or computer software to experiment with composition, write the text, and plan the design. Practise drawing parts of the subject, as needed (see chapter 5), or explore the various tools in a computer program.

5. Find, or create, interesting typefaces (fonts or letter designs) that suit your project. Letters have their own character and mood (figure 10.2).

6. Select two or three of the most successful draft copies, and discuss them. Challenge students to articulate the parts of their compositions they think are most successful. Students may meet in small groups, or they can conference with the teacher individually.

7. Discuss the criteria for the project, and encourage students to revise their designs.

8. Use art media or computer graphics to create a good copy. Suitable art media include: pen and ink, collage, relief printmaking, watercolour or acrylic paint, photography, video, and animation. Almost any art medium can be used, and then photographed, so the artwork can be integrated into the composition. Encourage students to explore the medium and feel comfortable with it, before applying it to their design.

9. Photograph and display the finished projects.

10. Ask students to reflect on the process they used to develop their design and share their insights with others. What problems did they encounter? What strategies did they use to solve problems? Will they look at graphic designs differently now that they understand some of the processes involved?

Using Computer Graphics

The process for a computer graphics project will vary, depending on the software that is used (see appendix D). Choose a software application that is suitable for your students and the project variables you have selected (figure 10.3). There are a variety of software programs available for graphic design, presentation, animation,

and editing photographs and video. You can preview many of these software programs on the Internet, and video tutorials, free downloads, or free trial periods are available for many programs.

Here are some general tips for integrating information and communication technology (ICT) successfully into your art program:

- Start small. For example, begin by having each student create one page of a class PowerPoint presentation.

- Test the compatibility of all the equipment and software beforehand (see digital images, chapter 21), and try the project yourself to anticipate where students might require extra assistance.

- To avoid frustration, teach each component skill of the project. Alternatively, teach a few students the process, and have them tutor their peers, so that each student gets help when needed.

- Set up separate files, or provide students with flash drives, or CD-Rs, and teach them how to save their work. It is frustrating when files are accidentally deleted and hours of work are lost.

- Share knowledge and resources with other teachers. Specialize in specific aspects of a new technology, and then swap classes with other teachers who have learned about other programs, hardware, or approaches.

Computer Graphics and Media Literacy

Computer graphics are important tools for graphic design and commercial art projects. New technologies can help users create and manipulate images, add text design, and produce clean, high-quality images that were once the domain of professional artists and typesetters. Accessible software programs mean that younger students can now use computers to create illustrated research projects and multimedia presentations. Computers can hold the attention of reluctant learners and help them produce a slick-looking product they can take pride in.

Photography can provide a link between students' creative artwork and graphic design. Artwork in any media can be photographed and imported into computer applications (see chapter 21).

The use of computers has some disadvantages, such as cutting and pasting text and images that are not credible, not fully understood by the student, or not properly acknowledged. Students may also tend to spend more time on the appearance of their presentation than on the content, they may be distracted by the quantity of information, or they may visit non-educational websites.

The essential questions that teachers need to address is: How will we teach our students how to evaluate what is real or factual, and which sites are reliable sources?

Here are some exercises that encourage students to be critical viewers:

- To witness the manipulation of images in advertising and challenge the assumption that "seeing is believing," have a look at how photographs are altered. One good example is the video *Evolution*, sponsored by Dove,[2] which

2. Go to <http://www.dove.ca/en/default.aspx#/features/videos/video_gallery.aspx[cp-documentid=9150719]/>.

When the image is selected, different effects can be applied.

Spotlight

A spotlight lightens the image so that text can be applied.

Saturated colour changes the intensity.

The hues have been changed, and WordArt is applied.

The image is cropped, and a small selection is enlarged.

shows, in fast-forward, how make-up is applied to a woman's face to change her appearance. Then, a photograph of her face is further altered with a computer graphics program: Her neck is lengthened, her eyes enlarged, blemishes are airbrushed out, and so on. The woman's face is then placed on a billboard advertisement. The "real" woman is gone; the advertisement appearing on the billboard is a graphic designer's version of beauty. Advertisers create an ideal that a real human can never live up to and, thereby, create demand for their beauty products. Discuss with students what the implications might be for a young person who is continually exposed to images of idealized beauty.

- Balance ICT and hands-on learning. Provide opportunities for experiential learning to supplement the virtual experiences of the computer screen and television. For example, provide hands-on experiences with the topic of study, encourage actual cutting and pasting, ask students to design their own letters after viewing examples of typefaces or graffiti art, and try relief printmaking in addition to digital printing.

- Set up a reality test. Choose advertisements or websites that can be verified by student testing. Challenge students to create scientific tests to check the claims of various companies. For example, does one brand of paper towels really absorb "more than other leading brands"?

- Use the technology. Start with the real experience, and take photographs to document, for example, a field trip or the growth of seedlings. Then, import the photos into the computer. This gives students a sense of the origin and processes that might have been used to create – and alter – the so-called "factual" material they are viewing.

Additional Exercises

- Research the variety of careers that require expertise in graphic design and computer graphics. The list includes architecture, engineering, fine arts, illustration, technical drawing such as medical drawing, advertising, fashion design, landscape design, and mapmaking.

- Challenge students to find examples of interesting graphic and product designs in their homes and around the community. Suggest that they look at signs, CD covers, magazine or book covers, packages, clothing, cars, running shoes, and so on.

- Integrate graphic design with other subjects. For example, make an ad for a simple machine that was created in science class, print an invitation for a class recital, create a concrete image (built with lettering) from a favourite passage in a novel.

- Find comparative examples of graphic designs; for example, two similar types of crackers with different box designs, or a second edition of a book with a cover that is different from the book's first cover. Challenge students to evaluate which design suits the product best, and which parts of the composition are most, or least, effective.

Olivia Gude

PRINCIPLES OF POSSIBILITY
adapted from an article by Olivia Gude[1]

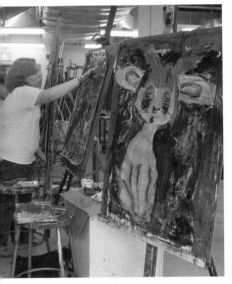

Teen artists created expressionist, brushy paintings while investigating the minor aesthetic concept of cute. Spiral Workshop: Painting: So Cute and Creepy. 2007

Olivia Gude speaks with passion about making art education meaningful, and she cites the need for art education as *"meaning making experiences* that engage and empower." [2] Gude outlines several "Principles of Possibility" that should be as fundamental to an art program as the principles of design.

Playing: Gude reminds us that "artists immerse themselves in a process of making, and sensitively interact with images and ideas as they emerge." Students who are accustomed to fixed goals and outcomes may need to discover or reclaim their ability to explore and experiment. Gude uses games played by Surrealist artists to encourage creative play, and suggests that teachers model a positive attitude toward experimentation.

Forming Self: Creating art can be important in the development of self and identity. Gude suggests that "(q)uality projects aid students in exploring how one's sense of self is constructed within complex family, social, and media experiences." Art assignments need to be about more than learning media, tools, and techniques. Assignments also need to address ideas of importance and relevance to students' lives.

Investigating Community Themes: Involve students in exploring community and global themes through community art projects such as "artworks, thematic shows, documentaries, posters, installations, murals, zines (student-made magazines)." These forms allow for personal engagement, a critical approach to an issue, as well as dialogue with a wider audience.

Encountering Difference: Multicultural themes and artworks help us to "see the world through the eyes of others – understanding the meaning of artworks in terms of the complex aesthetic, social, and historical contexts out of which they emerge." Gude stresses the need to provide context and to encourage a depth of understanding with selected artworks and artists. Contemporary artists need to be included as a primary source for providing that context, as well as for demonstrating continued cultural relevance and evolution of art and ideas.

1. Used with permission
2. *Art Education*, January 2007, Volume 60, No.1.

Attentive Living: "Drawing, painting, and photographing natural objects and phenomena sensitize students to the complexity and beauty of the world around them." Young artists learn to experience and appreciate the nature world, as well as the human-made world of architecture and design. Students can also begin to look critically at the psychological and social impact of design and advertising.

Empowered Experiencing: Art education should teach critical-thinking skills required to make meaning of contemporary society. Students who learn to view artworks critically, and engage in description, analysis, interpretation, and evaluation, are learning skills that transfer to other areas of study, and to other areas of social and political discourse.

Empowered Making: Art education is important because we all view, make, alter, present, or distribute images. Gude suggests that a balanced art program would include expressionism, realistic depiction, formal ideas, applied design, crafts and "do-it-yourself" projects, post-modernism, and digital technology.

Students explored how metaphors of the monstrous shape self and society. Spiral Workshop: Drawing Danger: Making Monsters. 2005

Deconstructing Culture: Contemporary art and art theory offer surprising and often powerful deconstructions and insights into aspects of visual culture. Gude offers two examples of deconstructions that turn common images or assumptions inside-out. "*Bricolage/Counter-bricolage* (the practice of making new meaning out of the pre-made materials at hand, including advertisements aimed at youth)" and "*detournement* (artists working with this method used parts of famous artworks and altered them to produce surprising and subversive new images) connect students to a rich tradition of subversive avant-garde artists."

Reconstructing Social Spaces: Students can be involved in reshaping their communities and construct a new way of seeing community spaces:

> Working collectively, students and teachers can literally reshape their schools and communities through creating murals, mosaics, sculptures, pavements, seating, installations, theme-based school art shows, magazines, pageants, projections, websites, videos, and countless other art forms.

Poetry and images transformed the cafeteria into the Marvelous Surrealist Café at Evers Elementary School. 2002

Not Knowing: Students learn that there are many ways of seeing, and learn tools for questioning assumptions. "They learn how to play, not just with materials, but also with ideas... these students will not mistake representations for reality as such. They will be able to entertain new ideas and new possibilities."

Gude concludes by saying: "If it is indeed true that our notions of what is real and what is possible are shaped in cultural discourses, we art teachers have the potential to change the world."

Olivia Gude teaches at the Spiral Workshop, University of Illinois, Chicago.

For more information on curriculum research by Olivia Gude, go to the Spiral Art Education website: <http://spiral.aa.uic.edu>.

Embracing mess led to exciting individual and collaborative artworks. Spiral Workshop: Drawing "Dirty" Pictures. 2007

Rhian Brynjolson, *A Curious Subject*, acrylic latex on canvas, 26" x 30"

PART **4**

WORKING IN COLOUR

In previous chapters, you and your students explored drawing, design, and the process of developing an image, as well as the elements and principles of design. Colour is also an element of design. Colour theory, painting techniques, and care of tools and materials are discussed at length in this section. In practice, however, techniques for working in colour are normally integrated with drawing and composition.

Colour media, such as paint, collage, pastels, crayons, and modelling clay, are fun, tactile media to work with. All encourage experimentation and enthusiasm for visual art.

When I was in art school, one of my painting professors referred to some colours of paint as "juicy," "sour," or "sweet." You often hear people refer to a particular colour as "depressing," "calming," or "happy." Colour can evoke a visceral or emotional response in the viewer. So, too, can the act of painting. There is a certain pleasure to pulling a paintbrush or fingers through the pudding-like

consistency of thick paint. For both of these reasons – to experience a vivid range of colours and to get the proper paint consistency – it is an advantage to use good-quality materials. The experience of painting and the end product are enhanced when the paints are not runny or lumpy liquids and the colours are not chalky. Paint chemistry has recently improved tempera paints. True colours are now available in block and liquid forms. You can purchase relatively inexpensive watercolour paint in small tubes; these provide more intense colours than do student paint boxes.

Modelling clay varies tremendously – from sticky, unworkable goop or old crumbly lumps, to quality brands that stay pliable for months and do not stick so persistently to tabletops. Through experimentation and financial circumstances, you will find your own balance between making do with what is in the school supply cupboard and using new materials.

COLOUR THEORY 11

INTRODUCTION

Colour is an element of design.[1] In this chapter, you will find information on the basics of colour theory. Colour theory includes the nature of colour and how to mix colours. Use this chapter as a reference for chapters 12–17. If students encounter problems with colour media, you can look for solutions in this chapter.

Figure 11.1. Students at École Constable Edward Finney School use eyedroppers to measure and mix colours.

Adapt the exercises to the ages and abilities of your students. Beginners need experience with colour mixing to learn to predict how colours will interact. Younger students might be presented with trays of paint that contain only two colours, the three primary colours (red, yellow, and blue), or black and white. Students might find only yellow and red paint at the painting easel one day and notice that when the colours are mixed together they make orange. For older students who are inexperienced in art or who lack confidence with painting, colour exercises may also be a good introduction to painting. When students are encouraged to experiment with colours in various combinations, they are discovering how to mix the secondary colours, tints, and shades.

Students can use any colour medium to practise mixing colours, including oil pastels, pencil crayons, crayons, collage, sculpture, and paint. Paint is the preferred medium, as the liquid colours mix thoroughly to make secondary colours more recognizable and uniform (see chapter 12 for tips on painting). The exercises in this chapter are a good introduction to the messy, liquid qualities of paint. The exercises also provide students with an introduction to the routine of using paint in the classroom. This is a good time to establish the physical set-up for painting and storing paint supplies, as well as routines students can follow to access materials and clean up. Delegate specific clean-up jobs to the students, and paint-proof your classroom. This will make the tasks less stressful and ensure that painting remains an enjoyable and frequent activity in your classroom (see appendix C).

1. Shape, line, texture, value, form, and space are the other elements of design studied in this book (see chapter 5).

BOOKS TO HAVE HANDY

PICTURE BOOKS

The Cremation of Sam McGee by Robert Service, illustrated by Ted Harrison.

My Busy Colours by Pan Macmillan, illustrated by Angela Brooksbank.

TEACHER REFERENCES

Color by Betty Edwards.

COLOUR EQUATIONS

primary + primary = secondary

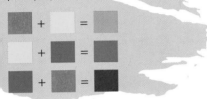

Fasica's (age 4) colour book, Wellington School. Teacher: Jennifer Cobb

Figure 11.2. Fasica is learning how to mix primary and secondary colours.

TOOLS & MATERIALS

- paint: tempera (liquid or block paints), acrylic, or watercolour
- trays (for distributing paint): Styrofoam egg cartons for liquid paint, small trays for watercolour)
- palettes: white Styrofoam trays or plastic lids
- paintbrushes: variety of sizes and shapes
- paint smocks
- containers (for water): wide and flat-bottomed containers help to reduce spills
- newspaper to cover tables (or wash tables after painting)
- paper: try a variety of papers such as heavy construction paper, watercolour paper, and Bristol board (see appendix A)
- pencils
- paper towels
- water
- erasers
- sketchbooks
- optional: see Additional Exercises (page 177)

COLOUR THEORY

Be aware that colour theory in art is different from the science of light. The primary colours in the light spectrum (red, green, and blue) combine to produce white light. The primary colours in materials such as paint (red, yellow, and blue), are used in combinations to make thousands of colours, and produce a dark brown or grey when mixed together.

Primary and Secondary Colours

The three primary colours are red, yellow, and blue. These three colours can be mixed in different combinations to produce other colours. Secondary colours – orange, green, and violet – are those that result from the mixing of two primary colours (figure 11.2).

MIXING COLOURS

One basic exercise is to start with a colour wheel. Show students how to draw a colour wheel: Make a circle on a piece of paper. Divide the circle into six sections (like a pie), and pencil in the names of the primary and secondary colours in the following sequence: red, orange, yellow, green, blue, and violet (figure 11.3). Explain to students that they are going to paint their colour wheel with these six colours, but they are going to use only three colours of paint – red, yellow, and blue – to do so.

Students should get into the habit of mixing colours on palettes or trays before painting the colours on paper (figure 11.4). This gives them more control of the colours they are mixing. When students are mixing colours, make sure they start with the lightest colour and gradually add small amounts of the darker colour.

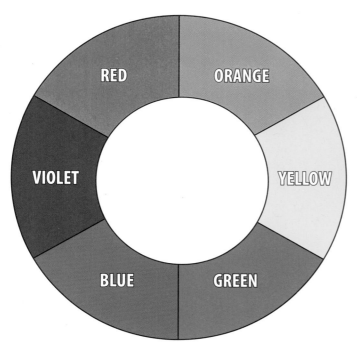

Figure 11.3. Colour wheel

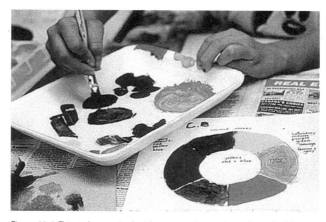

Figure 11.4. This student is using liquid tempera paint to paint a colour wheel. Some brands of red paint contain a yellow pigment; students may end up mixing a violet that is almost brown. The problem can be solved by using a "cool" red paint.

For example, when they are mixing yellow and blue, have them start with yellow and add a small amount of blue. Remind them to clean off their paintbrushes before dipping the brushes into a new colour. This way, they will avoid polluting the colours. Some painters work with several brushes at once, reserving a brush for a specific colour.

Tertiary Colours

Students can also practise mixing tertiary colours. Tertiary colours are those that result from combining a secondary colour (orange, green, or violet) with more of one primary colour (red, yellow, or blue). Tertiary colours include green with yellow and violet with blue.

Hues, Pigments, and Dyes

Paint colours are not true hues (a hue is a pure colour) – paints are mixed with pigments and dyes that often contain a number of hues. If the paint you are using is labelled "red," it may actually contain any number of colours, ranging from cool violet-red to fiery orange-red. Mixing orange-red with blue may result in brown or maroon rather than violet! You need to experiment with paint brands and types, or even with food colouring, to find true hues that accurately produce the colour equations for your students.

Pigments are natural minerals that are mined from the earth, such as ochre and cobalt. Dyes are vegetable-based. The source of the material explains the interesting names and varying toxicity of some artist-quality paints, such as ochre, cobalt, titanium, cadmium, umber, and sienna. Student-quality paints are less toxic, but the colours are less exact. Student paints are also less lightfast (less permanent) than artists' paints.

TIP Some varieties of red paint are actually orange and, when mixed with blue, make brown rather than violet. You will need a "cool" red, or you will have to "cheat" and provide purple paint.

TIP To make bright, solid colours, it is important not to mix too much water with the paint. Dry brushes on paper towels before dipping into liquid paint. Use minimal amounts of water with block paints. Some brands of paint are much brighter and have a thicker consistency than other brands.

Sunflowers, Sophom Nhem, grade 6, Wellington School

Figure 11.5. Sophom used an analogous colour scheme of yellow, green, and blue for her field of flowers.

Analogous and Complementary Colours

Explain to students that colours next to each other on the colour wheel are *analogous*. For example, yellow, orange, and red are analogous colours (figures 11.3 and 11.4). These colours harmonize easily in a painting – if they are similar enough they blend in when next to each other (figure 11.5). Colours opposite each other on the colour wheel are called *complementary*. For example, red and green are complementary colours, as are yellow and violet and orange and blue. Placed next to each other in a painting, each complementary colour stands out and contrasts the other.

Look for analogous and complementary colours in the classroom and community, in artworks, and in picture-book illustrations. Experiment with paintings that use only two or three analogous colours, or two or three complementary colours. For vibrant colours in a painting, place complementary colours next to one another (figure 11.6). When complementary colours mix, they become reduced (see page 173).

Dry Dock, Steven Bothelo, grade 6, Wellington School

Figure 11.6. Steven used a complementary colour scheme of red and green, and strong contrasts in white and black, for his painting of a boat. He outlined with black pencil crayon after the paint was dry.

Reduced Colours

Brown and grey are made by mixing any two complementary colours (red + green, orange + blue, yellow + violet) together. These mixed colours are called *reduced colours*, because the pure hues become less brilliant (figure 11.7). Brown is a difficult colour to mix, because paint colours are not true colours – they are mixed with pigments and dyes that often contain a number of hues. Balance the colour with a touch of its complement (the colour 180 degrees opposite on the colour wheel) until an acceptable brown is achieved. If the mixture is too green, add a touch of red. If it is too orange, add a touch of blue. If it is too yellow, add a touch of violet.

Colour and Depth

Reduced colours may be used to produce an illusion of depth in the backgrounds of paintings, because reduced colours appear to recede. On the other hand, pure, brilliant hues appear to "pop out." Place pure colours in the foreground of an image, or use them to create a focal point – our eyes are drawn to the brightest colours first. You can still paint a red shape into the background of a painting, by cooling the red slightly with blue or by reducing the red with a small amount of green.

Cool and Warm Colours

Colours may be described as having a temperature (figures 11.8 and 11.9). Cool colours are the colours of ice, shadows on snow, and water, and include blue, blue-green, and blue-violet. Warm colours are fiery, or sunny, and include orange, red-orange, and yellow-orange. Even a warm colour, such as red, has a range of temperatures, from cool alizarin crimson (slightly violet) to warm cadmium (slightly orange).

Colour, Mood, and Atmosphere

Particular colours can produce different moods or atmosphere, and this can be applied in painting or to interior design. Reduced colours and cool colours can produce a calm or somber atmosphere. Blue is often equated with sadness. Yellow and pastel colours (colours tinted with white) are lighter in appearance and mood. Pure hues and complementary colours produce tension or excitement.

Colourblind Artists

Students who are genuinely colourblind may be able to mix secondary colours – especially if the paint tray is labelled – but they may have trouble with more subtle mixes. Usually, colourblindness is limited to a specific combination of complements, such as red-green or violet-yellow. Depending on the situation and the students' preferences and personalities, you may provide them with specific formulas (or pre-mixed paint), or you can accept their "accidental" combinations as simply their own way of seeing.

Bowl of Fruit, block tempera on paper, Danna Slessor-Cobb, age 10

Figure 11.7. The artist used reduced colours in this painting. Danna mixed every colour she used with a small amount of its complementary colour to produce an overall brown or grey effect.

Polar Bear, block tempera on paper, Danna Slessor-Cobb, age 10

Figure 11.8. Danna used a range of cool colours for her polar bear.

Lion Cub, block tempera on paper, Noni Brynjolson, age 11

Figure 11.9. Noni used a range of warm colours in her painting.

tempera paint, Charlene Moneyas, age 14, Wanipigow School

Figure 11.10. To make tints, start with white paint. Using a small amount at a time, add a chosen colour until a "true" colour is achieved. The result should be a gradual transition from light to dark.

tempera paint, Noni Brynjolson, age 11

Figure 11.11. To make shades, begin with a chosen colour. Add a small amount of black at a time. The result is a gradual transition from light to dark.

Tints and Shades

Colours have values as well as hues. Value refers to the lightness or darkness of a colour. Tints are colours in which white has been added to make the colour a lighter value. Shades are colours in which black, or another dark colour, has been added to make the colour a darker value. The addition of black can cause the colours to become dull and grey. Using dark brown, dark blue, or a dark violet usually produces a richer dark value. For a clear example of tints and shades in artwork, look at book illustrations by Ted Harrison (see Books to Have Handy, page 170).

A simple exercise for exploring tints is to paint a grey scale, or value chart (figure 11.10). Have students follow these steps:

1. On a sheet of paper, draw a long rectangle, and divide the rectangle into several boxes.

2. Paint the first box white.

3. Select a colour. Mix white paint on a palette with a small amount of the selected colour. Paint this mixture inside the second box.

4. Add a bit more of the selected colour to the mixture on the palette, and paint this mixture inside the third box.

5. Continue in this manner until all of the boxes are painted.

Students will notice that the colour becomes progressively brighter, from white at one end of the chart to the pure hue on the other end. The colour progresses from a lighter to a darker value.

The same method can be used to explore shades. Distribute sheets of paper and have students do the following (figure 11.11):

1. On the sheet, draw a long rectangle, and divide the rectangle into several boxes.

2. Select a colour, and paint the inside of the first box with that colour.

3. Mix the colour on a palette with a very small amount of black, and paint this mixture inside the second box.

4. Add a bit more black to the mixture on the palette, and paint this mixture inside the third box.

5. Continue in this manner until all of the boxes are painted.

Students will notice that the colour becomes progressively darker, from the selected colour at one end of the chart to black at the other end. The colour progresses from a medium to a very dark value. Note that adding black can cause the colours to become dull and grey. Experiment with using dark brown, dark blue, or a dark violet to produce richer dark values.

Students may try any of the value exercises (see chapter 5) with paint or other colour media. It may take some practice for young artists to see the light and dark values of a colour. Try monochrome paintings (using one colour plus black and white) as an introduction to painting values.

Transparency and Opacity

Transparency refers to whether or not the viewer can see through the paint to the surface underneath (such as a window pane). Watercolour paint is a very transparent medium, allowing areas of white paper to show through and giving the illusion of light. *Opacity* refers to how well paint covers up the surface. Wall paints and primers have a great deal of opacity, to hide the previous paint colours and irregularities underneath. Tempera paint and gouache are more opaque than watercolour.

More or less water or medium added to paint will produce more or less transparency. A semi-transparent wash of paint is a watered-down version of a colour. Add water to tempera and watercolour paints, and water and acrylic medium to acrylic paints. Gloss medium will add a shine to acrylics; matte medium produces a dull, or flat, surface. Oil paints contain toxins and are diluted with mineral spirits and oils that make them too toxic for classroom use.

Students may use paint to try any of the value exercises (see chapter 5). Have them mix their paints on a palette with varying amounts of water to produce light and dark values. Challenge advanced students to paint with white paint on a dark surface.

Colour Harmony

Some colours appear to clash, while others harmonize. Artists like Pierre Bonnard can make colours sing (figure 11.12). To produce colour harmony in an artwork, try some of the following approaches:

- Use a limited palette (a limited number of paint colours). Use the same primary hues to mix the secondary and tertiary colours in the painting. For example, using the same blue to mix greens and violets will add unity.

- Begin with a monochrome version of an image. Paint the image in one colour, plus white and black. Add small amounts of other colours, mixing each with a small amount of the initial colour.

- Gather paint sample cards from a paint or hardware store. Sort and match colours until you have a few colours that harmonize with one another. Mix paint to match your sample cards.

VIEWING

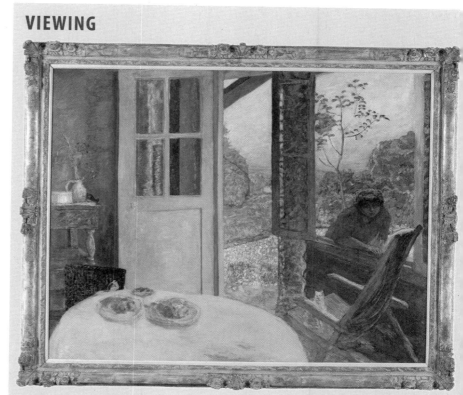

Pierre Bonnard. *Dining Room in the Country.* 1913.

Figure 11.12. In Bonnard's paintings, colours are used in an almost surreal way. He uses very small brush marks, which capture the light and movement of a scene. Bonnard's colours are symbolic rather than representational. They express an inner state, rather than simply capturing what is visible. His work helps us to understand that colour is not just an abstract element, but is connected to our memories and emotions as well. Ask students to use a certain colour repeatedly, or suggest they use unusual colours next to each other, as a way of experimenting with and coming to new understandings about colour.

- Tint each colour in your palette with a bit of white, and experiment with different tints of the same hue. Colours will harmonize more easily if they are all the same value.

- Begin with a painting that is monochromatic or analogous, then mix a complementary colour of the same value, and use a small amount in one part of the painting.

Colour Schemes

A colour scheme is a set of colours that harmonize, balance, or emphasize one another. Analogous or complementary colours may be used as colour schemes (figure 11.13). Another simple approach is to use triadic colour (three colours), such as primary colours (red, yellow, blue), or secondary colours (green, violet, orange).

Colour and Meaning

Colour can have symbolic meaning. Artists may use the symbolism of colours to add depth of meaning to their works. Colours may have specific cultural or religious meaning, or associations. Think of holiday colours, flags, costumes, and religious artifacts. Symbolic creations, such as Tibetan sand paintings and Ojibwa medicine wheels, have particular teachings connected to each colour. Colour can have emotional and sensory impact, as in "seeing red" or "feeling blue." Colour also has political associations with, for example, skin colour, flags, and the Green movement.

Skin Tones

Skin tones can be challenging colours to mix. Skin tones range from tinted peach, rich brown, to a nearly black blue-brown. For very light skin tones, mix yellow with a small amount of red and white. For browner skin, mix a rich, reddish brown, or burnt sienna, and tint slightly with white. Add more yellow or red as necessary. For dark skin tones, mix browns, such as burnt umber, with a touch of blue, and shade with black. All skin tones will appear to be a lighter value where they reflect light, and will appear darker where a shadow falls. Be conscious of referring to all skin tones positively and inclusively; you might try naming them as caramel, chocolate, coffee, peach, and so on. Some brands of paint and pencil crayons are available in sets labelled "people colours."

Playing with a variety of bright colours to represent people can be a way to build tolerance and discuss issues of racism and community in an imaginary context. Using unlikely analogous or complementary colours in portraits can produce some interesting effects: Mixing in a complementary colour can produce a reduced colour for shadows and darker values.

Figure 11.13. Nancy used a garden catalogue as her initial reference, and then she mixed acrylic paints to create inventive colour combinations.

Additional Exercises

Here are some additional ideas for using colour in the classroom:

- Colours may be introduced in limited combinations so that students can explore colour mixing in a controlled way. For example, put out two colours in a pre-school paint centre, and allow young artists to "discover" that yellow and red mix to make orange.

- Use colour as an element of study. You might introduce a monochromatic project. For example, put out all-green sculpture materials; look at all-green paintings; find objects, foods, clothing, or animals that are green; and practise "green" behaviours such as recycling.

- Introduce colour theory as a set of colour exercises that are a companion to more creative projects. Students who are adept at drawing, but have limited painting experience, may be willing to try small-scale experiments in their sketchbooks. In this case, students can work systematically through the aspects of colour theory: primary, secondary, tertiary, analogous, complementary, reduced, warm and cool, mood and atmosphere, tints and shades, monochromatic, transparency and opacity, colour harmonies, meaning and symbolism, and mixing skin tones.

- Analyze the colour schemes in the classroom, the community, advertising, fashion, professional artworks, and students' artworks. Try mixing and using particular sets of colours that apply to the topic of study or are of interest to students (figure 11.14).

- Make a monochromatic painting. Look at a variety of houseplants, then draw and paint some of the large leaf shapes in various colours of greens. For example, mix hundreds of variations on the colour green by tinting with white, shading with violet, warming with orange, cooling with blues (intense or even fluorescent), and reducing with brown.

Green, grade 1 students, Wolseley School

Figure 11.14. This display of student work was a result of work by two teachers, Donna Massey-Cudmore and Andrea Stuart, who teach art as a well-integrated part of their curriculum. The graph at the top is a math exercise. Students measured varying amounts of yellow and blue food colouring, using an eye-dropper to count drops onto pieces of paper towel. The results were then pieced into a graph.

VOCABULARY

analogous	palette
atmosphere	pigments
background	primary
colour spectrum	reduced colours
colour wheel	scheme
complementary colours	secondary colours
cool colours	shade
harmony	space
hue	symbolic
intense colours	tertiary colours
monochromatic	tint
mood	transparency
opacity	warm colours
paint: acrylic, tempera, watercolour, gouaches	(see appendix B for definitions)

Mackayla took this portrait shot at Art City.

Spotlight
COMMUNITY ART CENTRES
by Rhian Brynjolson

Creelynn's close-up shot shows contrasting textures.

Community art centres can be valuable resources for your young artists and your art program. Many centres provide after-school programs, drop-in activities, art exhibits, events and murals, gallery space for student shows, and opportunities to network with artists. Many of the artists are more than willing to visit schools, give arts training workshops for teachers, and offer other partnerships for providing arts programming.

ART CITY

Located in Winnipeg, Manitoba, Art City[1] is a non-profit community art centre in the city's West Broadway neighbourhood. The centre provides high-quality, free-of-charge, art programming to participants of all ages. Wanda Koop, Art City founder, artist, and activist, says: "We are not necessarily making artists, we are giving people the opportunity to think creatively, and my feeling is that if you can think creatively, you can survive almost anything."

Art City provides drop-in art programs for children, teens, and adults as a way to enrich both the local community and the city's arts community. Local and international artists, as well as art students, are hired to run imaginative programs. Workshops encourage self-expression, communication, and creativity; they foster a sense of self-worth, ownership, and accomplishment for participants. Past projects include parades, beautifying community garden spaces, murals, exhibitions and workshops

Andrea's photograph captures some young photographers in action at Art City.

Marissa took this photograph in her neighbourhood.

1. Source: <http://artcityinc.com/media/>. Used with permission.

in photography, drawing, painting, screen-printing, sculpture, clay, hip-hop dance, music, video, and "sock monster" puppets.

Art City also works in partnership with schools and community groups to provide on-site programming. For example, one inner-city school applied for funding to run an after-school program. Artists arrived in a van, unloaded tubs of art supplies, and got to work with small groups of students. Through this portable drop-in program, students were able to try a variety of media and techniques, such as silkscreen prints, painting, photography, jewellery-making, and sculpture. The program gives students opportunities for self-expression outside the demands of a formal curriculum. Art City artists are also good role models and interact well with students.

GRAFFITI ART PROGRAMMING

Graffiti Art Programming Inc. (G.A.P.)[2] is a not-for-profit community youth art centre in Winnipeg that uses art as a tool for community, social, economic, and individual growth. G.A.P. crosses genres, working with artists in traditional art media, urban art (including hip-hop art, graffiti art, and street art), Aboriginal art, contemporary art, performance art, and video. Free programming is offered to youth and their families.

Through programs, exhibitions and events, an artists' cooperative, and its website, G.A.P. promotes youth art, provides studio space where young artists can take creative risks, contributes to neighbourhood beautification and community development, and fosters a sense of creative cooperation and self-healing.

My own experiences with G.A.P. led to a workshop for art teachers on graffiti as an art form. The workshop began with a visit to G.A.P. for a visual presentation and discussion of graffiti art. We then tried our hands at cutting stencils, designing letters and images, using a variety of spray paints and nozzles, and sampling an assortment of permanent markers. This experience helped us to appreciate both graffiti as an art form and G.A.P.'s work to bring training and recognition to young artists.

Student photographs were displayed at the Graffiti Gallery, in a partnership with community arts organizations and the United Way.

Opening night at *One Life: One Lens*. The exhibition of young artists' photography was well attended!

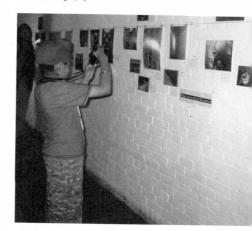

A young photographer helped to document the exhibition.

2. Source: <www.graffitigallery.ca>. Used with permission.

LEARNING TO PAINT 12

INTRODUCTION

This chapter explores basic painting techniques, tools, and materials (see chapter 11 for introductory exercises on colour mixing and colour theory). The painting techniques are for thick paint and are appropriate for tempera, gouache, latex, and acrylic paints. For information on using more transparent colour, see chapter 14, Watercolour.

TOOLS & MATERIALS

- pencils
- erasers
- sketchbooks
- paper (a variety of heavy papers work with paint, such as heavy construction paper, Bristol board, cardstock, heavy wrapping paper; see appendix A). Students can work with smaller brushes on small papers, 8½" x 11" (21.5 cm x 28 cm) or with bigger brushes on larger paper, canvas, cardboard, or wood.
- tempera paint blocks, or liquid tempera or acrylic paint set out in foam egg cartons ("cool" red, yellow, blue, white, black), one set per two to four students
- paintbrushes, assortment of flat-head (square-tipped), ½" to ¾" (1.5 cm to 2 cm) sizes; larger brushes are required for larger surfaces)
- wide, flat-bottomed water containers (wide containers tip less easily)
- newspapers for covering tables (or wash tables afterwards)
- paint smocks
- rags or paper towels
- access to a sink, or two large pails of water (one for clean water and one for dumping paint water)
- soap and water for washing brushes
- optional: chalk
- optional: see Additional Exercises (page 185)

tempera paint on Bristol board, Clinton Whiteway, grade 4–8 class, Matheson Island School

Figure 12.1. Clinton paid careful attention to light and dark values, accurate colour, and interesting brush marks in this painting of a fox.

BOOKS TO HAVE HANDY

PICTURE BOOKS

The Cremation of Sam McGee by Robert Service, illustrated by Ted Harrison.

Josepha by Jim McGugan, illustrated by Murray Kimber.

TEACHER REFERENCES

Color by Betty Edwards.

messy table in an artist's studio

Figure 12.2. Students can use a variety of paints. Check to ensure they are non-toxic and safe for classroom use. Good-quality paints will produce more satisfactory results. Cover tables, and have students wear paint smocks when they are working with acrylic paints.

TIP Have paper towels handy to "erase" spills if mistakes happen or paint is dripped across a page. Paint can be erased by gently dabbing the area with a clean, wet brush and then with a paper towel. When the spill is dry, paint over it with thick paint tinted with white.

TEMPERA, ACRYLIC, AND LATEX PAINTS

Tempera paint is a versatile medium, and, like artists' gouache, it is fairly opaque (not transparent). Tempera paint can be used in a variety of ways, including the following:

- It can be applied in thick layers with a fairly dry paintbrush.

- It can be mixed with more water for a wash, or watery application, of paint that lets pencil or permanent pen lines show through. This painting technique is a good one to introduce to students who are more comfortable with drawing media than they are with paint media.

- It can be combined with other colour media. First, draw with oil pastel or crayon, and then paint over top with watery tempera. The oil or wax will resist the paint, and the drawing will show through.

- Use thick tempera paint on top of collages or to decorate masks and sculpture.

- Paint on a variety of surfaces – for example, burlap, rocks, pieces of wood, or cardboard boxes.

- Coat tempera paint with a gloss finish such as PVA (an acrylic gloss medium) to brighten colours, give a shiny finish, and preserve the otherwise powdery surface.

Acrylic paints are available in a range of qualities from washable paint (similar to tempera) to artist-quality paint that tends to be more lightfast (permanent and non-fading), much thicker, and of truer colour. Latex paint is typically used as interior house paint and comes in larger, less expensive cans than acrylic paints. Latex paint can be found at paint and hardware stores in a wide range of colours, which makes it the preferred paint for murals. These paints are permanent on a wide range of surfaces such as paper, wood, canvas, and other natural materials.

Some disadvantages of using acrylic and latex paints in the classroom are the following:

- Some acrylic and latex paints are toxic. Buy only student-grade brands that are labelled *non-toxic*.

- Some students have latex allergies.

- These paints may not wash out of clothing or rugs. Even washable acrylic paint may stain clothing.

- Paintbrushes must be washed thoroughly with soap after each session.

- They are more expensive and more challenging to control than tempera paints.

Appropriate Subjects

For beginners, choose easily recognizable subjects in simple settings. Help students find visual references (for example, magazine and book photos, postcards) that have clear pictures of their subjects in settings with interesting colour ranges. For the starting exercises, students can use landscapes from calendar photos or close-up photos of animals from wildlife magazines. Ideally, the pictures will relate to topics being studied by the class. Encourage students to avoid scenes or

subjects that contain too much black. Remind students that they will be reducing their subjects to simple shapes; the more details, the more challenging their subjects will be to paint.

As an alternative, find images with interesting colours. With students, make viewfinders by cutting windows out of cardboard or file folders. Ask students to find interesting colours (or particular mixtures of colours, such as tints, shades, or analogous colours; see chapter 11) and place their viewfinders over the colours. Challenge students to reproduce the colours in the viewfinders and paint an enlarged version on their paper. These more abstract images can provide a safe beginning for students who are not confident with drawing (figure 12.3).

Preparation

Set out materials (see page 181). For liquid tempera or acrylic or latex paints, put out colours in Styrofoam egg cartons – you can close the lids and re-use the paint for up to two weeks. Use plastic lids or Styrofoam trays as palettes for mixing colours. For block tempera paints, set out paints in standard plastic trays or individually in tuna cans, and have Styrofoam trays or plastic lids available for students to use as palettes. Place books and irreplaceable photos inside large Ziploc bags or plastic sheet protectors to avoid paint splatters.

Process

1. Observing

 Look at *The Cremation of Sam McGee* with your students. Make sure students note the wavy bands of colour in both the sky and snow. The colour of each band is very similar to the one next to it. Select one picture in the book, and ask students how many different tints and shades of one colour they can see in it.

 Hold up a copy of *Josepha*, and, as a class, look at the sky on the book's cover. The wavy bands of clouds and variety of colours are similar to those drawn by Ted Harrison in *The Cremation of Sam McGee*. The drawing in each book is quite simplified – every subject is reduced to its most basic shapes.

 As a class, discuss some of the differences between the two books. One difference is the clean lines between colours in Harrison's work and the rougher edges in Kimber's work.

 Point to different areas of each picture, and ask students which colours the artist of each might have mixed to make a particular colour.

2. Drawing

 Tell students that they are each going to use pencil or white chalk to make a simplified drawing of their subject on a large piece of paper (figures 12.4 and 12.6). They are to draw only the basic shapes, and avoid detail and shading. Some students may wish to try a few quick practice drawings in their sketchbooks first to get a feel for their subjects and to decide which background elements will fit into their drawings. Ask students to divide up large areas of their backgrounds with wavy lines and irregular shapes. These might

detail of group art installation, grade 3 students, Wellington School. Teacher: Rhian Brynjolson

Figure 12.3. Abstract explorations with paint can be quite beautiful. This piece, by a grade 3 student, has expressive brush marks and drips, a contrast of light and dark values, and complementary colours (red and green).

pencil sketch, Madelaine Calanza, age 11, Wellington School

Figure 12.4. Madelaine made this sketch in preparation for painting. The landscape has been reduced to its most fundamental shapes.

correspond, roughly, to shapes of clouds, shadows, or colour changes in their photographs. Students may choose to handle edges with either a clean edge (or oil pastel line) or with brush marks overlapping the areas of colour (figure 12.5).

3. Painting

Students are now ready to begin painting. Arrange desks or tables so that students can easily share paint materials. Have them look carefully at their subjects for areas of reflected light and shadow that appear to change the colour of their subjects. Remind students to pre-mix their colours on their palettes and to use a rich variety of colours, tints, and shades.

Even advanced students will find it useful to mix small colour swatches on scrap paper or newspaper to match the colours in their subjects before they start their paintings. This procedure serves as a reminder to students to mix a variety of colours rather than use the paints straight from the containers. Remind students to wash and dry their paintbrushes before using a new colour. Suggest that they start with the lightest colours (whites and tints) and use darker colours, especially black, last. Also, suggest that they avoid painting small details (eyelashes, for example). It is acceptable to leave these out, and easy to add in fine details later with a coloured pencil, chalk, or oil pastel (figure 12.7).

Encourage students to experiment with a variety of brush marks. Demonstrate how a paintbrush is pulled rather than pushed, so that the bristles remain together. Light pressure, or turning a square brush edgeways, will produce a fine line. More pressure will produce a thick line. Paint can be dabbed on in dots or in overlapping marks. Brush marks can swirl to convey movement, or their length and direction can correspond to the texture of an animal's fur.

Rich layers of colour can be achieved by allowing one colour to dry and then painting over top with other colours to add highlights, shadows, textures, or patterns. As advanced students finish their paintings, help them look for details – light reflections, shadows, and textures – that they may have missed. Often, a few light reflections, such as the gleam in an eye or the sparkling on water, will help add life to young artists' paintings.

> **TIP** Set the black paint aside until near the end of the session. This will encourage students to mix other dark colours to achieve shades and will prevent black from mixing with other colours and turning them grey. Use black last.

Sometimes We Can't Make It On Our Own, acrylic on canvasboard, Misty, grade 12 student. Teacher: Rhian Brynjolson

Figure 12.5. Misty used masking tape to create the clean, straight edges in this painting. The geometric composition, recurring image of the tree, and the text provide unity.

Canada Geese, Jamie Scott, age 13, Matheson Island School

Figure 12.6. (left) Jamie began his picture by drawing with chalk onto a large, coloured piece of Bristol board. (right) He worked carefully to match the colours and values of his reference photograph.

Additional Exercises

Here are some additional exercises your students can do to learn painting techniques and explore a variety of painting tools and materials:

- Use one of the following to combine paint techniques with observational drawing:

 - Make observational drawing with pencil, crayon, or pastel. Cut out, and glue it onto a painted background.

 - Use coloured chalks, pastels, or permanent felt pens to draw on top of the dry paint.

 - Paint background colours with thick paint, and then draw into the wet paint with the "wrong" end of a paintbrush.

- Use a deliberate colour scheme for the entire painting: monochromatic, analogous, complementary, warm colours, cool colours, tints, shades, reduced colours, or intense colours (see chapter 11). Try the colour schemes systematically: Make a simple sketch, photocopy it several times, and paint a different colour scheme on each photocopy. Compare the different effects of each approach. Alternatively, draw simple arrangements of still-life objects such as flowers, fruit, toy dinosaurs, or stuffed animals. For each lesson, discuss the desired colours of paint to use, or discuss which colour scheme would be appropriate for each subject.

Killer Whale, Bradley Mowat, grade 7, Matheson Island School

Figure 12.7. After the paint dried, Bradley added some details and highlights with soft pastel (chalk).

- Coat finished tempera paintings with PVA (a type of acrylic gloss medium) to give them a shine and brighter colour. Dab the PVA on carefully so that the colours do not run together.

- Look at paintings by other artists. Examine what kinds of colours, brush marks, and subjects they painted. Advanced students might like to paint a detail of one of these artists' works to learn more about brush handling and colour sensibilities (figures 12.8 and 12.10).

- Create an entire painting using small dots of colour. This approach is called *pointillism*. See paintings by Georges-Pierre Seurat for examples. Artists such as Vincent van Gogh, Claude Monet, and members of The Group of Seven, painted in the impressionist style – they used loose, overlapping marks to represent the light and shadow and colours in an image. American painter

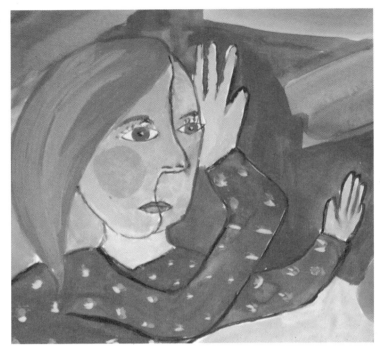

block tempera on paper, Noni Brynjolson, age 11

Figure 12.8. Noni made this painting after she visited a Picasso exhibit.

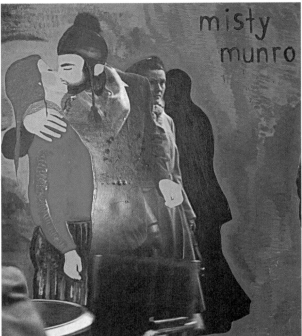

Misty, grade 12 student. Teacher: Rhian Brynjolson

Figure 12.10. Misty found a poster of a famous photograph and painted over the image to produce her own artwork.

Jackson Pollock painted in the expressionist style, using brush marks and drips of paint to decorate the surface of his paintings. Encourage students to experiment with a variety of brush marks and styles in their own work (figure 12.9).

■ As a class, paint a mural or large painting (figure 12.11). Use sturdy brown butcher paper, cardboard, or plywood, and provide large house-painting brushes. Students can work in groups, taking turns at painting specific areas. Pieces can also be painted on separate paper, cut out, and then glued into the mural, so that the whole piece becomes a large collage. For very large murals, cut 4' x 8' (1.2 m x 2.4 m) sheets of plywood into 4' x 4' (1.2 m x 1.2 m) sections that can be managed and stored in a classroom. These panels can be installed on a large wall, or the exterior of a building, after they are painted.

■ Mix sand, laundry starch, fine straw, or other materials into the paint to vary its texture and transparency. Glue a variety of objects onto a surface before painting. Challenge students to identify what elements they are adding to their painting; for example, shapes cut from cardboard, lines created with string, the textures of mesh bags or pieces of pegboard.

■ Paint with different brushes (thick, thin, long-handled) or use sticks, sponges, homemade paintbrushes, rollers, and so on to achieve a variety of marks. Also, make very small paintings 6" x 8" (15 cm x 20 cm) with tiny (#6) brushes. Play background music, and vary the rhythm of the brush marks to the rhythm of the music.

Ashley, grade 12 student. Teacher: Rhian Brynjolson

Figure 12.9. Ashley experiments with paint marks. A beautiful surface can be painted with splatters and paint drips.

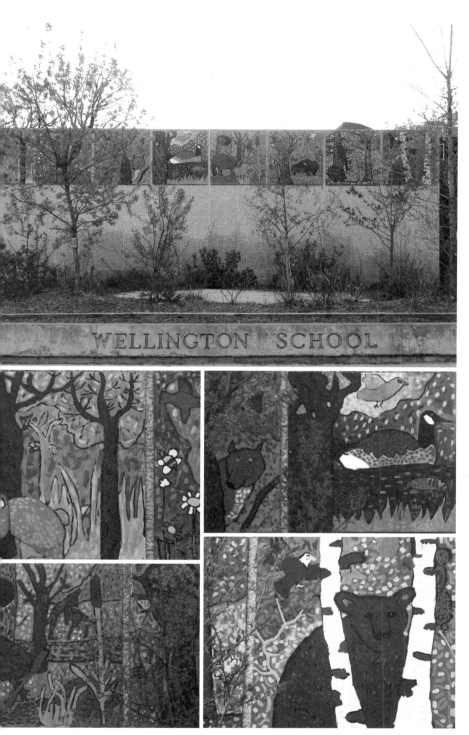

acrylic paint
analogous colours
background
brush marks
collage
colour scheme
complementary colours
expressionism
gouache
hue
impressionism
intense colours

latex paint
monochromatic
mural
opacity
palette
pointillism
reduced colours
shade
tempera paint
tint
transparency
(see appendix B for definitions)

Figure 12.11. This mural was painted by students at Wellington School in Winnipeg. Students worked indoors, in small groups, on 4' x 8' (1.2 m x 2.4 m) plywood panels. The theme of the mural was Manitoba animals in their habitats, which fit the science curriculum. The mural was then installed on the outside of the building, and a ceremony was held to unveil the mural for the community. The trees in front of the mural were planted as part of a boreal forest project and are native to the area.

EXPLORING PAINT WITH BEGINNERS 13

INTRODUCTION

Painting can become a regular part of classroom activity. Establish a painting centre in a quiet corner of the classroom, by setting up an easel with a supply of paint and paper. Alternatively, provide students with access to a cupboard of supplies near a table.

During non-directed painting times, students can learn about how to handle paint, how paint drips, and how colours mix. They can experiment with their grip on the paintbrush, and learn how to move their arms, wrists, and hands in order to make a variety of marks. Very young students may talk to you as they paint. They may describe a person, a house, or an event as they give their thoughts, as experiences form, and as they work out relationships and scenarios on paper. Dialogue and communication through the visual symbols in their paintings are important to students. Studies show that students spend twice as long at a drawing or painting activity if an adult is present to offer conversation and encouragement (Brittain 1979). Learning to communicate through visual symbols also has obvious importance as a pre-writing exercise.

Young students are not troubled if their painted symbols of objects do not correspond to actual appearances. Their satisfaction derives more from the act of painting than it does from the aesthetic qualities of finished products. Adults may compliment these paintings, and see some of them as "pretty," but what they value in the painting is not likely to correspond to the students' original intentions or values.

Figure 13.1. This young artist at Wellington School has been given a limited palette of blue, white, and black at the painting centre, so he can discover the effects of adding tints and shades to a primary colour.

The painting techniques that follow are probably not new to most of you. What is of interest is how the paint explorations are combined with collage to produce a finished image. This process represents the best of pedagogy in early childhood education: The child is able to explore and discover without excessive adult assistance, the process teaches valuable concepts and skills, and there is a recognizable product that will be valued by most viewers.

In this chapter, you will find the following:

- Exercises students can do to explore painting techniques freely and still produce the kind of recognizable, completed image that is valued by adults and older students.

- Collage exercises that give students opportunities to handle scissors, glue, and a variety of painting tools.

- Techniques for using students' beginner-level paintings to make simple book illustrations.

Students will explore paint techniques and learn how to combine their paintings with cutting and pasting. This media-based approach is based on books by Eric Carle. Although the activities are most suited for younger students, older students will also have fun experimenting with different colours, textures, and patterns.

BOOKS TO HAVE HANDY

PICTURE BOOKS

The Mixed-Up Chameleon (and other books), written and illustrated by Eric Carle.

Who Is the Beast?, written and illustrated by Keith Baker.

TIP Spread out extra newspapers on the painting surface. There will be lots of wet paper, and you will need lots of drying space. Print students' names on the newspapers or on the backs of their paintings. Later, this will make paintings easier to sort.

TIP For easy cleanup, have a pail of soapy water available to soak paintbrushes, rollers, toothbrushes, and so on. If you do not have a sink in the classroom, have an empty pail available to pour used paint water into, and another pail of water handy for washing hands.

PAINTING TECHNIQUES

Preparation

Spread out newspapers on tables, and prepare the materials. You can do the painting exercises in one of two ways: (1) Introduce painting techniques one at a time over several days, each as a separate art activity. (2) Set up several centres around the classroom (you will need extra adults for this), and be prepared for one short, more hectic, session!

Explain to students that they will not be painting pictures. They will be experimenting with paint and trying to fill a whole page with interesting colours and patterns. Demonstrate each technique before your students try it. Keep the completed paintings in the classroom, as students will be using them later for cutting and pasting (see page 196).

These explorations with beginners are typically messy. Have rags handy. Students should wear old clothes or smocks. Tables should be set up in a tiled (not carpeted) area in case of spills. Clean up spills by placing newspapers over the wet area until the paint or water is absorbed.

You may want to anticipate which colours are most suitable for the topic of study, and set out the appropriate range of colours. For example, if the class is studying frogs, you might set out frog colours at one table, water lily colours at another, and pond colours at a third centre. This way, students will have coloured papers that correspond roughly to their subjects when they begin to cut and paste.

Process

Splatter Painting

- white or coloured paper (approximately 8½" x 11" [21.5 cm x 28 cm]), several sheets per student; construction paper or heavier paper is suitable
- scissors, several pairs
- tempera block paints (red, yellow, blue, black, white; optional: orange, green, purple, brown), several sets
- water and water containers (preferably with wide, flat bottoms)
- toothbrushes (one per student)
- paint smocks
- rags
- newspapers
- optional: objects such as toy spiders, leaves
- optional: window screen
- optional: see Additional Exercises (page 195)

TIP Gently tap excess water off the brush before rubbing the brush on the paint block.

TIP Make sure students point the toothbrush down at the paper and not up at their faces.

Have each student do the following:

1. Set out a sheet of paper.
2. Dip a toothbrush in water, and rub it on a paint block.
3. Aim the bristles down at the paper. Hold out a finger or a small piece of window screen. Push the loaded toothbrush over the finger (or across the window screen),
4. Let the paint splatter over the paper. It will end up looking like spray paint.

Splatter painting works with stencils, too. Have students make their own stencils from cut paper, or set objects (leaves, toy spiders, hands) on a piece of paper, and splatter paint around them. The stencils or objects leave blank spaces on the paper, surrounded by splatter painting. (This is a good companion exercise for teaching about shape and negative space, page 68.)

Encourage colour mixing. Students can do this by rubbing the toothbrush on more than one colour, or by splattering layers of a variety of colours (figure 13.2).

kindergarten class, Luxton School

Figure 13.2. Block tempera paint was used to make this splatter painting.

Sponge Painting

- white or coloured paper, 8½" x 11" (21.5 cm x 28 cm), several sheets per student
- tempera block paints (red, yellow, blue, black, white; optional: orange, green, purple, brown), several sets, or small amounts of liquid tempera in shallow trays
- water and water containers (preferably with wide, flat bottoms)
- paint smocks
- newspapers
- sponges (use large sponges cut into 3" [8 cm] pieces)
- paper towels (for wiping hands)
- optional: see Additional Exercises (page 195)

TIP To avoid puddles on the paper, squeeze excess water out of the sponges first. Encourage students to use their muscles as they wring out their sponges.

kindergarten class, Luxton School

Figure 13.3. Block tempera paint was used to make this sponge painting.

kindergarten class, Luxton School

Figure 13.4. Block tempera paint was used to make this impress painting.

TIP You can call impress painting "speed painting" – the paint must be very wet; avoid excessive brushing. For other interesting patterns, use objects such as bubble wrap plastic, keys, and leaves pressed into the wet paint.

Sponge painting leaves interesting marks on the paper (figure 13.3). Like plastic-wrap techniques (see Impress Painting, below), sponge painting is used for decorating walls and furniture. For more finished images, sponge painting can be used with stencils (see splatter painting) or with sponges that have been cut into a variety of geometric shapes. Repeating these shapes produces patterns (page 69).

Each student can do the following:

1. Set out a piece of paper.
2. Wet a sponge, and rub it on paint blocks.
3. Press the sponge onto the paper, using an up-and-down motion.

Encourage colour mixing: Dip the sponge into more than one colour, or layer the colours on the paper.

Impress Painting

TOOLS & MATERIALS

- white or coloured photocopy paper, 8 ½" x 11" (21.5 cm x 28 cm), several sheets per student
- tempera block paints (red, yellow, blue, black, white; optional: orange, green, purple, brown), several sets
- water and water containers (preferably with wide, flat bottoms)
- plastic wrap or bubble wrap, leaves, other flat objects
- paint smocks
- large paintbrushes (#12)
- newspapers
- optional: see Additional Exercises (page 195)

Impress painting is normally a watercolour painting technique. Impressing objects into wet paint leaves an interesting variety of marks in wet tempera (figure 13.4), and in acrylic paint as well.

Have each student do the following:

1. Set out a piece of paper.
2. Use a paintbrush to paint quickly on the paper, with any mixture of colours, to fill the page.
3. Press wrinkled plastic wrap into the wet paint – the wrinkles will produce a pattern in the paint. Leave until dry.
4. When the paint is dry, pull the plastic wrap off the paper.

Crayon Rubbings

TOOLS & MATERIALS

- white or coloured photocopy paper, 8 ½" x 11" (21.5 cm x 28 cm), several sheets per student
- tempera block paints (red, yellow, blue, black, white; optional: orange, green, purple, brown), several sets, or small amounts of liquid tempera in shallow trays
- water and water containers (preferably with wide, flat bottoms)
- wax crayons or oil pastels (pieces of old crayons without wrappers are best)
- assortment of flat objects with rough or bumpy texture (window screen, sandpaper, rubber-soled shoes, plastic netting, Lego block bases, pegboard, and so on)
- large paintbrushes
- sticks, plastic forks, or wide-toothed combs
- paint smocks
- newspapers
- optional: see Additional Exercises (page 195)

TIP Sometimes, the paint may completely cover the crayon. Reasons this may happen are: (1) the paint is too thick (solution: dab the painting with a wet paintbrush or a paper towel to remove the thick paint, add more water to the paint, and repaint the area), (2) the brush has been rubbed back and forth over the crayon image excessively (solution: dab the paint with a paper towel), or (3) the crayon was applied too lightly (solution: try again, pressing harder with the crayon).

kindergarten class, Luxton School

Figure 13.5. Crayon rubbings

Rubbing crayons over various surfaces is a good way to explore texture and pattern (see pages 73–75). Review texture with your students. Remind them that texture is how something feels when it is touched. Have students touch their hair, a tabletop, a carpet, the bottom of their shoes. Ask them to think about how each texture feels.

Challenge students to find objects that have hard, rough, or bumpy surfaces (figure 13.5). They can use objects found in the classroom, in a natural environment, or at home. On a table, set out objects that have rough or bumpy textures (for example, onion bags, corrugated cardboard, Lego bases, or math blocks).

Now, have each student do the following:

1. Select an object from the table.
2. Place a piece of paper over the textured object, and hold down the paper firmly over top of the object.
3. Rub the side of a crayon over the paper and object, pressing hard. This method of producing marks is also called "frottage" by artists.
4. With a large paintbrush and watery paint, paint over the rubbing; the wax crayon will resist the paint.

Roller Painting

Painting with a roller and painting with a brush have very different feels to them. Roller painting is a good technique for filling in large areas of colour on a mural, making background for display, or repainting a wall (figure 13.6).

Have each student do the following:

1. Set out a piece of paper.
2. Dip the roller in the paint, and roll it back and forth on the paper.

3. Dip the roller into other colours to layer and mix colours on the paper.

4. Let the paint dry, and wash rollers thoroughly after use.

- white or coloured photocopy paper, 8 ½" x 11" (21.5 cm x 28 cm), several sheets per student
- liquid tempera paints (small amounts of red, yellow, and blue in shallow trays)
- paint smocks
- several soft rollers or brayers, 4" to 6" (10 cm to 15 cm) (Small, foam, wall-painting rollers may be substituted.)
- newspapers
- optional: see Additional Exercises (page 195)

Students can make their own stencils. Cut shapes out of old file folders, place on paper, and go over them with a roller dipped in paint. The stenciled area will remain blank. Green painters' tape, available at a paint or hardware store, can also be used to create a pattern on stiff paper or Bristol board; roll paint over it and then peel off the tape.

Students can also use a stick, plastic fork, or wide-toothed comb to draw into the wet paint.

kindergarten class, Luxton School

Figure 13.6. Roller painting

COLLAGE: CUTTING AND PASTING

- photocopy paper, white or coloured, 8 ½" x 11" (21.5 cm x 28 cm), several sheets per student
- scissors, one pair per student
- painted paper (gathered from previous sessions)
- glue or glue sticks
- optional: construction paper, pencils
- optional: see Additional Exercises (page 195)

In this cut-and-paste exercise, students use paintings from the previous sessions to make cut-and-paste pictures or book illustrations. This technique is based on Eric Carle's picture books. Carle must have great fun experimenting with paint colours and effects before cutting and pasting pieces for the characters and settings in his illustrations!

TIP Do not provide glue until after students have arranged most of their pieces. It is easier to introduce the idea of overlapping and putting large background pieces underneath the main subject *before* the pieces have been glued.

Appropriate Subjects

For early years' students (K–1), a simple, recognizable subject, such as an animal, "my house," or a car works well. Subjects with obvious geometric shapes are easiest. For older students, find visuals similar to those in *Who Is the Beast?* that show a rich variety of patterns and colours, and complex, overlapping shapes.

Preparation

Explain the term *overlapping* to students. To do this, you will need visual references such as magazine photos, calendar photos, and picture books. Examine pictures that relate to a current topic of study; for example, an animal surrounded by jungle leaves, a person in a crowd, a car on a busy street. This is a good exercise for teaching prepositions: Use cutouts to demonstrate how one thing can be placed *in front of, behind, under, over, beside,* and so on.

Figure 13.7. These paint samples were left to dry after a busy painting session. They will be saved for cutting out shapes on another day.

Process

As a class, look at *The Mixed-Up Chameleon* (or another book by Eric Carle). Notice how parts of Carle's illustrations look like students' paint samples! Explain that Carle uses scissors to make his pictures. He cuts out each part of the subject separately and places the piece behind or in front of another piece. Show students how they can cut the edges of shapes to indicate texture; for example, a zigzag edge around the contours of a cat can indicate how furry it is.

Look at examples of students' subjects, and discuss what shapes students will need to cut out to make their subjects – for example, a jellybean shape for a bear's body and rectangles for legs. Demonstrate this method, showing students that small cutouts can even be used for details like whiskers. Make sure no pencils or felt pens are on the tables, as student will want to use these rather than small cutouts.

Tell students they are going to be cutting out shapes from their own paintings (figure 13.7). Ask them to choose their most interesting colours and patterns. Demonstrate how light-coloured or white pieces do not show up well on white paper. Suggest they use brighter coloured pieces, or paste their pieces onto coloured construction paper.

Pierre, nursery class, Wellington School. Teacher: Jennifer Cobb

Figure 13.8. Pierre, a proud young student, and his dad show a cut-and-paste picture.

Have students cut out shapes and arrange them on their sheets of paper. Show them how to glue down the background pieces before they glue down the objects in the foreground of the picture (figure 13.8).

Some older students may wish to draw the subject first, rather than simply cut out a shape. Suggest they draw the subject on the back of the painting. That way, when they cut out the shape, they can flip it over to the painted side, and the pencil marks will not show. Hand out the glue after students have had a chance to experiment with various placements (figure 13.9).

Additional Exercises

Here are some additional exercises students can do to build their awareness of various paint techniques:

- Use other painting techniques (figure 13.10) to produce the paint sample papers:
 - Make string paintings: Fold a piece of paper in half. Place a dab of paint and a piece of string inside the fold, close, and pull out the string. The string will move the paint to make interesting marks on the paper.

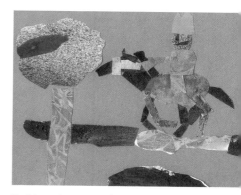

The Prince, paint, cutting and pasting, Joel Dyck, age 8, South Oaks School

Figure 13.9. Joel used his patterned papers to illustrate one page in a class book.

Iain Brynjolson, age 6, Luxton School

Figure 13.10. Iain made this bubble painting by blowing with a straw into a pail of water, dish soap, and paint. He then used the paper to catch the coloured bubbles.

Iain Brynjolson, age 6, Luxton School

Figure 13.11. There are many ways to create interesting marks on paper. For this painting, Iain placed paper, a few drops of paint, and a marble into the bottom of a lettuce dryer.

VOCABULARY

background	pattern
brayer	rubbings
collage	shape
cut and paste	splatter painting
illustration	texture
impress painting	watercolour
overlap	(see appendix B for definitions)

- Use washable felt pens: On a piece of paper, make a variety of lines with washable felt pens. Paint over the lines with water, and watch the colours run together.

- Make marble paintings or golf-ball paintings: Place a piece of paper, a marble (or golf ball), and a dab of paint in the bottom of a pan or lettuce dryer. Roll the pan from side to side (or turn the handle of the lettuce dryer). The marble (or the golf ball) will leave paint tracks on the paper (figure 13.11).

- Use sand: Mix sand with liquid tempera paint. This will make the paint thicker and give it a rough surface texture. Encourage students to mix colours together on the paper.

- Use watercolour techniques on paper to make a background to paste pieces onto: Mix food colouring and water, or dissolve half a tube of Pentel brand watercolour paint in a half cup (118 mL) of water. Paint onto good-quality (Dessin or watercolour) paper, and avoid over-brushing. For a grainy surface or snowflake pattern, sprinkle salt on small areas while the paint is still wet.

- Students can use their cut-and-paste pictures as the basis for a story, writing (or telling) to describe the illustrations they have already made. You may need to prompt them: "Your picture shows a cat walking on a fence. What happens next?" Or: "The cat is in a mud puddle! How did it get there? How will it get out?"

WATERCOLOUR 14

INTRODUCTION

TOOLS & MATERIALS

- student-grade watercolour paints (buy watercolour paint in tubes, place a small dot of each colour on a plastic tray or palette), avoid using white paint with beginners; allow paint to dry before using
- watercolour paper, or Dessin paper, torn or cut into small rectangles (cut large papers into approximately 6" x 8" (15 cm x 20 cm)
- soft paintbrushes, ½" (1 cm) in size
- masking tape (several rolls)
- paper towels
- water and water containers (wide, flat bottomed containers are less likely to tip)
- salt (in salt shakers)
- plastic wrap
- palettes (Styrofoam trays or plastic container lids), one per two or three students
- paint smocks
- felt pens (ultra fine-tipped, black, permanent, non-toxic, e.g., Sharpie)
- optional: sand (small amount of fine, dry sand)
- optional: white wax crayons or oil pastels
- optional: see Additional Exercises (page 201)

Watercolour[1] is an ideal medium for illustration. It is a much more transparent medium than tempera paint is, and it can be used overtop pencil or permanent pen drawings. Watercolour can provide brilliant colour and, when dry, can also be drawn over with pencils, pencil crayons, or pastels.

Watercolour techniques – wet-in-wet, salt, and impressing objects – result in beautiful marks and effects, even if the original drawing is weak. This makes them success-oriented techniques for students. Watercolours take a very short time to paint and to dry. In addition, the small size of the paper used – expensive paper that is torn or cut into roughly 6" x 8" (15 cm x 20 cm) pieces – makes it

VIEWING

Patrick Dunford, *The Beekeepers*. 2006.

Figure 14.1. Painting with watercolours can be a way of giving up some of the control we have when we use other media. British artist J.M.W. Turner popularized the medium in the 19th century, with his romantic scenes of extreme weather. Other artists have used watercolour to create a softer, lighter effect than oil paint would produce. In Winnipeg-artist Patrick Dunford's painting, two figures are painted loosely in a sepia tone. In this example, the artist used watercolour to capture and express the fluidity of memory. Without lines or texture, what we focus on instead are the soft patches of colour that blend together and give the painting the appearance of an old photograph.

1. See appendix A for a full description of materials for watercolour painting.

Autumn Forest, watercolour, Tyler Hammerstedt, grade 8, San Antonio School

Figure 14.2. Tyler began with a simplified pencil sketch, then used the wet-in-wet watercolour technique for his landscape painting.

BOOKS TO HAVE HANDY

PICTURE BOOKS

A Promise Is a Promise by Robert N. Munsch and Michael Kusugak, illustrated by Vladyana Krykorka.

Owl Moon by Jane Yolen, illustrated by John Schoenherr.

The Third-Story Cat, written and illustrated by Leslie Baker.

Would They Love a Lion?, written and illustrated by Kady MacDonald Denton.

The Yesterday Stone by Peter Eyvindson, illustrated by Rhian Brynjolson.

Posy! by Linda Newbery, illustrated by Catherine Rayner.

TIP You may substitute food colouring (diluted somewhat with water) for watercolour in a "wash." When diluted, colours are painted over an entire picture or a page of writing on regular paper. Food colouring has bright, accurate colour for colour-mixing and works with crayon-resist: Draw first with a white or coloured crayon, and then paint over with diluted food colouring.

TIP Paper will "pill," or roughen, if it is brushed too much. Just dab the colours on the paper, rather than brush back and forth. Quality watercolour paper (see appendix A) will not pill as easily as less expensive brands.

possible for students to produce a quick series of images required for an illustration project.

With watercolour paint, students can do the following:

- explore new materials and paint techniques
- combine drawing and painting
- produce small painted images quickly for a series of illustrations

Appropriate Subjects

A simple subject in a landscape – an animal in a field, a sailboat on a lake – provides an easy introduction to watercolour painting. Painting large background areas of a landscape, such as sky, water, or ground, allows students to experiment freely rather than paint inside the lines of a complex drawing.

Preparation

Put a small dab of each colour of paint (except white) around the outside of the palettes. Only a very small amount of each colour is required. Explain to students that because each colour is very concentrated, you have set out enough paint for about 20 paintings! Let the paints dry out before using them with beginners; this will prevent students from accidentally scooping the whole paint dot onto their paper. Avoid using white paint with beginners; it is not necessary, because adding water to the paint will increase its transparency and allow the white paper to show through. Using white watercolour paint may result in the colours appearing muddy. Fill water containers half full, and place with other materials.

Students can use masking tape to attach their pieces of watercolour paper to the tables to keep the papers flat while they work on them. Tell students to tape all four edges to the table evenly. The tape, when peeled off later, will create white borders around the edges of the paintings.

Process

As a class, look at watercolour paintings or at illustrations in books such as *Owl Moon, Would They Love a Lion?, A Promise Is a Promise*, and *The Third-Story Cat*. Point out to students how the colours in the illustrations run together (look especially at the last illustration in *The Third-Story Cat* and at the skies in *A Promise Is a Promise*).

Call attention to the horizon line in a landscape – the line where the sky appears to meet the ground. Remind students that the sky is not just a strip of blue at the top of the page.

Introduce your students to painting with watercolours by following the steps below to make a very simple landscape painting (a painting of land and sky):

1. Create sky and ground by using a pencil to lightly sketch a horizontal line across the paper.

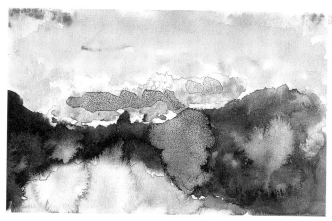

watercolour, Eden Jerao, grade 5, Wellington School

Figure 14.3. Using the wet-in-wet technique produces irregular edges.

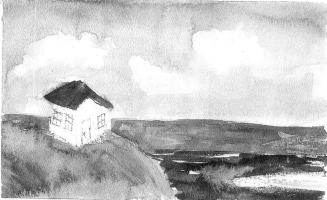

watercolour, Noni Brynjolson, age 11

Figure 14.4. Noni used crayon-resist for the house and the surf in this picture. She made clouds by using facial tissue to lift the blue paint off areas of the sky.

2. Apply white crayon or oil pastel on small areas of the paper that are to remain white – wax or oil will resist the water paint. While the paper is still dry, also draw on it with the crayon or oil pastel. With more experienced students, suggest that they use white crayon marks for white areas of a subject, light reflections, snow on a tree branch, and so on.

3. With a soft paintbrush, gently brush water onto the top half of the paper. Explain that with *water*colour paint, water is applied to the paper before the colour. This is called the *wet-in-wet* technique. Make sure the paper is thoroughly wet, and remove puddles by dabbing them with a tissue or paper towel (figures 14.2 and 14.3).

4. Involve students in your demonstration by asking what colours are in the sky at different times of the day, or in different kinds of weather. Gently touch the brush to the appropriate paint colour, then touch the brush to the paper. Remind students that only a very small amount of paint is needed.

5. Wash out the paintbrush before dipping it into a new colour. If the paper is wet enough, the colours will run and pool on the paper in interesting ways.

Tornado, watercolour, Michael Noh, age 9, St. John's- Ravenscourt School

Figure 14.5. Michael added texture by sprinkling sand onto the watercolour paint at the bottom of his picture.

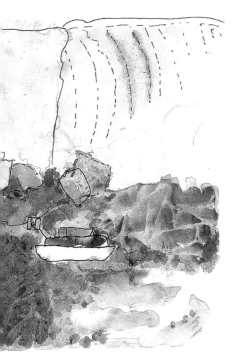

Waterfall, watercolour, Laura Chantharangsri, grade 5, Wellington School

Figure 14.6. Laura pressed wrinkled plastic wrap into the wet paint to produce a wave-like effect. Impressing other objects – bubble wrap, leaves, plastic mesh, and so on – will produce other interesting effects.

6. Make clouds or erase paint by scrunching a paper towel or facial tissue and touching or tamping the wet paint (figure 14.4). Produce a snowflake effect by sprinkling salt onto wet or damp painted areas, then let dry.

7. Paint water onto the bottom half of the paper.

8. Add the ground colours: blue-violet for snow; greens and yellows for grass; brown and grey for rock, and so on. Wash the brush before dipping it into a new colour. Mix colours by dabbing them next to each other on the paper. Rich mixtures of colour are the result of using more than one colour in a given area. Try adding small amounts of analogous colours into each area; for example, add small amounts of yellow or brown into green, add violet into blue (see chapter 11). You may need to wet the paper again before adding a second colour.

9. Sprinkle on a small pinch of dry sand (figure 14.5), or press wrinkled plastic wrap (figure 14.6) into the wet paint, and leave on paper until dry. Some of the sand will stick to the paper to provide a rough or gravelly surface. Plastic wrap will leave marks resembling leaf, rock, or wave patterns.

10. Allow paper to dry, then carefully pull the tape off the edges.

COMBINING DRAWING AND WATERCOLOUR

After students have explored basic paint techniques, show them some variations that produce a finished image or illustration.

Choose a subject, and gather visual references. Because students have begun with a landscape, the subject may be a simple object, animal, or person in a landscape. Alternatively, students may be painting an illustration for text (see chapter 9).

Look at *Would They Love a Lion?* and *Posy!* with your students. Notice the wonderful, wobbly, broken quality of the pen lines and how the colours overlap the lines. This is a good time to remind your students not to worry about painting over the lines. Some white edges and overlapping colours lead to beautiful watercolour effects (figure 14.7). The white edges of unpainted paper throughout the painting resemble light reflections, and they help to keep the image from looking muddy and overworked.

watercolour and ink, Eden Jerao, grade 5, Wellington School

Figure 14.7. Eden looked carefully at the reference photo, then drew contour lines with a fine-tipped black felt pen. This approach resulted in interesting, irregular shapes and an almost abstract image.

Have students do the following: Use a pencil to draw, or trace, one of their line drawings directly onto a small, blank piece of watercolour paper. Avoid shading in areas with a pencil. If desired, use black or brown, fine-tipped, permanent, non-toxic felt pens to trace over the pencil lines (see chapter 6) and then paint over with a wash (a watery layer) of watercolour paint (figure 14.8). Cut out the figure, and paste it onto the landscape painting, or continue painting the background on the paper. Start with the sky and other large areas. Very small areas and details may be washed over with watery paint, painted with a very small brush, or left blank, to be coloured with pencil crayons later, when the paper is dry.

Remind students to include salt, sand, tissue, and plastic-wrap techniques in areas where the effects will be appropriate to the image.

Additional Exercises

Encourage students to try some of the following exercises to practise their watercolour painting techniques:

- When using watercolour for illustration, work on very small paintings, 4" (10 cm) square, and produce them quickly (figure 14.10).

- Add collage with cut-out subjects (see chapters 6, 13, and 15). Since students have started to paint landscapes (or backgrounds), it makes sense for them to draw subjects or characters separately, cut them out, and glue them onto their paintings. They can then produce a number of images easily and quickly (figures 14.9 and 14.11) and glue them into prepared settings.

- Many objects produce interesting patterns when pressed into wet paint. Use bubble wrap plastic, leaves, paper towel, Lego, shoe soles, and so on.

- Advanced students can use the three primary colours to paint with watercolours. Have them layer the colours to produce secondary colours. First, use yellow in all areas that will be yellow, green, or orange, and allow to dry. Add a cool red hue in areas that will be red, violet, or orange. Paint over with blue any areas that are blue, violet, or green. Brown or grey areas will require layers of all three colours. This technique is called *glazing* and can be used with other paint colours as well (see chapter 11 for other colour combinations). Look at *Would They Love a Lion?* for examples of glazing.

- Use dry-brush techniques for night scenes or other scenes that require dark colours. Students might paint in most of the scenes with the wet-in-wet technique, let the paint dry, and then use slightly thicker watercolour paint, including white paint, gouache, or tempera on top to add more solid forms, light colours, and details with a drier brush. Interesting, irregular brush marks can be produced with an almost dry paintbrush.

T Is for Tulips, watercolour, Fasica, nursery student, Wellington School. Teacher: Jennifer Cobb

Figure 14.8. Fasica made this painting by drawing with washable felt pens and then painting a "wash" of water over the lines.

watercolour, cut and paste, Riley Gray, age 8, St. John's-Ravenscourt School

Figure 14.9. Riley drew and painted the bird, then cut and pasted it onto the swirling background. With cutouts, students can use watercolour techniques freely in the background and still add in a carefully drawn subject or character.

watercolour and salt, Noni Brynjolson, age 10

Figure 14.11. This image has a sunset sky created with watercolour paint and salt. The mountains are cut out from black paper.

- Pencil crayons, chalk pastels, or oil pastels on top of dry watercolour paint add form and detail (figure 14.12). As a class, look at *The Yesterday Stone* for examples of extensive pencil drawing on top of watercolour paint.

- Make postcards. The 6" x 8" (15 cm x 20 cm) landscape watercolour paintings make perfect postcards. Use this exercise as the basis of a writing project. Have students write about imaginary journeys on the backs of their postcards, and send the postcards home. Alternatively, mail art correspondence to students from another school or another city.

watercolour pencil crayons, Noni Brynjolson, age 10

Figure 14.12. Noni used watercolour pencil crayons on watercolour paper to colour her image. Next, she used a wet brush to carefully blend the colours.

Illustration for *Tale of the Pompom*, watercolour and ink, Shannon Barbour, age 9, Niakwa Place School

Figure 14.10. This watercolour painting is only 3½" x 4½" (9 cm x 11 cm), an ideal size for a series of book illustrations. Shannon matted the illustration with a piece of coloured paper (to frame it) before gluing it onto a book page.

VOCABULARY

analogous colours	palette
background	primary colours
characters	secondary colours
glazing	setting
gouache	wash
horizon line	watercolour
landscape	wet-in-wet technique

(see appendix B for definitions)

INTRODUCTION

A collage is an image made of a variety of scraps and/or recycled materials that are cut out and glued onto a surface. Collage is a versatile medium and may be combined with drawing or painting. Artists use collage to integrate a variety of materials, art forms, and cultural artifacts into their work, such as newspaper headlines, photographs, advertisements, decorated papers, objects, and fabric.

Mixed media refers to a combination of approaches, such as painting over a collaged image or combining drawing and painting. The term may also be used to describe a collage that has a variety of materials glued onto a surface.

Collage is a tactile medium and provides opportunities for teaching about texture, pattern, shape, and colour. If materials are selected with care, making collages becomes a no-fail exercise that teaches some basic elements of art in a non-threatening way – even students with weak drawing skills can produce beautiful images. Working in mixed media – with collage, or with a combination of drawing, textured paint, and collage – allows students to do the following:

- Explore elements and principles of design. With collage, artists can physically move materials or subjects in an image, to experiment and easily make changes in their work.

- Learn to view collected objects or items from their environment as possible art materials.

- Make decisions about how to represent an image with a variety of found or recycled materials.

- Learn to use a variety of basic materials and tools.

VIEWING

Miriam Schapiro, *Provide*. 1982.

Figure 15.1. Collage is a way of creating unexpected associations between images gathered from a variety of sources. Picasso was one of the first artists to use the technique, when he glued found objects directly onto the surface of a painting. While this new technique was not immediately understood, it eventually became accepted as a way to create images. Miriam Schapiro had her own way of making collages: She used pieces of fabric, a material associated with women's work. What do the collaged pieces of fabric represent in this image?

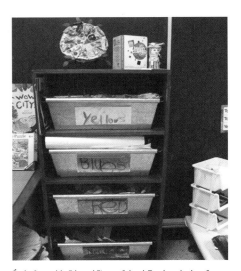

École Constable Edward Finney School. Teacher: Andrea Stuart

Figure 15.2. For easy access, these collage materials have been sorted by colour.

TIP To unify a composition choose materials that represent one element of design, for example, all yellow materials (colour), materials with curved lines (line), or materials cut into rectangles (shape) (see chapter 5).

BOOKS TO HAVE HANDY

PICTURE BOOKS

Alexander and the Wind-up Mouse, written and illustrated by Leo Lionni.

How the Animals Got Their Colors by Michael Rosen, illustrated by John Clementson.

Smoky Night by Eve Bunting, illustrated by David Diaz.

The Dragon's Pearl by Julie Lawson, illustrated by Paul Morin.

The Paper Crane, written and illustrated by Molly Bang.

Who Is the Beast?, written and illustrated by Keith Baker.

Window, written and illustrated by Jeannie Baker.

The Weaving of a Dream, written and illustrated by Marilee Heyer.

The Wolves in the Walls by Neil Gaiman, illustrated by Dave McKean.

COLLAGE

TOOLS & MATERIALS

- pencils
- erasers
- sketchbooks
- masking tape
- white glue
- hot-glue dispenser for heavier materials
- scissors (including some larger, sharp pairs) (several pairs)
- heavy cardboard or mat board for the backing material
- miscellaneous items (when introducing collage, or working on specific subjects, it may be worthwhile to offer only one category of item at a time. You may change these lists to suit your topic or the availability of materials.)
 - natural items (for landscapes and animals): small stones, twigs, dried leaves and flowers, tree bark, moss, shells, fur or fake fur, horse hair, small (bleached) bones, sand, straw, seeds, beans, rice, and so on
 - machine parts (for robots or spaceships): tinfoil, small machine parts, computer components, telephone cable wire, hardware (nuts, bolts, and so on)
 - plastic packaging (for city scenes, people, or interior scenes): plastic packaging, bottle caps, candy wrappers, washers and screws, and so on
 - fabric (for people, interior scenes, or landscapes): fabric scraps, quilt batting, cloth ribbon, lace, seam binding, buttons, yarn, embroidery thread, tassels, felt pieces, beads, junk jewellery, and so on
 - paper (for any subject – it allows for straight-edged precision and pattern for buildings, people, animals, and plants): textured or patterned wallpaper samples, paint chip samples, construction paper, origami paper, coloured photocopy paper, newspaper, magazines, handmade paper, painted papers, scrapbooking paper, paper doilies, used greeting cards, postcards, old photos, and so on
- optional: see Additional Exercises (page 206)

Appropriate Subjects

An appropriate subject is a single, recognizable image in a setting; for example, a spaceship on an alien planet or an insect on a plant leaf. More challenging subjects and settings have interesting surface textures, shapes, colours, and patterns that may relate to the materials being used. Some examples might include recycled packaging that can be used to create a goat on a junk pile, dry leaves and natural items to make a tiger in a jungle surrounded by overlapping plants, and fabric scraps assembled to represent a person with a quilt.

Beautiful collage images may be made with abstract images (having no recognizable subject). To choose a topic and select materials, think about using one element of design to unify the composition – for example, all yellow materials (colour), materials with curved lines (line), or materials cut into rectangles (shape) (see chapter 5). Challenge advanced students by introducing several elements of design into one collage project.

Locate visual references that students can use to find subjects and settings. Images from magazines, calendar photos, and interesting objects all work well.

An object, live subject, or replica may be a good subject for young artists – they can touch an actual guinea pig, for example, and then touch the collage materials to decide which one feels as furry.

Preparation

Collect materials and several empty boxes or trays to hold the loose materials and scraps as students work (figure 15.2). Set out materials and tools in centres so they can be shared by students.

Process

Ask students to sketch their subjects or designs in their sketchbooks. Remind them to pay attention to how the elements of the picture will fit together (see chapter 8). To fill in large empty spaces, encourage students to add features, shapes, or a horizon line.

Younger students often prefer to skip the preliminary drawing exercise. Instead, they want to handle the materials and experiment by cutting and gluing. They will use the textures, patterns, shapes, and colours to suggest the images to themselves as they work (figure 15.3).

Look at artworks or at picture books such as *Window* or *Smoky Night* with your students. Ask students to name some of the many materials that the artists used to make their images. Encourage students to look at how the artists achieved a variety of colours, patterns, and textures. Suggest that these elements help to make the illustrations interesting to look at.

As a class, look at *Who Is the Beast?* Point out how only part of the tiger is showing in each illustration. Some elements of the picture overlap (are in front of or behind) others.

Have students touch some of the miscellaneous materials they are going to use to make their own collages, and encourage them to describe some of the textures (rough, smooth, soft, and so on) of the materials. Ask them to think carefully about which textures, colours, and patterns will be right for their subjects and as parts of their backgrounds. When students are ready to make their collages, they can select the materials they plan to use (figure 15.4).

Show your students how to arrange scrap materials to create a background that covers all of the cardboard backing. Materials can overlap. After students have filled in their backgrounds, have them select miscellaneous items and cut out shapes for the main subject. Encourage them to choose colours and textures that contrast with the background materials. Remind students that it is easier to cut out each part of a subject separately. To make a cat, for example, cut out the body, head, legs, ears, and tail as separate pieces instead of in one piece. You can encourage students to overlap pieces and to think about how they are going to place the pieces. Hand out glue only after students have most of their pieces cut out and arranged on the background.

École Constable Edward Finney School. Teacher: Andrea Stuart

Figure 15.3. Students are exploring a variety of shapes, colours, and textures of materials through collages.

CAUTION! Allow only adults to handle hot-glue dispensers. Lower temperature glue dispensers are available for students. Show students how to use these: Put a dot of glue on the larger of two pieces, and push the smaller piece on with a stick (never use your fingers for this job). Hold the glue dispenser over a piece of cardboard to catch drips. Stress that students should take turns and set the dispenser on the counter between turns rather than pass it from hand to hand.

Tropical Fish, cut-paper collage, Dong Nguyen, grade 3, Wellington School

Figure 15.4. Simple, coloured paper can be used to create images with a variety of shapes and patterns.

Encourage students to use cut-out pieces for smaller details, instead of using felt pens or pencils to make the details. To maintain students' interest in and patience with the project, suggest they work on their collages in two or three short sessions rather than in one long session. When students have completed their collages, they may wish to frame them with a border pattern of repeated objects.

Additional Exercises

Here are some additional exercises your students can do:

- Use miscellaneous materials, such as small toys or layered cardboard, to build three-dimensionally out from the background. Use heavy cardboard or wood as a base, and secure pieces in place with a hot-glue dispenser.

- Make peek boxes: Cut out a viewing hole (1" [2.5 cm] in size) at one end of a shoebox. Cut out a larger rectangle at one end of the box's lid, and cover it with coloured cellophane (to let in coloured light). Have students make collages inside the boxes based on stories they have written. Make sure students think about perspective and depth and about how, inside the boxes, some things should be placed closer to the eye (view hole) than others.

- Use small collages to illustrate stories. Each student can make a series for his or her own story, or several students can each create a panel for one story. If collages are very thick or fragile, it may be better to use photographs of them when compiling into a book format. Cover a collage with clear plastic to use as a book cover.

- Make collages using only one type of material, such as fabric scraps or a variety of patterned papers (figures 15.5 and 15.6).

Angy, high school student. Teacher: Amy Karlinsky

Figure 15.5. Angy used patterned paper to make these collage images based on Métis beadwork designs.

Tahareh and Sheyanne, high school students, Elmwood High School. Teacher: Briony Haig

Figure 15.6. Students used patterned papers to create landscape images. Quality papers, such as scrapbook paper, provide a successful outcome.

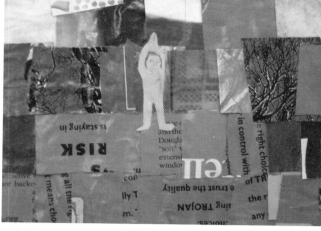

- For an example of subtle colour combined with minimal drawing, look at *The Paper Crane*. Acquire some paint sample papers, and combine samples with pencil drawings to make collages.

- For an example of bright colours, with an emphasis on pattern and shape, look at *How the Animals Got Their Colors*. Make collages from brightly coloured paper scraps that have interesting edges and patterns.

- Look at *The Weaving of a Dream*. Although the book illustrations are painted, they are beautiful examples of decorative patterns in illustration. Use candy wrappers, origami paper, or patterned scrapbook paper to make richly coloured and patterned collages.

Noni Brynjolson, age 7

Figure 15.7. Magazines provide a palette of colours, values, and text.

- Make collages from magazine photographs (figure 15.7). Cut out pieces of magazine photos to build an image similar to the images in the book *The Wolves in the Walls*. This is a time-consuming process – students will flip through magazines endlessly – but it can result in humorous and convincing images.

- Combine drawing, text, collage, and computer images into one image or illustration. See *The Wolves in the Walls* for unusual examples that use gesture drawing, cut-out images and text, and computer graphics.

- As a class, look at *Smoky Night* for examples of how to use collage for border designs that relate to the subject matter of the story.

COLLAGE AND PAINT

Painting on collage involves mixing paint and texture to create interesting varieties of surfaces and colours. In this exercise, a collage is constructed with the focus on shape and texture – the colour of materials is ignored. Colour is painted in after the initial image is constructed. It is also possible to begin a collage by painting a surface and embedding or gluing materials afterwards (figures 15.8 and 15.9).

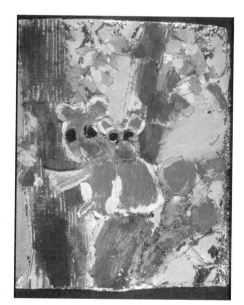

Koala Bears, mixed media, Channa Tach, grade 2, Wellington School

Figure 15.8. Channa used a variety of textured wallpapers, buttons, tinfoil, and paint to construct her picture. Her collage would make a good book cover.

TOOLS & MATERIALS

- acrylic or liquid tempera paint set out in Styrofoam egg cartons
- material for additional texture (sand, confetti, chopped straw, and so on; pre-mix these materials with the paint)
- palettes (white plastic trays or lids)
- stiff paintbrushes (well-used brushes are fine to use), ½" to 1" (1 cm to 2 cm)
- water containers and water
- newspapers or plastic (to cover tables)
- paper towels
- paint smocks
- pail of soapy water (for washing brushes after painting)
- optional: see Additional Exercises (page 208)

Cat, mixed-media collage, Noni Brynjolson, age 11

Figure 15.9. Noni constructed this cat out of paper, shoelaces, buttons, sequins, tinfoil, yarn, a feather, and a seashell.

TIP Introduce painting with a simple colour-mixing exercise on scrap paper (or newspaper). Pick a common background colour (for example, green or blue), and challenge students to mix as many variations of that colour as possible (they can mix small amounts of colour onto their palettes and paint small dabs of colour onto scrap paper). Have them (1) tint the colour by adding white paint, (2) shade the colour with a small amount of black, and (3) add small amounts of other colours such as yellow, blue, red, purple, or brown (see chapter 11).

VOCABULARY

collage
elements of design:
 line, shape, texture,
 form, space
horizon line
materials
overlap
pattern

principles of design:
 balance, proportion,
 movement and
 expression, emphasis,
 contrast and variety,
 unity and harmony,
 repetition, and
 rhythm
shade
tint

(see appendix B for definitions)

Preparation

As a class, look at *The Dragon's Pearl*, and ask students what they notice about the pictures. Explain that the illustrator travelled to China to research this book and brought back earth, straw, and other materials to mix in with his paint. Fabric, found objects, and a pearl were glued onto the canvas he painted. This approach gives the painting a surface texture that is interesting to look at.

Process

After students have completed their collages, have them close their eyes and touch their artworks. Ask them if each part of their collage has an interesting texture to touch.

Look again at *Who Is the Beast?* with your students. Notice that there is variety within a colour; for example, there are many greens, not just one, in the leaves (see chapter 11). Notice that some leaves are unusual colours and have interesting patterns.

After your students have mixed several varieties of a colour on their palettes, they can begin to paint their collages. Encourage them to paint over the entire collage – care should be taken to paint up to the outside edges of the pictures. Use large brushes except when painting minute detail.

Additional Exercises

Here are some exercises you can do with your students:

- Add a coat of PVA (acrylic gloss) to painted collages to give them a shine. Dab on PVA with a paintbrush after the paint has dried. Be careful not to over-brush; it will cause paint to smear. Wash brushes thoroughly after use.

- Make collages in which the subjects and backgrounds are painted separately and glued together when dry. This contrast will make the main subjects stand out from the background.

- With pencils or black pencil crayons, sketch simple images onto pieces of cardboard. To make textured paint, mix sand or other fine material with acrylic or liquid tempera paint. Apply the textured paint directly onto the cardboard.

- Apply a base colour of paint to the paper, and then continue adding cut-out materials and other items to the collage after the paint has dried. Find materials with colours that harmonize or contrast the paint colours (see chapter 11).

INTRODUCTION

Two kinds of printmaking are discussed in this chapter – monoprints and relief prints. Printmaking provides variations of an image; students can take the same image through several distinct states, or stages. Printmaking provides students with opportunities to do the following:

- Begin with a simple drawing, and experiment with a variety of colours, patterns, and marks.

- Produce multiple images for experimentation or illustration.

- Use familiar materials in a new way.

- Solve problems with reverse images, contrasting colours, and art tools.

Tiger, monoprint in progress, grade 5 student, Elm Creek School

Figure 16.1. A monoprint produces a mirror image of the original drawing. Paint is applied to wax paper and transferred to construction paper. The resulting image has interesting, obvious brush marks and soft edges.

MONOPRINTS

TOOLS & MATERIALS

- white paper, 8½" x 11", or 11" x 17" (21.5 cm x 28 cm, or 28 cm x 43 cm)
- pencils
- erasers
- wax paper, Plexiglas, or mylar
- stapler
- "soft" paper (white or grey construction paper) or drawing paper (Mayfair or Dessin), 8½" x 11", or 11" x 17" (21.5 cm x 28 cm or 28 cm x 43 cm)
- acrylic paint (small amounts of red, yellow, blue, black, white) or a very good-quality liquid tempera paint
- paintbrushes, flat-head, 1½" (1.5 cm)
- water containers (with wide, flat bottoms to prevent tipping)
- plastic lids or Styrofoam trays (for palettes)
- paper towels
- newspapers (to cover tables; lots of table space is required)
- paint smocks
- pail of soapy water (for washing paintbrushes)
- optional: see Additional Exercises (page 212)

BOOKS TO HAVE HANDY
PICTURE BOOKS

Brian Wildsmith's Animal Gallery by Brian Wildsmith. (Note: The illustrations are not monoprints, but some of the paintings of the animals have a similar texture.)

Monoprints are closely related to paintings. With a monoprint, students begin with a drawing that includes textures, patterns, and contrasting colours. Students end up with three versions of their original images – a drawing, a painting on wax paper or Plexiglas (overhead transparency sheets of mylar work, too), and a reverse printed image with exaggerated brush marks and soft edges. Making monoprints requires some care and patience.

Appropriate Subjects

Appropriate subjects are those with easy-to-recognize shapes, interesting textures and patterns, and contrasting colours between the main subject and background (for example, a red fox in front of green foliage, or simple geometric shapes in primary colours). Magazine and close-up calendar photographs of familiar objects or animals make ideal visual references.

Otter, pencil on paper, Odessa Redekop, age 10, Elm Creek School

Figure 16.2. Odessa's drawing has interesting contours and lots of texture. It is ready to be assembled into a "wax-paper sandwich" – with the drawing face up on the bottom, the wax paper in the middle, and construction paper on the top.

Preparation

Ask students to select a visual reference (calendar or magazine photo, for example) and sketch their subject in pencil (figure 16.2). Include line, texture, pattern, and areas of light and dark value (see chapter 5).

Pre-test the brand of acrylic paint you have to ensure that it will adhere to the material you are using as a printing plate – wax paper, Plexiglas, or mylar. Set out the paints in Styrofoam egg cartons.

If students have limited experience with mixing colours, set aside the drawings, and have them work on mixing secondary colours, tints, and shades (see chapter 11). Students can practise mixing the colours, tints, and shades that occur in their reference photos by covering pieces of scrap paper with small colour swatches.

TIP Students will need to refer to their photographs while they are painting. To protect the photos from paint splatters, place books inside clear plastic bags, or prop the books and photographs on nearby ledges. You may also use laminated or disposable photographs.

Process

Demonstrate the following steps for making monoprints (figure 16.3 a–d):

1. Make a "sandwich" with the initial drawing.

 For wax paper: Lay a sheet of wax paper on top of the drawing, then lay a sheet of construction paper (or another soft, absorbent paper) over the wax paper. Staple the top or left sides together (whichever falls on the long side of the papers).

 For Plexiglas or mylar: Secure the drawing to the desktop, centre the clear plastic sheet on top of the drawing, and attach it securely to the desktop as well. Place a sheet of paper on top of the plastic sheet, taping one edge to the plastic (or to the tabletop) and folding it back. The tape will act as a hinge so that the paper can be lifted and set back in place several times.

2. Fold back the paper layer, and paint on the wax paper or plastic sheet (the drawing will show through as a guide). Start on a piece of the background,

Seal, monoprint, Noni Brynjolson, age 8

Figure 16.3 a–d. This series shows how Noni assembled the pieces. Enough of the drawing (a, b) showed through the wax paper for Noni to use it as a guide for her painting. She applied a small amount of paint and folded over the construction paper. When she rubbed the paper with the heel of her hand, the paint transferred to the construction paper (c), creating a monoprint (d).

rather than on the main subject, to test the thickness of the paint and the quality of the brush marks. Take care to keep the paintbrush fairly dry.

3. Apply paint in small areas at a time, carefully settling the construction paper back down onto the paint and rubbing gently every few minutes, while the applied paint is still wet. The paint will transfer to the paper from the wax paper or plastic.

4. Repeat this procedure – painting and transferring – a small area at a time. Care should be taken about the length and direction of brush strokes, as the strokes produce a pattern on the printed side.

5. Interesting marks may also be produced by scraping areas of wet paint off of the plastic plate. Use a rubber eraser, the sharp end of a paintbrush, a comb, or another object to draw lines or patterns into the wet paint, before transferring it to the paper.

6. Leave the wax paper "sandwiches" open to dry thoroughly before storing, or wash the Plexiglas plates to use them for another print. This prevents the layers from sticking together as they dry.

Monoprints produce a soft-edged image with exaggerated brush marks (figure 16.4 a–c). The image is similar in appearance to the painted illustrations in *Brian Wildsmith's Animal Gallery* and to paintings by Marc Chagall.

Some students become frustrated by the lack of exactness in the printed image. Explain that this exercise is an experiment with a soft-focus image – and remind

TIP If the paint blotches, the paint is too thick or the paintbrush is too wet. Dry the brush on a paper towel before dipping it in paint, then apply a thin layer of paint. If no paint transfers, the paint has dried too quickly. Paint a smaller area with a bit more paint, and "print" immediately. Wash brushes thoroughly with soapy water after using acrylic paint.

Wild Dog, pencil on paper, paint on wax paper, and monoprint, Dean Savage, age 10, Elm Creek School

Figure 16.4 a–c. Dean's drawing (a), painting (b), and print (c) clearly show the stages of a monoprint. The final print (c) has beautiful surface marks.

Desert Scenes, Noni Brynjolson, grade 6, Luxton School

Figure 16.5 a–c. These three scenes show how (a) the original drawing, (b) the wax paper, and (c) the completed monoprint are all used as backgrounds for illustrating a story with cut-out drawings.

students that their more precise pencil drawings are still intact and protected by wax paper or plastic. Original drawings can best be preserved by photocopying them, and using the photocopies for the monoprints.

Monoprints may also be combined with ink drawing – just be sure that the paint is thoroughly dry before using permanent felt pens to add more defined lines, texture marks, or patterns.

Additional Exercises

Monoprints are time-consuming to make. Here are some shortcuts that may be helpful if you want your students to use this method for a series of illustrations:

- Use a paintbrush or soft rubber roller (brayer) to paint directly onto an object, cover the object with paper, and rub gently. Suitable objects will have an interesting surface texture. Try a large, partly frozen fish, various shaped leaves, halved vegetables (peppers, squash, mushrooms, for example), small flat toys, machine parts, and so on. This technique is an interesting way to produce a clean image or patterns for border designs.

- Make small monoprints, 4" x 6" (10 cm x 15 cm) with a close-up view of the main subject.

- Use the original drawing, the wax-paper image, and the monoprint, and modify each to use as a separate illustration (figure 16.5 a–c).

- Use the monoprinting technique for painting the background, then cut out the original or photocopied drawing of the main subject, and glue it onto the printed background.

- Use the original drawing and make several monoprint versions, experimenting with a different colour scheme each time (see chapter 11). Just replace the wax paper, or clean the Plexiglas, for each version.

RELIEF PRINTS

<div style="sidebar">

TOOLS & MATERIALS

</div>

- pencils
- sketchbooks
- felt pens, fine-tipped, washable, non-toxic (e.g., Sharpie)
- variety of materials suitable for relief prints (material must be smooth with no bumps, imprints, or scratches): Styrofoam trays or plates, dense Styrofoam insulation, battleship linoleum, soft plastic or rubber erasers, carving blocks (see appendix A), or wood
- scissors
- white glue
- acrylic paint or good-quality, water-based block-printing ink (one colour, black, is sufficient for the first effort; red, yellow, blue, black, and white, or a range of bright colours, are required for colour prints)
- several soft brayers (these are printmaking rollers; soft rubber produces the best results; four students can share a brayer)
- variety of soft papers, such as rice paper or construction paper, white or assorted colours, cut to 4" (10 cm) larger than the size of the plate or printing block. Tyvek (a building material) is also suitable as printing paper (see appendix A).
- newspapers to cover tables (several layers are required; fold the pages over when they become full of wet paint)
- paper towels or rags
- paint smocks
- wooden spoon or printmaker's baren (The back of a wooden spoon or the heel of the hand can be substituted.)
- linocutting tools
- modelling clay (e.g., Plasticine)
- rolling pin
- X-acto knives
- optional: printing press (see appendix A)
- optional: see Additional Exercises (page 215)

> **TIP** Acrylic paint is easy to work with. It dries quickly, allows multiple-colour prints, is less expensive than block-printing ink, and can be used with other projects. Good-quality block-printing ink has a more even consistency and produces richer colours; however, it may take longer to dry.

BOOKS TO HAVE HANDY

PICTURE BOOKS

The Loon's Necklace by William Toye, illustrated by Elizabeth Cleaver.

The Cremation of Sam McGee by Robert Service, illustrated by Ted Harrison.

Strega Nona, written and illustrated by Tomie dePaola.

Introduction

The method described here requires students to carve a line into a Styrofoam plate with a pencil (figure 16.6). The groove of the pencil line will remain uncoloured as paint is rolled over the surface of the plate with a brayer, and the print is transferred to paper. This project generates enthusiasm – and mass production – as students experiment with contrasting colours and printmaking tools. For instructions for carving linoleum or blocks, see page 218.

Students can make print editions, signing and numbering their prints to exchange with friends, to frame and give as gifts, or to paste on gift cards. Students can also use prints as multiples for collage, cutting and pasting their images into a sequence of illustrations, or creating pictures that have crowds, herds, or flocks.

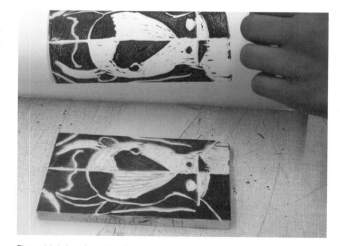

Figure 16.6. A student at Machray School carefully lifts the paper off of the printing plate. The finished print will be a mirror image of the lines carved into the plate.

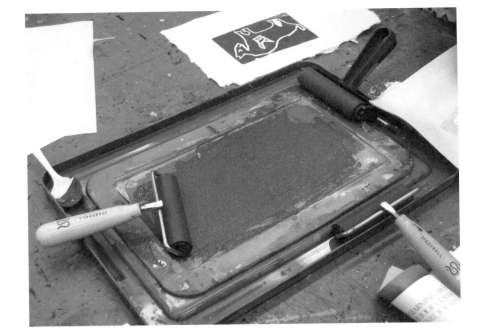

Figure 16.7. Paint and brayers are ready for students to use. Use a small amount of paint on the roller, and roll evenly over the plate.

Appropriate Subjects

Have visual references available for students to make observational drawings. Appropriate subjects are those that students can easily recognize; for example, leaves, flowers, and animals. A single subject, drawn fairly large, is preferred. See *The Cremation of Sam McGee* or *Strega Nona* for examples of drawings with simplified shapes. Advanced students may try more difficult subjects.

Preparation

Cover tables or desks with newspaper. Set out materials (figure 16.7). Have students cut off the lip from the Styrofoam plates or trays, so they will have a flat surface to work on. Put small amounts of printing ink on additional Styrofoam trays (one teaspoon [5 mL] at a time).

Process

Have students follow these steps to make Styrofoam relief prints:

1. Students can practise drawing simplified versions of their subjects in their sketchbooks. When they are satisfied with the results, have students use felt pens to re-draw the images on Styrofoam trays. (The pen will not scratch the tray. Mistakes can be wiped off with a damp paper towel and will not show up in the finished print.)

2. Have students use sharpened pencils to draw over the lines they made with the felt pens. Make sure they press hard enough to carve evenly into the surface of the tray (small holes are not a problem).

3. Demonstrate the printing process to students: (a) Squeeze a small amount of paint or printing ink onto a clean tray – start with one teaspoonful (5 mL). (b) Roll a brayer through the ink in several directions until the brayer is evenly coated. (c) With the brayer, roll the paint onto a carved Styrofoam tray, called a *printing plate*, until the tray is evenly coated. (d) Quickly move

TIP If a student has found the initial drawing difficult, he or she can trace the drawing or an enlarged or reduced photocopy of the drawing onto a thin Styrofoam tray: Lay the drawing under the tray on an overhead projector. The light from the projector will help the drawing show through the Styrofoam plate, enabling the student to trace it. Alternatively, lay the drawing on top of the plate and retrace the drawing, pressing firmly. The lines will carve through the paper into the plate.

TIP The image that transfers to the paper will be a mirror image of the carved plate. Remind students that any words and letters will need to be written backwards!

TIP Too much paint or "globs" of paint on the brayer will fill in the grooves in the tray and produce a poor print (clean excessive paint from the plate with a paper towel and an old pencil). Too little paint will produce a poor print, or will cause paint to dry too quickly and stick to the paper. If either of these happen, wash and dry the plate, and try again.

the tray to a clean area, cover with a piece of paper, and rub the covered surface in a circular motion with the heel of your hand, a wooden spoon, or a baren. Rub the entire surface evenly, paying attention to edges. It is important to hold the paper still; avoid letting it slide on the surface of the tray (figure 16.8). (e) Peel off the paper, and view the print.

4. Encourage students to print with a variety of paint colours, on a variety of coloured papers. Students may have success on their first attempt, or it may take them several tries to get the right amount of ink spread on the tray. Add small amounts of white paint into colours that are to be printed on dark paper. For a "rainbow roll," squeeze very small amounts of two colours onto a tray. Roll the brayer repeatedly, in one direction only, until it is evenly coated. Then, roll the brayer onto a Styrofoam plate, rolling in one direction. The two colours will remain distinct on the edges, with some mixing in the centre.

Figure 16.8. Hold the paper in a loop to centre it on the plate.

Additional Exercises

Here are some additional exercises your students can do to develop skills with printmaking:

TIP Work quickly. If the paint becomes too dry it may tear or stick to the paper. Clean torn paper off the plate with water, dry the plate with a paper towel, and try again.

- A plate may be cut into a few simple shapes for a multicolour "jigsaw" print. Roll a different colour onto each piece of Styrofoam, set the pieces carefully in place on a clean surface, place paper on top, and rub. The colours will transfer to the paper.

- Cut and paste the finished prints to produce clean-looking images. Cut carefully around the subjects in the prints, arrange, and paste on coloured paper.

- Produce layered images. First, look at the illustrations in *The Loon's Necklace*. Note which parts of the illustrations are relief prints, and notice where the cutouts overlap. Use additional cutouts of coloured construction paper and scrap papers, painted with a brayer, to make interesting colour samples for cutting and pasting.

- Use the cut-and-paste method (above) to make illustrations. The printed cutouts can be used as the main characters, while the background elements may be cut out of coloured paper. Trade pieces with classmates ("Will you trade me a leopard for a whale?"), or work cooperatively to produce illustrations with multiple characters (figure 16.9). This method solves the problem of having to re-draw the characters in every illustration. This technique also works as a starting point for writing (see chapter 8).

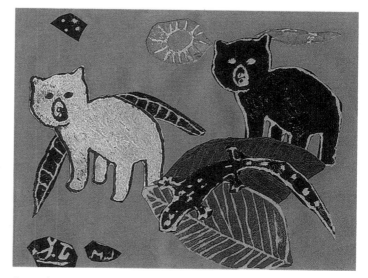

Bears and Salamanders, Jonathon Kulchyski and Laura McPerson, grades 4–5 class, San Antonio School

Figure 16.9. Prints by Jonathon and Laura were cut and pasted into one picture. The bears were printed with different colours of acrylic paint, on different colours of construction paper, from the same printing plate.

Figure 16.10. Prints can be made using a variety of surfaces. To make this fish print, a young artist painted a partly frozen fish with tempera paint.

- Take prints directly from assorted flat objects that have interesting shapes or surface patterns (for example, leaves, machine cogs, partly frozen fish). Roll the paint on with a brayer, and print as a relief print (figure 16.10).

- Make linocuts (figure 16.12). (See page 218.) Experiment first with a variety of linocutting tools, making a variety of cutting marks such as hatching, crosshatching, and dots. To print, use the same printing process as with Styrofoam prints. This technique works well with any subject or style that has pattern (a spotted leopard or a striped tiger, for example).

- For young students: Carve modelling clay, such as Plasticine, to make relief prints. Use a rolling pin to flatten the modelling clay onto a table, outline the image with a pencil, and carve out areas with a dull tool (a pencil, plastic knife, or wooden tool that will not damage tabletops). Print as above, rubbing gently.

VIEWING

Carlos Cortéz, *Welcome Home!* 1965.

Figure 16.11. Printmaking refers to the transfer of ink from a block, or plate, onto a surface such as paper. It includes woodcuts, engraving, lithography, silkscreening, and even photography. Because of the strong, clear lines it creates, printmaking is an excellent medium for designing posters. Carlos Cortéz was a Mexican-American artist who made prints using blocks of linoleum – linocuts. Cortéz created politically inspired cartoons, many involving striking workers or labour activists. This piece was created by Cortéz as an anti-war statement during the Vietnam War, but holds just as much significance when considering other world conflicts.

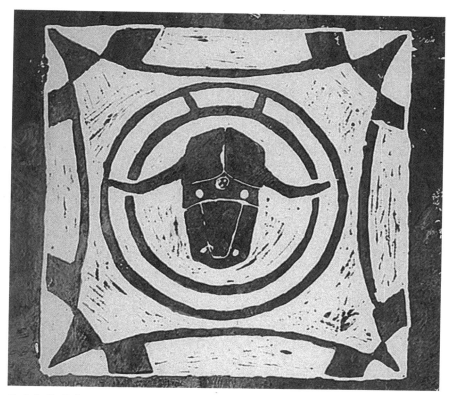

The Native War Pig, linocut print, Ryan Bride, grades 7–9 class, Australia

Figure 16.12. Ryan rolled a brayer in several colours of printing ink to produce this multicoloured linocut print.

- Make an oversized print. Use a large piece of Styrofoam insulation as a plate. Carve into the Styrofoam with a pencil and X-acto knife. Place a large piece of paper or Tyvek (see appendix A) on top, and use a smooth, rounded block of wood as a baren to transfer the image.

- Make a collograph. A collograph is a printing plate made from several objects glued onto stiff cardboard. Glue a variety of nearly flat objects (string, cardboard cutouts, and so on) onto cardboard. Roll on paint or ink with the brayer, cover with paper, and rub gently with the heel of the hand. This is a good way to explore the surface texture of various objects.

Ann Rallison

PRINTMAKING:
COLOUR REDUCTION PRINTS
from an interview with Ann Rallison

Outline the pencil marks with a ballpoint pen.

Cut safely by placing the cutting hand on top.

Ann Rallison visited a class of grade-six students to begin a printmaking project. Students would be making prints where the plate is carved a second or third time to print additional layers of colour, a technique called *reduction printmaking*.

Students began the project by asking their classroom teacher, Theresa Campinelli, questions about Chinese New Year. This led to research about the symbol of the ox. Students then searched for images of oxen in magazines and on the Internet, observed their subject carefully, and practised look-drawing.

Session 1

Students went to the school art studio, where they were each given a block, called a *printing plate*, which they would be carving. Artists traditionally use linoleum or wood for printmaking plates, but vinyl flooring, vinyl erasers, and new printmaking products (such as Nasco brand Safety Kut blocks) are much easier to carve. Each student was also given a piece of paper that matched the size of the block. On the paper, each student drew an ox, transferred the image to the plate by placing the pencil drawing face down on the plate, and rubbing the back of the paper with a pencil. Students then outlined their drawings directly on the block with a ballpoint pen, tidied up the lines, and shaded the areas they would be cutting away.

Next, Ann prepared to show the students how to hold and use the cutting tools when carving printing plates. She had the students gather around a large table so that everyone could see her. This is something she has students do whenever she teaches a new process or concept. Ann is aware that her students learn more from the visual demonstration of each step of a new process (or concept) than from verbal or written instructions. She told students to hold the cutting tool with the cutting hand on top of the hand that holds the plate. They were cautioned not to pull the cutting tool toward the hand that is holding the plate!

Once the students were comfortable with the carving process, they began cutting away outlines and small areas on their blocks. When the cut lines were smooth and deep enough to hold ink, Ann showed them how to roll the brayer (roller) through the ink in several directions to get an even coating of colour on the brayer. Students then rolled ink on their plates – about 2.5 mL (half a teaspoon) seemed to be the right amount of ink to begin with. Ann had sorted the colours and, since the students would be printing two colours, she had put out the lighter colours for the first session. Some students had too much ink on their brayer, and so the ink filled in the lines on the plate. They had to wash their plate and try again with less ink. If the lines still filled with ink, students carved them a bit deeper. At this point, one of the student's plates broke in half, but she solved this problem by deciding to print each half a different colour.

Brayers and ink are ready to roll!

Each inked plate was set on a magazine – students could turn to a new magazine page to keep the surface clean. The paper with the drawing was placed on top of the inked plate. Students were shown how to rub the back of the paper with a spoon, which they used instead of a printmaker's tool, or baren. When the paper was lifted – ta da! – a monocolour (one colour) print!

Each student printed five copies – each a different colour – washing the block and drying it between colours. Prints were hung to dry on a line that was strung across the room. Those students who finished early were encouraged to carve an image of their choice on the back of a new plate and make a print of their choice.

Make a "hand sandwich" to flip the paper and plate.

Session 2

In the second art class, Ann showed students how to carve away more of the plate and add a horizon line and pattern. Ann set out some darker ink colours and demonstrated how to register the plate (line it up carefully with the first colour before setting the plate face down onto the paper). She then had students make a "hand sandwich" by sliding the plate and paper toward them, placing a hand on top and a hand underneath, and flipping the plate so the paper was on top. The back of the paper was rubbed again with a spoon to transfer the ink.

Students were also shown how to edition their prints – writing the title, numbering each print (1 of 5, 2 of 5, and so on), and signing their name at the bottom.

Ann believes in using quality materials – inks, brayers, and papers – to produce good-quality results. She also takes time to carefully mat, frame, and display her students' artworks.

Ann Rallison is an artist and art teacher who specializes in printmaking. She teaches art at Machray Elementary School and Laura Secord Elementary School, in collaboration with classroom teachers.

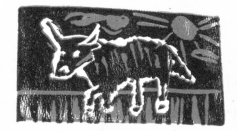
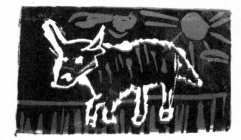
These two prints are from the same printing plate.

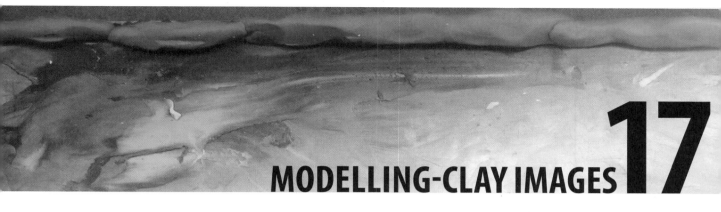

MODELLING-CLAY IMAGES 17

<div style="sidebar">TOOLS & MATERIALS</div>

- pencils
- sketchbooks
- erasers
- modelling clay (such as Plasticine) in a variety of colours: white, black, red, yellow, blue, orange, green, violet, brown
- modelling tools, such as sticks, toothpicks, paperclips or loops of wire for carving, garlic presses, spatulas, textured items for impressing clay (such as burlap, window screen, and pegboard)
- pieces of stiff cardboard or paper plates (for backing)
- plastic knives
- scissors
- pail (with soapy water for washing desks)
- optional: pasta machine
- optional: see Additional Exercises (page 224)

LOW-RELIEF IMAGES

Coloured modelling clay (such as Plasticine) can be applied on a stiff backing in a thin layer to create a picture. The coloured modelling clay is spread in a thin layer, like paint. This method is used by illustrator Barbara Reid in her books, *The Party, Effie, Have You Seen Birds?* and *The Subway Mouse*. The illustrations are low-relief images; low-relief means working close to the picture plane (the surface of the picture) rather than with a completely flat image or a three-dimensional model. The image may be slightly raised above the backing to which it is stuck, but it still functions as an image rather than as a sculpture.

Preparation

Students will require visual references for their items or scenes, such as photographs from magazines or calendars. Appropriate subjects are single, easily recognizable animals or objects in simple settings. More challenging subjects will have many small parts or patterns, or overlapping parts, such as tree branches across the front of the picture, or a tiger partially hidden by leaves. Details can be added with small pieces of modelling clay for things such as fish scales, feathers, and tiger stripes.

Medieval Knight, grade 8 student, Treherne Elementary School

Figure 17.1. The young artist who made this added texture to the knight's chain mail and finished the illustration with a decorative border.

BOOKS TO HAVE HANDY
PICTURE BOOKS

The Party, Effie, The Subway Mouse and *Have You Seen Birds?*, written and illustrated by Barbara Reid (and other books illustrated by Barbara Reid).

Provide students with pieces of stiff cardboard or paper plates, which they can use for the bases of their pictures. Set out small pieces of good-quality modelling clay, such as Plasticine, in trays or on paper plates. Three or four students can share materials. Set out the background colours first. Unless your topic of study is camouflage, assist beginners by putting out background colours that contrast with the colours of their subjects. For example, a grey elephant will not show up well against a grey sky; however, a pink flamingo will contrast nicely, or stand out, in front of green leaves.

TIP Students will produce more developed images if they take time for observational drawing (see chapter 5).

Process

This is a three-part exercise. First, students will practise drawing their main subjects and backgrounds. Second, they will apply the background colours of modelling clay onto the backing. Finally, students will use modelling clay to construct the main subject and details and add them into their pictures. You may want to divide this project into two or more sessions.

Practise Drawing

Have students study the shapes, patterns, and textures (figure 17.2, top) that they will need to build (see chapter 5). Students can then practise drawing the shapes of their main subjects and backgrounds in their sketchbooks.

Apply Modelling Clay to the Background

1. As a class, look carefully at *The Party*. Discuss how the illustrator made the sky first, the ground second, the main subjects third, and added the foreground details last. Point out the overlapping edges to prove this point. The tree branches at the front of the picture are set on top of the other modelling clay pieces. Explain that it is much easier to construct the background, or the entire sky, before placing the foreground elements on top to overlap the background pieces. It is more difficult to fill in modelling clay around fixed subjects afterwards.

2. Look at sky colours in the book. Demonstrate, with small pinches of modelling clay, how to mix light blue (white + blue), midnight blue (blue + black), sunset colours (yellow + red = orange, white + red = pink, and so on). Mix small amounts of colour at a time, by squishing them together repeatedly between your fingers.

3. Look at various cloud shapes (long and thin, round, animal-shaped) in the pictures. Point out that the sky is not just a strip across the top of the page; it takes up a big portion of the page in some pictures.

4. Show students how to spread modelling clay over the top half of their cardboard backings, one small piece at a time: Warm a piece of modelling clay in your hand, and spread it over the cardboard, pushing sideways with your thumbs or with flat-tipped tools until you have covered half of the backing.

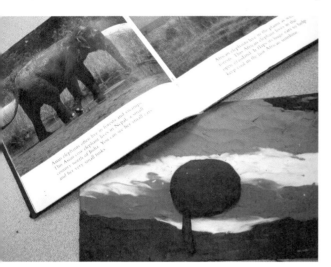

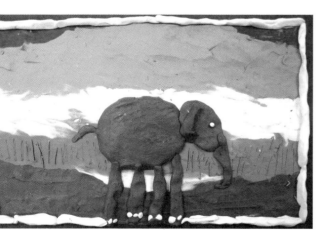

grade 1 student, Wellington School. Teacher: Harbans Rihal

Figure 17.2. (top) A young student looked carefully at a photograph in a book to study the shape of an elephant's body, before (bottom) completing this picture.

5. With students, look at the ground in the pictures. Point out that the ground covers a large portion of the page, not just a strip across the bottom. Explain that the horizon line may be flat or bumpy. Talk about colours (figure 17.4) and how the four seasons can be indicated by different colours on the ground (for example, green for summer or white for winter). Demonstrate how to mix some of the tertiary colours (see chapter 11). Explain that there is more than one colour of green (for example, yellow-green and blue-green), and that white snow may have blue or violet shadows. Have students fill in the ground areas on their backings with modelling clay.

Construct the Subject and Details

Before beginning this stage, tell students that they will construct their main subjects with modelling clay, separate from their backgrounds. Explain that making their subjects separately allows them to change the size, shape, and colour of a subject without destroying the background that they have already made.

1. As a class, look again at *The Party*. Point out that the characters are made from more than one piece and more than one colour of modelling clay. Talk to students about the shapes they will need to construct their subjects and other pieces in the foreground, or front, of their pictures.

2. Demonstrate how to roll fat and thin cylinders of clay, how to roll spheres and flatten them for circles, and so on: Flatten a piece of modelling clay, and cut out a straight-edged shape with a plastic knife. For a thin sheet, extrude the clay through a pasta machine. Use a garlic press for fine hair or grass.

3. Have students make their subjects on pieces of scrap paper (they can then peel the paper off the back or cut around the subject with scissors). Alternatively, students can build their subjects on a tabletop and use a spatula to lift them off the table. Whichever method they use, ensure that students do not spread the modelling clay too thin, or it will stick to the table. (You may want to try this ahead of time – some brands of modelling clay are too sticky to remove once they have been placed on a tabletop.) Have students assemble their subjects from modelling clay and apply them onto their backgrounds.

4. As a class, look again at *The Party*. Point out surface textures (for example, lines scratched into the ground to represent grass) and details (for example, the food on the table). Students can achieve texture marks by impressing objects (figure 17.5, right), such as a small piece of burlap, gently into the surface of the modelling clay. Show students how to use small shapes of different colours to build patterns (figure 17.5, left). Explain how attention to details – such as adding buttons to clothing and tiny white dots on eyes to show reflected light – will benefit their final products.

VIEWING

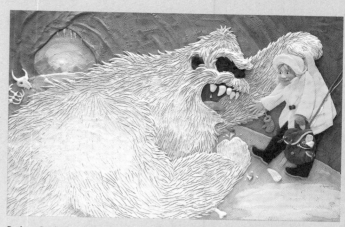

Barbara Reid. "The Yeti yanked her up and sniffed her…" from *Peg and the Yeti*

Figure 17.3. Barbara Reid has created dozens of books using her signature modelling clay illustrations. Many students will be able to relate to her colourful and playful technique. This image is from the children's book *Peg and the Yeti*, written by Kenneth Oppel. It is about a girl who decides to climb Mount Everest. Working with modelling clay allows Reid to capture details like the texture of the Yeti's fur, or the humorous actions of the girl as she throws a crumb into his mouth while being dangled in the air. Modelling clay is a forgiving medium, and can be photographed to create a lasting image.

grade 1 student, Wellington School. Teacher: Harbans Rihal

Figure 17.4 . (top) A young student carefully studies the colours in the reference photograph. The modelling clay is mixed and blended before it is applied to the image. (bottom).

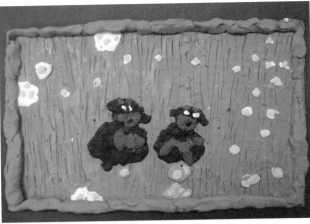

grade 1 students, Wellington School.
Teacher: Harbans Rihal

Figure 17.5. These modelling clay images have been finished with attention to pattern and texture. (right) The artist used a toothpick to scratch in a texture for the grass. (left) The artist added small pieces of clay to create the giraffe's pattern.

5. Look at the borders of the illustrations in *Have You Seen Birds?* There is a long, thin cylinder of bright colour around the outside of the pictures. For a finishing touch, students may want to add borders around their images (figures 17.5 and 17.6). You can coat finished pieces with PVA (acrylic gloss or Podge) to give them a shiny finish.

Display the completed images in the classroom. You can also photograph them or make colour photocopies so that students can use them as illustrations in stories and other displays.

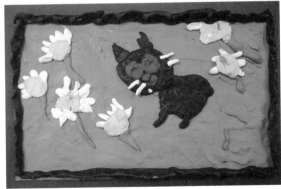

grade 1 student, Wellington School. Teacher: Harbans Rihal

Figure 17.6. (left) A student covers the backing with modelling clay before (right) adding the animal, foreground details such as flowers, and a frame.

Additional Exercises

Here are some additional exercises your students can do with modelling clay:

- In both *Have You Seen Birds?* and *The Party*, the illustrator uses interesting vantage points: close-up, from above or "bird's-eye view," from below, front, and back. Make modelling clay illustrations from interesting vantage points (see chapter 8).

- For illustration projects, keep in mind that making a modelling clay image is hard work! Make cardboard pieces much smaller 4" x 4" (10 cm x 10 cm) for a series of illustrations.

- Incorporate objects such as hair, feathers, bits of coloured foil, or dried flowers into modelling clay scenes. See the caterpillar in *Effie* for an example of this.

VOCABULARY

background	primary colours: yellow, red, blue
contrast	
detail	secondary colours: green, orange, violet
foreground	
geometric solids: sphere, cylinder	shape
illustration	tertiary colours: red-violet, blue-green, and so on
illustrator	
impression	texture
modelling clay	two dimensional
pattern	vantage point

(see appendix B for definitions)

Rhian Brynjolson, *Cute Couple*,
fabric and found materials, 6' x 8'

SCULPTURE

A sculpture is a work of art in three dimensions (3-D), having height, width, and depth. Sculptures may stand, sit on a tabletop, or be suspended. Sculpture projects range from very small beads and miniature figures, to life-sized or enlarged pieces made from a variety of media.

Many sculptural media are suitable for very young students and for students inexperienced in art. Materials that have been used successfully in classrooms include modelling clay, papier-mâché, cardboard, paper, wood, cement, plaster, foam rubber, plastic, and vinyl. Found objects (a polite term for junk and recyclables), such as dolls, machines, toys, mannequins, discarded books, and shoes, may also become sculpture materials.

Working with sculpture allows students to do the following:

- Carve, construct, and add materials to build forms.

- Gain experience with sculpture tools and techniques, and use media that are tactile and easy to manipulate.

- Learn vocabulary related to texture, shape, and spatial relations (for example, *inside, outside, above,* and *through*).

- Develop large and fine motor skills and coordination.

- Solve problems (for example, how to attach pieces, how to choose suitable materials, how to innovate and be inventive).

- Handle basic tools such as scissors, staplers, tape, glue, hammers, saws, and paintbrushes.

- Transform ordinary objects into something different and imaginative. This is a good experience in creative play for children whose entertainment (for example, watching television and playing video games) is, typically, passive.

- Incorporate concepts used in drawing, composition, colour, and space into three-dimensional works, and experiment with new media.

- Create prototypes or inventions that help them learn about other curricula, such as human body systems, simple machines, and musical instruments.

MODELLING CLAY AND CERAMICS 18

TOOLS & MATERIALS

- clay (see section headings in this chapter for appropriate types of clay)
- vinyl tablecloths
- small boards, or pieces of stiff cardboard, to collect sculptures
- tools: wire, sharp sticks, sculpting tools (some sharp, some blunt, and some with a wire loop for carving), plastic cutlery, toothpicks
- textured items: the bottom of a shoe, burlap, window screen, and so on
- rolling pin, heavy cardboard tube
- paper
- scissors
- pencils
- sketchbooks
- duct tape or electrical tape
- paints
- paint smocks
- small plastic bowls
- tinfoil
- newspapers
- visual reference
- optional: tempera paint, paintbrushes, and acrylic medium or Podge
- optional: pasta machine (for creating thin sheets of modelling clay)
- optional: textured items to press into modelling clay or clay

Additional for modelling clay:

- optional: to build a base and armature (supporting skeleton): wooden block, wire, wire-cutters (or pre-cut wire), screws, screwdrivers, hot-glue dispenser, tinfoil
- muffin tins, for setting out small amounts of coloured modelling clay
- optional: see Additional Exercises (page 231)

Additional for clay (ceramics):

- plastic containers for water and slip
- plastic bags (to cover work in progress)
- spray bottle
- sandpaper
- access to kiln
- assortment of low-fire (cone 06), non-toxic glazes, or tempera paint and acrylic gloss medium (Podge), or acrylic paints
- optional: see Additional Exercises (page 241)

Teacher: Doreen Beaupre

Figure 18.1. Tools have been set out for use with clay. The container is a coil pot made from clay.

BOOKS AND VIDEOS TO HAVE HANDY

PICTURE BOOKS

The Subway Mouse, written and illustrated by Barbara Reid.

VIDEOS

Wallace and Grommet: Three Amazing Adventures. DVD, 2005.

VISUAL REFERENCES TO HAVE HANDY

Three-dimensional objects related to the topic of study.

INTRODUCTION

The term *modelling clay* is used to include a variety of modelling materials, including inexpensive, non-drying Plasticine, and a more expensive, acrylic-based product such as Sculpey, which can be hardened in a conventional oven. Most of the materials are not really clay. Real clay is a mineral-based, natural material, commonly used for making ceramic ware such as plates and coffee mugs, as well as pottery, tiles, and sculpture.

Modelling clay and clay are versatile media. It is easy to model forms, impress textures, and change the work by adding to and carving away. When colours of modelling clay are mixed, a wide palette or range of colours can be achieved. Fine detail and pattern can be incorporated. For young children, modelling clay can provide a bridge from the real, three-dimensional world to a flat, pictorial, two-dimensional surface. For more advanced students, modelling clay can provide a bridge from familiar drawing and painting to sculptural work.

A variety of modelling clays and natural clays are available for classroom use. With each medium, demonstrate the process first, then have students follow the process steps to model their own creations. How much you demonstrate and how much you would like students to discover through their own experience with the materials will depend on your students. You may wish to observe students at play and watch for teachable moments when they have made discoveries about their process, techniques, or resulting forms. Alternatively, you may wish to teach the process step-by-step, until students feel confident enough to work independently.

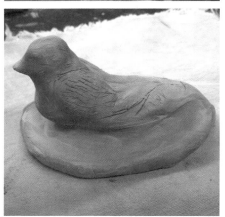

high school students. Teacher: Amy Karlinsky

Figure 18.2. Play dough, modelling clay, and clay can be modelled into a variety of forms. A cat by Nanette and a bird by Angela are made from natural clay. Natural clay is often referred to as ceramics.

PLAY DOUGH AND SALT DOUGH

Flour-Based Play Dough

Flour-based play dough is ideal for very young children, who can use it to explore plastic media – plastic in the sense that it can be manipulated, stretched, and stuck together. Play dough is non-toxic, inexpensive, and easy to make, and easy to tint with food colourings. Play dough is less desirable than natural clay for precise sculptural work for artists, although some salt-dough recipes can be modelled easily and baked for permanency. Many play-dough recipes can be found on the Internet, but two tried-and-true recipes from an elementary teacher who makes play dough weekly for her students are on page 229.

Preparation

Look at subject matter with students. Discuss how a subject is made up of basic forms (in math curricula these are called *solids*). Set out the play dough one colour at a time, or set out two primary colours that will form a secondary colour when mixed; for example, yellow and blue will make green (see chapter 11).

Figure 18.3. Cookie dough can also be used as a modelling material. This is a Vincent van Gogh cookie made for a University of Winnipeg art history students' bake sale.

Appropriate Subjects

Both play dough and salt dough are suitable for building basic geometric forms – spheres, cones, cubes, rectangular prisms, pyramids, cylinders, and so on. Play dough creations are most successful when they are fairly small, or flat like gingerbread people. Salt dough is used to build small sculptural forms, then baked in a slow oven for permanency.

Process for Play Dough and Salt Dough

Students can explore different ways to create a variety of solids, including the following:

- Flatten play dough with a rolling pin, or extrude the dough through a pasta machine.

- Use cookie cutters or a blunt knife to cut out shapes. To produce worm-like strands, push the flattened dough through a garlic press.

- Make patterns by pressing textured items into the dough.

- Build solids or volumes of the subject, and then push (attach) the shapes together firmly to create the form.

MODELLING CLAY AND POLYMER CLAY

Modelling clays, such as Plasticine, are non-hardening, non-toxic, and available in a full range of bright colours. Polymer modelling clays, such as name-brand Sculpey, have a PVC (acrylic) base and can be oven-baked at low temperatures for hardening. Polymer clays are very expensive, so you may want to encourage students to work on a very small scale.

Preparation

For the exercises below, you will need clay in the three primary colours (red, yellow, and blue), as well as in black and white. Secondary and tertiary colours may be purchased or mixed from these colours. Polymer clays are available in an eye-popping range of brilliant colours; select colours suitable for the topic of study. Some brands of modelling clays are greasy and may stick to tabletops. All brands need to be warmed up in students' hands before they are pliable.

Set out the following:

- modelling clay (cut into small blocks, and place the blocks on trays)

- equipment: pasta machine, garlic press, textured objects to press into the clay, and modelling tools – blunt knives, sticks, forks, and loops of wire

- pre-cut wire (or wire and wire-cutters for older students)

PLAY-DOUGH RECIPE

4 cups (1 L) flour
2 cups (0.5 L) salt
2 tbsp (30 mL) cream of tarter
4 cups (1 L) water
2 tbsp (30 mL) canola oil
food colouring

1. Put all ingredients in a heavy saucepan. Stir over medium heat until mixture is thick and forms into one ball.
2. Allow to cool slightly, then knead until mixture is a uniform texture.
3. Store in plastic (Ziploc) bags in a refrigerator for up to one week.

SALT-DOUGH RECIPE

4 cups (1 L) flour
2 cups (0.5 mL) salt
cold water (enough to form a stiff dough)

Salt dough should be used immediately. After modelling, bake in a very slow oven (200ºF/95ºC) until hardened. It may then be painted with tempera paint (use very little water) and coated with Podge or acrylic gloss medium when cool.

TIP Most three-dimensional sculptures will require an armature – a skeleton made from a sturdy material – to prevent the sculpture from slumping. If movable parts are required, the armature should be made of strong, flexible wire. The wire can be wrapped with tinfoil and moulded to provide a lighter, more three-dimensional armature. This will reduce the amount of modelling clay required to build the figure. Figures can stand up if they are bottom-heavy; otherwise, attach a loop of wire to a base made from wood or another heavy material.

- (optional) materials for bases (for example, blocks of softwood – pine or spruce are best; hardwoods are difficult to use with hand-tools) – stones, or other heavy materials)

- (optional) hot-glue dispensers or screws and screwdrivers (for attaching wires to the base)

Appropriate Subjects

Both modelling clay and polymer clays can be used to make two-dimensional images (see chapter 17) and small-scale sculptures (figure 18.4). Because modelling clays (for example, Plasticine) tend not to harden or dry out, they are ideal for movable *claymation* (animation) characters. Any animal, human, or fantastic creature will provide an interesting subject for a movable sculpture (figure 18.5). Students can also sculpt props and pieces of a setting to make a diorama. Pieces need to be small, 6" (15 cm) or less, in order to stand and hold their weight, or they may be supported by an armature (skeleton) of wire and tinfoil (for building instructions, see below).

Polymer clays, such as Fimo and Sculpey, are less suitable for claymation, but have the advantage of hardening for more permanency when they are baked at a low temperature in a regular oven. Older students can use polymer clays to make small (4" [10 cm]) sculptures and jewellery. To reduce the amount of expensive polymer clay that is used, build an armature of wire and tinfoil, and then cover it with a thin sheet of polymer clay extruded from a pasta machine.

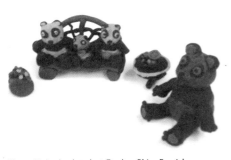

Nancy, high school student. Teacher: Rhian Brynjolson

Figure 18.4. Nancy made these detailed miniature figures in art class. They would be perfect for an animation project.

École Constable Edward Finney School. Teacher: Donna Massey-Cudmore

Figure 18.5. Students used modelling clay and pipe cleaners to study the body parts of their insects.

Process

1. Initial Drawing. Have students practise draw their subjects in their sketchbooks or on pieces of scrap paper. Students can study the geometric forms, patterns, textures, colours, and negative spaces of their subjects. Advanced students can then revisit composition and think about principles of design that might apply to their sculptures. For example, have students consider how to make their sculptures balance, give a sense of movement, and check the proportion of various parts (see chapter 5).

2. Armature (figure 18.7). (a) Cut a piece of wire approximately 12" (30 cm) long (half this size if you are using expensive polymer clay). Make a small loop in the middle of the wire – this will support the head. (b) To make the body, bend and twist the wire together for about 2" (4 cm). Separate the ends to make legs. For feet, make small loops on the end of each leg. (c) With either a wood screw or hot-glue dispenser, attach one leg to the wood base. (d) Attach another piece of wire across the shoulders, for arms, and wrap around once to attach. (e) Four-legged animals require another length of wire,

Teacher: Briony Haig

Figure 18.6. Wire, pliers, and polymer clay are ready for student use.

Teacher: Cathy Woods

Figure 18.7. A student prepares the armature of a human figure. The armature will be wrapped in tinfoil to fill out the form.

doubled, to run from the neck to the back end and down to the back legs. (f) Add volume by wrapping the creature in tinfoil. Look at the original sketches to decide which parts of the figure need to bulge or taper. (g) Ensure that the armature is sturdy. To reinforce the armature, use flexible duct tape or electrical tape.

3. Modelling clay. Warm up the clay thoroughly in your hands, one small piece at a time. Modelling clay can be flattened by hand or extruded through a pasta machine to provide layers that will wrap around the armature (figure 18.8). Blend colours, and pay close attention to the form of your subject from a variety of angles – side, front, back, above, and so on. After the base colours and the form are established, begin adding small details and impressing texture marks. If the clay is difficult to work with it is either not warm enough, or it is too old and dried out.

Additional Exercises

Here are additional exercises for working with modelling clay:

■ Construct a three-dimensional scene or miniature stage set inside a closed environment (such as a shoebox with a painted interior). Use characters made from modelling clay to act out a story (figure 18.9). Take this exercise a step further by making an animated video, called a *claymation*. To do this, you will need access to a digital camera and a tripod (see chapter 21).

■ Construct a simple wire armature (as above). Draw and cut out a figure from a thin sheet of coloured foam rubber. Then, trace a second, identical shape on another piece of foam, and cut it out. Use a low-temperature hot-glue dispenser to fasten the sheets together over the armature. The resulting figure has some limited flexibility. It can be decorated with additional foam pieces or miscellaneous materials.

Creature, Kayla, Elmwood High School. Teacher: Briony Haig

Figure 18.8. A wire armature (skeleton), similar to the armature in the top photo, supports the wings of this composite creature made from modelling clay.

Elmwood High School. Teacher: Briony Haig

Figure 18.9. A student placed her modelling clay figure into a miniature stage set she created from found materials.

- Try the exercises for clay (below) with modelling clay. The modelling clay sculptures and pots can be photographed to provide a permanent record. Modelling clay cannot be fired in a kiln or used for food containers.

CLAY

Clay is a natural composite mineral material, common in areas near riverbeds and lakes. Commercial clays have been cleaned of organic materials and can be purchased ready to use on a potter's wheel, to pour into ceramic moulds, to paint over other clay pieces as slips, or to sculpt. Access to special equipment is required for finishing clay projects. Clay is dusty to work with, and so the use of a separate room, outdoor space, or art studio is highly recommended. Clay must be dried slowly and fired in a kiln (a high-temperature oven with firebrick insulation) in order to harden and become durable.

Before they are fired, clay pieces are quite fragile and called *green ware*. If your school does not have access to a kiln, you may be able to arrange with a neighbouring high school or ceramics studio to fire your students' artworks. Fired clay, called *bisque ware*, may be painted with tempera or acrylic paint, and finished with acrylic glass medium or Podge. Alternatively, it may be glazed (painted with a mineral-based medium) and re-fired for a permanent, dishwasher-safe finish. Glazes used by students, or for dishes intended to hold food, should have a safety label indicating that they are non-toxic.

There are several different types of clay:

- Porcelain is a white, fine clay body that is fired at a high temperature.

- Earthenware clays, commonly used in school art programs, are mixed in a range of natural colours and textures and can be fired at lower temperatures (1800°F/1000°C).

- Stoneware clay bodies are similar to earthenware clays, and are fired at intermediate temperatures.

- Raku clay is coarser than the above-mentioned clays, is ideal for sculpture, and can withstand rapid heating and cooling of raku firing (figure 18.10).

- Paper clay is a sculpting product that has paper pulp added to a natural clay body. The advantage to paper clay is that it can be painted without having to be fired in a kiln, and it is fairly strong when dry. If paper clay is fired, it produces a semi-opaque, ceramic bisque ware; a thin layer will allow some light to pass through the material. Use as clay.

Because clay has been used for thousands of years, there are endless examples of items available to teachers for its uses. A few examples include cooking pots, fine china, toilets and storage vessels, miniature and massive sculptures, painted ceramic tiles and mosaics, buildings constructed from clay bricks, and small objects such as pipes and beads.

Teacher: Rhian Brynjolson

Figure 18.10. Kryssy used raku clay to build this dragon in a high-school art class. Raku clay has more sand, which gives the clay a bit more structure for larger sculptures and for difficult extensions, such as these wings. The wings were supported with crumpled newspaper while they dried.

Figure 18.11. Clay is cut from the block with a loop of wire. Cover the clay with plastic to keep it moist.

TIP To make the transition from two- to three-dimensional work easier for students, have beginners build or carve a frieze, which is a flat rectangle, or clay tile, with a slightly raised image.

TIP To make the job of sculpting easier, have a three-dimensional model of the subject available. Students can then examine the model from various views — front, side, top, and so on, and, also, touch the bumps, dips, or various surface textures.

Preparation

Cover tables with cloth or vinyl tablecloths. Set out modelling tools (see page 227). Cut clay into small pieces by pulling a length of wire through it – similar to the way you use a cheese-cutter (figure 18.11) – and cover with plastic until it is used. Make slip by dissolving clay in water (to a pudding-like consistency). Find visuals (or math blocks) relating to geometric forms (solids) – sphere, cube, cylinder, cone, rectangular prism, and so on. Also, find visuals of the subjects to be sculpted, or works by the artist being studied.

Appropriate Subjects

Start by making small bowls, using pinching, coil building, or slabs (these processes are described below), to gain experience with handling the material. Pieces that extend outward tend to break off – either because the pieces dry too quickly and crack, or they get bumped and break. Simple, rounded forms that do not have too many extensions are best. An apple or a cat curled into a spherical shape is much easier to carve than is a gangly giraffe or a deer with antlers. Whenever possible, have extensions such as tails fold back, or wrap around, and be continuously attached to the clay body.

Basic Process

Before they start working with the clay, have beginners familiarize themselves with a very small piece of it. Distribute small pieces of wet clay, and ask students questions such as the following:

- How does the clay smell? (like mud puddles!)
- What does the clay feel like?

VIEWING

Honoré Daumier, *François-Pierre-Guillaume Guizot (1787–1874), Deputy, Minister and Historian.* 1833.

Figure 18.12. Working with clay allows students to explore form and shape in three dimensions. It can be a way to solve spatial problems and build models, environments, toys, and other objects. Daumier's clay sculpture is a bust of Guizot, who was Prime Minister of France for a brief period in the 19th century. Daumier often got into trouble for his satirical cartoons that lampooned the monarchy and the government in France. His portrait of Guizot is no exception, as the man's lumpy head stares vacantly into space in a less than noble manner.

Figure 18.13. Attach pieces together by scoring (scratching the points of attachment). Dab on a small amount of slip (watery clay). Then squish the pieces together, and smooth over the joints. Try to avoid trapping air bubbles inside the clay body.

Dragon Hatching, ceramic sculpture by Kryssy. Teacher: Rhian Brynjolson

Figure 18.14. When Kryssy's first dragon sculpture was fired, it exploded in the kiln. The cause was likely moisture trapped inside the clay body. Clay needs to dry thoroughly before firing. Kryssy solved the problem by reassembling her dragon and adding a clay egg. The sculpture is held together by the glaze, which fused all of the clay pieces together.

Savannah, high school student. Teacher: Rhian Brynjolson

Figure 18.15. This smudge bowl began as a simple pinch pot.

Students can use the clay to model basic geometric forms. As the clay dries, students will notice that it becomes stiffer, and small surface cracks begin to appear.

It is important to understand that the wetness or dryness of the clay helps to determine the techniques that should be used to get the best results. Very wet clay is easy to pinch and pull. Slightly drier clay is easier to stand up in larger slabs. Leather-hard clay is a better consistency for carving fine details, but it breaks easily. As a general rule, model the basic shape of your subject or vessel while the clay is wet. As the clay hardens, attach pieces, and have it stand with some supports. At a drier stage, you can carve and scrape the clay. When the clay is completely dry, you can sand, scrape, or file the surface smooth.

To attach pieces of clay together (such as legs to bodies, or handles to cups), use a sharp tool or toothpick to score (scratch in parallel or crosshatched lines) the piece and the area to which the piece will be attached. Dab on a small amount of slip (clay dissolved in water to a pudding-like consistency). Squish the pieces together, and pull the edges of the pieces together with a tool or finger until the clay appears seamless (figure 18.13).

Place unfinished clay work on a board covered with newspaper, spray the clay with water, and cover with plastic. It is possible to re-wet the clay with a spray bottle or keep it damp by wrapping it with wet paper towel.

To dry finished pieces, wrap them loosely with plastic so they dry slowly and evenly. Over the next couple of days, check to ensure that they are drying evenly – small extensions should be covered with plastic so they dry at the same rate as the central pieces. Clay work should dry thoroughly for a week before firing. In a humid environment, larger pieces may need more time to dry.

When it is time to fire the clay, carefully stack the clay pieces in a kiln, and fire to the appropriate temperature for the clay body. Make sure the kiln is properly installed, out of reach of young students, and vented. Most bisque ware is fired to cone 06 (see appendix A). Follow your kiln's operating directions carefully, and respect safe handling procedures (see page 239). Let the kiln cool completely before opening it to remove the clay (figure 18.14). The firing and cooling may require 24 hours.

Process for Pinch Pots

1. Take a small piece of clay and make an impression in the centre of it with your thumb. The piece should now look like a small pot.

2. Pinch the pot evenly around the edges to form a uniform side wall. At this point, you can do the following: Set the bottom of the bowl on the tabletop to create a flat bottom, press textured items into the clay, and/or use a sharp tool or toothpick to scratch patterns into the clay.

3. As the clay becomes slightly drier, or leather-hard, the top edge of the bowl may be smoothed, scalloped, built up with a coil of clay, or cut into a shape or decorative pattern (figure 18.15). Use a small amount of water to smooth surface cracks or re-wet the clay.

Process for Coil Building

1. Roll clay pieces into cylinders or "worms" (figure 18.16).

2. Coil the clay cylinders around to make tight, flat spirals, and then begin wrapping the coils upward. The clay can be left in coils, or smoothed so that coils disappear into a seamless bowl (figure 18.17).

Figure 18.16. This student is using her experience with modelling clay to begin making a larger form. She is beginning by rolling cylinders.

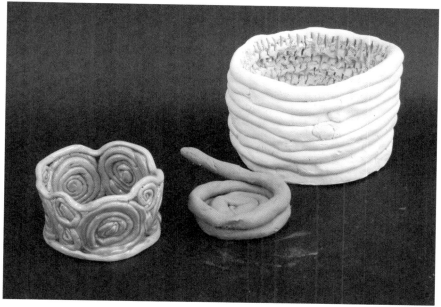

after-school art program. Teacher: Doreen Beaupre

Figure 18.17. These pieces show coil building in progress.

Process for Slab Building

1. Use a slab roller, rolling pin, or stiff cardboard tube to roll out a piece of the clay from the clay slab to a thickness of about ¾" (2 cm).

2. Cut out one long rectangle. The easiest way to do this is to cut out a piece of paper as a template, lay it on top of the clay, and cut around it. For a small dish, start with a rectangle that is 2" x 12" (5 cm x 30 cm).

3. When the clay is dry enough to support its own weight (after a few minutes), stand the rectangle on edge, and form it into a hollow cylinder. Overlap the edges slightly, score the edges, use a small amount of slip to secure the connection, and blend clay together at the joint (figure 18.18).

4. Set the clay cylinder on the remaining clay slab. Cut around the outside of the base to make the bottom of the dish. Attach the sides of the dish to the bottom, smoothing the inside and outside edges where they are joined.

5. Press textured items into the clay before or after the slabs are cut and joined. Patterns may be scratched into the clay with a sharp tool or toothpick. The top edge of the dish may be smoothed, scalloped, built up with a coil of clay, or cut into a shape or decorative pattern.

TIP Beware of very thick clay pieces (more than 2" [5cm] or air bubbles), as any air or moisture trapped in the clay body will cause cracking, or it will collapse when the piece is fired in a kiln. Larger sculptures will need to be hollowed out from the bottom. Hollow sculptures will need a hole for hot air to escape. Air bubbles should be popped with a sharp tool or toothpick. Avoid folding the clay as you work, because air pockets will be trapped inside.

TIP Before young students coil the clay, cover the inside of plastic containers with paper, and have students build with their coils inside the containers – this technique provides some support for their structures.

Figure 18.18. These are examples of slab-building techniques in a high school art class. The clay is rolled out with a rolling pin, the shapes are cut out, and then the clay pieces can be stood up and curved into a cylinder or other closed form. Texture has been added with a roller.

6. Experiment with taller rectangles and larger dishes or vases. Use slab-building techniques to make clay boxes (cut out and join four squares or rectangles for the sides of the container). It will save work to shape these out of scrap paper first, to check the sizes and proportions.

7. Slab-built cylinders and rectangular prisms can become the basis for making larger sculptural forms (see below).

Process for Slumping

Slabs of clay (above) may also be simply "slumped" over a low object to create a plate or platter, or raised form.

1. Roll out a slab of clay, and cut it into an oval, rectangle, or other interesting shape.

2. Set out a large platter, plate, or shallow bowl, line it with paper, and lay the clay over top. The clay will assume the shape of the object it is set in or over.

3. The clay may then be impressed with textured objects, or carved (figure 18.19).

Process for Moulds and Supports

Moulds and supports are useful for building larger clay pieces (figure 18.20).

Ceramic Moulds

Ceramic moulds are available so that clay slip may be cast (poured).

1. Pour slip into the mould (use pre-mixed slip as directed), and wait for approximately an hour.

2. Pour out the liquid clay to leave an even coating of ⅜" to ½" (0.5 cm to 1 cm) around the inside of the mould.

grade 5 students, Sister Macnamara School.
Teacher: Cathy Woods

Figure 18.19. Students rolled out thin slabs of clay and slumped them over crumpled newspaper to give them a three-dimensional bulge. They used bright glazes to add colour.

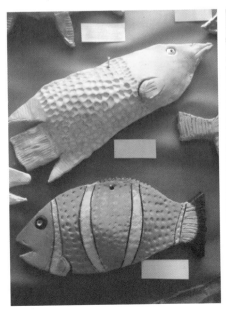
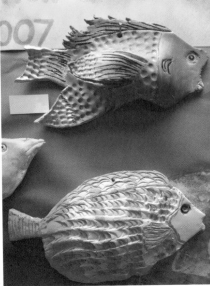

3. When the clay is dry, open the mould, and remove the hollow clay piece, sanding the joints when dry.

4. To finish or customize the piece, carve into the leather-hard clay, add pieces, or sand until smooth.

Moulds and supports can also be made from common, recycled objects in the following ways:

- Wrap slabs around cylinders such as tin cans, slump or fold them over bowls or sushi plates, or form the slabs over a variety of other objects. Remove the clay from these objects before it dries (it shrinks 10 percent and will crack). Also, keep in mind that clay is sticky. Wrap objects in a couple layers of newspaper, or coat the objects with cornstarch, so that the clay will slide off easily.

- To support a tall sculpture, such as an animal figure with long legs, place the sculpture or projecting piece over a solid support such as a plastic container wrapped in newspaper, or a small box. Set the sculpture and support on layers of newspaper so that it will (hopefully) not resist as the clay shrinks and dries.

Savannah and Leona, high school students. Teacher: Rhian Brynjolson

Figure 18.20. Clay may be poured into plaster moulds. These large vases were cast in plaster moulds.

Process for Sculpting

1. Have students make observational drawings of the subjects they are going to sculpt. Advanced students may want to draw their subjects from a variety of angles – side, front, back, above, and so on. Challenge students to think about the spaces surrounding their subjects and the negative spaces contained within their subjects. Remind students that pieces protruding from their sculptures will be difficult to support – long cylinders such as tails, swords, hair and so on should fold back toward the base of the sculpture. For example, figures might be posed so that an extended arm is supported by a fold in a coat, or arms might be folded close to the chest. Show students examples of clay sculpture, including simplified forms, that may encourage beginners.

2. Build the basic form of the sculpture, using the pinch, coil, or slab method. Begin to pull out and attach other simple volumes (solids) until the subject is crudely shaped. At this point, details can be added, or they can be carved in as the clay becomes harder. If the clay becomes too hard, spray a small amount of water on the clay, or cover parts of the form with wet paper towel. Too much water may cause the clay to crack.

Process for Carving

Carving is an exercise in removing negative spaces to reveal a three-dimensional form.

1. In a sketchbook, make a drawing of the subject and then draw the edges of the block of clay closely around the subject. Shade in the areas between the subject and the perimeter of the rectangle; these are the negative spaces that will need to be carved away.

grade 4 students, Wellington School. Teacher: Susan Bukta

Figure 18.21. These clay animals have been drying for a week and are ready to be fired in the kiln. The students who made them paid careful attention to the surface textures of their animals. The bases have been hollowed out so that the clay will dry evenly.

TIP To make this process more creative, have students make their own moulds: Pour clay into wet sand, or press objects into wet plaster and then press in, and remove, slabs of clay when the plaster is dry.

2. Begin with a small block – a cube or rectangular prism – of soft clay. Examine each view, such as the front view, side view, or top view, and make a rough sketch of the form of the subject onto each view. As the excess clay is carved away with a wire loop tool, continue to turn the clay to check the form from different angles. Carve away the wet clay until the rough form of the subject emerges. Clay can be added back in if too much is removed.

3. Score the area, and use a small amount of slip to attach, or re-attach pieces. When the clay is leather-hard, continue to carve smaller details, smoothing and scratching with a variety of blunt and sharp tools.

4. If the sculpture is more than 2" (5 cm) thick, hollow out the base with a wire loop tool, by carving from the bottom. If the clay becomes too hard, spray the sculpture with a small amount of water, or cover parts of the form with wet paper towel. Too much water may cause the clay to crack (figure 18.21).

Process for Hand Throwing on the Potter's Wheel

It takes practice to use a potter's wheel (figure 18.22). Wheels may be electric, or kicked (foot-powered). Although wheels have an adjustable basin to catch drips and splatters, wear an apron to protect clothing. To learn the basic techniques and hand positioning, teachers may want to take a course or have an experienced artist demonstrate and explain the use of the wheel. Also, look carefully at hand-thrown bowls, mugs, vases, and pots, and notice the thickness of the walls, how the bottoms are trimmed, and their approximate sizes and shapes.

1. Begin with a small piece of clay pushed onto the centre of the wheel. Have a small pail of water and a sponge handy. The first challenge is to centre the clay properly.

2. As the wheel spins, push down on the clay with the palm of your left hand, and push it toward the centre with the palm of your right hand. Drip small amounts of water over the clay to keep it slippery. The aim is to create a compact, smooth cylinder that does not wobble as it spins.

3. Once you have a solid cylinder, overlap your thumbs, and push down gently in the centre to create a shallow depression.

4. Place your left thumb over your right hand, and squeeze the inside wall of the bowl with the fingers of your left hand, while your right palm supports the outside wall. It may help to balance your elbows on your knees, as it is not easy to keep your hands steady during this process. Watch that you do not catch a fingernail in the clay; long nails are not recommended.

5. When you have a bowl shape, stop the wheel, and cut the clay from the wheel with a loop of wire.

6. When your bowl is leather-hard, you can stick it back on the wheel with a piece of soft clay, and use a carving tool to trim the rim, sides, or (if it is turned upside down) the bottom.

7. Let dry thoroughly, sand smooth, and fire.

Figure 18.22. It is important to keep hands steady when working on the potter's wheel. This can be done by supporting the elbows and locking one hand over the other.

Figure 18.23. A coil bowl, with turtles, and a "thrown" piece (made on the potters' wheel) are ready to be fired. Before firing, they are called "green ware." After firing, they will become "bisque ware," and they will be ready to be glazed.

Firing Clay

1. When clay pieces are thoroughly dry (figure 18.23), which may take several days, they can be stacked carefully in a kiln and fired to the appropriate temperature for the clay body.

2. Bisque firing (the first time clay is fired) is commonly to cone 06 (1800°F/1000°C). Bisque firing produces a chemical change in the silica and alumina in the clay through dehydration and vitrification – in simple terms, the water molecules are removed, and the minerals realign and bond. After the bisque firing, the clay will no longer go back to its original state or absorb water. At this point, the clay may be painted or glazed.

Painting and Glazing

Bisque Ware

- Bisque ware may be either painted or glazed. If the ware is glazed (figure 18.25), it will need to be fired in the kiln a second time.

- If the pieces are not being used for food, they may be painted with tempera or acrylic paints (see chapter 12). Experiment with more and less water – a watery application will allow texture marks to show through the paint more clearly. Tempera paint may be coated with PVA (acrylic gloss medium or Podge) to give it a shiny, finished appearance. Do not re-fire.

Glazes

To glaze clay, you will need to purchase or manufacture non-toxic glazes. Glazes contain alumina, silica, and oxides that bond chemically into a glass-like surface when heated in a kiln. The colour of the liquid in the bottle is different from the colour of the finished fired glaze. There are a variety of glazes available (figures 18.24 and 18.26). Check the recommended firing temperatures for your clay type and kiln; there are colourful, non-toxic glazes available for low-temperature firing at cone 06 (1800°F/1000°C).

CAUTION! The kiln must be properly installed out of reach of young students and vented with an exhaust fan. Kilns operate at very high temperatures; follow your kiln's operating directions carefully, and respect safe handling procedures. Let the kiln cool completely before opening. A lock may be placed on the kiln to prevent it from being opened during firing. The entire firing and cooling process may take 24 hours.

Dorothy, high school student. Teacher: Rhian Brynjolson

Figure 18.25. Dorothy brushes glaze onto the base of a clay piece. The piece has been fired once, and is almost ready to go into the kiln for a second time. Metal-tipped stilts will keep the glaze from sticking to the kiln shelf.

Patricia, high school student. Teacher: Rhian Brynjolson

Figure 18.26. A high-school student modelled this human figure from clay. She chose a semi-transparent glaze that allows the surface irregularities of the clay to show through.

Figure 18.24. Glazes can produce a variety of colours and patterns when fired at a high temperature. Make test tiles so that students can see what each glaze looks like after it is fired.

Figure 18.27. Non-toxic glazes are brushed onto the bisque ware (clay that has been fired once). The pieces are then placed in the kiln a second time.

1. Brush on the glaze with a paintbrush in several thin, even coats. Avoid glazing the bottom of the piece, as glaze will stick to the kiln shelf. Small stilts are available to hold clay pieces above the shelf.

2. Re-fire the clay pieces, taking care that the pieces are not touching each other or the sides of the kiln. Set the pieces on stilts designed to hold the glazed pieces slightly above the shelf (figure 18.27).

Raku Firing

It may be worthwhile to make arrangements with an artist to visit, or participate in, an outdoor raku firing. The intense heat and oxygen-reduced atmosphere of burning organic materials, such as leaves, in a gas-fired raku kiln, create interesting colour variations in the surface of the specialized glazes.

Additional Exercises

Working with natural clay and modelling clay provides endless possibilities. Here are some variations for developing specific projects:

- Use small amounts of play dough, inexpensive modelling clay, or clay, to learn about an element or principle of design. For example, impress textured objects into dough or clay to learn about texture and pattern, or model geometric forms to learn about form.

- Make ceramic tiles from clay, and paint the same image or pattern on several tiles. Arrange these tiles to study repetition and symmetry.

- Study clay artifacts, such as cooking utensils, objects, and sculpture from a particular historical period, culture, or location. Sketch or recreate these pieces, or compare and contrast them to contemporary objects or artworks.

- Combine forms in playful ways. For example, combine an animal form into a bowl, or a face into a cup. Look for artists' examples of playful juxtapositions (combinations) of useful objects with other subjects (figure 18.28).

grade 1 class, École Constable Edward Finney School. Teacher: Andrea Stuart

Figure 18.28. Each student in the class made a slice for this ceramic pizza.

VIEWING

Edmonia Lewis. *Forever Free.* 1867.

Figure 18.29. Edmonia Lewis created this sculpture out of white marble. An artist of both Native-American and African-American descent, Lewis made *Forever Free* after the American Civil War to represent the emancipation of slaves. In the sculpture, the chains wrapped around the man's arm do not seem to restrain him. The woman kneels in prayer, as both figures look upwards. During the time period in which Lewis worked, it was unusual to see African Americans immortalized and idealized in such classical form (an African-American female artist was also a rarity). Lewis's sculpture symbolizes hope, presenting a vision of strength and freedom for the future.

VOCABULARY

bisque ware	pinch pot
carve	play dough
ceramics	polymer clay
clay	porcelain
coil pot	potter's wheel
cone	pottery
earthenware	raku
fire	salt dough
forms	score
geometric forms: cube,	sculpt
sphere, rectangular	sculpture
prism, cone, cylinder	slab
glaze	slip
kiln	slump
modelling clay	stilts
mould	stoneware
paper clay	template

(see appendix B for definitions)

Spotlight
ART EDUCATION MEETS SOCIAL JUSTICE
by Cameron Cross

rt education is powerful. Whether students are creating art with an art specialist in an art room or working across the curriculum with a classroom teacher, art can reach deep inside them like nothing else.

As an art educator, I believe that we have a crucial role in educating the whole child. The Internet, our own personal experiences, and a new arts curriculum provide us with new ways and tools to assist our students in constructing their understanding of art, themselves, and their world.

As we help our students prepare for the future, we need to be open-minded to new possibilities. As creativity expert Sir Ken Robinson says: "We don't have a clue what the future will look like in five years, and yet we are educating our students for it." This is precisely why it is so important for us to help students with their creative and critical thinking skills.[1]

One important "21st-century skill" we can help our students develop is that of good global citizen. Today's world is so interconnected that everything we do in one area affects all other areas on some level. For this reason alone, we should always be thinking of ways for students to (a) realize their creative potential, (b) become greater creative problem solvers, and (c) think critically about the world around them. In art, as we all know, this means much more than teaching the elements and principles of design and the colour wheel.

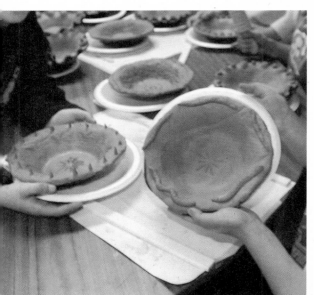
Students at Montrose School are creating "Empty Bowls."

Many of us in the art education field have been fortunate enough to take part in social justice art initiatives. Of the many ways to facilitate social responsibility, two social justice art initiatives are close to my heart as an educator: *Empty Bowls* and *Brush Out Poverty.*

Both Empty Bowls (www.emptybowls.org) and Brush Out Poverty (www.brushoutpoverty.org) use art as vehicles for communication. Curriculum requirements – skill building, cultural awareness, communications, elements and principles of design, media, and technique – are evident and fostered by

1. <http://www.ted.com/talks/ken_robinson_says_schools_kill_creativity.html>

Empty Bowls

- Students create and design ceramic bowls.
- Students invite parents and community to the school for a simple meal of soup and bread.
- At the event, the ceramic bowls are put on display. Following the meal, viewing takes place.
- Bowls are purchased, and the money is donated to a local food bank.
- Students take their ceramic bowls home, where they are left empty as a reminder that there are empty bowls in the world – and even in our own community.

Brush Out Poverty

- We set up a situation and ask students a leading question: "Let's say you want to communicate something to some African children who are living in an orphanage because of AIDS. However, you can't talk to them on the phone or write them a letter. Could you use paintings as a form of communication? If so, what would you paint?"
- Students make paintings that they exchange with students who live in an orphanage for AIDS-affected children in Africa. The exchange provides an artistic, cultural, and social awareness exchange between children.
- The artwork is photographed or photocopied before being sent to Africa. The photographs/photocopies are displayed alongside the artworks received from children in Africa. Through this activity, students become aware of orphanages in Africa that are in need of medicine, educational materials, and other basic needs.
- Cards or prints are made from the children's artwork and are sold as a school fundraising initiative. One hundred percent of all proceeds goes directly to the African orphanages involved in Brush Out Poverty.

Students at the Salama Centre, Majengo Village, Tanzania, paint pictures, which they will exchange with students in Canada.

the teacher. At the same time, the objective of each program – to help those in need – is met. Students think about social issues while they create their artworks. The means of communication is more directed, and there are far-reaching social implications at work, as well.

Making learning meaningful for students is always on the minds of teachers, parents, and especially the students themselves. When learning lacks meaning, it is often ineffective. I believe that as our world becomes smaller, through technology and travel, the need to foster social responsibility in our students becomes clearer. It is no longer acceptable for any of us to be passive observers of situations in the world. We all must be active participants in creating a safer, healthier planet. Through art, this is possible.

Young artists at the Salama Centre display their completed artworks.

Cameron Cross is an artist and art education consultant for the Pembina Trails School Division.

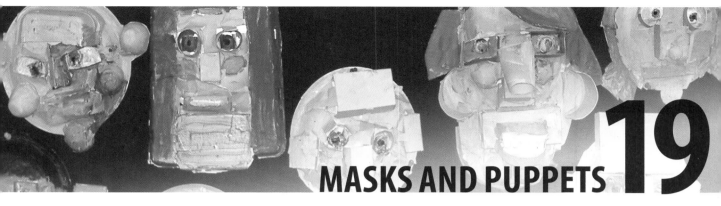

INTRODUCTION

This chapter introduces the basic techniques for making masks and puppets out of paper, foam rubber, papier-mâché, and plaster. (Puppet bodies may be constructed out of sticks, cloth, or rolled paper and wire.) In mask and puppet construction, students gain experience in making basic sculptural forms, such as cylinders, spheres, cones, and cubes, as well as extend their knowledge of portrait drawing to three-dimensional faces.

Masks can be used as disguises or for inventing characters. Masks may be combined with drama – acting out plays, legends, or skits – or simply displayed on a wall. Masks are used in ritual, theatre, and dance in many cultures around the world. The fascination of masks is in taking the familiar form of a face and transforming it with animal, magical, eccentric, or expressive properties. Before students make their masks, ask them: "Who do you want to become?" The masks they construct may become powerful tools for growth and self-reflection.

Puppets are ideal for learning about character and for developing and presenting stories (see Shadow Puppets, chapter 9). Students can design their own human, animal, or fantastic characters, or they can develop puppets from characters described in books. As students play with their puppets, they act out scenarios and develop voices and plot lines. A puppet show is an accessible theatre form that translates well to animation and video (see Part 6).

VIEWING

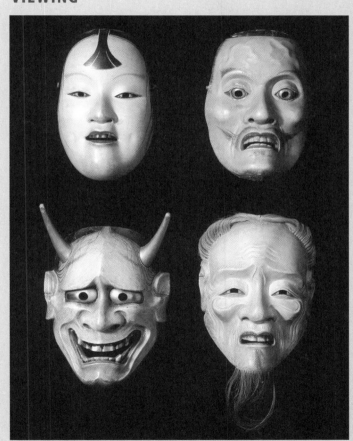

Japanese Noh Masks. Pitt Rivers Museum, University of Oxford

Figure 19.1. Masks are part of many cultural traditions, and are used to heighten drama and create exciting characters for theatrical performances. These masks are part of Noh, a form of traditional Japanese musical drama. Noh masks can be used by actors to play the roles of animals, demons, gods, or other nonhuman characters. They are often carved in such a manner that by tilting them slightly, different emotions are displayed. Many students find mask-making to be their favourite art activity, since the finished product is an invitation to play and act as another character.

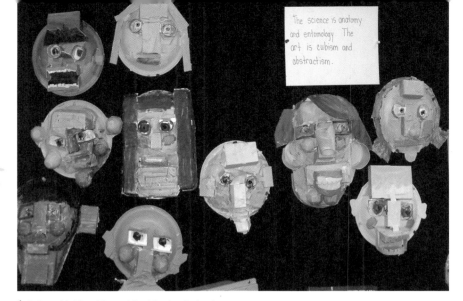

École Constable Edward Finney School. Teacher: Andrea Stuart

Figure 19.2. Students studied faces to create these cubist masks from papier-mâché.

Preparation

Set out a variety of good visual references, such as calendar photos, postcard pictures, picture books, and magazine photographs. Once students select their subjects, they can do additional research in the school library, visit a museum (if accessible), and use Internet sources. Also set out the tools and materials that will be needed for the project (see below).

Appropriate Subjects

Encourage students to research their subject. Some successful examples of school projects include making undersea creatures and characters from stories and myths; studying mask or puppet designs from a particular culture or country; and making theatre masks, hidden identity masks (with text written on the inside of the mask), decorated goalie masks, and animal masks.

Basic Process

In general, the process will be the same for any face – human, animal, fantasy, or artists' puppets or masks. As a class, look at examples of the subject of study. Have students look carefully at particular features and sketch a variety of examples, such as noses, eyes, and so on. Discuss the prominent characteristics of the subject: for example, a crocodile's head is long, it has many crooked teeth and bumpy skin; a goalie mask is designed to be fierce and intimidating, and the design may relate to the hockey team's name and team colours.

Next, have students draw preliminary sketches of what they want their own masks or puppet heads to look like. After completing several different designs, ask each student to choose his or her strongest design. Choose which technique you are going to use – paper, foam rubber, papier-mâché, or plaster – and collect all the necessary materials (see below). You may want to try the exercises (or parts of them) first, to determine how to adapt them for your students.

PAPER OR FOAM MASKS

- sketchbooks
- pencils
- erasers
- Manila tag, used file folders, or lightweight cardboard (cereal boxes)
- white glue
- masking tape
- stapler and staples
- paper hole punch
- large elastic bands or elasticized string (for wearing masks)
- optional: paper cups, paper plates
- low-temperature hot-glue dispenser
- optional: see Additional Exercises (page 248)

Additional for foam masks:

- colourful craft foam (available in sheets), or larger blocks of foam rubber (available where furniture or futon mattresses are manufactured); substitute foam for the cardboard and Manila tag
- stapler and staples (for thin sheets) or low-temperature hot-glue dispenser (regular glue will not work with foam rubber)

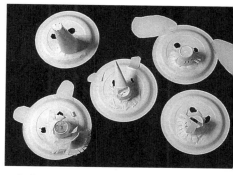

grades N–3, San Antonio School

Figure 19.3. Students used cylinders (paper cups and Styrofoam cups), cones, and flat pieces of Manila tag to build ears, snouts, horns, tongues, and whiskers on their animal masks. Cylinders and cones were attached by cutting slits around the rim of the cup, then folding out the edges around the rim, and securing them with glue and masking tape.

Process for Paper or Foam Masks

Sizing the Mask

Have students draw their masks in their sketchbooks.

Distribute a piece of Manila tag or foam to each student. Students can use their selected drawings as guides for sketching the outline and main features of their masks onto Manila tag or foam. (For young artists, provide a template, such as a paper plate, for the approximate size required for their face.)

After students know the types of masks and the kinds of creatures they are going to design, have them determine how large they want their masks to be. Students can do the following to determine how wide their masks should be:

1. Place the Manila tag (or foam) over the face, and measure (approximately) from ear to ear. On the Manila tag (or foam), use a pencil to mark where the ears are.

2. Feel for the placement of the eyes, and, with a pencil, carefully make a mark over each eye.

3. Feel where the nose is, and use a pencil to carefully mark it.

4. Cut the Manila tag (or foam) to size, and cut out the eyes and the nose.

Constructing the Paper or Foam Mask

If masks are to be worn, students can punch two holes at ear-level for attaching elasticized string, then reinforce the holes with masking tape on the inside surface of the masks. Remind students to cut a hole for the nose to protrude, so that they can wear their masks up against their faces.

TIP The eyeholes in the mask do not necessarily have to correspond to the eyes in the creature's face.

TIP Paper and foam are ideal materials for introducing young students to sculpture techniques, because these materials are easy to manipulate. In addition, students gain experience with folding and rolling flat materials to make three-dimensional forms (forms that have depth as well as height and width).

CAUTION! Allow only adults to handle hot-glue dispensers. Lower temperature glue dispensers are available for students. Show students how to use these: Put a dot of glue on the larger of two pieces, and push the smaller piece with a stick (never use your fingers for this job). Hold the glue dispenser over a piece of cardboard to catch drips. Emphasize to students the importance of taking turns, and show them how to set the dispenser on the counter between turns rather than pass it from hand to hand.

TIP Young students may need assistance cutting out the outlines of their masks and the two small holes for the eyes.

Students can use paper-sculpting techniques to build projecting pieces for their masks. To sculpt paper, roll paper cones or cylinders, fold into boxes or angles, or cut paper into strips and make paper curls. These forms can be used to build three-dimensional parts on masks – for example, cones for horns, cylinders and cubes for snouts, curls for hair or a mane (figure 19.3). Make tabs that can be folded and attached with glue, staples, or masking tape to the surface of the masks. The masks are ready to be painted and decorated.

Students can decorate their masks with cut pieces of coloured paper or foam. Use a stapler, or a low-temperature hot-glue dispenser, to attach pieces. Good-quality glue sticks or tacky white glue work for paper masks. To look at cutout patterns, see *How the Animals Got Their Colors*, or look carefully at masks made by other artists.

Additional Exercises

Here are some additional exercises students can do to practise making paper or foam masks:

- Make a hand-held mask. This type of mask covers the top half of the face only and is supported by a stick that is hand-held. Cut a paper plate in half, and attach a stick with masking tape or hot glue. With foam masks, roll the foam around the stick, and use a stapler and hot glue.

- Make a mask that is attached to a headband or hat. With this type of mask, the face is visible, which makes it ideal to wear for performances, because the voice is not muffled. It is also safe to wear, because the mask sits above the student's face, giving the wearer a clear view.

- Make a mask from a large block of foam rubber. Carve the foam rubber with a bread knife or hacksaw. Cut a slit in the bottom of the foam block so that the block will fit on the head and be worn like an oversized hat. The carving process is for older students only, and the foam bits cling to clothing, carpets, and brooms!

theatre masks, Rhian Brynjolson

Figure 19.4. These masks were made by the author for a theatre performance. The masks sit on top of the actors' heads (like hats), allowing the faces of the actors to show.

PAPIER-MÂCHÉ MASKS

TOOLS & MATERIALS

- sketchbooks
- pencils
- erasers
- newspapers
- scissors
- flour (or wallpaper paste)
- several pails and wide, plastic containers (1-gallon [3.75 L] size, for mixing paste and for washing up)
- water
- masking tape (one roll per three or four students)
- whisk, hand-mixer, or blender (for mixing paste)
- pieces of cardboard (cereal or potato chip boxes)
- base for beginning masks (one of: plastic wrap to cover newspaper, paper plates, head-sized balloons, inexpensive store-bought masks)
- optional: petroleum jelly (a thin coating of petroleum jelly on hands and wrists prior to handling the paste makes hand washing easier later; dry paste will not stick to the hair on your arms)
- optional: white tissue paper
- optional: fan or heater
- optional: see Additional Exercises (page 251)

Figure 19.5. The base at the top has been built around a large balloon. After the papier-mâché dries, the balloon is popped. The back is then cut off, which results in a mask with a very round front. Alternatively, the base may be made by rolling newspaper into a ball and squishing it into the desired form.

BOOKS TO HAVE HANDY

TEACHER REFERENCES

Papier-Mâché Today by Sheila McGraw.

Preparation

Students will need two or three 90-minute sessions to make their papier-mâché masks and another session to paint and decorate the masks. You will also need a room with lots of table space and no carpet, and adult volunteers to help very young artists add protruding features to their masks. Shelf space is required for drying masks. If you are in a damp room or basement, you may need to turn on a fan or a heater to prevent mould from forming on the masks as they dry.

Make the glue solution: Add enough flour or wallpaper paste to lukewarm water to make a glue that is the consistency of heavy cream. Use a whisk or beater to eliminate lumps. The glue solution may not keep well, even in the refrigerator, so you might need to make a new batch for each session. Cover tables and drying areas with newspapers.

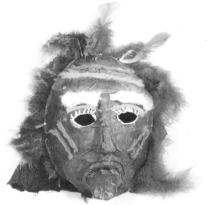

grade 6 student

Figure 19.6. This is an example of the kind of mask that can be made using papier-mâché.

TIP Students can use their paper masks (above) as a supporting structure for their papier-mâché masks.

TIP Papier-mâché masks require more time to make than paper masks do. The advantage to papier-mâché masks is a lightweight, versatile, inexpensive medium that is easy to model into three-dimensional forms.

Process for Papier-Mâché Masks

Session One

1. In their sketchbooks, have students sketch their subjects' faces or heads, so that they can study the forms they are going to build.

2. Choose one of the following techniques for the supporting structure of the mask:

 - Newspaper base: Take several large sheets of newspaper, bunch them up to head size, and fold the edges under, leaving a smooth, rounded surface

on top (figure 19.5). Tape the newspaper edges together on the underside, and cover with plastic wrap so the masks can be removed later.

- Balloon base: Blow up a balloon to about head size. Cover half of it with two or three full layers of papier-mâché (see below), and allow to dry (figure 19.5). Remove the balloon – pop it, if necessary – and cut the sphere in half. The resulting half-sphere should fit, roughly, over the face (figure 19.6).

- Paper plate base: A paper plate is easy to use, but it provides a flat, uncomfortable mask. Simply build up protruding forms – nose, ears, forehead, chin, horns, and so on – on top of the paper plate, or use the method for paper masks (see page 247).

- Plastic mask (or mannequin head): This mask does not require a base. You can apply papier-mâché directly onto the plastic mask (it will stay permanently attached). Alternatively, you can cover the plastic mask with plastic wrap first to make it possible to separate the mask from the papier-mâché afterwards. You can find inexpensive plastic masks at craft stores or, during Halloween season, at many other stores.

3. After you have made the base for the mask, apply the papier-mâché. Tear newspapers into strips that are about 1" (2.5 cm) wide, making some strips short and some longer. Dip a strip of newspaper into the glue, slide extra glue off with fingers, and place the strip over the base. Smooth each piece on with fingers. Build up at least three layers of crisscrossing strips – the mask will be weak if all pieces go in the same direction. Allow to dry.

4. Leave holes for eyes, or let papier-mâché dry, and cut holes with scissors before the next session. Masks that are balloon-based may be cut open (in half) when dry.

Sessions Two and Three

This stage may be spread out over a couple of classes.

1. Have students feel their own faces to find which features protrude. Ask them to look at their sketches or photographs of their creatures and decide where surfaces on their masks need to be built up. Students can use crumpled newspaper, or cut-out cardboard shapes, and masking tape to attach features such as noses, foreheads, cheeks, horns, chins, and ears (figure 19.7, top).

2. Have students cover these additions with two crisscross layers of papier-mâché and make sure the additions are securely attached. Other materials, such as sticks and wires, can also be attached to the mask with strips of papier-mâché (figure 19.7, bottom). Make sure to smooth each piece as it is applied. Pay attention to the type of surface desired:

- For a wrinkled surface, students can dip a partial sheet of newspaper into the glue and scrunch it up slightly when applying.

- For a smooth topcoat, students can use small pieces (layers) of white tissue paper, and sand any rough edges when dry.

- For a rough surface, make papier-mâché pulp: Mix together small squares of newspaper, a small amount of glue, and lots of water in the blender (the water prevents blender burn-out). Take a handful of pulp, squeeze out

Figure 19.7. (top) Cardboard cutouts form the ears and nose of this cat-like mask. Balled-up newspaper, dipped in the flour and water glue, gives form to the eyes, nose, and cheeks. (bottom) The cardboard and newspaper additions have been smoothed over with a layer of newspaper strips that have been dipped in glue.

TIP When papier-mâché is applied in very thick layers, it tends to dry very slowly. Therefore, students with very challenging designs might need to build up the form in several stages. A small snout or ear, for example, is easier to attach than a long one. If a student wants a long snout or ears, wait until the initial attachment dries, then add additional layers to enlarge or lengthen the facial feature.

extra glue and water, and apply to the surface – the pulp can be moulded like modelling clay. It may also be sanded smooth when dry.

- For spikes, cut shapes from Manila tag or cereal-box cardboard. Attach the spikes with masking tape, and then cover them with small pieces of papier-mâché.

Additional Exercises

Here are some additional exercises students can do to practise making papier-mâché masks:

- Students can work cooperatively to create oversized sculptural heads. Use large supports such as cardboard boxes, Styrofoam packaging materials, or cardboard tubes, to make oversized heads. Some appropriate subjects include "Wild Things" (from *Where the Wild Things Are* by Maurice Sendak), a dragon dance costume (with a length of fabric attached), or mythical creatures. For another example, see carved wooden masks by West Coast artists such as Henry Hunt.

- Display masks or create oversized puppets: Attach a long, sturdy stick to the mask, add a large piece of fabric below the mask, build hands, and attach them to the fabric. Attaching shorter sticks to the hands will enable two or three students to operate one puppet. Another way to create a body for a mask is to stuff clothing with quilt batting. Sew, staple, or use hot glue to attach the clothing together.

- Use mask-making as a companion exercise (figure 19.8) to drawing or painting animals, portraiture, or composite creatures (see chapters 5 and 8).

- Wear the masks, and play-act in small groups. Start with a script, or create a story or screenplay, using the masks to represent characters in the story. When acting out the play, consider how the characters move, what noises they make, and how their voices sound. Think about questions such as: In what setting would the characters live? What problems might they encounter?

Desiree, Elmwood High School. Teacher: Briony Haig

Figure 19.8. In this example of a finished mask, the student combined a face with an interesting form.

PLASTER MASKS

TOOLS & MATERIALS

- sketchbooks
- pencils
- erasers
- petroleum jelly (to cover students' faces) and hair bands or shower caps (to cover students' hair)
- one 5-lb. roll of plastic-embedded gauze wrap
- pails or basins filled with lukewarm water
- facial tissue
- scissors
- large plastic bags (such as garbage bags) or plastic table cloths
- optional: hacksaw
- optional: see Additional Exercises (page 253)

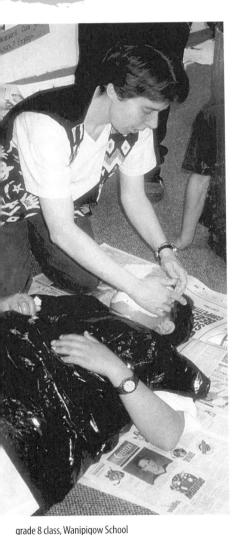

grade 8 class, Wanipigow School

Figure 19.9. The author covers a student's face with strips of plaster wrap.

Making plaster masks is an interesting experience for students. These masks are modelled directly on students' faces! The plaster-embedded gauze wrap is very easy to manipulate and build with. Plaster hardens very quickly and becomes durable and very hard overnight. However, the materials for plaster masks are more expensive, and the masks are heavier and uncomfortable to wear. This exercise is intended for students in grades three and up, although it has been done successfully with younger students.

Preparation for Plaster Masks

You will need a couple of 90-minute sessions to make plaster masks and another session to paint them. You will also need a room with lots of table space and no carpet, and additional adults to help young students. Shelf space is required for drying the masks. Cover tables and drying areas with newspapers. Cut strips of varying sizes of the plaster wrap. Ask students to pair up with someone they trust.

Process for Plaster Masks

Session One

1. Explain to students that you are going to make a plaster mask. Ask for a volunteer to help you model the technique.

2. Spread out newspaper or plastic over an area of the floor or tabletop. Lay out materials (listed above). Have the volunteer student tie back his or her hair, if necessary. Coat the volunteer's entire face with petroleum jelly. Pay special attention to any facial hair, such as eyebrows and the edge of the hairline – any uncoated skin or hair may stick to the dry plaster and make removal more difficult. Ask the student to lie down with the back of his or her head on the newspaper, face-up. Make sure the student's head is on newspapers, then cover the neck and upper body with plastic to protect clothing. Give the student some paper towel to catch any uncomfortable drips of water.

3. Dip each strip of plaster into the water, then slide it between two fingers to remove extra water that might drip on the volunteer's face. Place the strips on the student's face, eventually building up two to three layers everywhere. Avoid the eyes, nostrils, and hair. Really brave (and older) students can put petroleum jelly on their eyelashes and straws (for breathing) in their nostrils. Make an X of plastic wrap over the bridge of the nose (for strength), and reinforce the outside edges of the face with extra strips of plaster. Gently smooth down each piece as you apply it (figure 19.9).

4. When you are finished, the student may sit up and walk around or look in a mirror, but should avoid smiling or yawning. The plaster takes about 10 minutes to harden. Explain that while the mask is drying, it is going through a chemical reaction that may make the mask feel slightly warm. When it is firm enough, the student can work his or her fingers around the edges of the mask to remove it. The mask will be fragile at this point, so place it on a ball of crumpled newspaper for support, with the student's name underneath. It will take about 24 hours to completely harden. Students may now team up and work on each other's faces. This is an exercise in trust!

Session Two

The masks from session one will become the bases for building interesting creature or character masks in session two.

Have students look at their sketches or photographs of their characters and creatures. They can then decide where the surfaces of their masks need to be built up. Students can attach cut or folded pieces of cardboard to their masks with additional strips of plaster gauze. Pieces of plaster gauze can also be used to build up areas and to add small bumps, warts, and folds (figures 19.10 and 19.11). Dry plaster is hard, but can be cut or scraped with scissors or a hacksaw blade. To enlarge or reshape a mouth or other part of the mask, found materials such as sticks, twine, or shells can be incorporated and attached with plaster strips. When finished, set the masks aside, and allow them to dry.

Additional Exercises

Here are some additional exercises students can do to practise making plaster masks:

- Photograph the masks, and include them as characters' faces in book illustrations.

- Build three-dimensional works from the masks (see chapter 18). Use sticks, cardboard, crumpled paper, and masking tape to build the armature (structure), then cover with papier-mâché. Make a body, a collection of objects that relate to the character, or attach the mask to an object such as an over-sized book.

- Work inside the mask, painting or gluing in pieces of paper or found materials. Use writing or drawing to show that what the character might feel or think is different from what the outward appearance suggests. This is effective for self-identity pieces, and for examining characters in situations from history or literature.

PAINTING AND DECORATING MASKS

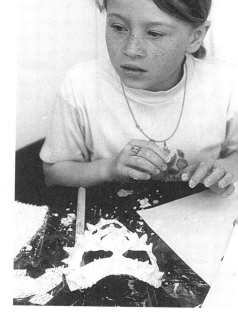

plaster mask, Laura McPherson, age 9, San Antonio School

Figure 19.10. Laura has nearly completed her plaster mask.

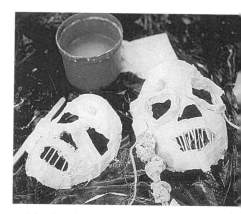

grade 4 students, San Antonio School

Figure 19.11. Plaster gauze is an easy medium to work with. Students can add features to their masks with dry plaster and strips or lumps of plaster. Other materials, such as cardboard pieces, twine, wire, wooden doweling, and shells, can be attached with plaster strips or a hot-glue gun after the plaster has hardened (about 24 hours).

CAUTION! Allow only adults to handle hot-glue dispensers. Lower temperature glue dispensers are available for students. Show students how to use these: Put a dot of glue on the larger of two pieces, and push the smaller piece with a stick (never use your fingers for this job). Hold the glue dispenser over a piece of cardboard to catch drips. Emphasize to students the importance of taking turns, and show them how to set the dispenser on the counter between turns rather than pass it from hand to hand.

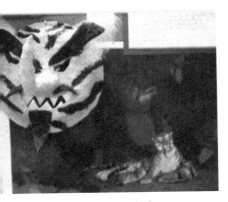

grade 5–6 class, Sister MacNamara School.
Teacher: Cathy Woods

Figure 19.12. A student used a visual reference to paint colours and patterns on a mask.

Preparation for Painting Masks

Cover tables with newspaper. Have your students take another look at their visual references (figure 19.12). They should look carefully at the particular colours and patterns of their subjects. Encourage them to give some thought to whether they will paint literal versions of what their subjects look like, or if they want to alter the colours. (See chapter 11 for suggestions about mixing colours and colour schemes.) Students may also want to practise mixing some of the paint colours, or drawing features or patterns, on scrap paper or in their sketchbooks. A wide variety of mask images are available on the Internet from artists and cultures around the world.

Process for Painting and Decorating Masks

Use tempera or acrylic paint. Remind students to apply white and other light colours first; use dark colours and black last. Students may do a small painting first to test their colours. Brush paint thoroughly into any rough areas on papier-mâché or plaster masks to ensure the whole surface is covered with paint.

When painting a pattern, remind students to paint the background colour first, let the paint dry, then paint the spots, stripes, fish scales, and so forth on top of the base colour. This is easier than painting around each leopard spot! Tempera paint may be coated with PVA (acrylic gloss or Podge) to give it a shine. Just dab the PVA on gently with a brush, and avoid over-brushing, or the paint may smear.

Miscellaneous objects may be glued onto the masks when the paint is dry. Use a hot-glue gun to add tufts of hair, fake fur, buttons, and feathers; use white glue to add sequins or glitter (figure 19.13). Challenge students to be thoughtful about their choice of additions to their masks. Think about the character of the mask (scary, fierce, or gentle), the main colours, and the texture of the subject (shiny, scaly, feathery, or hairy). Place the objects on the mask, and make decisions about them, before gluing them on.

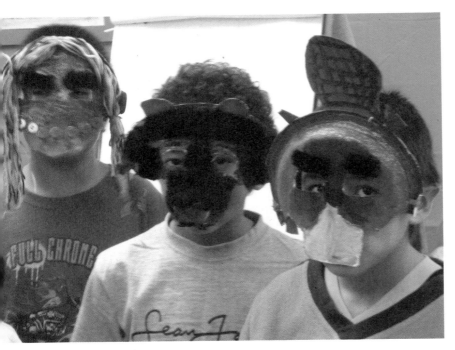

grade 4 students, Wellington School

Figure 19.13. Students can use a low-temperature glue dispenser to add textured materials, such as straw, fake fur, and buttons. These students display the masks they made for a drama class.

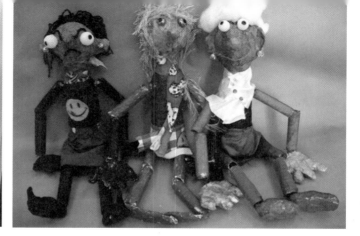

grade 2 students, Wellington School. Teacher: Rhian Brynjolson

Figure 19.14. This oversized puppet has a foam rubber head and hands, made from carpet underlay. The nose, ears, lips, and eyes were glued on with a hot-glue dispenser. The body is made from second-hand clothing stuffed with quilt batting and hot-glued together.

puppets, grade 3, Sister MacNamara School. Teacher: Cathy Woods

Figure 19.15. These movable puppets have coin rollers and wire for an armature.

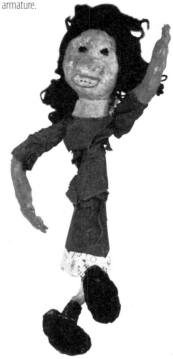

puppet, grade 2, Luxton School. Teachers: Andrea Stuart and Donna Massey-Cudmore

Figure 19.16. This puppet, like a porcelain doll, has a head, arms, and feet modelled from clay and then fired and painted.

PUPPETS

TOOLS & MATERIALS

- for head, hands, and feet: see Process (below)
- wire and coin rollers, or clothing, or sticks (for armature)
- quilt batting
- liquid or block tempera paints, or acrylic paints
- acrylic gloss medium, or Podge
- paintbrushes
- paint smocks
- low-temperature hot-glue dispenser
- materials for decorating puppets, such as hair, yarn, feathers, beads, buttons, sequins, fur, straw, shredded paper, sticks, and so on
- sketchbooks
- optional: see Additional Exercises (page 256)

Process

1. Building a puppet head is very similar to building a mask. Begin by creating a character. Next, build a spherical structure for the facial features. Create a large puppet head, using any of the methods described for masks. Use the same sculpture materials used for masks to make hands and feet (figures 19.14–19.16). The same techniques may be used to create much smaller (fist-sized) heads for smaller projects. Make smaller puppet heads by using the following adaptations:

 - Foam rubber. Carve small blocks of foam rubber to make puppet heads. Young artists can snip foam rubber with safety scissors; older students can carve with serrated bread knives or hacksaw blades.

 - Paper. Use smaller paper circles, or use a small cardboard box or tube, as the base for the head. Finger-sized puppets can be made by rolling small rectangles of Manila tag into a cylinder, or use coin rollers.

CAUTION! Allow only adults to handle hot-glue dispensers. Lower temperature glue dispensers are available for students. Show students how to use these: Put a dot of glue on the larger of two pieces, and push the smaller piece with a stick (never use your fingers for this job). Hold the glue dispenser over a piece of cardboard to catch drips. Emphasize to students the importance of taking turns, and show them how to set the dispenser on the counter between turns rather than pass it from hand to hand.

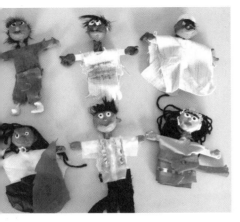

puppets, EAL Class, Wellington School.
Teacher: Subbalakshmi Kailasanathan

Figure 19.17. These puppets have a simple supporting structure with cloth, modelling clay, and found materials added.

sock monkey, high school student, Villa Rosa. Teacher: Amy Karlinsky

Figure 19.18. This sock puppet monkey can be adapted to develop human clothing and characteristics. Simple hand-stitching is required.

VOCABULARY

armature	mask
balance	model
carve	mould
character	papier-mâché
colour scheme	pattern
creature	plaster
facial features: eyes,	portrait
nose, mouth, ears,	puppet
chin, forehead,	sculpt
cheekbones, neck,	shape
hair	structure
foam rubber	texture
geometric forms:	three-dimensional
sphere, cube,	wire
rectangular prism,	(see appendix B for definitions)
cone, cylinder,	
pyramid	

- Papier-mâché. Use a smaller supporting base, such as a partially inflated balloon, Styrofoam ball, or ball of newspaper. Cover with papier-mâché, build features, and build a neck (to attach the body).

- Plaster. Use a smaller supporting base, such as a Styrofoam ball or ball of newspaper. Cover with plaster (figure 19.17), build features, and build a neck (to attach the body).

- Cloth. Create a sphere by putting a handful of quilt batting into a stocking, sock, or piece of stretchy fabric. Tie the neck with a string. Use a hot-glue dispenser to add buttons or pieces of felt or fabric for eyes, ears, nose, and mouth.

2. To build bodies for the puppets, use any of the following methods:

- Use heavy tape or a hot-glue dispenser to attach a stick or string to the head. Attach a piece of fabric to the bottom of the head (around the neck) to form the body and arms. Paint or decorate the fabric. Make hands for the puppets from the same material as the heads. For oversized puppets, have students simply trace their own hands onto foam rubber or cardboard. Attach the hands to the fabric with hot glue or a stapler. Sticks or strings may be attached to the hands so that they can be moved independently of the body. If string or fishing line is used, attach the string to a stick, and hold the puppet from above.

- For small- to medium-sized puppets (12" [30 cm]), build a wire armature (supporting skeleton) for the body, and slide paper cylinders or coin rollers over the wire to give thickness to the body, arms, and legs.

- Make a very simple sock puppet by gluing buttons, felt, or fabric pieces onto a sock to make ears, eyes, nose, and mouth (figure 19.18).

- For life-sized puppets, collect used clothing, and stuff the clothing with quilt batting. Sew, staple, or use hot glue to fasten the clothes together. Use gloves and socks for the hands and feet.

Additional Exercises

Here are some additional exercises students can do to practise puppetry:

- Build a puppet theatre for your classroom. Use folding panels of wood, Coroplast (corrugated plastic), or cardboard. Make an opening near the top (for stringed puppets) or at the bottom (for puppets held up with sticks).

- Study puppets from particular puppet plays, time periods, or places around the world. For example, one elementary class studied Vietnamese water puppets that float on water, balanced on a cork!

- Make dolls or action figures by making the puppets self-standing. Bodies may be made out of any of the above-mentioned materials. Bodies may also be made by using old dolls or stuffed animals, and giving them a total "makeover" with sculpture materials.

CONSTRUCTION 20

INTRODUCTION

Students can construct three-dimensional artworks from a wide variety of materials. Experience with these artworks can encourage creative play, increase inventiveness, and provide opportunities for choice and problem solving.

Sculptural projects can be created on a large or a small scale. At Wellington School, in Winnipeg, Manitoba, our larger projects included life-sized whales and sharks for our school library; cement stepping stones for a garden sundial; painted Coroplast stage sets that folded, accordion-style, for storage; woodworking projects such as tables and stilts; and life-sized puppets for a video project.

Ecole Constable Edward Finney School. Teacher: Andrea Stuart

Figure 20.2. When sculpture materials are sorted by elements, students are encouraged to produce sculptures based on the elements of design, such as this all-yellow construction.

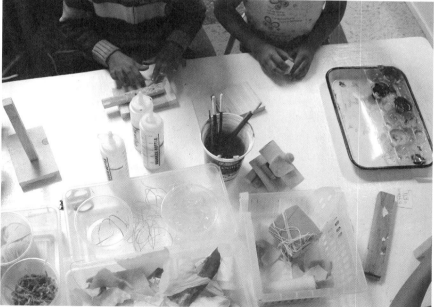
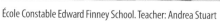
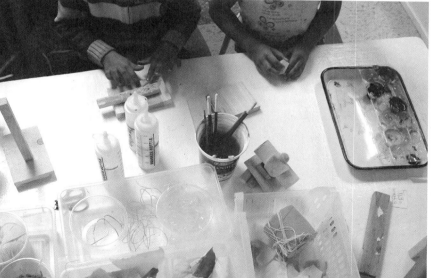

École Constable Edward Finney School. Teacher: Andrea Stuart

Figure 20.1. Sculpture materials are organized and ready for use.

SCULPTURE

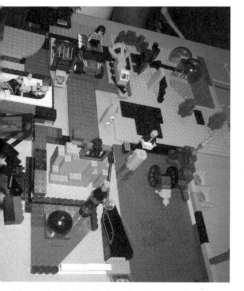

Sculpture – having height, width, and depth – is three-dimensional artwork. Sculpture projects range from very small beads and miniature figures to life-sized or enlarged pieces in a variety of media.

Some sculptures are self-supporting, others hang from the ceiling; some are inflated (supported by air) or carved from a solid, uniform material, such as wood or stone.

Most freestanding sculptures require an armature (see chapter 18) – a skeleton or structure for support (figures 20.5 and 20.6). An armature may be made with a base of wood, wire, chicken wire, cardboard (figure 20.7), plastic pipes, even found materials such as old Hula Hoops or plastic bottles. Pieces of an armature may be fastened together with nails, twists of wire, or duct tape, and attached to a solid base of wood, stone, or other heavy material. The armature needs to be sturdy enough to support the weight of the finished sculpture.

Florije, high school student.
Teacher: Rhian Brynjolson

Figure 20.3. Think outside the box for sculpture materials. This discarded book was altered by folding, cutting, and adding collage materials.

Preparation

Look at the various surfaces that can be used to make sculptures (pages 260–267). Show students process drawings by sculptors such as Leonardo da Vinci and Auguste Rodin. Have students note how these artists planned their work in their sketchbook, drawing the overall structure, as well as drawing various small details. Have students make sketches of the pieces they are going to construct. Encourage students to sketch their subjects from several angles and to think about how they will use their materials to build their subjects. Ask them to sketch and build an armature for their projects, if required (see page 259).

Find a suitable area to display the finished construction. Check your school's policy for displaying three-dimensional work, as some fire safety regulations ban large paper, papier-mâché, or cardboard constructions. Try to find a space where the sculpture will be visible, but somewhat protected or supervised.

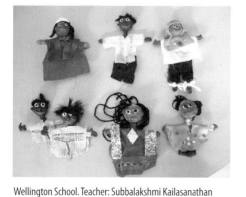

Figure 20.4. Building blocks such as Lego provide students with experience building with three-dimensional forms.

Appropriate Subjects

There are endless possibilities for constructed sculptures. The challenge is to find a suitable material and surface to represent the subject. Consider the size, form, colour, and texture of your subject. Even a large-scale sculpture such as a life-sized whale can be created when coloured plastic sheets are draped and stapled over a series of Hula Hoops, which act as supporting ribs. Find an interesting pose for your subject, and be aware of how your subject appears from all angles (front, back, side, top, and so on). Deciding how permanent the structure needs to be will help to determine which materials to select.

Wellington School. Teacher: Subbalakshmi Kailasanathan

Figure 20.5. These puppets have a simple armature of crossed wooden sticks.

ARMATURE

- pencils
- sketchbooks
- wide variety of materials that can be used for armatures, depending on the size of the finished sculpture
- optional: see Additional Exercises (page 269)

For small sculptures, less than 12" (30 cm):

- base: heavy material, such as a block of softwood (pine or spruce), or a stone
- stand: wire, wooden sticks, found materials (cardboard, scrap plastic)
- form: tinfoil, newspaper, found materials (cardboard, packing materials such as Styrofoam or bubble wrap), masking tape, chicken wire
- low-temperature glue dispenser (for attaching wire or wood to stone) or wood screws and screwdriver (for attaching wire loop to wooden base)
- wire-cutters and pliers (for bending and cutting wire)

For large sculptures, 12" (30 cm)or more:

- base: heavy material, such as a plank of softwood (pine or spruce), plywood, or a large stone
- stand: wire, wood (heavy sticks, 2" x 2" or 2" x 4" [5 cm x 5 cm or 5 cm x 10 cm] lumber), found materials (large cardboard boxes, scrap plastic bottles, pails, hoops, or barrels)
- form: newspaper, found materials (cardboard, scrap plastic, tubing, foam rubber, packaging materials such as Styrofoam or bubble wrap), and several rolls of masking tape or duct tape
- low-temperature glue dispenser (for attaching smaller pieces)
- wood screws and cordless drill, or hammer and nails (for attaching wood pieces)
- handsaw (for cutting wood)
- wire-cutters and pliers (for bending and cutting wire)

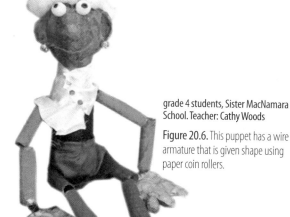

grade 4 students, Sister MacNamara School. Teacher: Cathy Woods

Figure 20.6. This puppet has a wire armature that is given shape using paper coin rollers.

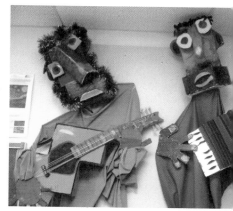

Teacher: Cathy Woods

Figure 20.7. These oversized cardboard puppets have cloth bodies. They are attached from above and so do not require an armature.

Process for Building an Armature

After students have sketched their subjects, they will need to make a sturdy supporting skeleton, or armature. Demonstrate safe handling of tools and materials and how to attach upright pieces to a base. To attach pieces, use a loop of wire held onto wood with a screw, or use duct tape, or a hot-glue dispenser. Keep in mind that the armature needs to be sturdy enough to support the materials that will cover it. (See wire sculpture and woodworking, pages 264–267.)

Building Form on an Armature

After building an armature, students can use a variety of materials to add form. Adding form means "fleshing out" the frame of the armature. An example of this, on a small scale, would be to begin with a single, supporting stick and wrap crumpled tinfoil around it to form the wider, rounder shape of an animal's body. For large sculptures, chicken wire is effective for adding form, but it is difficult to manipulate. If you use chicken wire, wear gloves and long sleeves, and have wire-cutters and pliers handy. Cardboard, small boxes and tubes, foam rubber,

CAUTION! Allow only adults to handle hot-glue dispensers. Lower temperature glue dispensers are available for students. Show students how to use these: Put a dot of glue on the larger of two pieces, and push the smaller piece with a stick (never use your fingers for this job). Hold the glue dispenser over a piece of cardboard to catch drips. Emphasize to students the importance of taking turns, and show them how to set the dispenser on the counter between turns rather than pass it from hand to hand.

crumpled newspaper, and rolls of masking tape are easier to manipulate than chicken wire. Scrap pieces of foam rubber, plastic junk such as bottles, Hula Hoops, trays and boxes, and other recycled materials may have the right volume and form to fill in the space. These pieces should be attached securely with twists of wire, hot-glue dispensers, or masking tape.

Creating a Surface Skin Over an Armature

A variety of materials can become the skin or surface of the constructed sculpture (figure 20.8), for example, papier-mâché, paper, plastic, fabric, and plaster.

Elmwood High School. Teacher: Briony Haig

Figure 20.8. These sculpture heads were built on Styrofoam heads, extended with wire. The wire was covered with nylon stocking, coated with PVA, and then painted.

TIP When papier-mâché is applied in very thick layers, it tends to dry very slowly. Therefore, students with very challenging designs might need to build up the form in several stages. A small snout or ear, for example, is easier to attach than a long one. If a student wants to make a long snout or ears, wait until the initial attachment dries, then add additional layers to enlarge or lengthen the facial feature.

PAPIER-MÂCHÉ SCULPTURE

TOOLS & MATERIALS

- sketchbooks
- pencils
- erasers
- newspapers
- scissors
- flour (or wallpaper paste)
- several pails and wide plastic containers (one-gallon size, for mixing paste and for washing up)
- water
- masking tape (one roll per three or four students)
- whisk, hand-mixer, or blender (for mixing paste)

Preparation

Papier-mâché is an inexpensive, lightweight, and versatile material for finishing sculpture (figure 20.9). You will need two to three 90-minute sessions to use papier-mâché and another session to paint and decorate. You will also need a room with lots of table space and no carpet. In addition, if you have young students, recruit additional adults to help them add protruding features to their sculptures. If you are in a damp room or basement room, you will need to turn on a fan or a heater to prevent mould from forming on the sculptures as they dry.

Appropriate materials for an armature for papier-mâché include cardboard pieces, tubes, and boxes; wood with wire or chicken wire; crumpled newspaper and masking tape. Assemble the armature securely (see page 259).

Make glue solution ahead of time: Add enough flour or wallpaper paste to luke-warm water to make it the consistency of heavy cream. Use a whisk or beater to eliminate lumps. Cover tables and drying areas with newspapers (figure 20.10). The glue solution does not keep well. You may need to make a new batch for each session.

Teacher: Cathy Woods

Figure 20.9. Papier-mâché is a versatile medium for sculpture. These animal constructions were built on top of cardboard cylinders.

Process

Look at initial sketches or photographs of the subject, and decide where the surface needs to be built up. Use crumpled newspaper or cut-out cardboard shapes and masking tape to attach small features such as noses, horns, chins, and ears.

To apply papier-mâché over the armature, dip the newspaper strips into the glue mixture, sliding the strips between your fingers to remove excess glue. Removing the excess will reduce dripping, and the papier-mâché will dry more quickly. Apply at least two crisscross layers of papier-mâché. Other materials, such as sticks and wires, can be also attached with strips of papier-mâché. Pay attention to the surface, smoothing each piece as it is applied. Allow the first layer to dry, and apply additional layers as needed.

- For a wrinkled surface, dip a partial sheet of newspaper into the glue, and scrunch it up slightly when applying.

- For a smooth topcoat, use small pieces (or layers) of white tissue paper, and sand any rough edges when dry.

- For a rough surface, make papier-mâché pulp: Mix small squares of newspaper, a small amount of glue, and lots of water together in the blender – the water prevents blender burn-out. Take a handful of pulp, squeeze out extra glue and water, and apply to surface; it can be moulded like dough. It can also be sanded smooth when dry.

FABRIC, PAPER, VINYL AND PLASTIC, FAKE FUR

- fabric, paper, vinyl or plastic, plastic bags, used clothing, nylon stockings, or fake fur (fabric and paper may be painted and decorated; plastic or vinyl may require taping or stapling to add decorative pieces)
- decorative materials (felt or thin, coloured foam sheets; coloured paper; coloured foil; found and recycled materials such as plastic lids; natural items such as feathers, twigs, or straw)
- stapler (note that plastic and vinyl sheets may be difficult to glue; use tape or a stapler) and staples, pins
- tape (packing tape or duct tape; duct tape is available in a variety of colours)
- scissors
- quilt batting, fishing line
- fabric stiffener
- tissue paper (coloured), dolls, shoes, teddy bears

Preparation

Begin by building an armature for your sculpture (see page 259). Choose suitable materials to cover the armature (see Tools & Materials, above).

The materials you choose should relate to the colours, patterns, or textures of your subject. Fun results can be achieved by using a completely inappropriate surface. For an example, see Meret Oppenheim's fur-covered teacup, *Object,* on page 45.

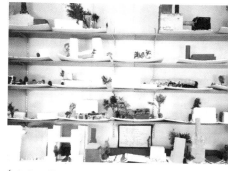

École Constable Edward Finney School. Teacher: Andrea Stuart

Figure 20.10. This space is organized for drying papier-mâché projects.

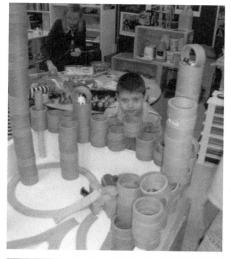

École Constable Edward Finney School. Teacher: Andrea Stuart

Figure 20.11. (top) This student is building structures with cardboard tubes. (bottom) The cardboard tubes have been covered with plaster wrap and painted.

Body Systems, plastic wrap and packing tape, grade 5 students, Wellington School. Teachers: Deb O'Neil, Joan Tohme, Bella Faria, and Rhian Brynjolson

Figure 20.12. These sculptures were constructed from plastic wrap and packing tape, using a student as the armature! The student was then extracted, and the body parts were made from tissue paper, fun foam, and more packing tape. This integrated project was part of a science unit about the human body.

Process

Option A

An armature can be covered or upholstered like a sofa. Fabric, cardboard, inexpensive plastic tablecloths, used clothing, soft patterned papers, and fake fur are examples of materials that can be draped, stretched, glued, nailed, tied onto, or wrapped around and stapled onto an armature (figure 20.11).

Cover the armature with the selected material, paying attention to areas where the armature requires further padding or tucking in. Quilt batting, foam rubber, rags, and shredded paper are handy for adding extra bulk.

Nylon stockings may be stretched over the armature. Paint with several coats of PVA (acrylic medium or Podge), latex, gesso, or acrylic paint. The coatings of PVA and/or paint form an acrylic skin for the surface of the sculpture, very similar to plastic.

Option B

It is possible to use the previously mentioned materials without an armature, if other supports, such as the following, are provided:

- Stuff, and pin shut, used clothing and nylons to make life-sized puppets or dolls.

- Cut and tape together plastic bags, and place over a high-speed fan or vent. The air will inflate the bags into ballooning, dancing forms.

- Dip fabric into fabric stiffener, and drape the fabric over objects to harden into interesting forms (for example, make hats by saturating fabric with fabric stiffener and draping the fabric over an empty ice cream pail).

- Stuff fabric with quilt batting, or other lightweight materials, and staple or stitch into interesting forms. Hang the forms from the ceiling with fishing line.

- Paint, decorate, cut out, and match paper figures with another identically shaped cut-out piece, stuff with lightweight materials, and staple together around the edges.

- Wrap plastic wrap, followed by a layer of clear packing tape, around parts of a person's body (figure 20.12). With a pair of scissors, carefully cut open the plastic, remove from the body, and tape back together with more tape to form a plastic cast of a human figure. The resulting sculptures are translucent, accurate representations that you can pose to sit in a chair or hang without an armature. The translucent plastic can be illuminated from inside or behind. This exercise can be adapted for exploring ideas of identity by placing personal objects or writing inside, or human body systems can be constructed from crumpled coloured tissue paper that is wrapped in clear packing tape and placed inside the figures. Other objects, such as dolls, shoes, or teddy bears can also be wrapped in plastic. The plastic cannot be painted, but pieces of coloured cellophane, translucent papers, lights, writing, and lightweight objects can be incorporated into the surface and interior spaces before the pieces are taped together.

PLASTER

<div style="writing-mode:vertical">TOOLS & MATERIALS</div>

- pencils
- sketchbooks
- plaster (see below)
- cement
- petroleum jelly
- plastic pails
- plastic moulds (containers), metal trays, wooden blocks, litre-sized milk containers
- basin for hand-washing
- plastic sheeting or newspaper (to cover the work surface or floor)
- stick (for stirring plaster)
- wire mesh, coarse fabric, tinfoil, or paper and tape to cover armature
- spatula, trowel, or palette knife

Process for Sculpting with Plaster

Plaster is a material commonly used for walls and drywall. Before fiberglass casts became popular, plaster was also used to make casts for fractured bones. Because plaster is heavy, it is suitable for small or medium-sized sculpture (figure 20.13). You can buy plaster in powder form as plaster of Paris, as pre-mixed drywall compound (or "mud"), and as plaster gauze.

- Plaster of Paris powder should be mixed carefully according to the manufacturer's directions, just before using. Plaster dries (hardens) very quickly. It will deteriorate if it is re-moistened.

- Drywall mud can be purchased pre-mixed, and some varieties dry more slowly and produce less dust than regular plaster, making them better suited for carving or sanding.

- Plaster gauze is easy to use. Cut the gauze into pieces or strips, dip in water, and wrap around the armature. Smooth each piece as it is applied. Small pieces of gauze may be squished and applied like clay.

Teacher: Cathy Woods

Figure 20.13. These figures have wooden bases, and wire armatures under their plaster exteriors.

To use plaster or drywall mud, cover the armature with a skin of wire mesh, window screen, tinfoil, paper and masking tape, or coarse fabric (figure 20.13). Use a spatula, trowel, or palette knife to apply coats of plaster or drywall mud, shaping and patting the plaster into place.

Process for Casting

Plaster and drywall mud can be poured, or cast, in moulds or containers (figure 20.14). Use a plastic dish with objects arranged on the bottom, or press a pattern into wet sand or modelling clay, and pour in the plaster. Coat the container with petroleum jelly for easy removal. This is the same technique that is used to make a child's handprint: Push the hand into clay or modelling clay, and then pour plaster to make a cast.

When the plaster has hardened, remove it from the mould. Alternatively, pour wet plaster into an upright container such as a milk carton. Peel off the carton when the plaster has hardened. Plaster can be carved, filed, and sanded when it is dry.

CAUTION! Close adult supervision is required when students handle plastic wrap, because of the danger of suffocation or cutting off circulation. Be careful not to wrap the plastic too tightly, and do not cover the nose or mouth. To avoid cutting skin or clothes when removing the plastic, use blunt-tipped scissors.

Sundial, grades 3–6 students, Wellington School.
Teacher: Rhian Brynjolson

Figure 20.14. Students made numbers for this sundial out of clay, and glazed them (see Clay, page 232–240). Students dug small holes, positioned flowerpots, and filled them with cement. Students then pushed the fired clay numbers into the wet cement, and left the flowerpots in the ground. The math to calculate the position of the numbers is challenging, considering the changing slant of the sun through the year. The centre rectangle shows where students must stand in each month to have their shadow fall on the correct time. Students made a second set of numbers (not shown) for daylight savings time!

BOOKS TO HAVE HANDY

PICTURE BOOKS

Posy! by Linda Newbery, illustrated by Catherine Rayner.

VISUAL REFERENCES

Students' gesture drawings or scribbled drawings.

Cement is made from powdered limestone. When mixed with water and sand, it hardens into concrete, like sidewalk blocks. Cement can be poured into solid moulds, such as metal pans or wooden boxes. You can buy it pre-mixed, or you can mix the cement on-site with a shovel, sand, and water. To get a pastel colour, mix the wet cement with commercial products.

Stepping stones may also be made by pouring cement into trays and tipping them out when the cement has hardened. Objects can be arranged in the bottom of the tray to stay embedded, or to peel out and leave a shallow depression in the cement. Wooden forms can be built for pouring cement in larger areas, like sidewalk blocks; these should be reinforced by laying pieces of scrap metal or wire in the bottom of the area before shoveling in the cement. Round blocks can be formed by digging a hole in the desired outdoor area, placing the rim from a large, plastic flowerpot in the hole, and pouring cement to fill up the rim. Clay tiles may be pushed into the wet cement as decoration.

WIRE SCULPTURE

TOOLS & MATERIALS

- wire (may be grey steel, wrapped in colourful plastic, or copper. Avoid toxic lead or aluminum wire. Wire found inside telephone cables is lightweight and easy to bend, but it may not hold its shape for larger projects. Copper wire is available in a variety of gauges, and it is more attractive and smoother than fence wire. Wire coat hangers are strong, but they are difficult to cut and twist.)
- wire-cutters and pliers (some needle-nose pliers have a cutting edge)
- base: block of wood or stone
- low-temperature glue dispenser (for attaching wire or wood to stone), or wood screws and screwdriver (for attaching wire loop to wooden base)
- optional: see Additional Exercises (page 265)

Appropriate Subjects

A range of subjects is suitable for wire sculpture. It may be simplest, however, to start with a single subject with fairly simple form. Challenge advanced students to create gesture "drawings" with wire; the multiple lines of wire can produce a vortex effect that is effective for conveying a sense of movement. Wire can create wild and untidy lines if it is loosely woven, giving a frayed or more abstract quality to a subject. Wire is also suitable for adding tiny spirals and embellishments to a subject. On a miniature scale, copper wire may be used for making small jewellery pendants or pins; small beads may be strung onto the wire. Wire may also be soldered (melted with a soldering iron) together with other scrap metals.

Process

1. As a class, look at *Posy!*, at contour drawing (see page 72), or at gesture drawing (see page 110). Point out the interesting line qualities in the drawings. Have students make contour drawings of their subjects in their sketchbooks.

2. After all students have made contour drawings, distribute a piece of wire to each student. Students may want to place the wire over their sketchbook drawings, and bend the wire to conform to the contours of their drawings.

3. Challenge students to extend the form outward from the surface of the sketchbook, to give it three-dimensional form. They can add variety to their sculptures by adding surprising loops and twists to the wire. Students can add movement by bending the wire to change the gestures, or poses, of their subjects.

Additional Exercises

To give students additional practice making wire sculptures (figure 20.15), have them do one or more of the following exercises:

- Create mobiles that hang from wire or fishing line. Kinetic (moving) sculptures have parts that are free to rotate or revolve, similar to a hanging model of the solar system. Challenge students to think of revolving and rotating subjects, share their ideas, and plan their mobiles in their sketchbooks. Appropriate subjects might include birds or airplanes circling in flight, atomic structures, dancers, or circus performers.

- Use wire sculpture as an armature (or supporting skeleton) for a surface treatment (see pages 259–264).

wire sculpture, high school art class. Teacher: Rhian Brynjolson

Figure 20.15. Wire can be wrapped tightly or loosely around an armature to create a solid form. Wire can also be used without an armature to create lines in space. In this wire sculpture, a tuque and a scarf have been added to the figure.

WOODWORKING

TOOLS & MATERIALS

- plywood (a variety of plywood and composite materials are suitable. Look for materials that are 3/8" to 5/8" [1 cm to 1.5 cm] thick, and are "one side good"; that is, smooth on one side)
- 2" x 2" boards (5 cm x 5 cm) (Use softwood such as spruce or pine. Try to find pieces that are straight and have few knots or irregularities; the knots are harder to drill into.)
- wood screws
- screwdrivers
- cordless drill, with drill bits and screwdriver
- sandpaper
- wood glue, or white glue
- paint (latex house paint, or acrylic paints)
- paintbrushes (some 3" brushes [7.5 cm], a range of smaller brushes)
- newspapers or plastic tablecloths (to protect tabletops)
- pencils
- sketchbooks
- metre sticks (or yardsticks) for measuring
- scrap wood (to place under drill)

CAUTION! Check for toxic heavy metals before using recycled electronic parts.

CAUTION! Allow only adults to handle hot-glue dispensers. Lower temperature glue dispensers are available for students. Show students how to use these: Put a dot of glue on the larger of two pieces, and push the smaller piece with a stick (never use your fingers for this job). Hold the glue dispenser over a piece of cardboard to catch drips. Emphasize to students the importance of taking turns, and show them how to set the dispenser on the counter between turns rather than pass it from hand to hand.

CAUTION! Long lengths of wire may be a hazard if the tips are near students' faces. Demonstrate how to work with the wire laying flat on a tabletop and use tools such as wire-cutters safely. Safety glasses are recommended for this activity.

CAUTION! Before using hand tools in the classroom, be sure to demonstrate how to use them safely. Set up workstations so that the tools can be carefully monitored by adults. Show students how to do the following:

- hold tools such as saws, hammers, or screwdrivers close to the body as they walk, not run, from one station to another
- place objects on a piece of scrap plywood on the floor, or on a low table, when they are using a cordless drill or screwdriver
- place larger pieces of wood across an old chair, and brace with their foot when using a handsaw

Teach students the rock-paper-scissors method of solving disputes (rather than grabbing tools). Halt the class and re-teach these procedures whenever necessary.

grade 4 class, Wellington School. Teacher: Rhian Brynjolson

Figure 20.16. These single-string musical instruments can be tuned by turning a screw.

Preparation

Before students begin their woodworking projects, introduce them to working with wood by building a table together as a class (see below).

Have students plan their projects in their sketchbooks, submit a "shopping list" of required materials to the teacher, and then begin to build.

Woodworking projects are built onto a wooden frame or base, with additional wood pieces added on. Students can benefit from instruction in using woodworking tools to create basic projects, such as tables, chairs, or stilts. Older students who want to customize their projects may then require additional assistance from an adult who can help them use a scroll saw to cut additional pieces of wood.

The art component of woodworking projects comes from adding in imaginative or design aspects to modify the prescribed patterns, or using these building techniques to create wooden sculpture. Wood projects may be painted with non-toxic acrylic or latex paints (see Part 4).

Appropriate Subjects

Appropriate subjects for wood constructions may be abstract, or they may represent a human figure, animal, or object. Wood sculpture may incorporate natural forms, such as tree branches. They should be sturdy, balanced, and able to fit through the classroom door when completed!

A variety of woodworking projects are suitable for students. For older students, you may want to start with a simple, small-scale project so that they can gain experience with tools and materials, before encouraging innovation and variety in student projects. The process below describes the method for building a small table. This project may be altered by asking students to design the base structure, or by using a scroll saw to cut the tabletop into an interesting shape. There are a variety of plans available on the Internet for other simple projects, such as wooden stilts, birdhouses, wooden toys, chairs, chests, and musical instruments (figure 20.16).

Young artists can assemble pre-cut wood scraps. Assemble pre-cut wood scraps and attaching them with tacky white glue (leave white glue out to dry for a few hours before using), or an adult can assist them with a hot-glue dispenser. Wood sculptures can be painted with tempera paint and coated with acrylic medium.

Process

Woodworking Exercise: Making a Small Table

A small table is relatively simple to build (figure 20.17), and you can use mostly hand tools. Begin by building one table, as a class, so that students learn how to handle and use tools and materials safely and with caution. Later, small groups of students can make tables. This project has been successful with students in grades five and up. For beginners this is a woodworking exercise, rather than an art class. The creative piece is added as students adapt the shapes of their tables, create animals out of the four-legged armature, and begin painting.

- pencils
- metre stick
- handsaws
- screwdrivers
- cordless drill
- sanding blocks
- work gloves
- safety glasses
- paintbrushes
- paint

For the base:
- 10 linear feet of 2" x 2" (5 cm x 5 cm) softwood (such as spruce)
- 20 1¾-inch wood screws

For the tabletop:
- 8 ¾-inch wood screws
- 18" square (minimum) of "one side good" plywood, 3/8" to 5/8" inch thick

TIP The 18" square of plywood can often be pre-cut at the hardware store. Alternatively, recruit adults to assist students in cutting the tabletops from slightly larger pieces into interesting shapes: geometric, floral, simple animals, and so on, according to students' sketchbook drawings.

CAUTION! To use a cordless drill safely, place one or more thick pieces of scrap plywood on the floor under the wood pieces. Hold the drill straight up and down, and exert slow, steady pressure.

As a class or in groups, make one or more small tables by following the easy steps below (figure 20.17):

Step 1: Put the 2" x 2" board across two chairs (use old chairs that can be nicked with a saw). Measure and saw eight 15" (23 cm) lengths for the frame and legs (longer legs will require new measurements and a bit more plywood). Students can work in pairs to manipulate the lengths of wood safely.

Step 2: Before beginning to saw a piece, make a notch in it with the saw, and place the saw in the notch. Slowly, start sawing and, gradually, exert more force. Students can take turns. When one gets tired, another can take over.

Step 3: After all pieces have been sawed, sand them to remove splinters.

Step 4: Mark and pre-drill holes for the wood screws, so that the screws can be easily inserted with a screwdriver or cordless drill.

Step 5 a, b: Assemble the table.

Step 6 a, b: Paint and/or decorate the table.

Figure 20.17. The steps for cutting and assembling the wood pieces into a table.

PAINTING AND DECORATING SCULPTURE

TIP Right-handed students should hold the saw in their right hand, and steady the wood with their left foot and left hand. Both chairs and a friend should also be on their left side to help keep the wood steady. Use the reverse for left-handed students.

TOOLS & MATERIALS

- student-made sculptures
- visual references
- paintbrushes
- paint: exterior (latex house paint or good-quality acrylic); interior (tempera, latex, acrylic)
- decoration materials (sequins, glitter, fake fur, feathers, buttons, and so on)
- optional: PVA (acrylic gloss or Podge)
- optional: anti-graffiti clear-coat spray

Have your students take another look at their visual references. They should look carefully at the particular colours and patterns of their subjects. Encourage students to think about whether they will paint a literal version of what their subject looks like or they will alter the colour. (See chapter 11 for suggestions about mixing colours and colour schemes.) Your students may also want to practise mixing some of the colours or drawing features or patterns in their sketchbooks before applying them to their sculpture.

TIP Students who are waiting for a turn with the drill or screwdrivers can sand wood pieces. Use a sanding block to avoid splinters.

Use tempera, latex, or acrylic paint. Apply white and other light colours first; use dark colours and black last. Students may do a small colour drawing or painting first to test their colours. Brush paint thoroughly into any rough areas to ensure the whole surface is covered with paint. For outdoor sculpture, prime the area to be painted, then use exterior latex house paints or good-quality acrylic paints. Surfaces may be sprayed with an anti-graffiti clear coat.

grade 2 class, Sister MacNamara School. Teacher: Cathy Woods

Figure 20.18. These models of the community were built from wooden blocks. Pickling salt was used for snow.

When painting a pattern, paint the background colour first, let the paint dry, then paint the spots, stripes, fish scales, and so forth on top of the base colour. This is easier than painting around each leopard spot or fish scale! Tempera paint may be coated with PVA (acrylic gloss or Podge) to give it a shine. Just dab on the PVA gently with a brush. The paint may smear if you overbrush. Miscellaneous objects may be glued onto the sculpture when the paint is dry.

If additional materials are to be added, begin by providing limited choices that harmonize with the students' designs, or represent their subject, because beginners tend to glue everything onto their artwork! Discuss the selection criteria: What elements will provide unity or contrast? Which materials are most suitable? Most fun? Use a low-temperature hot-glue gun to add tufts of hair, fake fur, buttons, and feathers; use white glue or PVA to add sequins or glitter.

Additional Exercises

- As students become more confident and competent with tools and materials, they will be able to build a variety of projects. These projects can be adapted as students experiment with fanciful forms, such as chairs cut and painted to look like storybook characters, or as they investigate design aspects of commonly used objects. Artists and designers have stretched the boundaries of what things are supposed to look like into more or less functional, more or less aesthetically pleasing, forms.

- Take a community walk, and photograph buildings, natural features, and structures, such as bridges, in the community. Build models of these structures with pre-cut wood pieces. Use softwood scraps for the models, as hardwood is too difficult to hammer a nail into. Use a hot-glue dispenser or hammers and nails to attach pieces. Paint the models, and display them on an oversized community map. Allow students to explore the models through cooperative play (figure 20.18).

- Integrate art with science topics such as structures and simple machines. Use building blocks or motorized kits as the base for sculptures.

Jen Kirkwood

ENCOURAGING STUDENT EXPRESSION:

Embracing Constructivist Art Education in a Senior Years Art Program

by Jennifer Kirkwood

sketchbook detail, Emmy, Kelvin High School

Jen encourages her students to use their sketchbooks for idea development.

sketchbook detail, Emmy, Kelvin High School

Students can also use their sketchbooks to experiment with a variety of media and technique.

A constructivist approach to art education nurtures the evolution of learning from a teacher-directed to a student-centred environment. In a traditional skill-based program, students are expected to produce a pre-determined product. In a constructivist program, students decide the conceptual content, medium, and purpose of their work. There is plenty of room for developing skills in this setting; the real trick is finding sufficient balance between these pedagogical approaches.

To fully embrace the constructivist theory in the art program, we, as teachers, have to avoid envisioning a final product for any given project. We need to give up determining a set goal for the class. Instead, we need to dive head first into the possibilities presented by each student. Where do we start?

The basis of our art program has always been the sketchbook/idea journal component of the course. Skill building takes place in small assignments, as students complete two to three hours of independent drawing and painting in their sketchbooks every week. Students work from both life and original compositions with an emphasis on using the elements and principles of design. Throughout the semester, media demonstrations take place, and students are encouraged to try out new media, techniques, tools, and ideas.

Students are expected to explore and develop technical skills and practise media techniques in their sketchbooks. However, the main purpose of each student's sketchbook is for organizing, researching, and developing ideas – both written and visual – that help solve art problems presented in a project.

A self-portrait unit is one example of a constructivist art project I share with my high-school, mixed-grade class. I begin the unit with a handout in which students are asked to use the elements and principles of design to describe themselves. One question might be: "How would you describe yourself as a texture?" Another question might involve composition: "If you were to place yourself in a landscape, would you be in the foreground, middle ground, or background? Why?" From there, students write about defining moments in their childhood – important events, memories, and turning points that they feel have helped to shape their personalities.

We then go to the computer lab and look up personality types. We use the Enneagram method (at www.eclecticenergies.com), and each student determines the personality type that best describes him or her. Students take notes, and we have a general discussion about the various personality types, even predicting the personality types of various celebrities and teachers. For the next two classes, we watch the movie, *Eternal Sunshine of the Spotless Mind.* This film provides not only interesting visual ideas, but much discussion about personalities and how they determine behaviour. Another wonderful film for illustrating the concept of self is *Everything Is Illuminated.*

We provide students with different avenues for background research, then share with them various solutions to the idea of self as interpreted by artists through time. Using PowerPoint presentations, we look at self portraits of Albrecht Durer through to Frida Kahlo, Man Ray, Edward Hopper, Chuck Close, Jonathan Borofsky, and Do Ho Suh, to name a few. We also look at a variety of installations and other non-traditional new media artworks as examples of where, and how far, students might want to take their ideas.

With research in hand, students are encouraged to explore aspects, positive or negative, of their personalities that, once represented, speak to others who might share those same traits or feel connected for other reasons. Each student then branches off into his or her own explorations, and the personal journeys begin. As a rule, our art program encourages students to create works that ask more questions than they answer.

The results? There are always a large range of media and techniques chosen, including installations. One student created a wall of shelves filling one of my picture windows. On these shelves, she lined up water bottles (250 or so) filled with different materials: coloured water, muddy water, pebbles, broken glass, ripped up math tests, vinegar and nails, and so on. Behind the water bottles, she displayed the words "Vulnerability" and "I will not be vulnerable," which were partially obscured and distorted by the bottles. Another student made a life-sized "paper doll" from plywood and set it on a stand. Behind this, she strung a clothesline with a variety of her favourite clothes and accessories made from paper and Velcro. Viewers were encouraged to dress the "doll" by making fashion suggestions to the artist. Another student took a photograph of herself and created a blanket-sized knitting pattern of her face. Through performance and installation, she set up a chair and proceeded to knit herself as a blanket. Other students made drawings, paintings, and sculptures.

The constructivist art room is never a stagnant environment. Although it takes students time to adjust from a traditional, teacher-directed setting, it is rare that they want to return to it. Teaching this way is a challenge! No two students do the same thing it seems, and the atmosphere can parallel that of a hectic restaurant. However, when students take ownership of their learning – with the guidance they need and the safety net of an open-minded teacher – there is no denying the long-term benefits of nurturing critical and creative minds.

Jennifer Kirkwood is an art teacher at École Secondaire Kelvin High School.

sketchbook detail, Malhalia, Kelvin High School

These preparatory drawings by Malhalia helped her add convincing detail into her finished sculpture.

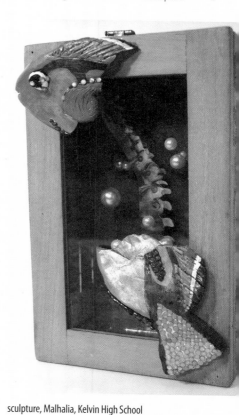

sculpture, Malhalia, Kelvin High School

Malhalia's finished sculpture is a unique combination of imagination and anatomical representation.

Rhian Brynjolson, *Holding Hands,*
acrylic latex on canvas, 72" x 36"

MULTIMEDIA

Multimedia artworks incorporate a variety of media, technologies, and electronic tools – both old and new. Examples include film cameras, digital cameras, web cams and video cameras; CAD programs (computer-aided design), image-editing and video-editing software, multimedia software programs that combine image, text, and sound (such as iMovie and Photo Story3); scanners, printers, projectors (such as LCD and opaque projectors), and Internet images. Many artists and book illustrators now integrate these technologies seamlessly into productions of their works.

There are strong arguments for using multimedia approaches in the classroom. Such approaches give students opportunities to create the kinds of slick-looking, successful images that we have become accustomed to viewing in recent years. A medium such as photography or videography presents students with choices of subject matter. Educators and parents should value student photographs for providing a window into a child's view of the world. The skills and comfort level that students require to use the technology, treat equipment with care, and understand video culture may be useful for developing job skills, personal expression, or learning to be culturally literate.

Multimedia art such as installation art is created for a specific context or location, often on a large scale. Students may be challenged to think about how an artist has used a particular space as part of the design of his or her artwork, or how the artist's own designs might be recreated as part of a larger exhibit. Performance art incorporates elements of drama, or participation in an exhibit over time, often with the artist as the actor. Performance art and art installations in public spaces, such as school corridors, allow students to investigate audience reactions to their ideas.

Students can experiment with multimedia art, enhance their learning, and have success-based art experiences by exploring a variety of websites, gadgets, and software programs. Mechanical and electronic media are rapidly changing and evolving to less expensive technologies that are user-friendly.

Although rapid change and rapid obsolescence also mean the need for continual replacement of electronics and ongoing learning, there are some basic processes, projects, and techniques that continue to be useful for the classroom.

PHOTOGRAPHY, DIGITAL IMAGES, AND ANIMATION 21

INTRODUCTION

A camera is an excellent tool for encouraging close observation and for looking at the world with fresh eyes. Photography gives students the opportunity to experiment with the composition of an image. Students can use photography to develop and communicate ideas about their own themes, interests, neighbourhoods, or viewpoints. Since no drawing skills are required, photography is a rapid and non-threatening way for students to produce images and experience success. Photographs are easy to reproduce, frame, and display.

Photographs can also be used to document classroom work in progress, and these process shots can be used to reflect on what was learned and document the learning that is taking place.

Both film and digital cameras have a place in the classroom. Film can be developed into prints for easy viewing, and CDs of the photographs (or selected prints) can be purchased if digital images are required. Digital cameras provide instant replay, so students can see immediately whether or not their photographs are successful. Digital cameras can be connected directly to a computer or television, allowing all students in the class to view the captured image. Computer software can be used to modify an image; for example, students can add text, change and layer images, and add animation effects. Students can display and share images with an easy-to-use software program such as PowerPoint. Laptop computers with built-in cameras connected to a variety of software can provide instant images with a selection of treatments for teaching colour theory, lighting, and composition.

Photographs from both film and digital cameras can be manipulated in computer software programs to enhance the composition or quality of the photographs, apply special effects, change the format for incorporating with text or artwork, and create animation projects.

Art City Community Art Centre

Figure 21.1. Preston took this action shot at Art City, a community art centre with programs for young artists. The photograph has a balance between an area of pattern and an area of solid colour.

PHOTOGRAPHY

BOOKS TO HAVE HANDY

PICTURE BOOKS

I Spy by Jean Marzollo, illustrated by Walter Wick.

The Butterfly Alphabet: Photographs by Kjell Bloch Sandved.

PHOTOJOURNALISM

Material World: A Global Family Portrait from Sierra Club Books.

TIP Students can handle and borrow disposable cameras without fear of loss or damage.

TIP Test all the camera equipment and software before introducing it to the class.

TOOLS & MATERIALS

- cardstock
- scissors
- cables
- memory cards
- digital camera(s)
- visual references
- optional: disposable cameras
- computer and editing software (for example, iPhoto, ArcSoft PhotoImpression, or Photoshop)
- colour printer, photo paper
- framing materials and tools
- optional: see Additional Exercises (page 282)

Camera Mechanics

A camera operates like an eye. The aperture, like the eye's pupil, allows in more light or less light. A lens focuses the image. The shutter, like an eyelid, opens and closes; on a camera, the shutter opens for fractions of a second. Usually it remains closed. A picture is taken by pressing the shutter release button. Depending on the age of your students, you can provide basic or detailed information about the way a camera works.

- With film cameras, the exposure of light-sensitive film captures an image, working much like the retina of a human eye. A wider aperture, or higher f-stop, on a film camera and longer exposure time will result in a lighter image. A variety of lenses, each designed for a specific type of shot, is available.

 Developing images from film cameras requires chemicals that are toxic. These should not be used without expert supervision and ventilation. Find responsible stores that will develop film, provide free CDs of images, and recycle chemicals and disposable cameras.

- On a digital camera, when you turn on the camera or open the lens cap, you can view your subject through a viewfinder or on an LCD screen. This is the view that will be captured by the camera. A flash provides extra light for indoor and night shots. A variety of lenses, each designed for a specific type of shot, is available for the more expensive LCD cameras. Most digital cameras have an optical zoom that allows for wider shots (landscapes) and tighter shots (closeups).

 Memory cards for digital cameras are available with high-storage capacities that can hold thousands of images. To develop digital images, use a cable to connect the camera to a computer USB port, insert the memory card into a card reader to connect to a USB port, or take your memory card to a commercial photo print booth. Images can be emailed to commercial printers, posted to a website, saved on a CD, or printed with your own colour printer. The quality of the print is determined by the resolution of the image. Digital cameras have a menu setting for larger files with higher image resolution measured in dpi (dots, or pixels, per inch). Photo quality is also affected by the quality of the software, printer, inks, and paper.

- Disposable cameras generally have a fixed focal length (range of distances where the subject remains in focus) that is good for middle-range shots but creates blurry closeups.

Preparation

Gather a variety of artists' photographs. Used photography books and calendars are good sources for large reprints of photographs. Choose photographs that demonstrate the elements and principles of design that will be important for the themes and art concepts that you plan to teach.

When I was an art teacher at Wellington School, my students and I collaborated on an art exhibition called *Playgrounds*. I contributed some of my paintings of children playing in the neighbourhood. Students painted self-portraits, then made videos, took photographs, and built a diorama of their neighbourhood. They wrote captions and artists' statements and made decisions about displaying their works. On opening night, students spoke to the audience about the exhibit.

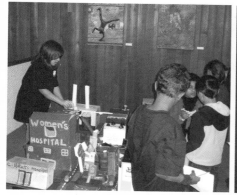

Figure 21.2a. Young artists set up a diorama of their neighbourhood in the art gallery. The diorama was created in an after-school art program that was run cooperatively by Wellington School, Art City, and the Lighthouse Program.

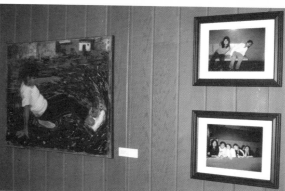

Figure 21.2b. Young artists displayed their works alongside the author's.

Figure 21.2c. Students' photographs presented a view of the neighbourhood from a child's perspective.

Figure 21.2d. Prior to opening night, students viewed their photographs and wrote artists' statements.

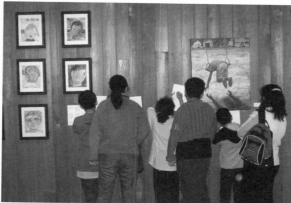

Figure 21.2e. The self-portraits on the left, painted by students in grades 2 and 3, were frame and displayed alongside a painting by the author. When the exhibit opened, young artists toured, sketched, and discussed the exhibition.

Figure 21.2f. A group of students watched and discussed a student's video that was playing in the gallery as part of the exhibit.

Wellington School. Teacher: Rhian Brynjolson

Figure 21.3. This photograph was taken by a student in the school's photography club. Students looked for interesting angles and points of view.

Appropriate Subjects

A wide variety of subjects work for photography, including the following:

- If your topic is the alphabet, you can have students concentrate on looking at shapes and lines that form letters of the alphabet (for example, the letter *O* can be found in a car tire, a capital *A* might be found in crossed tree branches).

- If students will be photographing artwork, or if they are going to make dioramas to photograph, examine, as a class, the I Spy series. Have students notice the composition and lighting of each densely packed scene.

- If your goal is to have students represent their own view of their neighbourhood (figure 21.2 a–f), or another topic of study, have students look at work by photojournalists. They can then reflect on what makes some photographs about a subject more visually interesting or more powerful than others.

Process

1. With your students, look at photographs. Ask them: "What makes some photographs more interesting to look at than others?" Discuss the light sources and shadows in the photographs, the vantage points (close-up, distant, from above, through, and so on), cropping (zooming in, or leaving some parts of the subject out), and other relevant aspects of the composition (see chapter 8). Many photography books discuss the rule of thirds, which means placing the main subject a bit off-centre in the viewfinder.

2. Introduce the theme or subject to be photographed. Brainstorm with students about how they might take the photographs in a way that makes the subject visually interesting (figure 21.3).

3. Make mock viewfinders: Fold and cut a small rectangle (5" x 7" [13 cm x 18 cm]) out of a piece of cardstock; it should look like a thick picture frame. Looking through the small rectangle is similar to looking through the viewfinder of a camera. Students can use these viewfinders to test some interesting angles, and various wide and tight shots of their subjects.

4. Digital cameras are good teaching tools. Encourage students to take turns with a digital camera and experiment with a variety of shots. Play the shots back on a computer monitor or television for a larger view. Challenge students to use art vocabulary when they discuss what is successful about each shot (see chapters 5 and 8). Students can also be challenged to use cameras to systematically play with elements and principles of design, like a visual scavenger hunt.

You can also suggest that students take photographs based on a particular theme. Challenge students to use photography to represent their own point of view about a matter of personal importance to them, or about a subject they are studying.

5. Print small copies of student photographs for sorting. If a double set of photographs is provided, students may want to take one set home. To avoid bullying issues, we established some simple ground rules for our school's photography club: (1) Digital copies and CDs that include shots of fellow students stay at school (to avoid having them altered or pasted on Facebook). (2) Unflattering shots of fellow students are deleted from the camera. (3) Release forms are required from students whose faces appear in any photograph that is to be displayed.

6. Discuss these issues (above) openly with students, because this is a good opportunity to talk about bullying, privacy, and the dangers of posting photographs in cyberspace or sharing them by cell phone.

7. Encourage students to sort their photographs into categories such as: most successful, most interesting to look at, most inventive, and most meaningful. Students can devise other categories for sorting, such as best friends, or pets. Students might work in small groups to pick out the best shots in others' works. Encourage them to use art vocabulary as they discuss their choices; for example, photographs that show texture, photographs with the colour blue, photographs with interesting shadows.

8. After photographs have been selected, display them on a wall, or arrange them in PowerPoint (you can burn them onto a CD-R for storage). Have each student write an artist's statement that explains why the photographs were taken, what was successful about the photographs, what he or she hopes the audience will notice, and of what the photographer is most proud. Remind students to use art vocabulary in their statements (figure 21.4).

> **TIP** The two most common pitfalls for student photographers seem to be the following: (1) taking blurry pictures, and (2) getting their fingers in the pictures. Remind students to hold the camera steady (tell them to tuck their elbows in by their sides). Have them think of squeezing the shutter release, rather than pressing down. Remind students to keep their fingers, hair, and hoods tucked away from the lens.

VIEWING

Sam Baardman, *Mud. River. Dreamer.* digital print on archival paper in pigment inks, 13" x 19"

Figure 21.4. This is a water-table photograph of and by photographer Sam Baardman. The photograph is an example of how a photographer can compose an image to represent his or her ideas. Baardman's statement shows how a brief explanation of the photograph in an *artist's statement* can enhance the viewer's understanding of the artwork or of the artist's intentions.

Artist's Statement

I have lived in Winnipeg all my life, and on the banks of the Red River for years. I have come to realize that the people who populate the river's domain are virtually unaware of its existence in anything but the most superficial terms – as a lovely scenic feature or as a force to be tamed in flood season. This series of photographs places people literally inside the river's banks, depicting ordinary moments – reading, sleeping, or simply gazing upwards – as occurring beneath the surface of the water in an unfamiliar and alien world. – Sam Baardman

DIGITAL IMAGES AND COMPUTER SOFTWARE

TOOLS & MATERIALS

- computer
- card-reader or USB cord
- photo-editing software (see appendix D)
- animation software
- digital camera
- tripod
- student photographs
- small drawing pads
- optional: see Additional Exercises (page 282)

Process for Altering Digital Photographs

1. Have each student take a series of digital photographs and select one image to alter.

2. Introduce software programs students can use to enhance the quality of their photographs, experiment with special effects, and explore the elements and principles of design (review chapter 10 for tips on using computer graphics).

 - To enhance their photographs, have students find a toolbar in the software program that allows them to adjust the image. They can experiment with cropping images, and with changing the brightness, exposure, contrast, saturation, hue, tint, sharpness, and temperature. Relate these tools to the elements and principles of design. Have students compare their results with professional photographs and advertising art to see how photographers and graphic designers build their images. Students can print the images they judge to be most successful (see chapter 4).

 - For special effects, have students find toolbars that let them apply effects that mimic a camera lens, such as blur, fishbowl, and distortion. They can also use illustration effects that mimic a poster (with several flat areas of colour), paintbrush, or crayon. Some software, such as Photo Booth, work with a built-in camera to provide instant special effects, such as a comic-book look, a pop-art treatment that mimics an Andy Warhol print, and effects that mimic various specialty lenses that bulge and stretch images. These programs are fun, the results are instant, and the tools engage students' interest in the visual aspects of a project.

 - Students can use software such as PhotoImpression to cut out an area of a photograph and paste it into a new photograph. Create effects such as composite creatures (chapter 7), or cut out students' faces, and paste them into photographs of students' artworks.

 - Students can use software such as PowerPoint, iMovie, or Comic Life to add text or create presentations.

BOOKS AND VIDEOS TO HAVE HANDY

PICTURE BOOKS

The Wolves in the Walls, by Neil Gaiman illustrated by Dave McKean.

VIDEOS

Wallace and Grommet: Three Amazing Adventures. DVD, 2005.

Process for Animation

Stop-animation involves creating images of a series of movements and then viewing them in rapid succession. It is much easier and less time consuming to create a series of photographs of a subject than to draw each frame (still image) by hand. It takes many shots to make a 30-second animation video; each shot is on the screen for less than half a second.

To show students, view a series of sequential photos in a slideshow fomat, in PowerPoint, or in iMovie. (Insert a dozen new slides and set the time for slide transitions on half a second [.05].[1]) Ensure students note the timing and duration of the animation effect.

One Classroom's Stop-Animation Project

At Wellington School in Winnipeg, Manitoba, students in Susan Bukta's class used modelling clay to create lava flows from volcanoes. Then, they set a digital camera on a tripod, and aimed it at an image made from modelling clay of lava pouring out of a volcano (see chapter 17). They took a photograph, moved the lava, took another shot, moved the lava, took a shot, and so on. The images were loaded onto the classroom computer.

To enable the students to work independently from the teacher, three students were taught how to use the Photo Story3 software. They, in turn, worked with each student in the class to build his or her story. The user-friendly software allowed students to import their own images, arrange them in sequence, tap the spacebar (to stop the automatic Ken Burns effect – where the photograph appears to be moving), use a microphone to add a scripted voice-over, correctly save their projects, and share their work with parents.

Suitable art media for stop-action animation projects include the following:

- Simple sculptures (figure 21.5) built with materials such as modelling clay, Lego, or building blocks. Use a desk lamp, aimed at a slant, to add dramatic effect.

- Record slow changes, such as the growth of a plant over time, if photographs are taken every few hours (during the school day) over a period of several weeks.

- Collage also works well for animation, as cut-out pieces can be moved easily across a background (see pages 204–208). In this case, set up the tripod so the camera aims down at a tabletop, and ensure that the image is well lit (avoid shadows). Simple paper shapes were used for the initial animations of the popular television cartoon series *South Park*.

Teacher: Rhian Brynjolson

Figure 21.5. An animation character, modelled by Savannah, moves into extreme close-up. This stop-action animation process means taking successive photographs of an image or three-dimensional model.

1. This option is well hidden under Transitions, Options, Advance slide automatically after a selected number of seconds.

Additional Exercises

Here are some exercises that students can do to practise photography and animation:

- Create flip-book animations on a small drawing pad (3" x 3" [7.5 cm x 7.5 cm] is sufficient). On the last page, draw a simple shape or character. Trace the shape or character onto the second-last page, making a small alteration. On the third-last page, trace the subject again with another small variation, and so on, until a series of at least twenty frames (single images) has been created. Flip through the book with your thumb, forwards and backwards, to observe the "movement" of the object or character. The rapid succession of images fools the viewer's eye into seeing a moving object. This is how cartoons were once created; each frame was drawn, inked, and then painted by hand! To extend this activity, look at Pivot Stickfigure software, or Flip Boom, which allows students to use electronic drawing pads to create simple animation (see appendix D).

- Advanced students can draw and paint animations. Place a sheet of plastic (Plexiglas or mylar) over a painted background or large photograph, and use masking tape to fasten the sheet to the tabletop. Practise gesture drawings of a figure in motion. Then, use a non-toxic whiteboard marker, or acrylic paint that has a retarder added (to slow the drying time), and sketch a simple figure onto the plastic. Take a photo. Use a rag to wipe away a small part of the figure, sketch again with small changes, take a photo, wipe and sketch, and so on.

- Animation effects can be added to a single photograph automatically with software (such as Photo Story3 and iMovie) that can apply a Ken Burns effect. Select the start and end point of the effect to control the direction of the pan shot (across the image) and the zoom (zooming in or out on a focal point).

- Introduce timid beginners to software programs that can provide them with successful art experiences. Photographs of pencil sketches can be colourized. Photographs of other artwork can be lightened, darkened, flipped, cropped, multiplied, distorted, and so on to play with composition and instantly try creative effects.

- Use iMovie or Photo Story3 software to add voice-overs, music, text, titles, sound effects, visual effects (such as lightning or grainy black-and-white effects) and music. Compose music on Garageband software to import into the iMovie animation.

VOCABULARY

animation
aperture
artist's statement
camera
CD (compact disc)
elements of design: line,
 shape, texture, form,
 space, value, colour
film
focal length
graphic design
lens
light
photography
photojournalism
principles of design:
 balance, proportion
 (comparative
 sizes and scale),

movement and
expression, emphasis
(dominance,
subordination, focal
point), contrast and
variety, unity and
harmony, repetition
(pattern and motif),
rhythm
rule of thirds
shadow
shots
USB port
vantage point: above,
 below, front, back
viewfinder

(see appendix B for definitions)

INTRODUCTION

Many students passively view hours of television and video every week. In this chapter, students go behind the camera and learn, firsthand, how videos are made. Through this hands-on experience, they will understand how television shots are built, and gain some insight into how to analyze, interpret, and evaluate what they view on television. Getting students behind the camera provides them with opportunities to communicate their own viewpoints and make their own statements. Making videos also creates positive and collaborative learning situations as crews of students operate cameras, direct, edit, compose music, write scripts, rehearse and act, build sets and props, make costumes, or make models or puppets for animation. You may find that many of your students, especially those who watch a lot of TV, really understand television and excel in video communications – they know instinctively how to set up a shot and edit it. Think of video as another language, another way to tell a story and express ideas.

TOOLS & MATERIALS

- video camera(s)
- tripod(s)
- cables (to connect video camera to television and computer)
- tapes or memory cards (if required, one per group of students)
- props, costumes, stage sets (as required)
- computer and monitor
- television
- software programs (see appendix D)
- optional: stage lights or desk lamps
- optional: see Additional Exercises (page 286)

VISUAL REFERENCES TO HAVE HANDY

Videos from the Cannes Lions archives at <www.canneslionsarchive.com>.

Know Your Equipment

Digital video cameras are similar to digital cameras (see chapter 21). Check your camera manual to find the settings to record, play, rewind, fast-forward, stop, and pause. Experiment with low light and various types and colours of lights and lighting angles, as these will make an enormous difference in your shots.

Figure 22.1. The video camera and tripod are ready for students to use.

TIP Use a tripod with a video camera. The tripod provides a steadier shot that is more watchable. It also protects the camera somewhat from being dropped or lost.

A tripod makes for steadier, more watchable shots that do not bounce or jitter as much as hand-held shots. A tripod also provides the camera with some protection from being dropped. Clips along the legs of the tripod allow the legs to be lengthened and shortened. Levers and screws (and sometimes a screw-turned handle) allow the top of the tripod to tilt, swivel, and pan (turn side-to-side). The shoe (a rectangular piece with a screw) at the top of the tripod is released with a lever, screwed onto the bottom of the camera, and then returned securely to the top of the tripod (figure 22.1).

AV cables connect the camera directly to a television. You can skip the editing process if you shoot scenes in sequence and do not repeat any shots. This is a crude approach, but quick and effective for beginners to get a sense of how the process works. They can take some video shots and play them back from the camera for the whole class to view.

A firewire cable connects a video camera to any computer that has a firewire port. With video editing software, sufficient computer memory, and a DVD burner, students can produce their own videos on DVD.

Preparation

Decide on the subjects and time available for your projects. Start with short video projects of from one to three minutes in length – beginner video is often not captivating to watch for longer periods.

Ensure that the camera battery is charged and there is a blank tape in the camera (if required). Most cameras have a release button on the bottom that slides open; to access the tape, pull the door open until it clicks. Check the operating manual for the features on your camera. Test the equipment beforehand. If you are playing video on a television, check the television's setting for playing video.

Find appropriate ads, videos, or film clips. These are readily available on websites such as YouTube, and on DVD at libraries. Look online for the annual Cannes Lions International Advertising Festival for examples of ads. Your students can use these to analyze television shots.

Pre-Teaching

1. Watch and analyze ads, videos, and film clips with your students. As a class, count how many individual shots are in one 30-second TV advertisement! Each shot is very short in duration. Next, students might make a quick sketch of an interesting shot and discuss what kinds of shots they see. For example:

 - tight (close-up)
 - wide (distant)
 - high (from above)
 - low (from below)
 - from behind (in back of)
 - through (through a window, between tree branches, and so on)
 - tilt (camera is tilted)

- moving shots, which might include:

 - zoom (camera moves in or out, from tight to wide, or from wide to tight)

 - pan (camera moves across or up and down)

 - flying, tracking (shots from a camera fastened to a moving cart or vehicle)

2. Ask students about the message of the ad or video. Have students look carefully at what they see in each shot. They will notice that not all of the shots show the whole subject. The camera may zoom in on a small part of the subject, or show odd, important, or visually interesting aspects. Shots may not show the main subject at all. Instead, one object may be used as a visual metaphor to represent another (for example, comets may represent razors, a leopard in a car advertisement may represent sleekness). If the image is effective, offensive, or odd, ask students why they think the director chose that representation. Look at composition (see chapter 8), and discuss which visual aspects are most important or interesting.

3. View some advertisements with students, and discuss critical viewing, truth in advertising, and the techniques that advertisers use to get a viewer's attention (see chapter 10).

Planning Video Projects

Longer videos and more polished projects require some planning. Students should sketch out their sequence of shots ahead of time on a storyboard, using a variety of shots. Any dialogue or narration, or any special notes about location, sound effects, lighting, or props, should be written underneath each sketch. Storyboards are used to plan books, videos, and feature-length movies (see chapter 9).

Students may write their own scripts for their videos. The lines can be read on-camera, or added later as a voice-over, if the video is to be edited.

When the initial storyboard is complete, decide how much time is available to spend on the project. Determine how elaborate or simple each piece will be. Use existing sets and materials, where possible. As a class, in groups of three or four, or individually, have students choose aspects of production that interest them – set-building, script-writing, acting, sculpting models; building or controlling puppets; adding sound, music, or voice; finding or making costumes; operating cameras, editing, and so on.

Appropriate Subjects

Beginning videographers may want to make advertisements, because ads are short and contain a variety of shots, and also because there are countless examples of creative advertisements available to view. Students' advertisements do not need to feature a commercial product. Students can create a short advertisement based on a topic of study or an issue of personal importance, such as an advocacy piece for environmental issues, rules about fair play, a campaign ad for school president, or a how-to video.

> **TIP** If you do not intend to have your students edit their videos, then plan to shoot each scene in sequence with the corresponding voices. You can take shots out of sequence and re-arrange on the computer later if you have the following: digital video camera, firewire cord, and firewire port on your computer; DVD burner; time; editing software (such as iMovie); and practise making short clips. Voices, additional sounds and music, and visual effects, may also be added during editing.

If each group of students works on a different aspect of the same topic, it may be possible to combine each section of video into a longer class project. Write an introduction and conclusion to the topic, and decide what shots will reappear in or between segments to unify them. For example, students in Kevin Daeninck's grade 6 class made a video about respect, showing how to play fairly. Each group of students made a short segment that demonstrated how to solve a dispute, and then recorded an introduction and summary statement that held the pieces together.

Process

To demonstrate use of the camera, hook up the camera to a television so that a larger number of students can see a camera lens view on the television screen. Alternatively, teach one or two students how to use the camera, and have them teach other students.

Turn on the camera, and find the play option. Turn to "camera mode," and demonstrate the different types of shots. Press "record." The display should change, and the camera will continue to record the image in the viewfinder as well as any sound within range. Turn to "play" mode, rewind, and play back your shot. Let students take turns experimenting with a variety of shots, such as tight, wide, pan, and zoom. Emphasize careful handling of equipment, and have students practise basic procedures. Teach the rock-paper-scissors method for handling disputes over who goes first, next, and so on. Keep each shot relatively short, a few seconds at most, as attention spans for homemade video tend to be short.

Additional Exercises

Here are some additional exercises that students can do to practise making videos:

■ Editing video is a time-consuming process. Some software is more accessible and easier to use than others. The editing software you use must be compatible with your other software in order for you to import extra sound clips and photographs, and add special effects. The video tutorials on iMovie make this program more user-friendly than most, and students can compose and import their own movie music from GarageBand. Professional videographers prefer Final Cut Pro. Connect the firewire cable to the camera and the computer, and import the project. Your software should give you options for arranging clips, deleting extra shots or frames, copying and pasting frames to extend or repeat shots, slowing down and speeding up the action, adding text for titles and credits, and editing sound. Burn your movie onto a DVD-R to play it on television, or play your movie on a computer connected to an LCD projector. Be sure to provide popcorn!

drawings and cut-outs by Sierra. Teacher: Rhian Brynjolson

Figure 22.2. These cut-out drawings have been placed on a patterned background. The cutouts are taped to fishing line and pulled across the background to create movement for video.

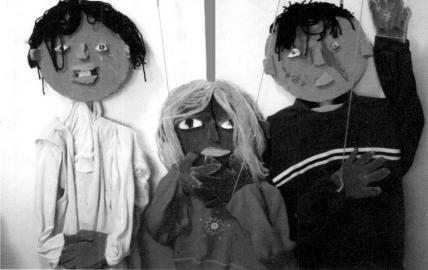

grade 2 students, Wellington School. Teacher: Rhian Brynjolson

Figure 22.3. Shots from *The Boy on the Moon*, written by Finlay Harper and used with permission to create a puppet video. Life-sized puppets were built, operated, and voiced by grade 2 students. Students in grade 6 operated the video cameras.

- Encourage students to view a variety of types of video and television and analyze how shots were produced. Reality television shows and advertisements continually blur the lines between what is real and not real in what we view. Challenge students to analyze how shots were made, whether the images on screen are real or constructed, or why the editor chose a particular shot to include on the video.

TIP When the "record" button is pressed, wait a couple of seconds before speaking or starting the action – there is often a delay before the camera actually starts recording. Because the microphone will pick up any surrounding sounds, the camera operator or director should use hand signals or message boards to communicate with actors. This is less of an issue if the video is to be edited, because the sounds can be recorded onto the video camera in a separate shot and pasted into the correct scene later.

VIEWING

Nam June Paik, *Eagle Eye*. video. 1996.

Figure 22.4. Nam June Paik, an American born in South Korea, is considered to be the first video artist. Paik began to use the new technology of video in the 1960s to make his artwork. Unlike film, video was easily accessible, and many began using it to document performances or make experimental work. In this piece, Paik combines old and new technologies to create the form of a thunderbird. A video depicts two opposing aspects of technology: satellite photographs of Earth signify exploration, while missiles represent destruction. Looking at these contradictory images, we wonder: How will humans use technology in the future?

VOCABULARY

advertising art	sound effects
dialogue	special effects
drama	storyboard
record	tripod
roles: director, actor,	video
camera operator,	video camera
editor, script writer,	videographer
set designer	visual metaphor
script	(see appendix B for definitions)
shots: pan, zoom, tight,	
wide, tilt, angled,	
tracking	

Spotlight
ARGYLE ALTERNATIVE HIGH SCHOOL VIDEO PROGRAMS

John Barrett, teacher

Of Mice and Men by John Steinbeck © 1936 Steinbeck Estate

From *Of Mice and Men*, Produced by Argyle Sox Productions, Argyle Alternative High School.

An action scene from the Argyle Sox production *Of Mice and Men*, by Argyle High School. Videos may be composed of hundreds of short scenes that are sequenced and given coherence in the editing process. Organization is required to ensure that all of the required shots are captured while the actors, set, props, and crew are available.

Argyle Alternative High School in Winnipeg, Manitoba, has a strong video production program that trains young artists in every aspect of filmmaking. In addition to their creative projects, students make educational videos, which are posted on their website for classroom use, and student videographers visit neighbouring schools to assist with recording special events. In 2008, Argyle Sox Productions created a modern adaptation of John Steinbeck's *Of Mice and Men* as their major project for the year.

Argyle's Video Production Program received the rights to produce *Of Mice and Men* from the Estate of Eleanor Steinbeck. Argyle pitched their proposal for their modern adaptation and then, at the estate's request, created a detailed 22-page treatment before final approval. Argyle then spent three months writing the script before producing their final draft.

Six professional filmmakers agreed to participate in an Aboriginal Mentorship Program for Argyle Alternative High School's production of *Of Mice and Men*. This was created through a grant from the Aboriginal Arts Office of the Canada Council for the Arts, and in association with the Winnipeg Aboriginal Film Festival.

Of Mice and Men was premiered at the 2008 Winnipeg Aboriginal Film Festival, and was presented again at the 2009 Freeze Frame International Film Festival.[1] The following program notes are from Freeze Frame's program guide:

"In this adaptation of John Steinbeck's classic novel, the main action of the story takes place today, in a rooming house in Winnipeg, rather than on a farm in California. Lennie and George are not migrant farm workers; rather, they are displaced Aboriginal teenagers who have left the desolation of their remote Northern community to drift across southern Manitoba, looking for work. As their destiny unfolds tragically, they keep dreaming, not of their own farm, but of their own place up North in the bush, where they could live off the land by trapping, hunting and fishing. With this amazing 'in-house' student production, the team at Argyle Alternative High School delivers a powerful and creative adaptation, served by strong acting and well-mastered filmmaking. Members of the cast and crew will present the film and respond to questions at the screening."

1. For more information about Freeze Frame, go to <www.freezeframeonline.org>.

Sixteen students made up the main cast and crew for *Of Mice and Men*. They earned credits in the Video Production courses they were enrolled in for the work they did on this project. Approximately 40 students (about one-third of the school's entire student population) worked in some capacity on the project, and earned credit in other courses. Some examples included the following:

- Students in the Health and Nutrition Class, under the supervision of their teacher, created a menu, shopped, and prepared meals for Craft Services as a unit of study.

- Art students helped with set painting and decoration, which went toward an art unit on design.

- Students in drama classes earning credit by playing both leading and incidental parts in the film.

The film was also screened at the IMAX Theatre, as a benefit for the Main Street Project, a local shelter for homeless people. Students in the video production program have also made a documentary on the Main Street Project. The documentary provides good experience for the students and will be used as an education tool by the shelter. This kind of partnership, involving students in making positive contributions to their community, represents the best practice in arts education.

Argyle Alternative High School. Teacher: John Barrett

Notice how the table lamp creates a focal point and lights the characters' faces in this shot of the set from *Of Mice and Men*.

Argyle Alternative High School. Teacher: John Barrett

Scenes from *Of Mice and Men*, Argyle Alternative High School video production, starring John Cook and Stanley Wood.

This feature is adapted from Argyle Alternative High School's website. To view Argyle's website, go to: <http://www.wsd1.org/argyle/home/Home.html>.

INSTALLATION AND PERFORMANCE ART 23

INTRODUCTION

Installation art is set up within a particular space, usually for a limited duration of time. Installation art may involve images, sound, and sculpture, as well as new technologies (projectors, computer monitors, and speakers). Installations rely on location or scale to provide an element of surprise or meaning. The value of viewing or making installation art is the powerful experience of seeing artwork transform a space. Installation art is not contained within a frame. It may incorporate, for example, a gallery floor, a classroom window, a city street, or an outdoor landscape.

Land artist Andy Goldsworthy creates lines, forms, patterns, and colour transitions with natural materials such as icicles, leaves, and twigs. Goldsworthy photographs his creations, but his original creations are temporary. This transitory work is contrary to the long tradition of art concerned with preservation of art objects and the archival quality of art materials. Goldsworthy's land art, also called *earthworks* or *earth art*, draws the viewer's attention to the beauty of natural elements. Building with natural materials is an accessible art form for most students, who can collect these materials from nearby parks or other natural settings.

Performance art by a visual artist is a live performance that communicates a concept through a dramatic presentation. The performance is often minimalistic (reduced to its most essential elements), and the intention is to unsettle the viewer or help the viewer see something a bit differently. The inclusion of a human being in an art gallery display is intended to add emotional impact and meaning to the artwork.

Performance artist Tehching Hsieh is an extreme example. Tehching has turned his entire life into a performance piece, including a year of self-imposed solitary confinement, a year spent living on the street, and a year tethered to a fellow artist. His hardships cause us to stop and rethink basic assumptions we hold about our lives. Advanced students might be

BOOKS TO HAVE HANDY

TEACHER REFERENCES
A Collaboration With Nature by Andy Goldsworthy.

FOR OLDER STUDENTS
Out of Now: The Lifeworks of Tehching Hsieh by Adrian Heathfield and Tehching Hsieh.

VIEWING

Lyndsay Ladobruk, *Re Tale*. 2009.

Figure 23.1. Performance art is broadly defined as the actions of an individual or group that can occur anywhere, for any length of time. It can take an infinite number of forms. Performance art often catches viewers off guard. It involves behaviours and actions outside of what we normally experience, and it often requires viewers to interact with the work instead of to passively view it. In Lyndsay Ladobruk's *Re Tale* piece, she stood mesmerized in front of a mannequin, which rotated on a brightly lit stage. Litter surrounded her, and she was dressed in clothing advertising numerous brands. Even without acting or speaking, Ladobruk communicated a critique of advertising, the idolization of beauty, and the associated waste of mass consumption.

VIEWING

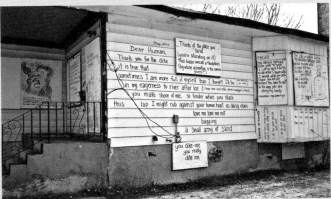

Figure 23.2. This is public art by the Riverbank Loan & Savings Company, an artists' collective interested in environmental issues. Poetry, art, and photographs were placed on an abandoned house (with permission) and on a sandbag dike after a flood on the Red River.

challenged to think about the ways that their own lives are works of art, or they could see themselves as artists in charge of creating artworks of their own lives. Keeping the principles of design in mind, they might ask themselves what they would change to improve, for example, the balance, harmony, variety, rhythm, or focal point of their own lives.

Appropriate Subjects

Both installation and performance art may include sculptural pieces, found objects, projected video or still images, text, natural materials, landscape, people, and/or animals. Begin with a concept, or a subject of study, and challenge and support students in finding new ways of seeing their subjects. Encourage students to investigate issues of importance or concern to them, such as questions of identity, current affairs, values, and transformation of social spaces or ideas (see Spotlight, page 164).

Preparation

Creating an installation is a worthwhile, but time-consuming, project. Rearrange your timetable to allow for longer blocks of project time. This will mean less time wasted setting out and cleaning up materials. Alternatively, find adult volunteers to assist young artists, and have them work with one group of students at a time.

Possible jobs include photography, painting, researching and writing information, building props or dioramas, making costumes, designing the layout of the space, role-playing, and acting as a tour guide or interpreter. Keep track of students' work, and plan how the parts will fit together with an accessible visual such as a SmartBoard or flipchart paper.

An installation project requires space. An empty classroom, a corner of the library, or an outdoor garden might work. Be careful about how pieces are attached to walls (consult your custodial staff about whether tacks or tape will do less damage).

Installation art can be used to extend sketchbook ideas and two-dimensional work into a much more concrete form. This is an experience of imagination brought to life! Installation work can be collaborative and builds skills in problem solving and imaginatively transforming materials. One high-school student, for example, created a self-portrait by lining up bottles with coloured liquid in a window, with labels such as "Vulnerability" and "I will not be vulnerable" (see Spotlight, page 270).

Process

If the entire class is working on one topic, break the project down into smaller pieces. Allow students to use their strengths to contribute to the group effort.

To undertake a project with your students, follow these steps:

1. Pick a theme or topic. The theme should relate to a topic of study and be open-ended enough to challenge advanced students.

2. Encourage students to research their topic. Follow up on their questions by providing real experiences and opportunities for hands-on learning.

3. Brainstorm with students to find different forms for presenting or sharing their learning. Challenge students to think about all of the various means for communicating concepts to an audience: museums, debates, art galleries, videos, advertisements, newspapers, talk shows, billboards, libraries, concerts, walk-a-thons, and so on.

4. Find a space, tools, and materials.

5. For group projects, negotiate the responsibilities of each member of the group, and record the information for future reference.

6. Provide guidance and enough time for students to develop their ideas and solve problems in their sketchbooks and when working with art materials.

7. Provide resources, allow field trips, and help students extend their understanding beyond the walls of the classroom. As their questions about a subject become more in-depth, provide access to experts who can give new insights and serve as role models. For example, a group of grade-3 students who were creating a classroom museum consulted a museum curator about her job.

8. As students begin working on the project, consult with the class, or groups of students, to create criteria for the finished project (see chapter 4). Revise and refine the criteria as the work progresses. Consult the criteria to evaluate the finished projects. Essential questions to ask might be:

 - What is this project teaching us about our topic?

 - How does this project teach us about our topic in ways that are different from other forms (for example, textbook, postcard, lecture)?

 - Have we learned anything that changes the way we think about this topic?

9. Share the installations or performances with other students, parents, and/or community members by holding museum tours, a gallery opening, a movie premiere, and so on. Practise any performance aspects of the event, for example, role-play, or reading scripts for tour guides. Share the work with a wider audience through photographs or video.

> **TIP** Be aware of fire codes, and avoid hanging paper near fire exits. Some of these requirements are easier to negotiate if there is an understanding that the installation is a valuable – and temporary – learning opportunity.

Negotiate decisions with groups of students, and allow them to lead with areas of the topic that interest them most. For example, when grade-4 students at Wellington School were studying a medieval castle community, they really wanted to know where everyone in the castle slept at night. Their teacher, Susan Bukta, was wise enough to rearrange her unit plan to accommodate their curiosity. What resulted was the deeper understanding that life in the castle was not fair, because some people slept in feather beds while others slept in straw by the fireplace. What an opportunity to teach about bigger ideas like fairness, democracy, evolution of human rights, or the structure of a community!

Museum of Ancient Egypt Project, grade 3 students, Wellington School.
Teachers: Emily Deluca Tarrono, Crystal Millar-Courchene, Rhian Brynjolson

Figure 23.3. Students created this Museum of Ancient Egypt and then acted in-role to guide other students through their exhibits. In these photographs of the hands-on exhibit, Isante paddles the boat (top), then bravely puts his head in a crocodile's mouth (bottom, right). Another student has volunteered to be the mummy (bottom, left).

Transforming an Empty Classroom into Ancient Egypt

At Wellington School in Winnipeg, Manitoba, students in two grade-3 classrooms visited the local museum and learned about the job of a curator before they began an installation project about Ancient Egypt. They looked carefully at how different kinds of displays communicate information.

Back at school, they worked with installation artist kc adams, who visited as part of the Learning Through the Arts program. She showed examples of her work and helped students build dioramas. Students then worked in the art studio to build large models, costumes, and props. They built the Nile River out of gym mats, a boat and pyramid out of large cardboard boxes, houses out of clay, "papyrus" scrolls from Tyvek, costumes and jewellery from cloth and clay.

Student initiative was encouraged! One student, for example, suggested that we build a life-sized sarcophagus, and then volunteered to be wrapped up as the mummy in the exhibit. Others created a crocodile. In the computer lab, groups of students worked with a support teacher to make electronic idea webs, made voice recordings of their explanations, and displayed their written research with LCD projectors. Back in the classroom, some students practised their roles as tour guides. They then gave tours to the other classes to share their learning.

This project allowed students to (a) work cooperatively, (b) learn and express their understanding through a variety of modes (for example, visual, kinesthetic, oral), and (c) repeat and reflect on their learning as the project progressed and students discussed how their museum would take shape. Students extended their thinking when other students touring the exhibits asked questions. The excitement that developed around the scale and novelty of the project fueled the investigations and created willing learners.

The creation and repetition of information, as well as the hands-on nature of the project, allowed all students to understand the nature of an historic community in very real terms.

Additional Exercises

Here are some additional exercises that students can do to learn more about installation and performance art:

- Visit a variety of galleries, museums, theatres, and public events, so that students gain experience with different forms of communication. Challenge students to incorporate aspects of these visits into their own work (including taking photographs, or drawing and writing in their sketchbooks). Encourage students to find connections in theme, form or design aspects between different cultural experiences, and to relate these to their own experiences and concerns.

- Provide small-scale opportunities for students to practise being "curators" of classroom displays or bulletin boards.

- Incorporate drama activities and visual art examples into main subject areas, so that students can experience a variety of modes of presentation with a variety of subjects. This is good teaching practice, as it allows students to process information in a variety of ways.

TIP The very hardest thing for a teacher is to *not* give students the answers to their questions. A very skilled teacher will encourage questioning and provide experiences and examples that allow students to discover answers, or ask deeper questions, without teacher interference. It is the teacher's job to anticipate what is required and to support the young artists' discoveries. As students learn how to ask questions and how to investigate a topic in depth, they are learning how to learn!

VOCABULARY

audience	installation
conceptual	land art: earthworks,
curator	earth art
drama	museum
gallery	performance

(see appendix B for definitions)

APPENDIX A TOOLS & MATERIALS

acrylic see *paint*

acrylic latex see *paint*

baren small, slightly rounded, wooden tool used in printmaking for rubbing paper. The heel of a hand or the back of a wooden spoon can be substituted.

bench hook piece of plywood that has a strip of wood nailed on each end (one on the top, the other on the reverse side on the bottom) that hooks over the edge of a table. A bench hook is used in woodworking to provide a stable edge while carving, cutting, planing, or chiselling.

blender common household item that can be used for mixing papier-mâché paste. A blender may also be used to make handmade paper (also see *hand-mixer* and *whisk*).

blocks of wood see *wood*

brayer soft rubber roller used in printmaking to apply paint or ink. Brayers should be between 4" and 6" (10 cm and 15 cm) wide. Rollers must be thoroughly cleaned after use or they develop hard lumps and will not produce even layers of paint. Store carefully to avoid scratching or gouging the rubber.

Bristol board see *paper*

bubble wrap sometimes called "plastic wrapping material"

camera essential tool for documenting student work, for integrating multi-media technology (digital images), and for students to use when completing photography projects. There are advantages to using each of the different types of cameras:

- digital camera: easy to use, and especially useful for documenting process work, completed artworks, and field trips, and for taking pictures for visual references. It has many uses when combined with good photo software. Ensure your camera is compatible with your computer system and software.

- disposable camera: can be lost or damaged with minimal consequences; therefore, students can take it off school property without worry. Disposable cameras are not designed for dim light, zoom, or close-up shots. Film can be developed or digital images can be placed on a CD.

- film camera: older or second-hand cameras may be inexpensive enough for students to use without undue fear of loss or damage. Choose cameras with manual settings that students can experiment with.

canvas heavy, closely woven fabric that artists paint on with acrylic and oil paints. Students often appreciate the "finished" look of a painting on canvas. Canvas may be stretched over a wooden stretcher (like a frame, with bevelled edges) and stapled along the sides. To stretch a canvas begin in the centre at one end, then with pliers pull the canvas tight and staple the opposite end, then each side; rotate around the canvas, pulling tightly before each staple. Prime the canvas with gesso to provide a less absorbent, smooth surface. Small canvas boards and stretched, ready-to-use canvas are often readily available and inexpensive.

cardboard collect a variety of sizes, thicknesses, and shapes for collage and sculpture projects. Boxes in a variety of sizes may become supporting structures for sculptural forms.

cardstock see *paper*

cement material used to hold sidewalks and building blocks together. Cement is a mixture of limestone and gypsum. It hardens when mixed with water. Concrete is a mixture of cement with sand or gravel. Cement can be cast into moulds for a permanent, relatively inexpensive (but heavy) sculpture material.

chalk or **"soft" pastels** available in a wider range of brilliant colours than chalkboard chalk. Chalk pastels can be expensive and tend to break easily. Use sparingly on coloured construction paper or charcoal paper. Blend or erase with a piece of tissue. Finished drawings will be fragile (chalk rubs off easily) unless sprayed with fixative, laminated, or placed in plastic sleeves.

charcoal commonly used drawing medium. Use charcoal on coloured construction paper; sturdy, brown butcher paper; or charcoal paper (this paper has a roughness or "tooth" that holds the charcoal on the surface). Finished drawings are fragile (charcoal rubs off easily) unless sprayed with

fixative, laminated, or placed in plastic sleeves. Charcoal comes in several forms:

- compressed charcoal: short and square, produces very thick, black lines, and is good for covering large surfaces. Wrap half of the stick with tissue to provide a handle.

- vine or sketching charcoal: comes in thin sticks that can be easily broken. It is not as black as compressed charcoal and can be used more like a pencil.

- charcoal pencil: least messy to use, but will not produce as dark a line as compressed or vine charcoal; not suitable for shading in large areas

charcoal paper see *paper*

clay composite mineral material used for sculpture, bricks, and ceramic ware. Clay occurs naturally in deposits along rivers and lakes, but is cleaned and available in blocks from suppliers. Clay may be modelled, thrown on a potter's wheel, or cast in plaster moulds. Clay must be fired in a kiln at high temperatures (near 2000°F/1100°C) for permanent hardening. Clay may be glazed for a glass-like finish. There are many varieties of clay:

- porcelain: white clay used for fine work with thin walls and a smooth surface. It can be fired at high temperatures.

- earthenware: buff or red clay that fires at low temperatures, making it ideal for use in schools

- stoneware: white clay with fine ground stone that can be fired at medium temperatures

- raku clay: clay to which coarser material is added. It can be fired rapidly in a gas kiln. The coarser composition also makes raku clay useful for larger sculptures with extensions.

- paper clay: contains paper pulp. This clay holds its form fairly well without being fired. It is easy to re-wet if it dries. When fired, the paper burns out, and the clay is lighter and slightly translucent.

clipboard or **drawing board** sturdy, flat surface that provides support if students are working on a carpeted area or outdoors where a hard surface is not available

coloured pencil also called "pencil crayon." Coloured pencils are a versatile drawing tool, and good for small areas of colour and detail. Keep coloured pencils sharp.

colouring sheets and **colouring books** These have no place in the classroom. Any artistic, creative, or motor skills students may learn can be encouraged through students' own drawings.

computer system A variety of computers are suitable for students to use in an art program. Consider the following when setting up your classroom computer system:

- monitor: the display portion of the system

- printer: Both inkjet and laser are available. There are several low-cost colour printers on the market. Before purchasing, check the price of refill cartridges and compatibility with your computer.

- software: computer programs for organizing, manipulating, and presenting images. If possible, explore any program before purchasing it. (See appendix D for more details.)

- Internet access: The Internet can provide myriad visual references for observation, drawing, and painting.

construction an assembled artwork; the building of sculptural (three-dimensional) forms

construction paper see *paper*

craft foam Thin sheets of coloured foam or Fun Foam are easy to cut; come in a variety of bright, solid colours; and can be glued with a hot-glue dispenser or stapled.

decorative tools objects used to decorate artworks

desk lamp light source used to create clearly defined areas of light and shadow

Dessin paper see *paper*

digital camera see *camera*

drawing ink liquid used for drawing. It is often expensive, messy, and may stain clothing, but yields beautiful results. Substitute black tempera paint or black felt pens whenever mess is a concern. Washable India ink may be diluted with dish soap and water for (slightly) easier clean up. Use ink mixed with varying amounts of water and a paintbrush for a "wash" drawing. Use a pen holder and drawing nib (for example, a "crowquill" nib) dipped in ink on a smooth-surfaced paper. Try dipping a feather or sharpened twig in ink for a wobbly, drippy line.

drawing pad notebook used specifically for sketching, drawing. Drawing pads vary widely in the quality of drawing paper they contain (see *paper*).

end papers sheets of paper pasted onto the inner covers, joining the book block to the covers

erasers White plastic erasers or Pink Pearl brand will not leave a pink smudge. "Gum" erasers are tan, square, and soft enough to be useful with pencil or charcoal. "Kneaded" erasers are for charcoal, and they can be folded over to provide a clean edge.

fabric material made from fibres or threads. Fabric can be expensive to buy new. Check for sales, and at used clothing stores and garage sales.

felt pens washable, non-toxic markers that are usually available in classrooms. They produce vivid colours. Keep extra lids on hand to replace lost ones. Try brushing water over marker lines to make the colours run in interesting ways. The disadvantage of felt pens is that colour mixing and shading are difficult, and varying the pressure on the pen will not vary the darkness of the line. Also, they are expensive and tend to dry out if not cared for. Avoid permanent felt pens unless they are labelled *non-toxic*. Fine-tipped, permanent, felt pens (for example, Sharpie) may be used for pen-and-ink techniques and with watercolour paint.

fixative Spray fixative is toxic and dangerous if inhaled. Check your school's health-and-safety regulations

before using a fixative. Keep in a locked cupboard, and use in a well-ventilated area after students have left for the day.

flour powder made from grain cereals. White wheat flour is used to make papier-mâché paste.

foam rubber spongy material; relatively easy to cut with scissors. Use thinner sheets or carpet underlay with younger students. Pieces of foam may be attached together with a hot-glue dispenser.

gesso a primer used to prepare a surface before painting. Gesso is commonly used on canvas to provide a smooth, white, sealed surface.

glaze coating applied to surfaces. Glazes are used with clay (ceramics) and must be fired in a kiln to chemically change into a glass-like surface. Glazes are available with a wide variety of colours, textures, and finishes (gloss is the shiniest, matte is the most non-reflective). They may be opaque (completely hides the colour of the clay), translucent (allows some of the clay colour and texture to show), or clear. Overglaze produces a shiny surface on top of other colours. Be careful to select glazes that are labelled *non-toxic* or *food safe* for use in schools, because other glazes may contain lead or other toxic heavy metals.

glue Several kinds are available. Use the glue most suited to your project:

- white glue: bonds most surfaces. One solution for storing and using glue is to put glue into squeeze bottles, and close with plastic hairpins. This solves the problem of stuck glue lids, and saves having to pour glue into dishes for each project.

- paper paste: can be homemade from boiled flour, sugar, and water. Less drippy than liquid glue, it can be applied with a craft stick or rectangle of cardboard.

- glue stick: adequate for most cut-and-paste projects, but expensive. Avoid coloured varieties.

glue gun tool useful for fastening large pieces or unusual materials with a strong bond of melted plastic

gouache see *paint*

graphite black material used in pencils (Lead is toxic and is no longer used.)

grey "sugar" paper see *paper*

hand-mixer useful tool for mixing papier-mâché paste (see also *blender* and *whisk*)

hot-glue dispenser see *glue gun*

kiln firebrick oven used for heating ("firing") clay pieces. Kilns may be gas or electric, and they may be regulated by digital or mechanical controls. For school use, cone 06 is sufficient (about 1830°F/1000°C). Kilns must be properly installed, vented, and locked for safe operation.

Lego brand of plastic building blocks with a wide variety of shapes

lens clear glass or plastic device used to bend or focus light. There is a natural lens in the human eye, and a mechanical lens in a camera.

linoleum product made from renewable materials. The linoleum used by artists is soft and smooth and has little in common with modern flooring products. A new, softer rubber version of block printing material is available at art supply stores. Old linoleum may be heated on a hot plate for easier cutting. Older and more advanced students can use linoleum for relief or block printmaking.

Manila tag and **Manila paper** see *paper*

markers see *felt pens*

mat board see *paper*

math blocks blocks used to teach mathematical concepts

Mayfair paper see *paper*

mirror reflective glass. Small, plastic locker mirrors are useful for drawing self-portraits, or for drawing symmetrical designs.

mobile hanging sculpture. A mobile is suspended from wire or string and may be designed to rotate or revolve. Use lightweight materials such as foam core, Fun Foam, or paper for constructing mobiles.

modelling clay Brands such as Plasticine are inexpensive and suitable for classroom use. Plasticine comes in a range of brilliant and subtle colours, and may be used to create two-dimensional images, or three-dimensional sculpture. Modelling clay may be used with a movable armature for claymation (animation) projects.

modelling tool Tool that may have a point for inscribing, wide surface for scraping, sharp edge for cutting, loops of wire for carving grooves, or flat surface for polishing. Simple substitutions include plastic knives, toothpicks, and combs.

monitor see *computer system*

mould can be formed from plaster around an original sculpture so that it can be duplicated or mass-produced; may have a specific form

movable models and **toys** small three-dimensional models and toys that are useful visual references. Students can look at or touch them while drawing objects from a variety of angles, exploring textures, or modelling a three-dimensional sculpture.

natural object object, not made by humans, that is found in nature. Natural objects include shells, tree branches, pebbles, dried plants, seeds, and sand.

oil pastels medium used for drawing to produce brighter colours. Oil pastels can be layered more effectively than crayons. Encourage students to mix colours. Try scratching lines into thick oil pastel with a sharp pencil.

overhead projector device for enlarging and projecting an image or text drawn on clear plastic (mylar)

paint mix with cornstarch, sand, natural fibres, laundry starch, or dish soap to alter its texture. Many types of paint are available:

- acrylic paint: can be used for printmaking, paper-marbling, and some specialty painting (advanced students may use acrylic paint on

paper or canvas). Acrylic paint is not recommended for most painting projects, because it is expensive, hard on brushes, and difficult for students to use well. Good-quality tempera paint may be substituted for acrylic paint if it is coated with PVA (acrylic medium).

- tempera paint: the preferred school paint. The round blocks of tempera paint are easiest to use. Blocks can be placed individually in clean tuna cans or set out in trays with different colour combinations. Students can mix colours directly on the blocks and then wipe the blocks clean with damp paper towels or sponges. New formulas of liquid tempera, produced by Chromacryl and Prang, have the bright colour and thick texture of acrylic paint, but are still washable. Set out small amounts of liquid paint in Styrofoam egg cartons (lids can be closed to keep paint from drying for the next session), or, for younger students, in larger paint pots with lids. Powdered tempera is no longer used, because it may be toxic.

- watercolour: comes in tablets, tubes, and liquid form. For salt, plastic wrap, and wet-on-wet techniques to be effective, this paint must be used with watercolour or Dessin paper. Use small amounts of paint on a palette or Styrofoam tray. Dried paint may be re-used with a wet paintbrush. Use with a large, soft brush. Replace lids on paint tubes carefully. To use a paint wash with very young students, pre-mix watercolour with water, or substitute with food colouring and water. Food colouring will produce bright colours and accurate colour mixing – use with a paintbrush or an eyedropper.

- acrylic latex house paint: can be used as a substitute for acrylic paint. Check the label to ensure the product is non-toxic. Paint for exterior use is most permanent and colourfast.

- gouache: artists' quality tempera paint. The paint is water-based and has a very flat, matte finish. It may be mixed with egg yolk to produce egg tempera paint.

paintbrush square, or "flat-headed," paintbrush is preferred for most work, because it can be turned to produce either a wide or thin line. Have a range of brush sizes available to students. Younger students will need large brushes (¾"/2 cm); older students will need these as well as finer brushes (½" to 3"/1 cm to 8 cm). Watercolour techniques require large, soft brushes that form a point when wet (slightly used school brushes are adequate). Clean paintbrushes after each use; keep a bucket of soapy water (dish soap is fine) available for students to drop their brushes in, then wash thoroughly. Store brushes bristle-side up after cleaning, to avoid having the bristles become permanently bent. Keep old or damaged brushes on hand to use with glue or PVA, or to produce interesting, quirky brush marks. Use feathers, twigs, string, sponges, house painting brushes, and so on to produce different kinds of marks.

palette Styrofoam egg cartons (with lids) are good for acrylic and liquid tempera paint. Styrofoam trays can be substituted, and can also be used with watercolour paint. (Palette also may refer to the range of colours used in a painting.)

paper The type of paper used will affect the outcome of the art project. Provide a selection of papers for collage projects. For drawing and painting projects, choose the highest-quality paper your budget will allow:

- Dessin paper: can be cut into small pieces and rationed out to students for watercolour projects or small-scale drawings. It is available in different "weights"; the heavier variety (100 lb.) is required for watercolour. Although it is fairly expensive, it costs less than most paper unless you have access to an artist's co-op.

- Arches, Strathmore, and Windsor-Newton papers: available in a variety of weights and tints. They are expensive, high-quality watercolour papers.

- Mayfair paper: heavier than any school or bond paper and allows for more erasing. The surface will hold slightly more graphite and ink than regular paper, making it good for pencil and pen drawings.

- construction paper: good for chalk pastel and charcoal drawings, although charcoal paper has more tooth (texture) and holds more chalk. Construction paper is also commonly used for cut-paper collage. Brightly coloured paper and patterned papers provide a different effect, and might be less likely to fade over time.

- charcoal paper, pastel paper, and grey "sugar" paper: have a "tooth" or surface texture that holds soft media such as charcoal, chalk, and pastel. Grey papers are helpful for allowing students to see (by contrast) the lighter and darker values they add to the grey.

- Manila tag, card stock, and brightly coloured file folders: excellent for covers for assembling students' books, or for collage projects. Old file folders make good sturdy "pop-up" books.

- Bristol board: similar to coloured Manila tag and available in a wide variety of colours and larger sizes. Single ply is similar in weight to file folders; 4 ply is much sturdier, but harder to cut with safety scissors.

- soft Manila paper: adequate for use with tempera paint, but too soft for most drawing projects; students will erase right through it.

- photocopy paper: adequate for most drawing projects. It tends to be sturdier than most art paper and has a smooth surface for fine pencil work and ink. It is not as good for painting, because the surface will ripple.

- rice paper: soft paper that can be used for block printmaking and watercolour.

- handmade paper: made by hand, using a mould; often contain interesting fibres and recycled materials

- scrapbook paper: comes in a wide variety of patterns and colours and is suitable for collage projects

- mat board: very hard and heavy material used for matting pictures (providing a coloured border) for

framing. Good-quality mat board is acid free so that the original drawing is less likely to yellow or fade over time. Bristol board may be substituted for short-term displays of students' works.

- Tyvek: vinyl construction material available in rolls of plain white at some art supply stores. It has a beautiful, durable surface for drawing, printmaking, and painting, and it can be substituted for paper.

paper fastener small brass fastener that is pushed through the paper and then opened to fasten the pages

papier-mâché Pulp is commercially available, but torn newspaper, water, and an old blender will produce a similar result. The paste does not store well, so use it the same day it is mixed.

pastel paper see *paper*

pencil Regular HB or primary printer (B) pencil is well suited to most drawing projects. Drawing fine lines or light grey tones may require a harder pencil (H pencils are hard; the higher the number next to the H, the harder the pencil). To get a very black line, try a B pencil (the higher the number next to the B, the softer the pencil and the blacker the mark). Pencil "lead" is actually graphite.

photocopy paper see *paper*

plaster Plaster of Paris is a powdered gypsum product that can be mixed with water to produce sculpture material. Plaster may be used with wrapping material, such as coarse cloth, or cast (poured) into moulds. Dry plaster may be carved and sanded, although it will be quite dusty. Pre-mixed drywall "mud" is a similar product, less dusty, and may be more convenient to use.

plaster wrap gauze containing dry plaster. It is the same material that is used in hospitals for plaster casts. Although relatively expensive, it is a versatile (and easy) sculpture material. It is available in large (5 lb.) or smaller rolls. To use, cut into pieces, dip in water, gently scrape off excess water, and shape. Plaster wrap bonds to materials such as cardboard, wood, and wire.

Plasticine brand name of a modelling clay. Most other brands are inferior.

Plexiglas/mylar clear plastic. Can be used as a painting and drawing surface. Check that the pens used are non-toxic.

plywood building material available in 4' x 8' sheets, made of thin layers of wood, layered for strength

polymer clay available in a full range of colours. The clay is very expensive, so it is best for small-scale (miniature) work. The clay may be used with an armature wrapped in tinfoil, so that only a thin "skin" of clay is required. Sculpey is a popular brand.

potter's wheel turntable device that allows clay to be shaped into a cylindrical vessel by an artist (potter); may be manual (kicked) or electric

printer see *computer system*

printmaking ink high-quality, water-based printing ink that gives the best results with relief printmaking projects

prop object used in a drama production, or for posing with to provide an interesting subject for a drawing (for example, an umbrella)

PVA (polyvinyl acrylic medium) water-based acrylic medium used to provide a glossy surface. It may be applied to a variety of surfaces, such as dry paint, modelling clay (for example Plasticine), wood, and papier-mâché.

quilt batting white, fluffy material that can be used to stuff soft sculptures, or to mimic snow or clouds

rice paper see *paper*

ruler straight tool with marks to indicate measurements

safety glasses clear plastic glasses worn to protect eyes while working with sharp objects or tools (for example, wire, chicken wire)

salt Table salt and coarse pickling salt can be sprinkled into wet watercolour paint to produce a crystalline pattern.

sandpaper rough material used to smooth wood surfaces

scissors Sturdy, sharp scissors are required for most projects. A few left-handed pairs may be required. Keeping scissors clean (free of glue or tape residue) will prolong their life. Emphasize safe handling, especially to younger children.

screwdriver tool used for turning screws into wood or metal. Screwdrivers come in a variety of shapes and sizes; Robertsons have a square end; Phillips have an X shape.

sculpting tool any tool used to build, smooth, or carve a sculpture. Hammers, putty knives, and files are examples of sculpting tools that can be used for specific media and effects.

simple machine machine (as defined in the science curriculum) that has straightforward mechanical parts, such as screws, levers, ramps, and wheel and axle. Taking apart small appliances will reveal a variety of these devices.

single-hole punch paper hole-puncher that makes one hole (rather than three)

sketchbook "book" of paper that can be assembled by a student or by a coil-binding device. Make sure covers are sturdy, to provide a solid drawing surface. Whatever paper overflows the supply cupboard is adequate for sketchbooks. Newsprint is the least desirable – it is grey, too soft to withstand much erasing, and too slick to hold much graphite.

smock Old shirts or T-shirts work well to protect good school clothes from stains. Assign a paint smock to each student, wash frequently, or store overnight in a freezer to keep sanitary.

software see *computer system* and appendix D: Software

stapler useful tool for fastening items that cannot be taped or glued

staple gun high-powered stapler for fastening items onto wood or other dense materials. Use with caution to avoid injury.

tangram simple geometric shape. Tangrams may be purchased, or cut from cardboard, Bristol board, or mat board.

tape adhesive material that has a variety of uses in the art studio:

- masking tape: ideal for paper; inexpensive; may be painted with acrylic paint
- duct tape: heavy-duty tape for securing large or heavy objects; available in a range of colours that can be used as a finished surface
- packing tape: fairly strong, clear, and can be used with plastic wrap as a sculpture material
- painting tape: green (usually) masking tape. It is less sticky than ordinary masking tape, so that it is less likely to strip paint from the wall. It is useful for masking or covering selected areas when painting (for example, to paint a straight line, paint next to a line of tape).

television Newer televisions have multiple inputs for video and audio. Use a TV to show images directly from a digital camera, video camera, or DVD.

tempera see *paint*

textured item item with an interesting surface that can be felt. Textured items can be used for rubbings or collage. Fur, cloth, rubber mats, shoe soles, manhole covers, gravestones, floor or ceiling tiles, Lego blocks, netted onion bags, and window screen are examples of common textured items.

tinfoil often referred to as "aluminum foil." It can be used with wire as a sculpture material, or it may be used under modelling clay to build up a form so that a thinner layer of clay is required.

toothbrush common household item that can be used for splatter painting

tripod helps the shooter take steady shots, prevents a camera from being dropped, and, when a camera is attached, the camera is more difficult to steal

Tyvek see *paper*

video camera Many types are available. Slightly outdated digital video cameras that use tapes may be useful for the classroom, because each group of students can keep its work on a separate

tape, and the cameras are not too expensive for student use. Check the compatibility of the camera with your computer software. Use video cameras with a tripod.

wallpaper paste adhesive that can be used to make papier-mâché paste

watercolour see *paint*

wax crayon common and versatile drawing medium. Use for crayon-resist (press hard with the crayon and then use watery paint on top), encaustic (paint with melted, coloured wax), rubbing (place paper on a textured surface and rub with a crayon), and for drawing.

whisk useful tool for mixing papier-mâché paste (also see *blender* and *hand-mixer*)

whiteboard marker useful tool for writing on plastic surfaces. Check that any markers used in the classroom are non-toxic.

wood choose smooth, straight pieces with few knotholes. Soft woods such as spruce and cedar are easiest to drill and cut. Scraps of hard woods such as oak or ash can be used with wood glue to make sculptural forms. Use "one side good" plywood for murals or tabletops. Use recycled or substitute products whenever possible. Inexpensive slats or branches are handy to support armatures for three-dimensional artworks such as puppets.

wire available in a variety of metals and gauges (diameters). Copper wire is flexible and easy to bend and cut. Wire is used with needle-nose pliers and wire-cutters. Scraps of cable may be sliced open to remove strands of thin copper wire coated in colourful plastic. Use short lengths and stress safety, to avoid having loose, sharp ends near students' eyes. Beware of some aluminum wires that have sharp burrs or splinters.

wire-cutter tool for cutting wire. Some needle-nosed pliers have a cutting edge.

wooden slat see *wood*

woodworking tools variety of tools that may be used by young students

under adult supervision, including hammers, handsaws, hand drills and low-power electric drills, tape measures, screwdrivers, and sanding blocks. Teach proper handling, provide extra adult staff or volunteers, and use safety precautions such as wearing safety glasses.

work gloves gloves made of leather that are worn to protect hands from scratches, heat, or corrosive materials

APPENDIX B ART VOCABULARY

abstract work where the subject is not represented exactly as seen; the subject is absent, simplified, or distorted

abstraction process whereby a representation is developed differently from the original subject

additive putting pieces together, or adding materials, to build a sculpture

advertisement and **advertising art** artwork, often called *commercial art*, created for, or used for, selling a product or point of view

aesthetic criteria basis for valuing or making judgments about the design and cultural significance of an artwork

aesthetics study of and system of organized ideas about visual experience

analogous colours colours next to each other on the colour wheel (for example, blue and green; green and yellow)

anatomy study of the structures of the body. Artists study the structure of the skeleton, muscles, and tendons in order to accurately represent them.

animation creating the illusion of movement with a series of sequential images, such as in a cartoon

aperture opening in a camera that allows in light; similar to the pupil of an eye

architecture design of buildings; study of structural design

armature structure supporting a sculpture; like a skeleton

art criticism informed judgments, writing, or discussions about artwork

art material object used to make art (for example, clay, graphite, paper)

art medium 1. material an artwork is made from (for example, oil paint, wood, clay); 2. technique used to make artwork (for example, photography, sculpture)

art specialist art teacher or knowledge-able artist working in a school

art teacher specialist teacher who has training in visual art

artist's statement artist's description of the intention, materials used, process, and/or reasons for making a work of art

assessment establishing criteria and making judgments about a work of art based on the criteria (see *formative assessment*)

asymmetrical balance two parts of a composition that may have different elements. However, the visual weight of the parts balance each other.

asymmetry design in one half of a composition is different from the other

atmosphere mood created in an artwork, influenced by the lighting, colour, subject, details, and so on

atmospheric perspective illusion of depth created on a two-dimensional surface by using bluer, lighter, or more reduced colours in the background

audience people who view an artwork

background area in an artwork behind the subject; farthest-away elements in the picture

balance each element in a composition, carrying visual weight, that can be offset or balanced by other elements. Balance may be symmetrical, asymmetrical, radial, or crystalline.

baren see appendix A

bench hook see appendix A

bisque ware clay pieces that have been fired in a kiln and are ready to be glazed. (Clay is fired once in a kiln before it is glazed, and then it is fired a second time after glaze is applied.)

blind contour line-drawing exercise done by looking carefully at the subject, not at the drawing surface

block printing relief printing from a slightly raised or carved surface rolled with paint or ink

border edge, design, or line framing an image

brayer see appendix A

brush marks variety of effects achieved by, for example, pulling, pressing, or scrubbing a paintbrush on a surface

CAD program computer-aided design program (see Google SketchUp as a user-friendly example)

camera digital, film, disposable, or video recorder

caricature exaggerated, often humorous, drawing of a face or figure

cartoon 1. humorous drawing; 2. animation; 3. quick sketch depicting a scene or situation

carving creating a three-dimensional form by cutting away material from a larger block

casting creating a three-dimensional form by pouring liquid into a mould and allowing it to harden. The poured material takes on the form of the mould.

CD-R recordable disk that can be used for storing quantities of information

ceramics 1. art of working with clay; 2. artworks, or products made from clay

chalk pastel drawing medium similar to coloured chalks, but available in a much greater range of colours

character person or animal in a story or illustration

charcoal black drawing medium made from burnt wood

chiaroscuro 1. dark scene with a single, strong light on a main character or event; 2. painting technique, using strong shadows and light

chroma intensity or reduction of a colour; also called *chromatic scale*

clay see appendix A

coil pot form built by rolling long cylinders (rope-like) of clay, and stacking them upwards from a spiral base

collaboration act of working with one or more people on the same project

collage composition constructed from pieces of paper and/or photos cut out and glued onto a background

collograph 1. variety of fairly flat objects glued onto stiff cardboard (in a pattern or randomly) to make a printing plate; 2. print made from a collograph plate

colour 1. visual effect caused by the reflection or absorption of light from a surface; 2. a group of colours arranged to achieve a particular effect

colour relationships interplay of colours on the colour wheel or within an artwork or design; colour schemes

colour schemes see *colour relationships*

colour spectrum band of colours that result when white light passes through a prism

colour theory ideas about how to use colour in a composition to achieve contrast and harmony. Considerations including hue, intensity, value, atmosphere, and symbolism.

colour wheel circular arrangement of colours, based on how paint pigments mix to produce the colour spectrum

complementary colours colours that are opposite each other on the colour wheel (red-blue, blue-orange, violet-yellow)

composite artwork that is composed of, or made up of, several pieces from a variety of sources

composition grouping, or placement, of design components on the page

compressed charcoal charcoal that has been pressed into a rectangular form and makes a very black mark

computer graphics manipulation of digital images and design work done on a computer; text and digital images may be combined

conceptual relating to an idea or process rather than on the visual representation

concertina accordion shaped with many folds

cone geometric solid that has a circular base and narrows to a point at the other end

construction 1. assembled sculptural form; 2. process of building a sculptural form

context setting, time, or situation of an artwork

contour edges of an object; a line that describes the edges of an object

contrast 1. marked difference or comparison in colour or other component of design; 2. variety of elements in an image that provide visual interest

cool colour colour with tone of blue, green, or violet

creature imagined composite animal, alien, or fantastic being

crosshatching repeated, parallel lines overlaid at an angle to other parallel lines

crystalline pattern that resembles a crystal or that creates a wallpaper effect of repeated images

curator worker in a gallery or museum who selects artwork (or artifacts), plans exhibitions, and creates displays and written materials for public viewings

curriculum government-mandated guidelines for teaching a particular subject

curvature bend or curve of an object

curvilinear having rounded or curved lines

cut and paste technique for building an image out of many small pieces. It may also be called *collage*. With cut and paste, the pieces of an image are easy to move, allowing choice in placement.

depth 1. in two-dimensional works, the imaginary measurement from the surface of the page inward that is used to create an illusion of three dimensions, or distance; 2. distance from front to back in a three-dimensional work

design formal structure or composition of a work of art

detail minute elements of an image

dialogue 1. conversations (with students) about the content or process of making art; 2. speaking parts in a text, film, play, video, and so on

digital 1. information stored or used in binary form; 2. computer images

dimensions in visual art, artwork may be created on a flat two-dimensional surface, sculpted into a solid three-dimensional form, and may incorporate time. The dimensions are: height, width, depth, and time.

dominance one element emphasized or given more visual weight in a composition than other elements

drama art form that involves acting in role

drawing 1. two-dimensional artwork made by materials such as pencil, ink, pastel, charcoal, or computer-drawing programs; 2. process of creating an image with art materials

drawing ink 1. liquid drawing material used with a pen handle and drawing nibs; 2. liquid contained in permanent markers or technical pens

dry-brush technique used for applying paint, using less water, a drier brush, and more opaque paint than in other brush techniques; usually used to produce interesting and irregular brush marks

earth tone colour that contains some brown hues

earthenware 1. clay for low-temperature firing; 2. ceramic ware fired at relatively low temperatures in a kiln

electronic media technology used to make artwork, for example, video, digital images, computer graphics, and multimedia artwork

elements of design 1. shape, line, texture, colour (and value), form, and space; 2. visual and tactile parts of a composition

ellipse elliptical or oval shape

emphasis focal point, or outstanding element, in an image

exposure length of time the aperture on a camera is open; longer exposures are required in low light

expression display of emotions

expressionism art movement that emphasizes artist's state of mind rather than objective observation; often characterized by exaggerated shapes and distored colours

facial features parts of the face, for example, eye, nose, mouth, ears, chin, forehead, and cheekbones

Fibonacci sequence mathematical sequence where each number is added to the previous number to produce the next number in the sequence, 0, 1, 1, 2, 3, 5, 8, 13 …. When the areas of these numbers are drawn as squares, they produce a spiral found frequently in nature.

field of vision entire area that a person can see

figurative artwork that represents a human figure

figure drawing 1. drawing the human form; 2. drawing that depicts the human form

film movie or video; the term *film* may refer to longer, thoroughly planned, or elaborate projects

filmmaker person who makes films

fire to heat clay in a kiln at high temperatures to produce a chemical reaction and a hard, durable product

flash drive portable device used for storing digital information

foam rubber soft material that can be sculpted (carved)

focal length distance between the camera lens and the farthest object in focus. A wide-angle lens uses a short focal length, a lens for a narrower field uses a longer focal length.

focal point part of a composition that draws the attention of the viewer

font design of letters of the alphabet

foreground what appears to be in front of the other elements of a picture; the area that appears to be nearest to the viewer

foreshorten how an object appears to change as it is tilts toward the viewer (for example, a foreshortened cylinder will appear to be a circle; the front end will appear to be larger than the back)

form 1. three-dimensional object; 2. geometric solid, or two-dimensional representation of a solid, such as a sphere, cube, rectangular prism, cone, cylinder, pyramid; 3. overall structure of an idea or artwork

formative assessment 1. establishing and referring to criteria during the process of creating artwork; 2. actively teaching and learning how to modify, redesign, and develop ideas

found materials recycled objects used to make artwork that are not commonly defined as art materials

frame 1. border, or an object with a glass front, for displaying artwork; 2. to give form, reference, or context to an idea

framework structure of an idea or process

freeware free computer software (or shareware)

gallery space designed for exhibiting artwork. An art gallery may be commercial (artwork is for sale), public, or artist-run.

genre type or form of artwork of a particular historical period, place, culture, and context

genre art artwork that depicts everyday life

geometric form three-dimensional solid such as a cube, sphere, or pyramid

geometric shape two-dimensional area, such as a circle, oval, square, rectangle, or triangle

geometric solid mathematical term for three-dimensional volume or form such as a cube, sphere, or cylinder

geometric volume see *geometric solid*

gesture movement or expressive action or pose

gesture drawing quick drawing with active lines that captures a sense of movement. (An active line has variation in the width, darkness, direction, and may be composed of several partial lines. Jagged marks used to indicate the fuzzy edges of a cat are examples of active lines.)

glaze see appendix A

glazing 1. act of putting glaze onto clay bisque ware (clay must be fired once before glazing); 2. painting technique using layers of transparent colour painted over a base colour to produce new colours

golden ratio and **golden rectangle** 1. mathematically derived rule of proportion said to represent harmony; 2. ratio of the length to the width of a rectangle that is considered the most pleasing to the eye, used by artists such as Leonardo da Vinci and Piet Mondrian in planning their compositions

gouache see appendix A

graphic art 1. artwork that involves drawing; 2. explicit images; 3. commercial art

graphic design visual communication of information, using elements such as typography, colour, and images, applied to print and electronic media

graphics electronic images; see *graphic art*

grey scale see *value chart*

green ware clay pieces that have not been fired. (Clay needs to dry for several days before it is dry enough to be fired in a kiln.)

grid horizontal and vertical lines that are placed at regular intervals. A grid is used to achieve correct proportion and placement when drawing.

ground surface or plane of the drawing, painting, or other artwork

gutter centrefold in a book

harmony principle of design that requires the inter-relation of elements in a composition that contribute to creating a unified whole

hatching repeated, parallel lines used to create texture and value

highlights 1. areas of reflected light; 2. lightest colours on a subject or in a drawing

hook aspect in an advertisement designed to get attention of the viewer or entice the viewer to buy a product or concept

horizon line line, real or imaginary, representing place where the sky appears to meet the ground

horizontal parallel to the horizon (parallel to the ground)

hue pure colour

illustration 1. visual image that (usually) accompanies a written text; 2. visual image, or series of images, that tell a story or convey an idea; 3. style or form of graphic design that may incorporate comic art, pattern, exaggerated form, or strong composition

illustrator 1. artist who works with magazine or book images; 2. artist whose images tell a story or convey an idea

image reproduction or representation of a subject (photograph, drawing, painting, and so on)

impress painting painting in which objects with an interesting surface texture or shape are laid on wet paint. The objects are removed when the paint has dried, leaving an imprint behind.

impression mark left after an object has been pressed into a soft medium (for example, screen pressed into clay)

impressionism school of painting that focuses on light and colour as a subject in painting. The artist uses looser brush marks, thick paint applied with a palette knife, or small dots of paint. Close up, the image tends to "dissolve" into individual marks.

installation or **installation art** artwork created or installed to create an experience within a specific space. Most installation art is not permanent.

intense colour pure hue, or saturated colours; a colour that appears brighter from being placed next to its complement. For example, yellow will appear brighter if it is placed next to violet.

juxtapose to place a subject into a new or surprising context so that it may be seen differently (for example, placing a urinal in an art gallery exhibit)

kiln device used for firing (heating) clay. Kilns are much hotter than conventional ovens; small electric kilns typically can fire at 2000°F (1095°C). Kilns are lined with fire brick for insulation and need to be installed according to manufacturer's specifications with proper ventilation.

kinetic sculpture three-dimensional artwork with moving or movable parts

land art artwork, often on a large scale, done out-of-doors and involving some natural materials; also known as earthworks, earth art

landscape drawing or painting of scenery, such as land, and/or water, usually conveying a sense of space or distance

layout plan or composition of an artwork or advertisement

leather-hard when clay dries to the point of being almost dry; still cool to the touch, but easily broken if folded

lens part of a camera (or an eye) that focuses light

life drawing 1. drawing the human form; 2. artwork depicting the human form, clothed or unclothed

light light source or light depicted in an image

light table table with a glass top, lit from below, used for tracing part of an image

line mark made by pulling a pencil across paper; representing the edges or contours of a subject on paper

line quality A line may be thick or thin, straight or wobbly, scratchy, zigzag, dark or light, broken, smooth and so on. Variations in line add interest to a drawing.

linear perspective 1. view from a single vantage point that gives the appearance of three dimensions; 2. system used to provide the illusion of depth on a two-dimensional surface

linocut relief print made from carving an image into a lino block (a linoleum-like material), and rolling it with printmaking ink. The image is then transferred onto paper.

logo simple design used to represent an organization, corporation, or brand

look-drawing looking carefully at a subject while drawing, allowing for a detailed representation of the subject; artist draws what he or she

can see, rather than what he or she assumes a subject looks like; also called *observational drawing*.

manuscript unpublished text or original text

marks lines, dots, shapes, or smudges made with art tools on a surface

mask disguise worn over the face. A mask may be decorative, symbolic, worn for traditional celebrations, or representative of a character in drama.

mass 1. visual weight of an object; 2. size and weight of a form

materials objects used to create artwork, such as wood, paper, plaster, papier-mâché, and paint

media 1. plural form of (art) medium; 2. materials used to create artwork or convey an idea; 3. public information systems (such as television, radio, Internet sources)

media literacy requires reading, viewing, understanding, and producing media texts and images, including electronic media

medium 1. singular form of (art) media; 2. a material used to create artwork or convey an idea; 3. a public information system

metamorphosis complete change or re-invention

middle ground central space in an artwork; area that is, or appears to be, between the foreground and the background

mixed media artwork made of more than one art medium

model 1. person who poses for an artist to provide a visual reference; 2. diorama or small-scale representation; 3. create a sculpture (for example, to build something out of clay)

modelling making a form by building up (additive sculpture) or carving away (reductive sculpture)

modelling clay manufactured, non-hardening product available for making three-dimensional artworks by building

up (additive sculpture) or carving away (reductive sculpture)

modelling tool tool used with material such as clay for carving, cutting, etching, smoothing, and so on

monochromatic made of one colour only; a colour scheme using one colour and varying the transparency, value, or intensity

monoprint printing process in which a single, unique image is produced

mood atmosphere or feeling conveyed in or by an artwork

mosaic image composed of tiles

motif commonality or repetition of elements in an image; pattern of elements or ideas

mould hollow vessel for casting (pouring) clay or other materials

movement principle of design. An illusion of movement in a still artwork is created with the repetition of elements that leads the eye across, "active" lines (irregular, flowing, or jagged), soft or blurred edges, depicting a subject in movement (a tilted object, an active gesture), or using tension, contrast, or imbalance in an image.

multimedia 1. artwork that incorporates more than one form (for example, written text, visual images, and sound); 2. artwork that incorporates electronic presentation (for example, integrating projected images, painting, and sculpture)

mural oversized painting, usually on a wall or building

museum space devoted to collecting, displaying, and interpreting cultural artifacts and artworks

narrative art artwork that tells, or hints at, a story in images and/or text

negative space area between and around parts of the subject

neutral colour reduced colour, tint, or shade; black, white, brown, grey

non-representational artwork without a recognizable subject

observational drawing drawing made by looking carefully at the subject while drawing; allowing for a detailed representation of the subject; drawing what is seen, rather than what is assumed a subject looks like; also called *look-drawing*

one-point (single-point) perspective schema for representing a scene, as seen from a single point of view; lines appear to recede in the distance and meet at a single vanishing point on the horizon (for example, a wide road appears narrower in the distance)

opacity opposite quality to transparency. An opaque object is one that cannot be seen through and obscures what is behind or underneath (for example, opaque paint hides the surface beneath it).

organic shapes that are found in natural objects, usually irregular and non-geometric

overlap shapes placed partially on top ("in front of") or under ("behind") other pieces

paint liquid colour medium that is usually applied with a brush. Paints commonly used in classrooms include acrylic, tempera, watercolour, gouache, and latex.

paint chemistry chemical composition of paint that binds the pigments (the minerals that colour the paint) together

paint program computer drawing program that mimics some drawing and painting processes. Users can create lines, colour fills, and insert a variety of marks and effects.

palette 1. tray for holding and mixing colours of paint; 2. range of colours used in an image

paper clay clay that is mixed with paper pulp to give it unique qualities. It is lighter than green ware, fairly strong, easy to re-wet, and semi-translucent when fired.

papier-mâché modelling material made with newspaper strips or pulp, applied with a flour-and-water glue or a commercial wallpaper paste

parts of the body The human body consists of many parts. In art, the trunk of the body is referred to as the *torso*. Use comparative measurements to achieve proportion in drawing; for example, the distance from chin to eyebrow equals approximately one hand.

parts of the eye The eye, the organ of sight, has several components. Students may find it easier to draw an eye if they observe the shape of each part: the white orb is partially covered by eyelids and becomes two triangular shapes; the iris and pupil are circles.

pattern repeated elements arranged in a sequence

performance or **performance art** artwork involving a staged action for an audience, often accompanying an exhibition or installation

perspective drawing accurately from a particular vantage point to give the appearance of three dimensions on a two-dimensional surface

photography art of composing or capturing images with a camera

photojournalism events that are documented by camera and communicated to an audience through the images, often accompanied by captions

pictorial space illusion of depth in a two-dimensional image. Pictorial space may be described as flat, shallow, or deep.

pigments what ground-up material paints are made out of (often minerals such as ochre, cobalt, and so on). Some paints and inks are made of dyes rather than of pigments. Pigments tend to sit on top of a surface; dye colours soak in. Some pigments, such as lead, are highly toxic.

pinch pot vessel made by pinching and turning pieces of clay

plaster ground product of limestone that chemically reacts with water and hardens; modelling material that may be cast (poured into a mould), applied with a coarse fabric wrap, or with a trowel; component of gesso; commonly used in building walls

play story, usually with dialogue, performed by actors

play dough modelling material made with flour, salt, and water, commonly used by young children

point of view single point in space from which something is viewed

pointillism small dots of colour used to paint an image (like pixels on a computer screen)

polymer clay commercial acrylic modelling clay that may be hardened by baking in a regular oven at very low temperatures

pop-up book picture book, usually for children, with papers folded and arranged to lift up three-dimensionally from the page

porcelain fine white clay with a very smooth surface that may be used for thin-walled vessels

portfolio collection of artwork selected by an artist to represent the range of his or her abilities or a particular theme

portrait image of a face

pose 1. position or stance of a figure; 2. to hold a position or gesture for a period of time so that it may be observed

positive space shape or form that represents an object rather than its surrounding space; distinct from negative space

potter's wheel see appendix A

pottery handmade object of clay

PowerPoint software program used for organizing and displaying a slideshow of images

primary term used for students in grades 1–4

primary colours red, blue, and yellow; used when mixing pigment-based colours; electronic media use magenta (intense pink), cyan (transparent blue) and yellow, or CMYK; distinct from the colours that compose white light

principles of design schema by which the elements in an artwork are organized. The principles of design are: balance, proportion (comparative sizes and scale), movement and expression, emphasis (dominance and subordination, and focal point), contrast and variety, unity and harmony, and repetition (pattern and motif) and rhythm.

printing plate surface used to transfer paint or ink onto paper; a material that is altered (carved, etched, or built-up) to produce an image, or multiple images, when printed

printmaking art of creating and transferring an image from a printing plate onto another surface

product end result of a creative process; a finished artwork

profile side view

projector device – opaque projector, overhead projector, or LCD projector – used for showing a slide, transparency, or electronic image on a screen

proportion size and placement of one part of a subject as compared to another part or the whole composition

props objects used by the characters in the story or play

puppet three-dimensional model of a character operated (animated) by a person who holds and speaks for the character, using strings, sticks, Velcro, or other attachments, or mechanics. Puppets vary in size from finger-puppets to oversized, and also in type.

- marionette: operated by strings
- stick (rod) puppet: operated from below, using thin sticks
- hand puppet (such as sock puppet): worn on one hand, like a glove; may also have parts operated by thin sticks
- finger puppet: small puppet worn on a single finger; used for small audiences
- body puppet: attached to the operator's clothing and moving with the person who operates it (operator often wears black and covers his or her face so the audience is able to focus on the puppet)

- shadow puppet: two-dimensional puppet with movable parts, operated in front of a back-lit screen (shadow, or silhouette, is viewed by the audience)
- oversized puppet (including mechanical model): may require several operators and electronic controls; large, lightweight puppet may be constructed with papier-mâché parts

puppetry art of operating and voicing puppets for an audience

radial elements that appear to move outward from the centre

raku 1. type of coarse clay that withstands rapid heating and cooling; 2. rapid method of firing where organic materials are burned to created a unique, varied surface

record to capture video footage; the record button on a video camera or sound recording equipment will capture visuals and/or sound

reduced colour colour mixed with its complement becomes somewhat brown or grey; the opposite of intense and brilliant. The intensity or reduction of a colour is called its *chroma* or *chromatic scale.*

reflect to think carefully about the process and learning involved in recent work as a means to reach some personal understanding

reflected light 1. light that strikes a surface before it reaches the viewer's eye; 2. quality of light appearing on a subject

relief raised area or indent on a flat surface

relief print print made from a plate with slightly raised or lowered (carved-out) areas

repetition recurrence of elements in an artwork

representation artwork depicting a concept or subject; an artwork with recognizable subject matter

resolution clarity of an image. A high-resolution digital image, as well as the capacity of a monitor or television screen, is defined by the pixels per inch (more accurate than dpi, or dots per inch). The image resolution capacity of a camera is measured in megapixels.

rhythm principle of design; elements placed at repeated intervals throughout a composition. Rhythm can create pattern, a sense of movement, and unity in an artwork.

roles parts played by various crew members; actors in a play

rubbing paper is placed over a hard, textured surface and rubbed with a drawing tool (such as crayon or pencil) to produce a pattern; also called *frottage*

rubric guideline for assessment with descriptions for each level of development in specific expected outcomes

rule of thirds guideline used in photography suggesting that subjects placed slightly off-centre (a third of the way from the top, bottom, and/or sides) create more interesting compositions

salt dough type of flour-based dough that can be used for modelling and baked for permanency at low temperatures in a regular oven

scale relative sizes of objects; "to scale" means that objects have been reduced or enlarged according to measurements corresponding to correct proportions

scene 1. view of a landscape or other large space; 2. selected part of a story or play

scheme or **schema** system for organization

score scratch or cut into a surface (using crosshatching)

scribbled drawing loose, active drawing with multiple outlines and wandering pencil marks; also called *gesture drawing*

script written plan for a movie or theatre containing dialogue and directions

sculpt to create a three-dimensional artwork using additive (building) or reductive (carving) methods

sculpting tool any tool used to build, smooth, or carve a sculpture

sculpture three-dimensional artwork; the process of creating a three-dimensional artwork. Common materials used for sculpture include papier-mâché, clay and modelling clay, folded paper, cardboard, wood, wire, recycled materials, plaster, cement, and metal.

sculptural having three-dimensional form

secondary colours green, violet (purple), orange. Secondary colours are the result of combining two primary colours: yellow + blue = green, yellow + red = orange, red + blue = violet.

self-portrait drawing, painting, or sculpture of one's self

setting 1. background story, or place where the story happens; 2. elements in the background of an image that indicate place or atmosphere

shade 1. black (or another dark colour); 2. to add amounts of a dark colour to create a darker value

shadow area of reduced light

shadow puppet two-dimensional puppet having sticks to operate movable parts behind a back-lit screen

shape 1. defined two-dimensional enclosed area; 2. geometric objects with predictable sides (facets) and corners (apexes) – for example, square, rectangle, triangle; organic shapes have irregular edges and variations – for example, an oak leaf or bubble

shape drawing simplifying a subject into basic geometric shapes to serve as a guideline for a drawing

shareware software for free public use

shots camera or video camera angles such as:
- pan: camera moves across
- zoom: camera lens is adjusted for a progressively more close-up or distant view
- tight: a close-up view
- wide: a distant view

- tilt: front of the camera is lifted up or pointed down
- angled: camera angled so it is no longer perpendicular to the ground from left-to-right
- tracking: camera follows a moving subject

sight an angle hold a straight-edged drawing tool in the air at arm's length, parallel to a view of the side of a subject, to check the tilt of part of a subject (relative to an imagined horizontal or vertical line)

sketch quick drawing, practice drawing, or a drawing that captures an initial idea

sketchbook book with blank pages used to collect or record images and develop ideas visually, sometimes incorporating text and research; also called an *idea journal*

slab wide, flat piece of sculpture material such as clay or stone clay that has been put through a slab roller or formed with a rolling pin. Slab building refers to the use of slabs (flat pieces) of clay to create a vessel or sculpture.

slab roller machine with cylindrical rollers that presses clay into wide, flat pieces for impressing, carving, or building

slip mixture made by adding water to clay and thoroughly mixing. Slip is painted onto damp clay to alter the colour or surface texture and is also used to attach pieces of clay (in order to assist in bonding).

slump technique for forming clay where it is laid over an object to create a convex form (bulge) or a concave form (bowl)

smudge mark made when a drawing medium is intentionally or unintentionally moved over a surface

solid three-dimensional form, rather than a flat shape. Examples of geometric solids are spheres, cones, pyramids, cylinders, prisms, and cubes.

sound effect sound added to enhance an audio track or live performance, such as a door closing or animal noises

space area or depth of field suggested in an image, or encompassing a three-dimensional object

spatial relating to space, form, placement, and orientation

special effect aspect added electronically during video editing

splatter paint paint dripped and dropped from a paintbrush with result similar to spray paint

studio area equipped with art tools and materials where artists work

still life collection of objects arranged to create an interesting composition

stilts objects used to support clay pieces in a kiln to prevent glaze from touching the kiln shelf

stoneware type of clay that is fired at relatively low temperatures; the products resulting from low-temperature firing

storyboard collection of visual references, thumbnail sketches, and information that serves as a plan for illustrations, film, television, or other projects. Storyboards may be rough drafts, or become detailed, richly layered, and visually interesting artworks.

structure built object; the supporting parts of a three-dimensional construction

style qualities of an artwork that indicate its context (time, place, culture, situation, ideology, or group of artists)

subordination principle of design in which an element is less important or dominant than another, creating visual interest

surface front or top area; the paper or material on which the image is contained

surrealism art movement that valued dream images and used juxtaposition to create absurd images. Surrealist artists include Magritte and Dali.

symbolic where one object represents another object or idea

symmetry balance or mirror image from one part of an image or form to another. The two parts of a mirror image are said to be symmetrical.

tableau drama form, where actors use their bodies to recreate a still image or snapshot of a scene

tangram geometric shape (such as parallelogram, triangle, or square) that may be arranged with other shapes to make patterns or pictures

technique particular method used to create a work of art. Different art media, tools, styles, and subjects require using different techniques.

template pre-drawn or pre-cut image used to create multiple copies. Students should be encouraged to create their own templates by drawing on Manila tag (file folders) and cutting out their own original designs, rather than using manufactured or copyrighted templates.

tertiary colour colour that results from combining a primary colour and a secondary colour; for example, yellow-green, blue-violet, red-orange

tessellation mosaic or artwork with interlocking shapes and patterns and no negative space that is organized on a grid. Artists such as M.C. Escher used grid drawing to created tessellated images. Tessellated images are most interesting if each tile is a complex interlocking shape, or when the grid appears to bend around a three-dimensional form.

text words of a story, poem, caption, research project, or other written work

texture 1. element of design; 2. the tactile quality, or how something feels when touched; 3. marks drawn to represent the surface qualities of an object (for example, rough, bumpy, smooth, furry, soft); 4. recreating a surface by adding textured material to paint or collage

theme central idea or subject of an artwork or series of works

three-dimensional having height, width, and depth; solid in form

thumbnail sketch small, quick drawing intended to quickly capture an idea or gesture

tint white added to a colour to produce a lighter value of that hue

tone term sometimes substituted for *value* when discussing reduced colours

tools objects used by an artists to manipulate art materials, for example, paintbrushes, wire-cutters, and pencils

transform change

transparency quality of being clear and see-though; opposite of *opacity*

tripod three-legged stand used to hold a camera or video camera steady in order to produce a focused shot; tripods are required for long-exposure shots

two-dimensional having height and width on a single, flat plane

two-point perspective schema for drawing three-dimensional shapes on a two-dimensional plane. Two vanishing points are place along a horizon line, and receding angles are derived by connecting the top and bottom of each vertical line to a vanishing point.

typography art of creating or applying fonts or letter designs

unity principle of design; the integrity of a composition; the careful arrangement of elements to create a seamless whole

USB port universal (widely used) opening used to connect devices and transfer data to and from a computer

value chart gradual shift from light to dark values; series of shades from white to black

value areas of light and dark colour; areas of reflected light and shadow

vanishing point receding parallel lines appear to meet at this point, usually along a horizon line

vantage point particular place from which a scene or subject is viewed; where the viewer is in relation to the subject, for example, a view from above, below, front, or back

variety principle of art; creating contrast or interrupting a predictable placement or pattern to create tension and visual interest

vertical straight up and down; at a 90° angle to the horizon

video short film

video camera camera for recording action

videographer person who makes videos

video tutorial online resource for learning step-by-step how to use a particular tool, product, or computer program

viewfinder 1. rectangular opening or LCD screen on a camera; 2. a rectangular opening cut into a card to mimic a camera's view or the shape of a drawing surface; used to help the viewer select an area of a subject for a composition

vine charcoal form of charcoal (burnt wood) used for drawing; thinner and less black than compressed charcoal

virtual created imaginatively and/or electronically, rather than real

viscosity consistency (thinness or thickness) of a liquid material such as paint

visual literacy ability to view, create, understand, think about, and communicate through images

visual metaphor using one subject to represent another subject, object, idea, or story in an artwork

visual reference object, photograph, person, book, or other image that an artist observes while planning or creating an artwork

visual tension imbalance, variety, or emphasis of elements or subjects in a composition

visual weight quality and/or placement of elements in a composition that allows them to harmonize or contrast with other elements. Contrasting elements or subjects are noticed first (overbalance other elements) and are therefore said to have greater visual weight.

volume three-dimensional solid (for example, cylinder, sphere, cube, pyramid)

warm colour colour with the tone of red, orange, or yellow

wash watery application of paint (watery enough to allow pencil or pen marks to show through)

wet-in-wet technique applying watercolour paint to wet paper

width horizontal measurement (from one side to another)

wire thin strand of metal used as an art material

work artwork; "the work" refers to a collection or series of artworks

TIPS FOR MANAGING PAINT IN THE CLASSROOM APPENDIX C

Painting is a messy activity. Water spills – and it is often the teacher who spills it. Paint ends up on the floor. Tables need washing. Students get paint on their hands and on whatever they are wearing. There are reasons why artists work in studios and wear dark clothing!

Painting activities do not have to destroy your classroom, however. With some planning, painting can be a calm, enjoyable, everyday activity for both you and your students. Here are some suggestions:

- Cover tabletops and/or desks with newspapers. You will then have to wipe up only a few spots at the end of the session.
- Place a large garbage can in an accessible location to all. Small wastebaskets will not hold large scraps of paint-splattered, rolled-up newspapers.
- Wear paint smocks. If students cannot bring in old shirts from home, buy inexpensive shirts at second-hand stores. Wash, and bring to the classroom for students to wear. Most paints do not wash easily out of clothing, and some families will not have the resources to buy new school clothes. It is important for students to focus on painting without worrying about ruining their clothing or of the consequences they may face if they do get paint on their clothing.
- Use block tempera paints. These paints are easy to clean up – just wipe them and stack the trays. (Do not stack the blocks together when they are wet. When they dry, you will need a crowbar to pry them apart.) Liquid tempera paint may be set out in Styrofoam egg cartons – just close the lids and store them for up to two weeks.
- Set up a place to store wet paintings. It is best to lay wet paintings flat – paint may drip if the paintings are left hanging to dry. Workable solutions include putting down a couple of plastic tablecloths in the hallway, setting up a drying rack, or spreading newspapers along the edges of the classroom.
- Set up a "painting centre" in one corner of the classroom – on a tiled portion of the floor and near a sink, if possible. Four or five students can paint while the rest of the students carry on with other activities. If you have very young students, try to find an assistant, parent-volunteer, or older student(s) to help with clean up.
- Be prepared for "exploration" behaviour when you first introduce paint. Students who are unfamiliar with painting, regardless of age, will be tempted to touch paint and make marks with their fingers. They may take a very long time to complete a painting; they are too busy learning how to mix colours and handle a paintbrush. They may become quite excited and not want to stop at the prescribed time, or they may be quite hesitant to make a mark on paper. You will need extra patience – until your students settle in and think of painting as a normal school activity.

- Have a supply of water handy. If there is not a sink in your classroom, keep pails of soapy water and a roll of paper towels or sponges on some newspaper in a corner of the classroom. Use one pail for collecting paintbrushes at the end of a session – this will prevent the paint from hardening on the brushes. Use another pail for hand washing. Keep a third pail for washing tables and wiping paint spills. Make sure paper towels and rags or sponges are handy.

- Plan your first paint sessions to end 10 minutes before recess or break time. You can insist that the students' area (or the entire classroom) is cleaned up before the students leave the classroom.

- Give students specific clean-up tasks. It is not enough to say: "Everyone clean up!" Chaos will ensue. Put students in charge of specific jobs, and the clean up will go quickly and smoothly. Even young students (after some practice) can collect brushes and paints, wash brushes, wipe paint trays, remove newspapers from desks, wipe desks, and spot-wipe the floor.

As your students become experienced with paint and the clean-up routine, painting sessions become much easier. My daughter said one of her teachers established a simple solution: "When we need paint we just take it out of the art cupboard. Then we clean up our own mess."

SOFTWARE FOR GRAPHIC DESIGN APPENDIX D

Many software programs are available for graphic design, presentation, animation, and editing photographs and video. You can preview many of these software programs on the Internet. In addition, video tutorials, free downloads, and/or free trial periods are available for many programs.

The following list includes some of the software programs used in many elementary schools (this is not a comprehensive list):

- Paint (Microsoft) for combining text, computer drawing, and photographs
- Word (Microsoft) for combining text and photos
- Comic Life for combining photos, speech bubbles, and comic book effects
- Photo Story (Microsoft) for presentations combining text, photos, video effects, and voice-over
- PowerPoint (Microsoft) for presentations combining text, photos, and design
- Keynote (Mac) for presentations combining text, photos, video, and design
- iPhoto (Mac) to manage and edit photographs
- PhotoImpression (Arc Soft) to manage, edit, and alter photographs
- Pivot Stickfigure Animator (free download) for animation
- Google SketchUp for 3D drawing
- SWiSH for animation
- Flash Animator for animation
- iMovie (Mac) for video, text, sound, and stop-animation
- Photo Booth (Mac) for instant photo effects
- TUX Paint (open source, free download) for simple drawing, colour, and effects

APPENDIX E USEFUL WEBSITES

All of the websites below appear in *Teaching Art*. You can explore many of the ideas presented in the book by visiting these sites on your own. This list was current at the time of publication; however, site addresses frequently change. Portage & Main maintains an up-to-date list on their website <www.pandmpress.com>.

(page 16) Philosophy of Reggio Emilia schools:
 http://ecrp.uiuc.edu/v3n1/hertzog.html

(page 22) United States Department of Education position on art education:
 http://www.ed.gov/teachers/how/tools/initiative/updates/040826.htm

(page 22) How arts education provides an effective medium for integrated, interdisciplinary learning:
 http://www.princetonol.com/groups/iad/

(page 22) Some benefits of teaching art in the classroom:
 http://www.ltta.ca/discussionzone/press/LTTAjun03-ResearchReport.pdf

(page 23) The contributions of art to understanding and developing other subject areas:
 http://www.swartzentruber.com/40-importance-of-art-education.htm

(page 38) Visual thinking strategies and an illustrative video of students using visual thinking strategies:
 http://www.vam.ac.uk/files/file_upload/5756_file.pdf
 http://www.youtube.com/watch?v=aVzcknOWpaE

(page 39) Learning environment:
 http://www.designshare.com/Research/Tarr/Aesthetic_Codes_1.htm

(page 46) Julian Beever's sidewalk chalk illusions:
 http://users.skynet.be/J.Beever/pave.htm

(page 50) The Generic Game by Project Muse:
 http://life.familyeducation.com/museums/art-appreciation/36139.html

(page 152) Altered book resources:
 http://naturebooksart.wordpress.com/

(page 158) Cannes Lions advertising awards videos:
 http://video.google.ca/videosearch?q=cannes+lions&hl=en&emb=0&aq=f#

(page 161) Dove campaign for self-esteem:
 http://www.dove.ca/en/default.aspx#/features/videos/video_gallery.aspx[cp-documentid=9150719]/

(page 165) Olivia Gude's Spiral Art Education website:
 http://spiral.aa.uic.edu

(page 178) Art City website:
http://artcityinc.com/media/

(page 179) Graffiti Art Programming Inc:
www.graffitigallery.ca

(page 242) Creative and critical thinking skills:
http://www.ted.com/talks/ken_robinson_says_schools_kill_creativity.html

(page 242) Empty Bowls:
www.emptybowls.org

(page 242) Brush Out Poverty:
www.brushoutpoverty.org

(page 271) Enneagram method of determining personality type:
www.eclecticenergies.com

(page 288) Freeze Frame:
www.freezeframeonline.org

(page 289) Argyle Alternative High School website:
http://www.wsd1.org/argyle/home/Home.html

Visual Art/Fine Arts Curriculum Documents

Canada

Alberta: http://education.alberta.ca/teachers/program/finearts/resources.aspx

British Columbia: www.bced.gov.bc.ca/irp/irp_fa.htm

Manitoba: www.edu.gov.mb.ca/k12/cur/arts/index.html

Ontario, elementary: www.edu.gov.on.ca/eng/curriculum/elementary/arts.html

Ontario, secondary: www.edu.gov.on.ca/eng/curriculum/secondary/arts.html

New Brunswick: http://www.gnb.ca/0000/publications/curric/vacok-8.pdf

Newfoundland Labrador: www.ed.gov.nl.ca/edu/k12/curriculum/guides/art/index.html

Northwest Territories: see Saskatchewan

Nova Scotia: www.ednet.ns.ca/index.php?t=sub_pages&cat=90

Nunavut: see Alberta

Prince Edward Island: http://www.gov.pe.ca/photos/original/ed_arts_found.pdf

Quebec: www.learnquebec.ca/en/content/curriculum/arts/

Saskatchewan: http://www.sasked.gov.sk.ca/docs/artsed/

Yukon: see British Columbia

United States

Alaska: www.eed.state.ak.us/tls/Frameworks/arts/5instrc6.htm#visual

California: www.cde.ca.gov/ci/cr/cf/documents/vpaframewrk.pdf

Illinois: www.isbe.state.il.us/ils/fine_arts/standards.htm

New York: www.emsc.nysed.gov/ciai/cores.html#ARTS

Australia

www.curriculum.edu.au/ccsite/cc_arts,17881.html

APPENDIX F ONLINE RESOURCES

This is by no means a complete list. Teachers are encouraged to seek out artists and artworks that have relevance and resonance with their students, local issues, and topics of study. Find local artists, artists from a variety of cultural backgrounds, and contemporary and historical artworks. Try local museums and galleries, artist-run galleries, arts education associations, community arts programs, and online resources.

This list was current at the time of publication; however, site addresses frequently change. Portage & Main maintains an up-to-date list on their website <www.pandmpress.com>.

MoMA (Museum of Modern Art, New York) offers online workshops, websites, and collections at:
http://www.moma.org/learn/programs/ed ucators#educators_online

Andy Warhol Museum (Pittsburgh, Pennsylvania) offers extensive resources and lessons, as well as teacher workshops, at:
http://www.warhol.org/education/index.html

Guggenheim Bilbao (Barcelona) offers lesson plans and projects at:
http://www.guggenheim-bilbao.es/aprendiendo_arte/secciones/aprendiendo_arte/introduccion.php?idioma=en

National Gallery (London, England) has resources for teachers, including selected artworks, online tours, and projects at:
http://www.nationalgallery.org.uk/education/default.htm

National Gallery of Canada (Ottawa, Ontario) has extensive images from its exhibitions and collections online at:
http://www.gallery.ca/english/index.html

Vancouver Art Gallery (Vancouver, British Columbia) has a virtual exhibition of the work of Emily Carr and online teacher's guides at:
http://www.virtualmuseum.ca/Exhibitions/EmilyCarr/en/index.php

Winnipeg Art Gallery (Winnipeg, Manitoba) features condensed virtual tours of current exhibits at:
http://wag.ca/

The Morris and Helen Belkin Art Gallery at the University of British Columbia (Vancouver) offers teacher resources, including online curricula and websites relating to cultural aspects of their exhibits at:
www.belkin.ubc.ca/

Berkeley Art Museum (Berkeley, California) offers an online gallery for children, with questions designed to activate their visual awareness at:
http://www.bampfa.berkeley.edu/education/kidsguide/welcome/welcomekids.html

REFERENCES

References Cited

Arnheim, Rudolf. *Visual Thinking*. Berkeley and Los Angeles: University of California Press, 1969.

Bloom, Benjamin. *Taxonomy of Educational Objectives, Handbook I: The Cognitive Domain*. New York: David McKay, 1956.

Brittain, W. Lambert. *Creativity, Art and the Young Child*. New York: Macmillan, 1979.

Chapman, Laura H. *Approaches to Art in Education*. New York: Macmillan, 1978.

Clarke, Pauline, Thompson Owens, and Ruth Sutton. *Creating Independent Learners*. Winnipeg: Portage & Main Press, 2007.

Edwards, Betty. *Drawing on the Right Side of the Brain: A Course in Enhancing Creativity and Artistic Confidence,* rev. ed. Los Angeles: Tarcher, 1989.

Eye Witness series. Toronto: Stoddart, 1990.

Falconer, Ian. *Olivia*. New York: Atheneum Books for Young Readers, 2000.

Gardner, Howard. *Intelligence Reframed: Multiple Intelligences for the 21st Century*. New York: Basic, 2000.

_____. *The Theory of Multiple Intelligence*. New York: HarperCollins, 1983.

_____. *Artful Scribbles: The Significance of Children's Drawings*. New York: Bann Books, 1980.

Hertzog, Nancy B. *ECRP*. Vol. 3, No. 1, Spring 2001. University of Illinois, http://ecrp.uiuc.edu/v3n1/hertzog.html

Housen, Abigail. "Aesthetic Thought, Critical Thinking and Transfer." *Arts and Learning Journal*, Vol. 18, No. 1, May 2002.

Johnson, Paul. *Literacy Through the Book Arts*. Portsmouth, NH: Heinemann, 1993.

Kindler, Anna. "Researching Impossible? Models of Artistic Development Reconsidered." In: Eisner, Elliot, and Michael D. Day. *Handbook of Research and Policy in Art Education*. PA: Lawrence Erlbaum, 2003.

Mavrogenes, Nancy A. "A New Look at the Illustrations of Randolph Caldecott." *Reading-Canada* 5, no. 4: 239–44 (lecture), n.d.

Nitzberg, Kevan (compiler). *Why Strong Arts Programs in Schools Are Essential for All Students*, http://princetonol.com/groups/iad

Phillips, Michael, and Salli Rasberry. *Marketing Without Advertising: Easy Ways to Build a Business Your Customers Will Love & Recommend*. Berkeley, CA: Nolo, 2008.

Project Muse (developer). "The Generic Game." Harvard University, http://www.
museum-ed.org/filemanager/docents/pdfs/beachlookingatart.pdf. Adapted
from Kathrine Schlageck. Marianna Kistler Beach Museum of Art. *EARLY
CHILDHOOD NEWSLETTER*. Volume II, Issue 5, March and April 2006.

Roucher, Nancy, and Jessie Lovano-Kerr. "Can the Arts Maintain Integrity in
Interdisciplinary Learning?" *Arts Education Policy Review* 96, no. 4 (March/April
1995): 20–25.

Shaw, Charles Green. *It Looked Like Spilt Milk*. New York: Harper 1947.

Sinatra, R., and I. Stahl-Gemake. *Using the Right Brain in the Language Arts*.
Springfield, IL: Charles C.Thomas, 1983.

Swartzentruber, Don Michael. "The Academic Patriarch: An Apologetic for
Visual Art." Presented at the Midwest Scholars Conference, Indiana Wesleyan
University, 2/25/05, http://www.swartzentruber.com/40-importance-of-art-
education.htm

Tarr, Patricia. *Aesthetic Codes in Early Childhood Classrooms: What Art Educators
Can Learn from Reggio Emilia*. Calgary: University of Calgary, 2001, http://www.
designshare.com/Research/Tarr/Aesthetic_Codes_1.htm

Tucker, Bill. "Minds of Their Own: Visualizers Compose." *English Journal* (December
1995): 27–31.

Upitis, Rena, and Katharine Smithrim. "Learning Through the Arts." *National Assessment*,
1999–2002, pp. 19–21, http://educ.queensu.ca/~arts/research_reports.html

United States Department of Education. *Improve Student Performance, Teacher
Update*. August 26, 2004, http://www.ed.gov/teachers/how/tools/initiative/
updates/040826.html

von Hagens, Gunther, and Angelina Whalley. *"BODY WORLDS: The Anatomical
Exhibition of Real Human Bodies."* Exhibition Catalog. Heidelberg: Art & Sciences
Publishers, 2006.

Wilson, Marjorie, and Brent Wilson. *Teaching Children to Draw: A Guide for Teachers
and Parents*. Englewood Cliffs, NJ: Prentice-Hall, 1982.

Winner, Ellen, and Lois Hetland. "Art for Our Sake: School Arts Classes Matter More
Than Ever – But Not for the Reasons You Think." *Boston Globe*. September 2, 2007.

Yenawine, Philip. "Notes on Aesthetic Understanding and Its Development."
Interactive Learning in Museums of Art and Design, 17–18 May 2002, New York,
http://www.vam.ac.uk/files/file_upload/5756_file.pdf

Teacher References: Books to Have Handy

Dodson, Bert. *Keys to Drawing*. Cincinnati: Northern Light Books, 1990.

Edwards, Betty. *Color: A Course in Mastering the Art of Mixing Colors*. New York:
Jeremy P. Tarcher, 2004.

_____. *New Drawing on the Right Side of the Brain*. New York: Jeremy P. Tarcher,
1999.

Finley, Carol. *The Art of African Masks: Exploring Cultural Traditions*. Minneapolis:
Lerner Publications, 1999.

Goldsworthy, Andy. *Andy Goldsworthy: A Collaboration With Nature*. New York:
H.N. Abrams, 1990.

Haab, Sherri. *Making Mini-Books*. Palo Alto, CA: Klutz, 1999.

Hart, Christopher. *Anime Mania: How to Draw Characters for Japanese Animation*.
New York: Watson-Guptill Publications, 2002.

Heathfield, Adrian, and Tehching Hsieh. *Out of Now: The Lifeworks of Tehching Hsieh*.
Cambridge, MA: MIT Press, 2009.

Johnson, Paul. *Literacy Through the Book Arts*. Portsmouth, NH: Heinemann, 1993.

Lynch-Watson, Janet. *The Shadow Puppet Book*. New York: Sterling; London: Oak Tree Press, 1980.

McGraw, Sheila. *Papier-Mâché Today*. Richmond Hill, ON: Firefly Books, 1990.

Menzel, Peter. *Material World: A Global Family Portrait*. San Francisco: Sierra Books, 1995.

Robertson, Craig, and Barbara Robertson. *The Kids' Building Workshop: 15 Woodworking Projects for Kids and Parents to Build Together*. North Adams, MA: Storey Kids, 2004.

Striker, Susan (illustrated by Edward Kimmel). The Anti-Coloring Book series. New York: Holt Paperbacks, 2001.

Picture Books for Children: Books to Have Handy

Allinson, Beverley (illustrated by Barbara Reid). *Effie*. New York: Scholastic Press, 1990.

Baker, Jeannie. *Window*. New York: Greenwillow, 1991.

Baker, Keith. *The Magic Fan*. San Diego: Harcourt Brace Jovanovich, 1989.

_____. *Who Is the Beast?* San Diego: Harcourt, 2003.

Baker, Leslie. *The Third-Story Cat*. Boston: Little, Brown & Co., 1987.

Bang, Molly. *The Paper Crane*. New York: Greenwillow, 1985.

Base, Graeme. *Animalia*. New York: H.N. Abrams, 1987.

Bouchard, David (illustrated by Henry Ripplinger). *If You're Not From the Prairie*. New York: Atheneum Books for Young Readers, 2002.

Brett, Jan. *The Mitten: A Ukrainian Folktale*. New York: Putnam and Sons, 1989.

Browne, Anthony. *The Shape Game*. New York: Farrar, Straus and Giroux, 2003.

_____. *Changes*. New York: Knopf, 1990.

_____. *Piggybook*. New York: Knopf, 1986.

Bunting, Eve (illustrated by David Diaz). *Smoky Night*. San Diego: Harcourt Brace, 1994.

Carle, Eric. *The Mixed-Up Chameleon*. New York: Crowell, 1984.

Chase, Edith Newlin (illustrated by Barbara Reid). *The New Baby Calf*. New York: Scholastic, 1984.

Choi, Yangsook. *Behind the Mask*. New York: Farrar, Straus and Giroux, 2006.

Clamp. *Legend of Chun Hyang*. Los Angeles: Tokyopop, 1996.

Cleaver, Elizabeth. *The Enchanted Caribou*. New York: Atheneum, 1985.

Cooper, Helen. *The Baby Who Wouldn't Go to Bed*. New York: Doubleday, 1996.

Creighton, Jill. *8 O'Cluck*. Richmond Hill, ON: Scholastic Canada, 1995.

Denton, Kady MacDonald. *Would They Love a Lion?* New York: Kingfisher, 1995.

dePaola, Tomie. *Strega Nona*. Englewood Cliffs, NJ: Prentice Hall, 1975.

Diaz, Jorge (illustrated by Øivid S. Jorfald). *The Rebellious Alphabet*. New York: Holt, 1993.

Drake, Ernest. *Dr. Ernest Drake's Monsterology: The Complete Book of Monstrous Beasts*. Cambridge, MA: Candlewick Press, 2008.

_____. *Dr. Ernest Drake's Dragonology: The Complete Book of Dragons*. Cambridge, MA: Candlewick Press, 2003.

Eyvindson, Peter (illustrated by Rhian Brynjolson). *The Night Rebecca Stayed Too Late*. Winnipeg: Pemmican Publications, 1994.

Fagan, Cary (illustrated by Nicolas Debon). *Thing-Thing*. Toronto: Tundra Books, 2008.

Félix, Monique. *The Story of a Little Mouse Trapped in a Book*. La Jolla, CA: Green Tiger Press, 1980.

Gaiman, Neil (illustrated by Dave McKean). *The Wolves in the Walls*. New York: HarperCollins, 2003.

Hathorn, Libby (illustrated by Gregory Rogers). *Way Home*. Milsons Point, NSW, Australia: Random House, 1994.

Heyer, Marilee. *Weaving of a Dream: A Chinese Folktale*. New York: Viking Kestrel, 1986.

Hoban, Tana. *Shapes, Shapes, Shapes*. New York: Greenwillow, 1986.

Hoffman, Mary (illustrated by Caroline Binch). *Amazing Grace*. New York: Dial Books for Young Readers, 1991.

Hutchins, Hazel, and Gail Herbert (illustrated by Dusan Petricic). *Mattland*. Toronto: Annick Press, 2008.

Jurgens, Dan. *Marvel Characters*. New York: DK Children, 2006.

Kellogg, Steven. *Best Friends: Story and Pictures*. New York: Dial Books for Young Readers, Puffin, 1986.

Lawson, Julie (illustrated by Paul Morin). *The Dragon's Pearl*. Toronto: Oxford University Press, 1992.

Lionni, Leo. *Alexander and the Wind-up Mouse*. New York: Knopf, 1974.

Littlechild, George. *This Land Is My Land*. Emeryville, CA: Children's Book Press, 1993.

Macaulay, David. *Black and White*. Boston: Houghton Mifflin, 1990.

Marzollo, Jean (photographs by Walter Wick). I Spy series. New York: Scholastic Press, 1993.

McGugan, Jim (illustrated by Murray Kimber). *Josepha: A Prairie Boy's Story*. San Francisco: Chronicle Books, 1994.

McLellan, Joe, and Matrine McLellan (illustrated by Rhian Brynjolson). *Goose Girl*. Winnipeg: Pemmican Publications, 2007.

McNaughton, Colin. *Suddenly!* San Diego: Harcourt Brace, 1995.

Mayer, Mercer. *A Boy, a Dog and a Frog*. New York: Dial, 2003.

_____. *Frog, Where Are You?* New York: Dial Book for Young Readers, 1969.

Milne, A.A. (illustrated by Ernest Shepard). *The House at Pooh Corner*. New York: Puffin Books, 1992.

Muller, Robin. *The Magic Paintbrush*. New York: Viking Kestrel, 1990.

Munsch, Robert, and Michael Kusugak (illustrated by Vladyana Krykorka). *A Promise Is a Promise*. Toronto: Annick Press, 1988.

Newbery, Linda (illustrated by Catherine Rayner). *Posy!* New York: Atheneum Books for Young Readers, 2008.

Oppenheim, Joanne (illustrated by Barbara Reid). *Have You Seen Birds?* New York: Scholastic Press, 1990.

Pan Macmillan (illustrated by Angela Brooksbank). *My Busy Colors*. London: Pan Macmillan, 2008.

Reid, Barbara. *The Subway Mouse*. New York: Scholastic Press, 2005.

_____. *The Party*. New York: Scholastic Press, 1997.

Rosen, Michael (illustrated by John Clementson). *How the Animals Got Their Colors: Animal Myths from Around the World*. San Diego: Harcourt Brace Jovanovich, 1992.

Sandved, Kjell B. *The Butterfly Alphabet*. New York: Scholastic Press, 1996.

Say, Allen. *Once Under the Cherry Blossom Tree: An Old Japanese Tale*. New York: Harper and Row, 1974.

Sendak, Maurice. *Where the Wild Things Are*. New York: HarperCollins, 1991.

Service, Robert (illustrated by Ted Harrison). *The Cremation of Sam McGee*. New York: Greenwillow, 1987.

Tankard, Jeremy. *Grumpy Bird*. New York: Scholastic Press, 2007.

Thomson, Sarah L. (illustrated by Rob Gonsalves). *Imagine a Night*. New York: Atheneum Books for Young Readers, 2003.

Tibo, Gilles. *Simon and the Snowflakes*. Plattsburgh, NY: Tundra Books, 1988.

Toye, William (illustrated by Elizabeth Cleaver). *The Loon's Necklace*. Toronto: Oxford University Press, 1977.

Van Allsburg, Chris. *The Mysteries of Harris Burdick*. Boston: Houghton Mifflin, 1984.

_____. *Jumanji*. Boston: Houghton-Mifflin, 1981.

Viorst, Judith. *Alexander and the Terrible, Horrible, No Good, Very Bad Day*. New York: Aladdin Books, 1987.

Watterson, Bill. *The Essential Calvin and Hobbes*. Kansas City: Andrews and McMeel, 1988.

Wiesner, David. *Tuesday*. New York: Clarion Books, 1991.

Wildsmith, Brian. *Brian Wildsmith's Animal Gallery*. Don Mills, ON: Oxford University Press, 2008.

_____. *Saint Francis*. Grand Rapids, MI: Wm. B. Eerdmans, 1996.

Willems, Mo. *Knuffle Bunny: A Cautionary Tale*. New York: Hyperion Books for Children, 2004.

Wynne-Jones, Tim (illustrated by Eric Beddows). *Zoom Away*. New York: HarperCollins, 1993.

_____. *Zoom Upstream*. Toronto: Douglas & McIntyre, 1992.

Yolen, Jane (illustrated by John Shoenbarr). *Owl Moon*. New York: Philomel Books, 1987.

Videos to Have Handy

The Nightmare Before Christmas. Written by Tim Burton, directed by Henry Selick. DVD. Disney, 1993.

Wallace and Grommet: Three Amazing Adventures. Directed by Nick Park. DVD. Dreamworks Animated, 2005.

INDEX

R

radial symmetry, 127
raku, 232, 238, 240
Rallison, Ann, 218–219
Re Tale, 291
reduced colour, 80, 173, 176, 185
reduction prints, 218–219
reflected light, 94
Reid, Barbara, 221, 223
relief, low-relief images, 221–224
relief prints, 213–219
repetition, 126, 132–133
representation, realism and, 63, 65
resolution, 276
rhythm, 132
rice paper, 213–219
Ringgold, Faith, 38
Rivera, Diego, 44, 107
Riverbank Loan & Savings Company, 292
roller painting, 193–194
rubbings, 75, 193
rubrics, 56–57
rule of thirds, 278

S

safety precautions
 cordless drill, 267
 film development, 276
 fire-retardant sprays, 262
 food allergies, 75
 food containers, 232, 239
 hand tools, 218, 266
 hot-glue dispensers, 205, 230, 247, 253, 255, 259, 265
 kilns, 239
 paints, 182
 plaster, 252
 plastic wrap, 263
 recycled electronic parts, 265
 safety glasses, 265, 267
 special-needs students and, 34
 wet cement, 264
 wire cutting, 265
La Sagrada Família (Gaudi), 38
salt dough, 228–229
sand, paint mixed with, 196
sandpaper
 as textured material, 10, 73, 193
 see also sculpture
scale, 127–128, 146
scenes, 138, 141–142, 147, 155
Schapiro, Miriam, 203
schemes, 172, 176, 177
Schiele, Egon, 37
scoring, 234

scrapbooking paper, 204, 207
scribbled drawing, 67, 68, 110
sculpting, 237, 248
sculpture, 108, 127, 225, 230, 232, 235, 237–238
 portraits and, 108
 see also clay and clay substitutes; construction; masks; puppets
secondary colours, 170, 201
Self-Portrait with Cropped Hair, 107
self-portraits, 103–108, 270–271
Sessō Tōyō, 90
settings, 155, 201
Seurat, Georges-Pierre, 185
shade, 174, 184
shadow
 depth and, 80, 83
 drawing media and, 90, 94–95
shadow puppets, 153–156
shape, 67–70
 challenging subjects and, 101, 104–106, 110–113
 collage and, 203–205, 207
 drawing media and, 91, 94, 95, 98
 illustration and, 142–143, 145, 149–150, 154
 modelling clay and, 222, 223
 painting and, 192, 194–195
sighting an angle, 82, 101
single-point perspective, 80, 81–82
Sixteen Jackies, 44
size, 127–128
sketchbooks, 12–15, 35, 45, 63–65, 270
 see also design, elements of; drawing media; illustration; painting
skin tones, 176
slab rollers, 235
slabs, 235–237
slab building, 235–236
slip, 233, 234, 236, 238
slump, 236
smocks, 190
smudge, 94
Snow, Michael, 100
sock puppets, 256
software, 313
solids, 77, 79, 82–83, 111, 223–224
Sometimes the Heart Is Tuned to Sadness, 128
sound effects, 282, 285
space, 79–85
special effects, 280–282, 286
special-needs students, 30–34, 173
splatter paint, 191
sponge painting, 191–192

Spotlight
 Argyle Alternative High School video programs, 288–289
 art education meets social justice, 242–243
 art in the pre-primary classroom, 86–87
 an art program that meets students' needs, 120–121
 community art centres, 178–179
 displaying student artwork, 60–61
 encouraging student expression, 270–271
 principles of possibility, 164–165
 printmaking, 218–219
 teaching art to teachers, 18–19
stages of development, 25–36
stencils, 191, 192, 194
stick puppets, 127
still life, 14, 185
stilts, 239–240
stoneware, 232
storage, 10, 12, 39
storyboards, 139–147, 159, 285
string paintings, 195
structure, 68, 80
 masks, 249–250, 255
student portfolios, 58–59, 60, 66
students
 gifted, 34–36
 social needs of, 120–121
 with special needs, 30–34, 173
 very young, 25–26, 69, 86–87, 102, 106, 189–196
 young, 102–103
subjects that are challenging to draw, 101–118
 composite creatures, 101, 114–118
 figures, 109–114
 portraits, 102–109
subordination, 129–130
Suh, Do Ho, 271
surrealism, 96, 100, 138, 164
Sydney Opera House, 42
symbolism, 175, 176
symmetry, 126–127

T

talented students, 34–36
tangrams, 69, 127
tape, 131
 see also construction; painting
Tascona, Tony, 43
tear-and-paste, 69–70
tempera paint, 93, 168, 175, 182–183, 185, 196, 239, 266

Image Credits

Every effort has been made to trace original sources of art and photographs contained in this book. The publisher would be grateful to hear from copyright holders to rectify any errors or omissions in future printings.

References below refer to images in the "Viewing" boxes and images of the author's art that appear on the pages specified.

The publisher has made every effort to acknowledge all sources listed below.

Page 3: *War Zone*. Collection of Vern Wiebe. Used with permission.

Page 43, Figure 3.8: Tony Tascona, *Yellow Transmission*, 1961 © CARCC, 2009. Image courtesy of the Centre for Contemporary Canadian Art.

Page 44, Figure 3.9: Andy Warhol, *Sixteen Jackies*, 1964. acrylic, enamel on canvas, 80-3/8 x 64-3/8", 81-7/16 x 65-5/16 x 2-1/8" installed. Collection Walker Art Center, Minneapolis, Art Center Acquisition Fund, 1968. © Andy Warhol Foundation for the Visual Arts/SODRAC (2008).

Page 45, Figure 3.10: Meret Oppenheim (1913–1985) © ARS, NY. *Object* (Le Dejeuner en fourrure). 1936. Fur-covered cup, saucer and spoon. Cup, 4 3/8" diameter; saucer, 9 3/8" diameter; spoon, 8" long; overall height 2 7/8". (130.1946a-c). Digital Image © The Museum of Modern Art/Licensed by SCALA/Art Resource, NY. The Museum of Modern Art, New York, NY, USA. © Estate of Meret Oppenheim/SODRAC (2008).

Page 50, Figure 3.13: The *Indian in Transition* by Daphne Odjig, 1978. Photo © Canadian Museum of Civilization, artifact no. III-M-15, image no. IMG2008-0624-0001-Dm.

Page 63: *And This Is Me*. Collection of Bob Haverluck. Used with permission.

Page 71, Figure 5.12: Reproduced with the permission of Dorset Fine Arts. Photography courtesy of Feheley Fine Arts.

Page 76, Figure 5.22: Whistler, James Abbott McNeill (1834–1903). *Arrangement in Grey and Black No. 1, or The Artist's Mother*. 1871. Oil on canvas, 143.3 x 162.5 cm. RF 699. Photo: J. G. Berizzi. Musee d'Osay, Paris, France; Réunion des Musées Nationaux/Art Resource, NY.

Page 90, Figure 6.2: © The Trustees of the British Museum.

Page 95, Figure 6.12: Arshile Gorky, American, 1904–1948, b. Armenia, *The Artist's Mother*, 1926 or 1936, charcoal on ivory laid paper, 630 x 485 mm, The Worcester Sketch Fund, 1965.510, The Art Institute of Chicago. Photography © The Art Institute of Chicago.

Page 96, Figure 6.16: Breton, André (1896–1966) © ARS, NY, and Tzara, Tristan, Hugo, Valentine and Knutson, Greta. Exquisite Corpse (Cadavre exquis): *Landscape*. (c. 1933) Composite drawing: colored chalk on black paper, 9½ x 12½". Purchase. (281.1937). The Museum of Modern Art, New York, NY, U.S.A. Digital Image © The Museum of Modern Art/Licensed by SCALA/Art Resource, NY; © Estates of André Breton and Valentine Hugo/SODRAC (2008); By permission of the estate of Tristan Tzara and Greta Knutson-Tzara.

Page 102, Figure 7.2: Van Gogh Museum Amsterdam (Vincent van Gogh Foundation).

Page 107, Figure 7.12: © 2009 Banco de México Diego Rivera & Frida Kahlo Museums Trust. Av. 5 de Mayo No.2, Col. Centro, Del. Cuauhtémoc 06059, México, D.F.; Digital Image © The Museum of Modern Art/Licensed by SCALA/Art Resource, NY.

Page 109, Figure 7.17: Digital Image © The Museum of Modern Art/Licensed by SCALA/Art Resource, NY.

Page 123: *Inside Out*. Used courtesy of the author.

Page 128, Figure 8.5: Courtesy Bob Haverluck, *Sometimes the Heart Is Tuned to Sadness*, 2007.

Page 136, Figure 9.5: Used courtesy of Pemmican Publications.

Page 142, Figure 9.11: Used courtesy of Pemmican Publications.

Page 154, Figure 9.40: Courtesy of the Center for Puppetry Arts, Atlanta, GA, USA.

Page 167: *A Curious Subject*. Collection of Vern Wiebe. Used with permission.

Page 175, Figure 11.12: Minneapolis Institute of Arts, The John R.Van Derlip Fund.

Page 197, Figure 14.1: Courtesy of Patrick Dunford.

Page 203, Figure 15.1: Miriam Schapiro, *Provide*, 1982. Acrylic and fabric on tan wove paper, 34 ¾ x 35 ¾". National Academy Museum, New York (2000.12).

Page 216, Figure 16.11: Carlos Cortéz, *Welcome Home!*, 1965, linocut, N.N., 11" x 8 1/2" (paper size), National Museum of Mexican Art, Permanent Collection, 2000.24, Gift of the artist. Photo credit: Kathleen Culbert-Aguilar.

Page 223, Figure 17.3: Image taken from *Peg and the Yeti*. Text copyright © 2004 by Firewing Productions Inc. Illustrations copyright © 2004 by Barbara Reid. Photography copyright © 2004 by Ian Crysler. Published by HarperCollins Publishers Ltd. All rights reserved.

Page 225: *Cute Couple*. Collection of Iain Brynjolson. Used with permission.

Page 233, Figure 18.12: Daumier, Honoré (1808–1879). *François Guizot (1787–1874), French politician and historian,* 1833. Painted clay, 22.5 x 15.4 cm. Inv.: RF3493. Photo: Hervé Lewandowski. Musee d'Orsay, Paris, France; Réunion des Musées Nationaux/Art Resource, NY.

Page 241, Figure 18.29: Courtesy Howard University Gallery of Art, Washington, DC.

Page 245, Figure 19.1: Pitt Rivers Museum, University of Oxford. Four painted wooden masks used in Nō theatre productions. Clockwise from top left; a woman; a man; an old man; an angry female spirit. 1884.114.34, 1884.114.50, 1884.114.9, 1884.114.56.

Page 272: *Holding Hands*. Courtesy of Richardson International Limited.

Page 279, Figure 21.4: *Mud. River. Dreamer*. Courtesy of Sam Baardman, digital print on archival paper in pigment inks, 13" x 19".

Page 287, Figure 22.4: Ackland Art Museum, University of North Carolina at Chapel Hill. Ackland Fund; Courtesy Carl Solway Gallery, Cincinnati, OH. Photographer: Chris Gomien.

Page 291, Figure 23.1: Lyndsay Ladobruk, *Re Tale*, 2009. Photograph by Roslyn Stanwick.

Page 292, Figure 23.2: Courtesy of Riverbank Loan & Savings Company. Photographs by Sam Baardman. Used with permission.